Romanesque Sculpture

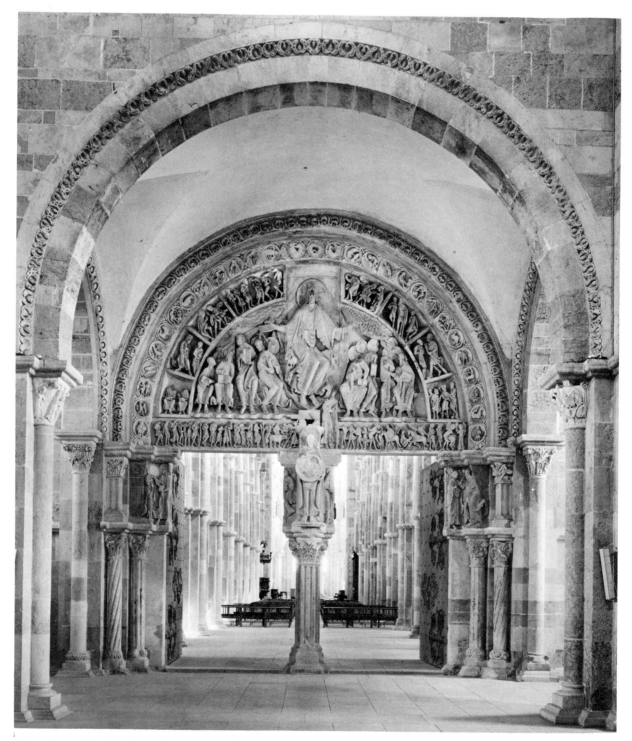

Central portal inside the narthex, La Madeleine, Vézelay. (Hirmer Fotoarchiv)

Romanesque Sculpture

*The Revival of Monumental Stone Sculpture
in the Eleventh and Twelfth Centuries*

M. F. HEARN

CORNELL UNIVERSITY PRESS
ITHACA, NEW YORK

First published 1981 by Cornell University Press.
First printing, Cornell Paperbacks, 1985.

Printed in the United States of America

Library of Congress Cataloging in Publication Data

Hearn, Millard Fillmore, 1938–
 Romanesque sculpture.

 Bibliography: p.
 Includes index.
 1. Sculpture, Romanesque. I. Title.
NB175.H39 734′.24 80-14383
ISBN (cloth) 0-8014-1287-0
ISBN (paper) 0-8014-9304-8

To Olivia Richey Hearn
and in Memory of
Anthony Jaroslav Srba

Contents

Acknowledgments

While writing this book I have incurred debts for assistance, which I gratefully acknowledge.

My colleagues in the Fine Arts Department of the University of Pittsburgh have generously shared their time and knowledge. John Williams gave many hours in discussion from the middle stages of research to the completion of writing, read the text in its first revised state, and offered helpful suggestions, especially for the first chapter. David Summers provided numerous bibliographical suggestions related to art theory and discussed various points at great length before I formulated the passages related to aesthetics in the second, third, and fifth chapters. Carl Nordenfalk read the entire first draft and gave helpful criticisms on a number of specific points. John Haskins generously assisted on issues related to the earlier art of migratory tribes in Eastern Europe and with several thorny points in the translation and interpretation of documents. Anne Weis, with the collaboration of William Panetta and Nicholas Jones of the Classics Department, kindly contributed translations of a difficult medieval Latin poem and an inscription.

The graduate students in my seminars on Romanesque sculpture from 1969 through 1974 stimulated both my thinking and my research, and some of them participated in the investigation of problems directly related to this project. In several cases they had insights or made discoveries which I accept as valid contributions and which are duly acknowledged in the notes. Two of these instances involved discoveries that have been developed into M.A. theses, available to readers in the Frick Fine Arts Library of the University of Pittsburgh. When a study is not available for consultation, however, full documentation for the relevant points is included in the notes. By citing these investigations I do not mean to set up my students as authorities but to give credit to those whose research efforts under my direction have aided my own.

Friends and colleagues outside the Fine Arts Department, too numerous to mention individually, have called my attention to useful bibliographical items and have given their encouragement through interest in this project. Two colleagues from outside the University of Pittsburgh, however, should be thanked separately. Carra Ferguson O'Meara, Georgetown University, generously read the first draft and made a number of helpful suggestions. And Thomas W. Lyman, Emory University, gave a meticulous reading of the last draft and offered textual criticisms from which the final version has greatly benefited.

Despite this abundant help and advice, I have not followed all the proffered suggestions. As a result, in some instances I undoubtedly have failed to correct errors which I might otherwise have avoided. So, while much of any merit ascribed to this book must be credited to others, I must accept full responsibility for all the shortcomings of my text.

Almost all my research was accomplished in the Frick Fine Arts Library and the Hillman Library of the University of Pittsburgh. I am particularly indebted to Elizabeth Fitton Folin, the former Frick Librarian, and to Elizabeth Booth, the recent Frick Librarian, together with Sherman Clarke and Barbara Salthouse, for their unstinting assistance. I also pursued some of my research in the New York Public Library and the Warburg Institute Library.

The University of Pittsburgh has provided most of the financial assistance requisite to carrying out this project. Through a grant from the A. W. Mellon Educational and Charitable Trust to the Fine Arts Department I was able to conduct a traveling

seminar in Europe in the summer of 1969, when I conceived the project. A Third-Term grant from the Faculty of Arts and Sciences in 1971 made possible the initial stages of research and writing. A sabbatical leave in the fall term, 1972, permitted further travel in Europe to the major sites of Romanesque sculpture. A research grant from the Faculty of Arts and Sciences in 1973 permitted me to obtain many necessary photographs.

Bette Tamenne, administrative secretary of the Fine Arts Department, has typed and retyped the manuscript with a diligence that can never be acknowledged with adequate thanks. Her cheerful assistance has been invaluable in keeping this project moving toward completion.

The encouragement and indulgence of my dean, Jerome Rosenberg, of my colleagues and students, and of my family made it possible for me to write most of this book during the years when I chaired the Fine Arts Department, 1973–1978.

M. F. HEARN

Pittsburgh, Pennsylvania

Romanesque Sculpture

Introduction

Romanesque sculpture, created in the eleventh and twelfth centuries to furnish and embellish churches, is, among the early traditions of European art, singularly alluring to twentieth-century eyes. Its formal abstraction, its grotesque expressiveness, and its imaginative treatment of spiritual themes appeal to us with such immediacy that this sculpture elicits aesthetic responses similar to those evoked by the art of our own time. Yet these carved images were produced in a period so culturally remote from our own that often their meaning and purpose are obscure to us; the circumstances of their creation, mysterious. This combination of familiarity and strangeness arouses our curiosity and, dissatisfied merely to react to it, we want to know how and why such art was made. How could work of such high caliber have been developed so rapidly when there had been no significant tradition of stone sculpture for nearly six centuries? Where did sculptors capable of this level of work come from and how did they function as artists? What purposes did this sculpture serve that made stone carving so desirable and what motivated patrons to commission such projects? To what extent does this sculpture represent the creative initiative of the artist and to what extent does it reflect the patron's own designs and desires? These questions and others related to them spurred me to conduct the investigation reported in this book.

Romanesque sculpture became the object of serious study only in the late nineteenth century. This belated concern for the earliest flowering of large-scale sculpture in Europe was one of the last manifestations of the interest in things medieval fostered by cultural Romanticism. Before that time, almost no one except antiquarians had investigated the history of Romanesque sculpture, much less admired it as great art. Since the end of the twelfth century, when the Gothic style rendered it obsolete, it generally had been regarded as barbaric and scarcely worth notice. Indeed, its very survival until our own time is due largely to a combination of benign neglect and the relative isolation of most of the great monuments from the large urban centers that were destroyed and renewed over the years.

By the time Romanesque sculpture was "rediscovered," the culture that had produced it had long vanished and no living tradition remained that could explain its meaning and the motives for its creation. Some of the great monuments had been dismantled and only fragments survived to attest to their existence. Even most of the documents that might have provided valuable information had been lost in the upheavals of Reformation and Revolution. Consequently, the pioneer scholars had virtually nothing to go on except the stones themselves. The first task they faced was simply to organize and classify the materials. Since Romanesque sculpture for the most part remains where it was originally installed, it could not be collected into museums, unlike paintings and portable objects. Wide travel was a necessity in order to acquire firsthand knowledge of the monuments, to make photographs, and to search local archives for documents. Only through this arduous method was it possible to assign dates to most monuments and to arrange them in stylistic families. Within a few years after World War I, the basic task of classification had been completed and the result was the organization of the study of Romanesque sculpture into the history of regional styles. The publication of large corpora soon placed unprecedented amounts of material in the hands of scholars everywhere. In this respect, an American, Arthur Kingsley Porter, made what was probably the most important contribution. His *Lombard Ar-*

chitecture (New Haven, 1914–1918), a still unrivaled collection of documents and photographs of north Italian churches and their sculpture, and his *Romanesque Sculpture of the Pilgrimage Roads* (Boston, 1923), with its nine volumes of photographs appended to one volume of text, covered the field more fully than any other publications.

The process of classification had been addressed almost exclusively to the formal properties of the sculpture, that is, to style. Emile Mâle in *L'art religieux du XIIe siècle en France* (Paris, 1922) attempted to redress this one-sided treatment with his study of the subject matter, or iconography, of these monuments. But despite the great impact of his work, the study of these two basic aspects of art was never truly synthesized and the greater part of scholarly activity was still devoted to formal problems. This concentration was partially inspired by the acceptance of the primitive and the grotesque in modern art, which enhanced considerably the appreciation of scholars for the parallel qualities in Romanesque images. While modernist critics such as Clive Bell (*Art* [London, 1914]) proclaimed Romanesque sculpture as one of the high points in the history of art, the central issue for medievalists revolved around the question of chronological priority among the regional styles. Very early in the process of investigation, the oldest centers were identified in France (Languedoc and Burgundy), Italy (Apulia, Emilia, and Lombardy) and Spain (Navarre, Castile, León, and Galicia). But disagreement over which was the earliest among them aroused heated controversy and the ensuing debates came to dominate all investigations. So heated was the argument that nearly everyone was drawn into the fray, permanently diverting scholars like Paul Deschamps from more fruitful lines of research, such as the relationship of the early stone sculptors to the artists of earlier traditions of ivory and gold work. Like the Hundred Years' War, this controversy over chronological priority was never finally settled but subsided into an uneasy stalemate. By the 1930s it was possible only to suggest tentatively that Romanesque sculpture did not begin in a single center but had several nearly simultaneous points of origin.

Nevertheless, the organization of the study of Romanesque sculpture into the history of regional styles made it difficult to encompass the subject in a unified conception. The attempt to create a synthe-

sis was undertaken by Henri Focillon, culminating in *L'art des sculpteurs romans* (Paris, 1931). Focillon was one of the most brilliant and perceptive art historians of his day, whose work is embued with an intellectual complexity and a poetic richness that cast a spell upon his readers. His synthesis exercised an enormous influence, which, though now much diminished, has remained pervasive until the present because no other has taken its place. Even though everyone would now agree that Focillon's work is outdated, its message cannot be escaped without conscious effort. For this reason, and also to clarify the ways in which the present book departs from his synthesis, it is appropriate to summarize here the basic points of his theory.

Because Romanesque sculpture is located primarily in structural settings, such as capitals, portals, and facades, Focillon regarded its development as that of wedding sculpture to architecture. At the point of consummation, he noted, the figures were frequently distorted, as if to fit the shape of the setting, and the compositions were so crowded, as if designed with a *horror vacui*, that almost no interval between figures remained. Moreover, the figures were often composed in such a manner as to make contact with the perimeter of the setting at as many points as was feasible. He imputed these characteristics to the observance of a "law of the frame," which he regarded as a codification of the fundamental artistic aspirations of Romanesque sculptural style. The development of this aesthetic law, however, had not resulted from a continuous evolution. It seemed to be in effect from the beginning in early-eleventh-century capitals, particularly those embellished with fantastic motifs. On the other hand, the large figural reliefs that appeared around the year 1100 seemed to embody a relatively humanistic style, the antithesis of that in the capitals. As Focillon saw it, the two styles began to coalesce around 1100–1110 and were gradually synthesized to produce the mature style of about 1125–1140. Confirmation of this dialectical process seemed to be provided by the concentration of sculpture in most monuments upon structural members rather than upon unarticulated wall surfaces. In the rare examples of frieze compositions the law of the frame was conspicuously not obeyed. But since Gothic sculpture had emerged from the tradition ostensibly ruled by the law of the frame, Focillon could be confident that the mainstream style of

Romanesque sculpture was the one he had defined as "architectural."

Although Focillon never articulated his theory in writing quite so bluntly, this summary represents fairly accurately the message it conveyed to other scholars. The purest example of that influence is found in the thesis of his student Jurgis Baltrušaitis, *La stylistique ornementale dans la sculpture romane* (Paris, 1931). Baltrušaitis, developing the theory to its logical extreme, attempted to demonstrate that the law of the frame was not merely an accurate definition of the Romanesque sculptural style but that historically it had actually produced the style. He observed that virtually every capital and large-scale composition was composed according to an abstract pattern, usually geometric in character. He deduced that the sculptors proceeded in their work after first blocking out the area to be carved with such a design. The means of making the sculpture thus became the factor that defined its formal character. Whether or not Focillon fully subscribed to this extension of his theory, the clarity of its statement reflected its meaning onto the reading of Focillon's works and enhanced considerably the promulgation of the law of the frame.[1]

Focillon's theory, without regard to its validity, proved very useful for the purpose of characterizing Romanesque sculpture in general. On the other hand, although his discussion of its development was richly larded with references to historical events and cultural associations, his concept of the revival of monumental sculpture was divorced from the real world. Despite his avowed interest in the artist and the artist's tools, materials, and techniques, he never channeled such data into his accounts of specific aspects of sculptural development. Consequently his analysis of the development of Romanesque sculpture was purely abstract and unrelated to actual circumstances of creation. Ultimately, when he sought an explanation for change and development he resorted to the Hegelian construct of historical dialectic, moved by the *Zeitgeist*. His synthesis of the history of Romanesque sculpture, then, precludes an explanation of how the sculpture was created within its medieval context.

Although most subsequent scholars have been fully aware that Focillon's synthesis was an analytical device rather than an actual process, no equally forceful formulation has appeared to take its place. Studies that are not so restricted in scope as to avoid the issue of a developmental theory are still founded upon his basic assumption that the style of Romanesque sculpture resulted from the wedding of sculpture to architecture.[2] However, close examination of any specific twelfth-century situation in which the law of the frame was ostensibly being defined reveals that this law is seldom even perceptually valid. Moreover, scores of detailed studies made in the decades following Focillon's synthesis have brought to light many archaeological and cultural factors that clearly imply that Romanesque sculpture does not represent one artistic phenomenon but several quite distinct ones. This pluralism is not only grounded in the incontestable existence of several regional styles but also exists within the tradition of any given region. Consequently, a synthesis of Romanesque sculpture must take into account both the multiplicity of styles and the multiplicity of artistic phenomena. Under such a condition, this sculpture cannot be characterized under a single formal rubric.

The state of the question in the study of Romanesque sculpture is at present somewhat chaotic. There is no unified outline that can be used to describe the historical pattern of development as a whole. Also, in recent years, the problems concerning interpretation of some of the monuments have been restructured in such a way that the previously perceived relationships with other monuments have been disturbed. The resulting conflicts remain unresolved because there is no general theory of development against which they may be tried. The issue at stake is that so few facts can be known about most sculptures that without a general approach there is no adequate basis for deciding which among several possible interpretations is the most likely.

[1] Meyer Schapiro's review of Baltrušaitis's book in "Über den Schematismus in der romanischen Kunst," *Kritische Berichte zur kunstgeschichtlichen Literatur* (Zurich and Leipzig, 1932–1933), 1–21, eloquently discredited the "law of the frame." However, its appearance in this publication was apparently not noticed by most scholars of Romanesque sculpture and it was not absorbed into the mainstream of scholarship on the subject. Its recent reissue as "On Geometrical Schematism in Romanesque Art," in the collection of Schapiro's articles *Romanesque Art* (New York, 1977), 265–284, will undoubtedly rectify that oversight.

[2] The emphasis placed on the identity of the sculpture as architectural and on the relationship of this sculpture to its setting was a natural concomitant of the dominance of architecture in the study of monumental medieval art.

Neither the classification theory, which chiefly traces the development of numerous regional styles, nor the *Zeitgeist* theory, which chiefly measures progress toward a stylistic ideal, can provide sufficient means for validating new monographic studies of specific monuments. This book is an attempt to construct a systematic theory of the development of Romanesque sculpture, based on the integration of several types of data and grounded in a unified method of classification.

The one generality applying to all Romanesque sculpture is that this art marks the revival of monumental stone sculpture after a lapse of nearly six centuries and the definitive introduction of the medium into the tradition of European art. This revival, prophesied by the sculpture of the eleventh century and fulfilled by that of the twelfth, was the cumulative result of several distinct stages of development. In this book I have attempted to distinguish these stages and to explain the character of the sculpture in terms of the actual circumstances in which it was created. While doing so I have also attempted to demonstrate that the style and format of a Romanesque sculpture are dependent on its meaning, that the meaning reflects the object's purpose, and that the purpose reflects specific aspects of medieval thought about the function and nature of images.

A systematic theory of Romanesque sculpture must embrace all stages of the development of this art, whether or not existing scholarship has already described some of them adequately for such a purpose. Hence, when the prevailing assessment of a relevant issue has seemed satisfactory to me I have summarized it. In other instances, when only some aspects of the scholarly literature have seemed acceptable to me, I have set forth my own arguments and conclusions. Inevitably, then, this book assumes alternately the characteristics of a handbook and an essay.

For each important ensemble of sculpture I have raised certain questions, whether or not there is information available to support an answer. In some cases, in order to deal with these questions at all it has been necessary to resort to conjecture. However, such speculation has been supported by the comparison of data for each category of related sculptures, so that similar information from two or more cases may be extrapolated for the instance where no datum survives. When information is networked in this way, its meaning is enriched, so that a fuller account of each sculpture becomes practicable to a degree not previously expected. In addition, the method gives usefulness to many isolated data that would otherwise have no constructive value. These conjectures will need further documentation in order to be accepted for monographic accounts of individual monuments, but for the building of the developmental pattern set forth here they have been carefully tested for consistency with similar situations. The validity of the developmental pattern itself has been tested by its ability to accommodate a great deal of variety in the history of specific monuments while maintaining its structural coherence. The value of the pattern is that it provides a basis for enlarging the interpretation of individual monuments and for testing the plausibility of new interpretations.

The history of Romanesque sculpture is a subject too large for any one person to be able to treat it exhaustively or definitively in every aspect. A broadly conceived study of moderate length necessarily limits the complexity of argument and the degree of detail. In no instance have I been able to do full justice to the variety of opinions that have been advanced. Generally I have concentrated discussion on the theories that stand closest to my own and I have documented my own arguments with compatible interpretation that responsible scholars have advanced independently. For the sake of brevity I have not set forth arguments against all opposing positions (including some recent ones), but I have taken these positions into account in my own thinking. I am fully aware that more can be said, and often needs to be, but I believe that the usefulness of this book lies in a dual purpose best served by a text of manageable size—to provide the student or interested reader with a balanced and coherent introduction to Romanesque sculpture and to suggest to the scholar some lines of investigation and some interpretations that challenge currently accepted theories.

From Antiquity to the Romanesque Revival

The revival of monumental stone sculpture in Western Europe, begun in the eleventh century and realized in the twelfth, marked the reappearance, indeed the reinvention, of this medium in the mainstream of Western culture after a hiatus of nearly six centuries. This revival, dominated by architectural sculpture and manifested most conspicuously in great portals and facade ensembles on sacred architecture, bore some important similarities to the long-lapsed sculptural tradition of Roman Antiquity. As in Imperial Rome, twelfth-century sculpture was grounded in the human figure, often life-size, and was both plastic and frequently monumental in conception. It was harmoniously related to a setting equally plastic in its articulation, a relationship that obviated any sense of arbitrariness in the composition of the images and guided the viewer's gaze in such a way as to order the significance of the images perceived. Moreover, this sculpture was public in function, giving palpable form to abstract concepts of religion and rulership. These similarities distinguish the revival from the faltering, random efforts in remote provincial centers during the intervening centuries. Hence the name "Romanesque," which has been attached to sculpture of the late eleventh and early twelfth centuries by modern scholars, is particularly appropriate. Yet the revival was not accomplished through systematic imitation of antique Roman sculpture nor did the sculptors learn their craft by virtue of observing antique examples. Rather, this achievement was realized only very gradually, in distinct stages, and with only occasional instances—albeit important ones—of direct antique influence. On the whole, Romanesque sculpture was based at most on a generalized admiration for the prestige of Roman civilization and a firm belief in its authority.

In some fundamental aspects the medieval tradition of stone sculpture was also very different from the antique. Roman sculpture was based on the freestanding statue, normally a life-size figure conceived to imitate natural appearance in either an ideal or veristic manner. This mode of plastic representation was extended to relief carving, in varying degrees of depth, and applied to architecture, public monuments, tombs, and furniture. It was also employed in the decoration of portable objects for both ceremonial and personal use, in which the conception of the figure remained monumental despite its production on a miniature scale. The Romanesque tradition, on the other hand, was based on the figure carved in relief and frankly represented as an artificial image. While centered on architectural decoration, often large in scale, the Romanesque revival actually began in earnest with smaller formats, such as tombs and church furnishings. Although this initial sculpture was plastic and more nearly monumental than miniature in conception, it emerged from a context in which the only prior continuous production was concentrated on portable objects on which the figure was most frequently conceived as a miniature and with a more pictorial than plastic quality. These differences were largely determined by factors related to the demise of the antique tradition and its flickering afterlife in the early Middle Ages. The revival cannot be properly understood without a brief sketch of the historical circumstances that fostered these differences and shaped the limits of artistic capabilities during the intervening centuries.

The Demise of the Antique Tradition of Monumental Sculpture

The end of the antique tradition of monumental sculpture is extremely difficult to describe or explain precisely. So much late antique sculpture has been lost that it is hard even to determine when its demise occurred. Extant sculpture creates the impression that little of significance was made after the middle of the fifth century or the beginning of the sixth, a period coinciding with the final collapse of the Roman Empire in the West. Yet, despite this vagueness, the fact that the tradition came to an end, terminating more than a millennium of Greco-Roman creativity, is incontrovertible. The causes of its cessation are complex and can be determined only by inference from archaeological evidence in conjunction with the flourishing of other artistic phenomena.

In the fifth century the antique tradition of sculpture would seem to have been threatened by the incursion of alien cultures from outside the Empire. Barbarian hordes, pressing the boundaries of the Roman provinces since the third century, broke into the Empire in the early fifth and, in the year 410, sacked the city of Rome itself. Although the first invaders, the Visigoths, soon left Italy and occupied Gaul, they were quickly replaced by the Ostrogoths, who established a kingdom in northern Italy. The fact that their own cultural heritage did not include a function or a taste for statuary has been attributed as the major cause for the lapse of the antique tradition.[1] Nevertheless, they admired Roman civilization and attempted to preserve it. Theodoric, the Ostrogoth king (489–526), is known to have had a life-size equestrian statue of himself cast in bronze and set up in his capital in Ravenna.[2] Moreover, when pagan cult images as well as public monuments in Rome were threatened by destruction in a wave of Christian superstition, he appointed a curator to oversee their protection as part of the public cultural patrimony.[3] Consequently, although much antique sculpture was undoubtedly lost at the hands of the barbarians and under their rule, they also continued its production and encouraged its preservation.

The rise of Christianity and its later triumph through the Edict of Milan in 313 should have constituted an inexorable threat to the continuation of figural art because of the prohibitions of images in the Pentateuch. If the Second Commandment (Exodus 20:4–5) proscribed all images, Deuteronomy 27:15 applied specifically to sculpture: "Cursed be the man that maketh any graven or molten image. . . ." Yet there was a contradiction contained in the Scriptures because the account of Solomon's Temple (1 Kings 6:19–36) explicitly describes sculptures of cherubim, overlaid with gold, both on the ark and elsewhere, a use of images that were both figural and sculptural and in a context that denoted official sanction. Whoever might take up the argument for or against images could be answered by the opposing Scripture. Moreover, Christianity had emerged within the context of antique culture and had absorbed many alien elements from that culture while it grew to dominance. The customary use of images in all other Mediterranean religions except Judaism had influenced a compromise, so that Roman Christianity employed images from a very early date, probably the second century. Although surviving works of art suggest that paintings far outnumbered sculptures in Christian usage, there is little evidence that Scriptural prohibition distinguished between the two media. To be sure, there was a great deal of discussion about images,[4] for and against, but most of it was addressed to painting. Even when sculpture itself was explicitly discussed, the issue at point was generally the use of the image and how it was to be regarded rather than whether or not a plastic representation itself was appropriate.

Regardless of the concerns of theologians, a considerable amount of Christian sculpture was made from the third century on, and there may have been

[1] The influence of barbarian taste upon the lapse of antique monumental sculpture has been stressed by French scholars, most notably Louis Bréhier, "Les origines de la sculpture romane," *Revue des Deux Mondes*, x (1915), 878; and Paul Deschamps, "Etude sur la renaissance de la sculpture en France à l'époque romane, *Bulletin monumental*, LXXXIV (1925), 89.

[2] This statue is known because it was removed to Aachen by the Emperor Charlemagne around 800 and was recorded by his biographer, Einhard. For a discussion, see Hartmut Hoffmann, "Die Aachener Theodorichstatue," *Das Erste Jahrtausend*, Textband I (Düsseldorf, 1964), 318–335.

[3] Caecilia Davis-Weyer, *Early Medieval Art, 300–1150, Sources and Documents* (Englewood Cliffs, N.J., 1971), 51–52, cited from *The Letters of Cassiodorus*, ed. Thomas Hodgkin (London, 1886), 213–214.

[4] Ernst Kitzinger, "The Cult of Images in the Age before Iconoclasm," *Dumbarton Oaks Papers*, VIII, 83–150; and Edwyn Bevan, *Holy Images: An Inquiry into Idolatry and Image-Worship in Ancient Paganism and in Christianity* (London, 1940).

some even earlier. Numerous sarcophagi, difficult to date precisely, survive from the third through the fifth centuries. For the most part their relief sculpture represents allegorical subjects such as the Sacrifice of Isaac, Daniel in the Lions' Den, Jonah and the Whale, and Christ as the Good Shepherd.[5] There are also some freestanding statuettes from the third and fourth centuries representing some of the same allegorical subjects, in addition to the famous figure of Christ as Youthful Teacher.[6] Moreover, there is even documentary evidence of cult statues (that is, putative portraits) of Christ from the first and third centuries, and of the Virgin and Apostles from the fourth century and later.[7] Although the number of such examples is

small and the evidence diminishes sharply after Christianity became the state religion of the Roman Empire at the end of the fourth century, it is clear that the lapse of the antique tradition of figural sculpture cannot be attributed to the Church or the Scriptural prohibition of images.

Already before Christianity became the state religion and before the incursion of the barbarian tribes, the antique tradition of monumental sculpture seems to have been in decline. Judging from extant examples, the inner core of this tradition, the freestanding statue, was the first type of sculpture to be substantially diminished. After the reign of the Emperor Gallienus (259–68) statues of pagan deities are conspicuously absent and are known to have been made only when earlier statues were destroyed and required replacement.[8] On the other hand, portrait statues, especially of rulers, enjoyed a resurgence in the fourth century, sometimes even on a colossal scale, and although archaeological evidence for their continued production diminishes sharply after the middle of the fifth century, documentary evidence testifies to their use in the Byzantine tradition into the eighth.[9]

Architectural sculpture on a monumental scale disappeared suddenly within the context of Imperial commissions in early-fourth-century Rome and elsewhere, most notably in the great Christian basilicas erected at the order of Constantine. Immediately beforehand, the completion of the Basilica of Constantine (begun by his rival Maxentius) and the Arch of Constantine had reaffirmed the highly plastic treatment of both architecture and its sculptured decoration in the antique tradition.[10] Then, in sharp contrast, the Christian basilicas were designed in a style notable for its flatness and lack of

[5] For numerous examples see Dom Joseph Wilpert, *I sarcofagi christiani antichi*, 3 vols. (Rome, 1929–1936), *passim*.

[6] Examples of the Good Shepherd are preserved in the Lateran Museum, Rome, and the Cleveland Museum of Art; those of Jonah and the Whale also are in Cleveland. The small statue of Christ as Youthful Teacher, shown as a boy seated and wearing a toga (the antique formula for images of philosophers), is preserved in the Terme Museum, Rome; see Wolfgang Friedrich Volbach, *Early Christian Art* (New York, 1962), pl. 36.

[7] The example from the first century was a statue, located at Paneas in northern Palestine, which was apparently one of a group of large-scale statues in bronze. Whether it had actually been made to represent Christ or (more likely) was originally a pagan deity that came to be regarded as Christ, it had been accepted as a portrait image. Reference to a plant in connection with the statue by early Christian writers has led modern scholars to suppose that the statue was originally an image of Asklepios, whose identity as a healer was transferable to Christ. (The statue was traditionally believed to have been set up by the woman with an issue of blood who was healed by Christ. Eusebius [*History of the Church*, VII, 18] regarded this show of gratitude as a practice of heathen custom.) For discussions of this statue see Kitzinger, "The Cult of Images," 94; and Bevan, *Holy Images*, 112. The third-century example is known from a documentary reference to a cult statue of Christ which was worshiped by the Emperor Alexander Severus along with images of other gods. In all likelihood such a statue was made outside the context of the Church and without Christian participation. See André Grabar, *Early Christian Art from the Rise of Christianity to the Death of Theodosius*, trans. Stuart Gilbert and James Emmons (New York, 1968), 287. Large statues of Christ, the Apostles, and angels were reportedly made of silver on the order of Constantine for St. John Lateran (see Richard Krautheimer, *Early Christian and Byzantine Architecture*, Pelican History of Art [Harmondsworth, 1965], 26) and for St. Peters. In addition, at St. Peters were also large bronze statues of St. Hyppolatus and St. Peter, the latter of which still exists. For the eighth and ninth centuries, Ilene Forsyth (*The Throne of Wisdom, Wood Sculptures of the Madonna in Romanesque France* [Princeton, 1972], 70) has collected references to a number of sculptures, probably in the round, of Christ, the Virgin, and the Apostles. Most of these images were made of gold or silver. The majority of the patrons were popes and, surprisingly, most of the examples were made during the period of the Byzantine iconoclastic controversy, when the creation of sacred images was likely to evoke criticism even in the West.

[8] This phenomenon has been impressively treated by Hans Peter L'Orange, "Late Antique and Early Christian Art: Sculpture," *Encyclopedia of World Art*, IX, 100–118.

[9] For examples of portrait statues, see Ranuccio Bianchi-Bandinelli, *Rome: The Late Empire, Roman Art A.D. 200–400*, trans. Peter Green (New York, 1971), *passim;* and Volbach, *Early Christian Art*, pls. 48–51, 64–71. For evidence of the last vestiges of the tradition of portrait statues, see Cyril Mango, "Antique Statuary and the Byzantine Beholder," *Dumbarton Oaks Papers*, XVII (1963), 71, n. 96.

[10] For a discussion of the Constantinian basilicas, see Krautheimer, *Early Christian and Byzantine Architecture*, 17–44. For illustrations of contrasting secular architecture of the Constantinian period see Bianchi-Bandinelli, *Rome: The Late Empire*, figs. 84, 165, 360. The same contrast can also be seen outside Rome in the basilica and the Porta Nigra of Trier, pls. 359, 165, both secular buildings.

articulation, a style in which monumental relief sculpture had no appropriate role. Significantly, the former function of architectural sculpture was assumed by mosaic decoration.[11] Even where sculptured ornament appropriately remained, it was reduced to a small scale and to low relief in a flat style, most frequently appearing as a decorative pattern. When figural ornament was still used, as in the fifth-century stucco panels in the Orthodox Baptistery of Ravenna, it was conceived in a nonplastic style.[12] Around the turn of the fifth century, the practice of embellishing public monuments with plastic figural reliefs came to an end in works such as the base of the Column of Theodosius in the great Hippodrome of Constantinople. Drawings of the Column of Arcadius, a few years later, indicate a much more pictorial style.[13] Thereafter, large-scale public sculpture apparently no longer served any function deemed necessary by Imperial or other patrons.

In smaller formats, stone relief sculpture on tombs and to a certain extent on furniture continued into the early sixth century. At that point, the carving on sarcophagi ceased to be figural and was devoted almost entirely to animal and foliate motifs.[14] Furniture is much more difficult to trace but the fragments in a large ambo from Salonika, now preserved in Istanbul and dated to the second half of the fifth century, seem to mark the end of the large-scale representation of the human figure. It is significant that already in the fifth century, for instance in the marble columns of the ciborium in San Marco, Venice,[15] the figures were conceived as miniatures, akin to the illustrations in illuminated manuscripts. A similar transformation also occurred in the conception of figures on portable objects.[16] Reduced to

miniatures, figural relief sculpture on portable objects was the one aspect of the antique tradition which lasted well into the early Middle Ages.

Throughout the fourth and fifth centures the production of sculpture for Christian purposes was basically parallel to that made for secular purposes and for other religions. There is no reason, then, to suppose that Christian thought about images, graven or otherwise, was the governing factor in the decline of the antique sculptural tradition. Rather, if anything, Christianity may have prolonged its existence because many of the last works, excepting portrait statues, were distinctly Christian in theme. The almost inescapable conclusion is that the antique tradition lapsed within the context of late antique culture as a whole. By the middle of the fifth century sculptured figures no longer seem to represent real human beings.

Concurrent with the rapidly decreasing range and quantity of sculptural activity there was an undeniable decline in technical proficiency. Because most of the sculptures remaining from the reign of Constantine and afterward represent subjects and purposes denoting Imperial or court patronage, it must be assumed that the style employed had official sanction and that the best sculptors are represented. In this light, although it would be naive to infer that the art of sculpture was somehow gradually forgotten, it appears that a major social shift, of which the abstract style may have been a symptom, also disrupted the traditional recruitment, training, and patronage of sculptors and was thereby responsible for this decline. In any event, there was no further production of monumental figural sculpture within the mainstream of Western culture until the Romanesque tradition began to emerge in the eleventh century. This lapse does not mean, however, that no stone sculpture of any kind was made in the following centuries. Fragments of architectural decoration and furniture carved with geometric, foliate, and animal motifs abound in Italy and elsewhere in the Mediterranean basin, attesting to a continuous tradition throughout the early Middle Ages.[17]

The demise of the antique tradition of monumental figural sculpture in the great centers of

[11] I am indebted to my colleague John Williams for the foregoing observations on the change in style of architecture and its decoration within the context of Imperial patronage in Constantinian Rome.

[12] For examples of architectural sculpture in the late Empire see Bianchi-Bandinelli, *Rome: The Late Empire*, and Volbach, *Early Christian Art*, pls. 14–15, 143, 162–163, 202–203, 206–211.

[13] Volbach, *Early Christian Art*, 322–323, and pls. 54, 55.

[14] For the transition from figural to nonfigural decoration on sarcophagi see Marion Lawrence, *The Sarcophagi of Ravenna* (New York, 1945), *passim*.

[15] See Volbach, *Early Christian Art*, 326, and pls. 78, 79, for the Salonika ambo; 326, and pls. 82, 83, for the columns of the ciborium in San Marco, Venice. For the disappearance of figural carving from furniture, compare these examples with the Ravenna ambo of the mid-sixth century, 347, and pl. 183.

[16] For the transformation of the figure in the sculpture of portable objects from a monumental to a miniature conception, compare the ivory diptych of the Nicomachi and Symmachi, end

of the fourth century, to virtually any object made a few years after A.D. 400. For illustrations, see Volbach, *Early Christian Art*, pls. 90, 91, and thereafter *passim*.

[17] For numerous examples see the *Corpus della scultura altomedieovale*, published under the auspices of the Centro italiano di studi sull'alto medioevo (Spoleto, 1974).

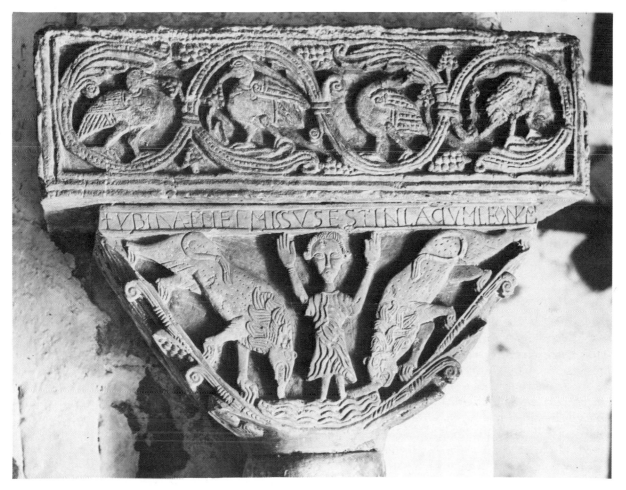

1. Stone capital with Daniel in the Lions' Den, c. 691, San Pedro de la Nave. (Archivo Mas)

the Empire did not preclude the continuation of figural stone-carving in remote provinces of what had been the Western Empire, from the late sixth century on. In the lands surrounding the Mediterranean, this carving, both on sarcophagi and in architectural decoration, was practiced in a nonplastic technique of flat, shallow relief in a highly schematized figural style. The most conspicuous of these regional survivals was in Visigothic Spain, where, from the late sixth century through the ninth, there was an almost direct but provincial continuation of the flat relief mode of architectural decoration that had flourished in Byzantine centers from the fifth to the mid-sixth century.[18] Another regional version of the same type appeared in the eighth century in northeastern Italy, especially in

Cividale and Aquileia.[19] Typical of this sort of sculpture is a capital in the church of San Pedro de la Nave (pl. 1), in northern Spain, built c. 691 under King Egica (687–701). In the carving. the naturalistic Greco-Roman tradition of figural representation is completely spent. The conception of the figure is abstract and linear, virtually a graven picture. No illusion of space remains, either in the composition itself or in the rendering of the figures. Indeed, the three faces of the capital, with Daniel in the Lions' Den on the front and the Apostles Philip and Thomas on the sides, were carved as distinct entities, independent in composition, scale, and meaning. Sculpture of this type was still made in the Mediterranean regions into the tenth century, but

[18]Helmut Schlunk, "La Escultura Visigoda," and "Arquitectura Visigoda del siglo VII," *Ars hispaniae* (Madrid, 1947), II, 233–307 *passim*.

[19]Geza de Francovich, "Osservazioni sull'altare di Ratchis a Cividale e sui rapporti tra occidente ed oriente nei secoli VII e VIII D.C.," *Studi in onore di Mario Salmi* (Rome, 1961), I, 173–236.

after the ninth century the human figure had virtually disappeared, displaced by animal and foliate motifs.[20]

The most enigmatic manifestation of a provincial survival of the late antique tradition occurred in the British Isles, the farthest-flung former province of the Roman Empire. Dating from the late seventh to the eleventh century, there are literally hundreds of sculptures, mostly fragments, of which a large proportion include figural compositions. Among the earliest examples particularly, the most important characteristics of this sculpture are that the figures are rendered in a highly plastic technique, although in a style that is both schematized and spaceless. Such a rendering of the figure in sculpture can have no antecedent other than the antique tradition, especially in view of the flat and abstract forms of all earlier art among Celtic and Nordic cultures. Yet, paradoxically, this sculpture initially appeared in a format peculiar to the British Isles, that of the high stone cross. The most important of these crosses is also accepted as the earliest, the Ruthwell Cross (pl. 2), located in Dumfriesshire near the border between Scotland and England. Current opinion places it in the late seventh century, not long after the Synod of Whitby established the authority of Rome over all Christians in England in 664. The strange subject matter has never been fully deciphered, but Meyer Schapiro has shown that its general theme relates to the eremitic Christian ideal of the Egyptian desert fathers which was embraced by the Celtic Christians in Britain. According to Schapiro, it can only have been made by an organized institution, that is, the Romanized English Church, and represents a conciliatory synthesis of Celtic and Anglian Christian purposes. Both its style and subject matter are reminiscent of eastern Mediterranean culture, the transmission of which may be owed to the influence of Theodore of Tarsus, who was Archbishop of Canterbury from 668 to 690.[21] Curiously, this indication of Mediterranean

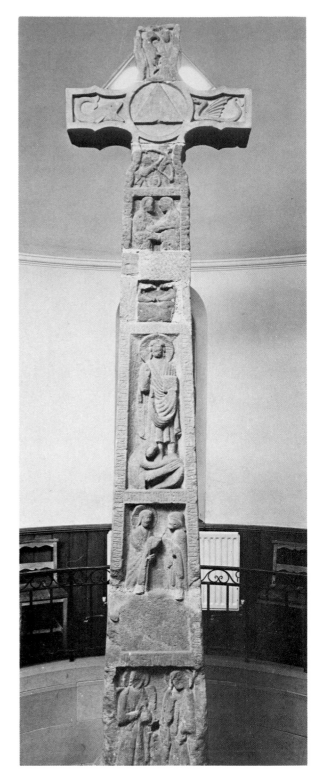

2. Stone cross with various themes, late 7th century, Ruthwell. (Courtauld Institute)

[20] For the Spanish tradition see Pedro de Palol and Max Hirmer, *Early Medieval Art in Spain* (New York, 1967), pls. 35, 45, 54.

[21] Meyer Schapiro, "The Religious Meaning of the Ruthwell Cross," *Art Bulletin*, XXVI (1944), 229–245. In France, an isolated example of sculpture of similar character is the tomb of Agilbert in the crypt of Jouarre. Although it is frequently placed in the late eighth century, Geneviève Aliette Maillé, in *Les cryptes de Jouarre* (Paris, 1971), 195–216, has convincingly related this sarcophagus to the context of monuments like the Ruthwell Cross, with iconography derived from the Orient.

influence appeared at a time for which there is no surviving sculptural counterpart at the supposed point of origin. Indeed, the last antecedent in the late antique tradition is the base of the Column of Theodosius (c. 390), in Constantinople. In addition to this mystery, we must contend with the anomaly of the introduction of sculptured images into a culture that ostensibly had no prior need for them.

Whatever its ultimate source, the relatively humanistic figural style and the technique of plastic modeling of the Ruthwell Cross were sufficient in themselves to sustain a lively sculptural tradition, modified by the influence of abstract ornament in barbaric art which diluted the antique inspiration. This tradition lasted in Scotland and England without subsequent external impetus until the Carolingian *renovatio* of the ninth century; in Ireland, it continued in an evolutionary development toward a more abstract figural style right through the eleventh century.[22] The only lasting significance of this phenomenon, however, was that it initiated a permanent craft of stone carving which was probably always separate from that of book illumination. With the exception of this sculptural activity on the periphery of Europe, no continuous production of figural stone carving remained to perpetuate even the flickering survival of the antique tradition.

The Afterlife of the Antique Tradition: The Carolingian Renovatio

The great *renovatio* of the Christian Roman Empire through the efforts of Charlemagne, crystallized by his coronation as Emperor of the Romans on Christmas Day, in the year 800, marked a virtually new beginning in sculptural activity in European culture. Charlemagne's purpose in sponsoring an artistic renascence was to enhance the prestige of his political aims and it implicitly included a revival of the Roman figural tradition. The applicable tradition, however, was not that of pagan Augustan Rome but of Christian Constantinian Rome, hence there were few sculptural models suitable for emulation other than sarcophagi and ruler portraits and little if any direct influence from Roman sculpture.

Carolingian purposes for sculpture were very dif-

ferent from those of the Romans: the greater part by far of Carolingian sculptural creativity was expended on the decoration of liturgical implements and other church furnishings that were limited in format by traditional requirements. Moreover, the materials used were those already established as appropriate for such purposes—precious materials such as gold, silver, bronze, and ivory. The production of these objects was feasible mostly in monasteries where labor related to ecclesiastical needs was an inherent part of the institutional program. That the style of Carolingian sculpture owes almost nothing to antique sculpture, then, is due to its liturgical purposes and monastic production rather than to the difficulties of finding suitable models.

Aside from the regimen of Christian worship, the most important function of Carolingian monasteries was the acquisition, preservation, and dissemination of Christian and ancient learning. As educational centers, the monasteries required many books and this requirement necessitated the establishment of scriptoria for the purpose of copying and illustrating texts. In this framework, the production of art was ancillary to education and it stemmed primarily from book illumination. This circumstance affected artistic style profoundly in two distinct ways. First, the illuminations were based primarily upon the models provided by the texts being copied. Since the most desirable texts were the most authentic available, usually the oldest, the illustrations were frequently of late antique date and provided ample means for a revival of late antique style. Second, book illuminations supplied the most accessible source of authentic images, with the result that when book covers, liturgical implements, and church furnishings were embellished with sculpture, both the style and the scale, in addition to the images themselves, were adapted from the book miniatures. The principal reason for this dependency was not rooted in expediency but in one of the basic Carolingian concepts of what constituted a valid image. The *Libri Carolini*, composed in 794 at the behest of Charlemagne to explain his regime's official attitude toward images, excluded original inspiration for the formulation of images, urging artists to seek good models for their work as well as good masters to instruct them.[23] Consequently,

[22] Lawrence Stone, *Sculpture in Britain: The Middle Ages*, 2d ed., Pelican History of Art (Harmondsworth, 1972), 14–18, 26–27; and Françoise Henry, *Irish Art during the Viking Invasions (800–1020 A.D.)* (Ithaca, N.Y., 1967), 133–194, pls. 65–112.

[23] Ann Freeman, "Theodulf of Orleans and the *Libri Carolini*," *Speculum*, XXXII (1957), 663–705, esp. 696.

most Carolingian sculpture not only grew out of the revival of late antique painting (in both its hieratic and classicizing modes) rather than of sculpture but it also developed without a monumental conception. Emerging from these circumstances, Carolingian sculpture constituted an afterlife, rather than a survival, of the antique tradition.

The one notable exception, redolent of survival, is the evidence of large-scale sculpture, much of it in the round, in secular culture. Such sculptures were apparently made of various materials—of wood sheathed in precious metals, of stucco, and even of stone. Unlike the small-scale sculptures, however, they were all figures of rulers and were probably what we would classify as statues. Their creation may well have been inspired by late antique ruler portraits, an inference that may be drawn from the fact that Charlemagne had a large equestrian figure of Theodoric removed from Ravenna and set up in the courtyard of his palace complex at Aachen.[24] None of these statues has survived except a life-size stucco figure of Charlemagne (pl. 3) in Müstair, which Christian Beutler has dated to about 800. The closest resemblance to the Charlemagne among other works of art is the late-fourth-century statue of the Emperor Julian.[25] The statues made of wood and precious metals were portable, and, as Ilene Forsyth has demonstrated, they were accepted as surrogates for the actual presence of the ruler represented, even in the papal court.[26] Although ruler portraits served a function quite distinct from that of Christian images, they apparently could be placed in or on a church. Such was the case with the Charlemagne statue and so likewise with documented sculptures, probably in stone, of the Emperor Louis the Pious and Pope Stephen at Saint-Pierre, Reims (c. 816), and of Charles the Bald (then king, later emperor) and Duke Nomenoi at the abbey of Glanfeuil (848–851).[27] Although other types of ruler images are recorded intermittently through the middle

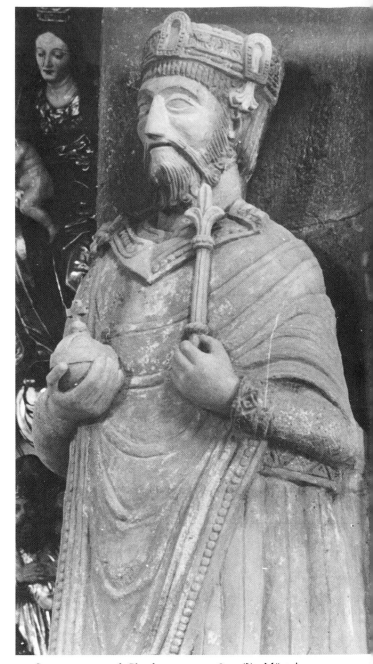

3. Stucco statue of Charlemagne, c. 800 (?), Müstair. (Bildarchiv Foto Marburg)

[24] Hoffmann, "Die Aachener Theodorichstatue," 318–335.

[25] Christian Beutler, *Bildwerke zwischen Antike und Mittelalter*, Düsseldorf (1964), 117–142. Victor Elbern, in his review of Beutler's book in *Zeitschrift für Kunstgeschichte*, XXVIII (1965), 266–267, differed with this early attribution and placed the Charlemagne statue in the twelfth century, mostly on stylistic grounds. His dissent, however, does not take into consideration the typology of art and I believe that Beutler is more nearly correct in placing such a ruler-portrait statue in the Carolingian period.

[26] Forsyth, *The Throne of Wisdom*, 75.

[27] *Ibid.*, 76; and Beutler, *Bildwerke*, 31–33.

of the tenth century, these large-scale sculptures were neither a permanent nor a pervasive aspect of medieval sculpture. They constituted a minor aspect of the Carolingian *renovatio* and represented only a fleeting reminiscence of the late antique tradi-

tion, perhaps inspired by the continuation of such portraits in the Byzantine tradition until the eighth century.[28]

Even more fleeting is the small amount of evidence for architectural sculpture, all of it in stucco. The remaining fragments, at Germigny-des-Prés and St. Laurent in Grenoble, both about 800, indicate only nonfigural decorative motifs. The chronicle of Hariulf, 1088, describing the great monastery of Centula (790s), however, gives accounts of (presumedly large) stucco panels of the Nativity, the Passion, the Resurrection, and the Ascension which were placed at various points in the church.[29] The Nativity, located in the vaulted outer vestibule that contained the tomb of the first abbot, Angilbert (a central member of Charlemagne's court), was set on a gold mosaic ground, probably over the door. The location of the stuccoes may have anticipated the later stone sculpture of the Romanesque period. In view of the very flat style of Carolingian architecture, though, it is unlikely that the sculpture was related in composition to the architectural setting. Moreover, given the apparently narrative character of the subject matter, the piece is most likely to have been related in conception to the tradition of miniature sculpture on portable objects. Because of the long chronological gap between this example and the next, a series of eleventh-century stucco sculptures, it appears that large-scale Carolingian relief sculpture did not inspire a continuous practice and certainly not one in stone.

There are, however, some examples of large, provincial stone sculpture which seem to have been based on Carolingian prototypes in portable objects. In England, an early-ninth-century panel from Breedon-on-the-Hill, Leicestershire, about two feet high, is carved with a half-figure of the Virgin beneath an arch, similar in theme to a Carolingian or Byzantine-inspired ivory.[30] The execution, though,

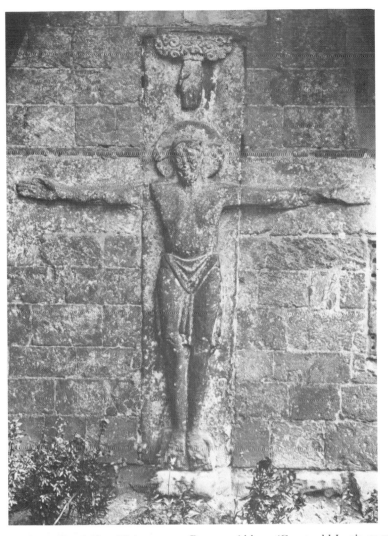

4. Stone Rood (Crucifix), c. 1010, Romsey Abbey. (Courtauld Institute —F. H. Crossley)

is naive, with a schematized physiognomy and an inordinantly large hand raised in blessing. Even so, the handling of the drapery hints of a highly sophisticated mode. In another example, the two stone angels placed above the chancel arch in the tenth-century Anglo-Saxon church at Bradford-on-Avon, Wiltshire, seem to represent part of a Crucifixion scene as in a Carolingian ivory.[31] About five feet in length, these reliefs are stiffly articulated but nonetheless directly based upon an impressive prototype. In France, a tenth-century Crucifixion relief, about three feet high, from the church of Saint

[28] Mango, in "Antique Statuary," 71, n. 96, has shown that ruler-portrait statues continued in the Byzantine tradition until the early eighth century.

[29] Cited by Kenneth John Conant, *Carolingian and Romanesque Architecture, 800 to 1200*, Pelican History of Art (Harmondsworth, 1959), 12–13. Reconstitutions of Centula based on the description of Hariulf are found in Georges Durand, "L'Eglise de Saint-Riquier," *La Picardie historique et monumentale* (Amiens and Paris, 1907–1911), IV: and Wilhelm Effmann, *Centula Saint-Riquier* (Münster, Westphalia, 1912).

[30] Alfred W. Clapham, "The Carved Stones at Breedon-on-the-Hill, Leicestershire, and their position in the history of English Art," *Archaeologia*, LXXVII (1927), 219–240, esp. 233–234.

[31] Stone, *Sculpture in Britain*, 34.

Mexme at Chinon,[32] suggests a similar source of inspiration, but its flat, crude carving is only a modest approximation of the obvious prototype. The Chinon relief, though, unlike the English examples, is but an isolated incident. Nevertheless, it is clear that both in England and in France the scattered stone sculptures do not represent work from the cultural mainstream.

Early in the eleventh century there was a resurgence of stone sculpture in England, the Pyrenees, and Dalmatia, near the same three areas where earlier there had been provincial survivals of the late antique tradition. This sculpture has often been interpreted as significant of a new beginning, especially since the major works are all examples of architectural decoration.

Among the three regions the sculpture of England is at once the most promising in its plasticity and yet the most conservative in theme and format. The most imposing monument is the early-eleventh-century Rood (pl. 4) at Romsey Abbey, Hampshire, which stands about six feet tall.[33] The iconography is unusual, for Christ is shown alive on the Cross with his head erect, blessed by the Hand of God, a theme that recurs from time to time in Carolingian goldwork and ivories.[34] Indeed, despite its large size the sculpture gives the impression of a magnified miniature. Moreover, the original location of this relief was probably above the chancel arch in the Anglo-Saxon church of Romsey Abbey,[35] a disposition similar to that of the earlier Bradford-on-Avon angels and consonant with the intentions for a large bronze crucifix of the Ottonian period of the Holy Roman Empire. Even so, although the plastic articulation of the musculature is relatively supple, the figure as a whole lacks the finesse of work native to the Carolingian tradition. The plasticity is misleading for it simply continues the stone-carving tradition that had survived in England since late Antiquity, albeit a tradition altered in the ninth century by Carolingian influence.

The concentration of sculptures in the Roussillon, at the base of the Pyrenees, has attracted more attention than any other early-eleventh-century stone carving because most of the examples are incorporated into exterior architectural settings. They seem, then, to prefigure the Romanesque development of portal and facade decoration. However, they are all executed in flat relief and are also quite naive in their figural style even though rather expertly finished. The most important examples are the reliefs set in the portals and facades of the small churches of Saint-Genis-des-Fontaines, Saint-André-de-Sorède, and Arles-sur-Tech.

The Saint-Genis lintel (pl. 5), dated by its inscription to 1020–1021, shows Christ in a mandorla supported by angels and flanked by Apostles standing beneath an arcade. The contemporaneous Saint-André lintel has a similar composition in which Christ is flanked by seraphim and half-figures of saints. Marcel Durliat has observed that both lintels imitate the format and subject matter of Carolingian golden altar retables.[36] Indeed, he reported, the Saint-André lintel is exactly the same length as the marble altar table of similar date located inside the church. While the Saint-Genis lintel is set into a facade that was rebuilt much later, the Saint-André facade is original and contains other sculptures (pl. 6). These include a window frame with symbols of the Four Evangelists and, beneath the window, two figures of lions which Durliat has related to the lintel in a unified iconographic program denoting the Apocalypse. Such a program would signify that the lintel was intended from the start to occupy its architectural setting.[37] Consequently, even if the Saint-Genis lintel had originally been an actual retable, the concept of placing sculpture on the church facade followed immediately thereafter at Saint-

[32] René Crozet, "Chinon, Eglise Saint-Mexme," *Congrès archéologique de France, Tours,* CVI (1948), 358–359.

[33] Stone, *Sculpture in Britain,* 40–41; and David Talbot Rice, *English Art, 871–1100,* Oxford History of English Art (Oxford, 1952), discussed in context, 92–121.

[34] See Peter Lasko, *Ars Sacra, 800–1200,* Pelican History of Art (Harmondsworth, 1972), for a specific example, an illustration of the cover of the Lindau Gospels, c. 870, pl. 59.

[35] The Saxon church of Romsey Abbey probably had a box nave, a tower chancel with porticus opening to the north and south, and an apsidal presbytery. For the reconstitution see Sir Charles Peers, "Recent Discoveries in Romsey Abbey Church," *Archaeologia,* LVII (1901), 317–320; and M. F. Hearn, "A Note on the Chronology of Romsey Abbey," *Journal of the British Archaeological Association,* 3d ser., XXXII (1969), 30–37.

[36] Marcel Durliat, *Roussillon roman,* La Nuit des Temps (La Pierre-que-Vire, 1954), 76–79. The sculptures of the Pyrenees were first studied in detail by Georges Gaillard in *Premiers essais de sculpture monumentale en Catalogne aux Xe et XIe siècles* (Paris, 1938), 54–74. The iconography of these lintels has recently been discussed in detail, but not in terms of a relationship to Carolingian models, by Mireille Mentré, in "Contribution aux recherches sur l'iconographie des éléments sculptés façades de Saint-Genis-des-Fontaines et Saint-André-de-Sorède," *Les Cahiers de Saint-Michel-de-Cuxa,* IX (1978), 163–170.

[37] Durliat, "Les premiers essais de décoration de façades en Roussillon au XIe siècle," *Gazette des Beaux Arts,* LXVII (1966), 65–77.

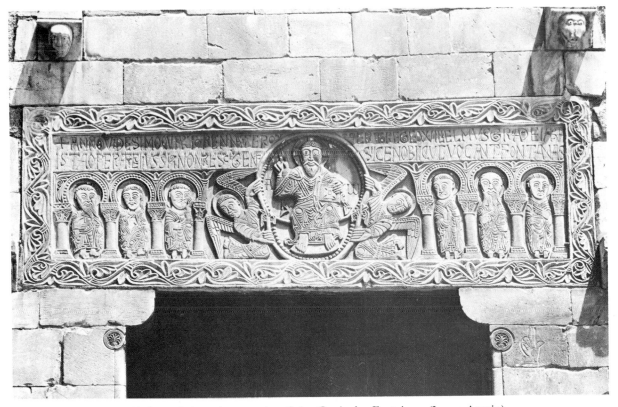

5. Marble lintel with Christ and Apostles, 1020/21, Saint-Genis-des-Fontaines. (James Austin)

André. Regarding the figural style of the Saint-Genis lintel, Henri Focillon maintained that the conformity of the outlines of the figures to the horse-shoe arches, projecting capitals, and bases of the arcade adumbrated the Romanesque "law of the frame" for monumental figures, an achievement not followed in the Saint-André lintel.[38] Focillon, however, was taking for granted that the aesthetic aims of the sculptor at Saint-Genis were identical with those he perceived in the later carvers of architectural sculpture. In actuality, it is more likely that the sculptor at Saint-André was simply making a more successful attempt to imitate the style of his putative Carolingian model. The similarity of the two lintels even suggests that the same artist was at work in both locations, in which case he may have regarded the Saint-André lintel as a stylistic improvement. Whether or not this was the case, the sculptor of each lintel achieved nothing like the style or plasticity of the original Carolingian conception. His use of marble would seem to associate him with the native

marble-working tradition of the Roussillon which produced a large series of altar tables like that at Saint-André, but the connection cannot be ascertained because none of the altar tables have any figural carving. His chip-carving technique, on the other hand, tends to make him an heir of the earlier Visigothic and Mozarabic tradition on the other side of the Pyrenees.[39]

Later in the century, at Arles-sur-Tech (c. 1046),[40] there is a stone cruciform relief (pl. 7) set into the tympanum area above the door of the church. In the center of the cross is Christ in a mandorla and in roundels at the end of each arm are the symbols of the Four Evangelists. The theme of the subject matter and its disposition is reminiscent of stucco or gold altar frontals (like that at Aachen, c. 1020), but the cruciform format is an original creation. The figural style is a reasonable approximation

[38] Henri Focillon, *L'art des sculpteurs romans*, Paris (1931), 71–74.

[39] Gaillard, in *Premiers essais*, 62–66, 73–74, follows the general French interpretation that these sculptures mark a new beginning, but that the flatness of the technique—which he emphasizes—follows the tradition of the earlier Visigothic and Mozarabic motifs which he cites as influences.
[40] Durliat, *Roussillon roman*, 80–81.

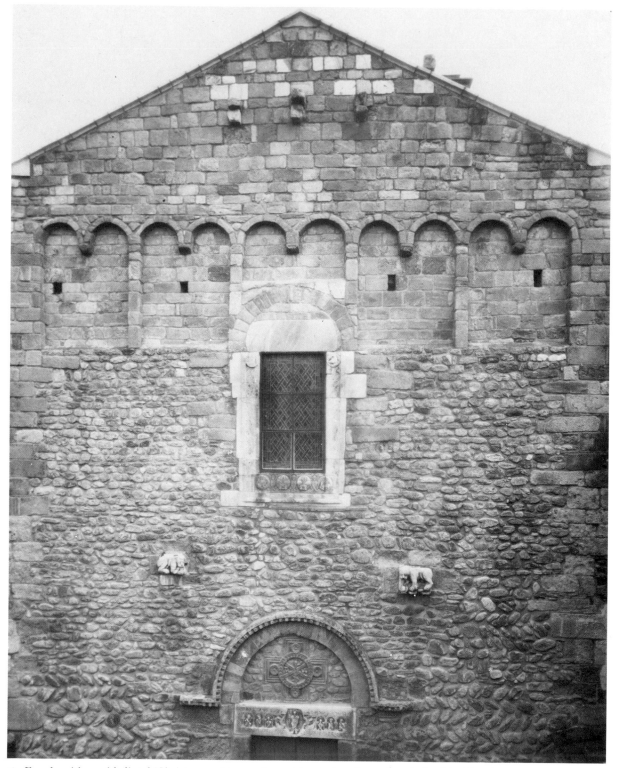

6. Facade with marble lintel (Christ, seraphim, and angels), window frame (symbols of the Four Evangelists), and lions, c. 1020, Saint-André-de-Sorède. (Archivo Mas)

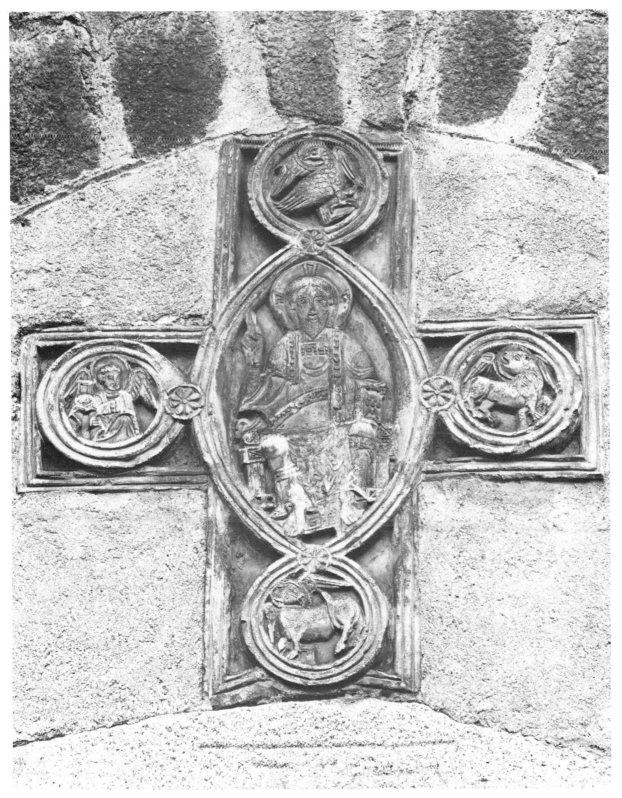

7. Stone cross set into doorway lunette, c. 1046, Arles-sur-Tech. (James Austin)

of that in goldwork or in ivory, as Paul Deschamps suggested.[41] But the quality of execution is much lower than that of a goldsmith and the flatness of the relief recalls the technique of the earlier lintels. Also, the bottom of the cross is curved, as if to fit the curved lintel of the doorway, and the relief is carved of ordinary stone, a material unknown in church furniture in the Roussillon. The Arles relief, then, confirms the adaptation of Carolingian formats associated with the altar to an exterior architectural setting related to the portal. Yet the sculptor's technique of carving still points toward the past rather than the future.

Of the Dalmatian sculptures, those from the churches of San Lorenzo and San Domenico in Zadar are both the most interesting and the most numerous. Ivo Petricioli has attributed all of them to the eleventh century, contrary to some other scholars who place them in the late eighth or ninth century in the context of the chip-carving reliefs of Cividale.[42] The chief justification for this later date is the change in format and subject matter, parallel, incidentally, to the change noted in England and the Roussillon. Otherwise, the abstract style and the chip-carving technique make it scarcely distinguishable from earlier sculpture of the region. The example of greatest importance from this ostensibly later group is the ensemble of reliefs which constituted the portal of San Lorenzo (pl. 8). The subject matter and style of the lintel is remarkably similar to that of Saint-Genis-des-Fontaines and Saint-André-de-Sorède, with Christ in a mandorla supported by angels and flanked by chimerical beasts. But the lintel is gabled, a distinctly architectural format that departs from the retable compositions in the Roussillon. In addition to the lintel sculpture, the jambs are carved with a vine-and-bird motif. This ensemble was undoubtedly the earliest complete doorway composition in medieval stone sculpture, but it had no further impact in Dalmatia or elsewhere.

In all these early reliefs, either the subject matter or the format (or both) is borrowed from other media represented in the Carolingian tradition. However, in figural style and technique these sculptures are completely separated from the cultural mainstream. The sculptors are the last exponents of much earlier

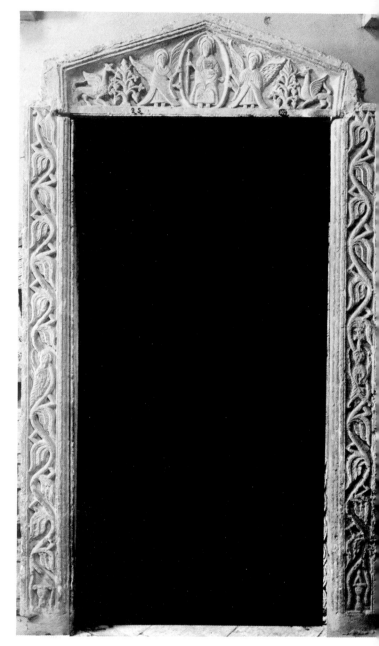

8. Stone doorway with Christ in a mandorla supported by angels on the lintel, 11th century, San Lorenzo, Zadar. (Alinari/Editorial Photocolor Archives)

and very provincial strains of stone-carving practice. There was no subsequent development of these experiments in any of these areas; the Norman Conquest of England in 1066 brought Anglo-Saxon sculptural practice to a sudden end; Dalmatia never produced any Romanesque sculpture; and the Roussillon lay dormant until the revival of

[41] Deschamps, "Etude sur la renaissance... romane," 68.
[42] Petricioli, "La scultura preromanica figurativa in Dalmazia ed il problema della sua cronologia," *Stucchi e mosaici alto medioevale: Atti dell'ottavo Congresso di studi sull'arte dell'alto Medioevo*, 1 (Milan, 1962), 360–374.

monumental stone sculpture was in full flower. Nevertheless, these examples adumbrate a new tradition, marking the reappearance of public sculpture in the form of architectural decoration. Significantly, their production parallels the first experiments in the plastic articulation of architecture, pointing toward the development of a relationship similar to that between Roman architecture and its sculptural decoration. Yet these parallel experiments in the early eleventh century did not coincide geographically and these sculptures did not lead to the future.

The generation of a new tradition of stone sculpture required the re-emergence of the concepts of plasticity and monumentality in the figural arts, to an extent greater than that which existed in any center prior to the eleventh century.[43] It also required the existence of sculptors who not only understood the highest practice of figural rendering and sacred iconography but also had the ability to apply their skills effectively to the medium of stone. As we have seen, no one who worked in the older tradition of stone carving was capable of fulfilling those conditions and there is no evidence that any such sculptor ever learned to do so. The creation of a new tradition simply could not occur except in the mainstream of European culture, in centers where new ideas could be generated.

The first signs of a renewal of plasticity in the conception of figural images appeared in the late tenth and early eleventh centuries in the Holy Roman Empire. As Carl Nordenfalk has observed, the first step was taken in the late-tenth-century manuscript illuminations of the Gregory Register Master and was followed in sculpture in the ivory relief of the Virgin Enthroned, preserved in Mainz (pl. 9). Although this ivory has frequently been dated to the middle of the eleventh century or later, Nordenfalk has placed it near the beginning of the century and attributed it to the Gregory Register Master, the only artist of the time who displays the ability to conceive an image as a plastic volume.[44] Compared to an "Ada Group" ivory of Christ in Majesty (pl. 10), c. 900, the difference is very tell-

[43]Erwin Panofsky, in *Die deutsche Plastik des 11.-13. Jahrhunderts* (Munich, 1924), 3-28, observed that the reemergence of the quality of plasticity was the first sign that a new development in the figural arts was about to begin.

[44]Carl Nordenfalk, "Der Meister des Registrum Gregorii," *Münchner Jahrbuch der bildenden Kunst*, 1 (1950), 73ff. See also *idem*, "The Chronology of the Registrum Master," *Kunsthistorische Forschungen Otto Pächt* (Salzburg, 1972), 69 and n. 29.

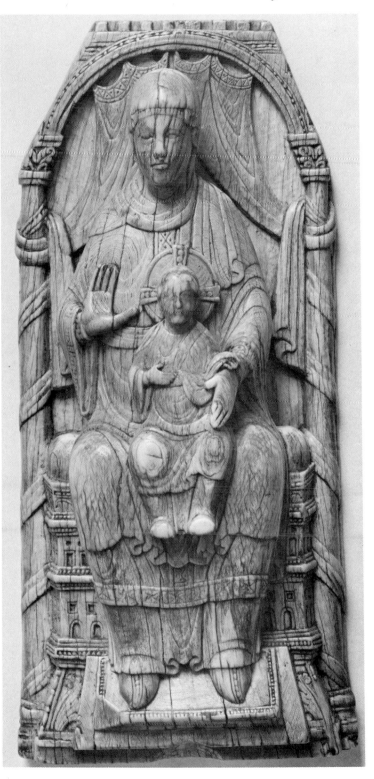

9. Ivory Virgin Enthroned, early 11th century, Reichenau (?), Mainz. (Hirmer Fotoarchiv)

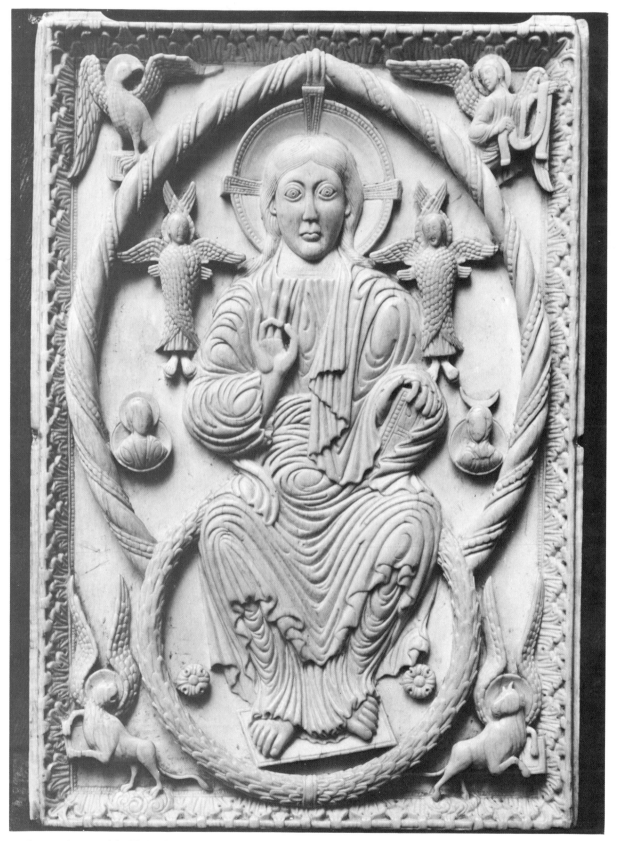

10. Ivory plaque with Christ in Majesty, c. 900, "Ada Group" style, Stätlichesmuseum, Berlin. (Bildarchiv Foto Marburg)

11. Gold repoussé altar with Christ, three archangels, and St. Benedict, made for Basel Cathedral, c. 1020, Musée Cluny, Paris. (Courtauld Institute—M. F. Hearn)

ing. In technique there is a basic contrast because the Virgin relief is carved from three sides while the Christ relief is carved only from the front. But more important is the fact that the Virgin is rendered in smooth, swelling volumes while the body of Christ is defined by a linear pattern of swirling drapery. Moreover, although the Virgin is actually only about eight inches high, the figure gives the impression of being monumental. The Christ relief, which is approximately the same actual size, was, on the other hand, clearly conceived as a miniature. The Christ figure represents the norm for the Carolingian tradition, even for the period of the Mainz Virgin and afterward. Impressive works such as the bronze door and the bronze column of Hildesheim, produced under the attentive eye of Bishop Bernward about 1015, have figural scenes that are actually larger than the Mainz Virgin, yet they remain pictorial miniatures. Even the golden altar frontal from Basel Cathedral (pl. 11) (made about the same time at the order of Emperor Henry II), which has figures more than two feet high, represents only a tentative attempt at monumentality. Indeed, it was only after the middle of the eleventh century that the implications of the achievement represented by the Mainz Virgin seem to have been understood and absorbed and then only in figures which are truly large. The outstanding examples are the wooden reliquary statue of the Virgin and Child (pl. 12), made for Bishop Imad of Paderborn, 1051–1076; the stucco tomb of Widukind, Duke of Saxony (pl. 13), at Enger-bei-Bielefeld, c. 1070; and the bronze tomb slab of King Rudolf of Swabia (pl. 14), c. 1081. In each of these three examples the principle of plasticity is manifested very differently: the Imad Virgin is a figure in the round, the Widukind tomb is modeled in deep relief, and the Rudolf tomb was cast from a plaster mold modeled in very shallow relief. Yet each of these sculptures is equally evocative of solid, three-dimensional masses. Their monumentality is affirmed no more by their large size than by the absence of the pictorial or incidental qualities of earlier sculpture.

The artists who made these works, unlike those who carved the crude stone sculptures of the provinces, seem to have possessed an understanding of the basic requirements for a new tradition of monumental sculpture. They could represent the human figure with the highest degree of skill possible in medieval culture and, besides, they could accurately fulfill the requirements of any icono-

12. Wood Virgin and Child, made for Bishop Imad, 1050s, Paderborn. (Landeskonservator von Westfalen-Lippe)

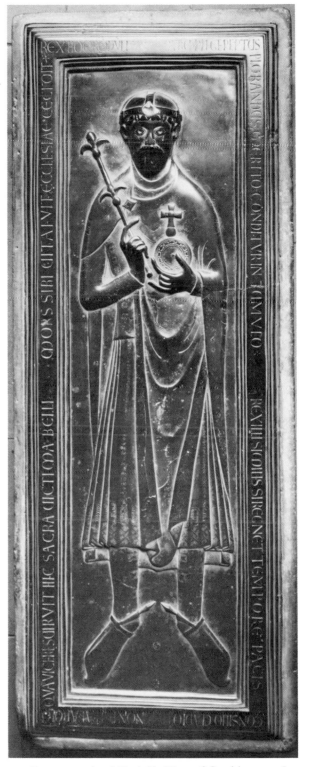

13. Stucco tomb of Widukind, Duke of Saxony, c. 1070, Enger-bei-Bielefeld. (Bildarchiv Foto Marburg)

14. Bronze tomb of Rudolf, King of Swabia, c. 1081, Merseberg Cathedral. (Hirmer Fotoarchiv)

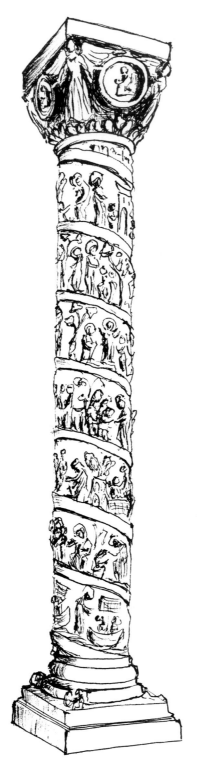

15. Drawing of the bronze column with scenes of the Passion of Christ made for Bishop Bernward, c. 1000/1020, St. Michael's, Hildesheim. (M. F. Hearn)

graphical specification. By the middle of the eleventh century they could also endow the figure with the qualities of plasticity and monumentality. Yet they worked in gold, silver, bronze, stucco, and wood. From the early ninth century, when the Carolingian tradition began, stone sculpture was notably infrequent. On what basis, then, could these artists have contributed to a revival of monumental sculpture in stone?

Although a detailed account of the sculpture of the Carolingian tradition is outside the scope of this study, certain aspects of its production are highly germane because this tradition provided the only continuous practice of sculpture prior to the revival of monumental stone sculpture. Of particular import is the variety of skill involved in working with the principal materials employed. In silver or gold, represented by the Basel altar (pl. 11), the direct method of production was the repoussé technique. The metal was gently hammered and creased from the back side to create embossed figures on the front. In order to preserve the delicate figures they were filled with a wax that hardened when dry and then were mounted on a wooden panel. The technical process, then, was fundamentally related to the practice of modeled sculpture and it permitted a high degree of fluency and subtlety in figural representation. Bronze objects, such as the Hildesheim column and doors and the "Krodo altar" preserved in Goslar (pls. 15, 16, 17), were cast in the lost-wax technique, which required the original formulation of the images also to be modeled, probably in clay or in plaster mixed with a hardening substance like sand or lime. This technique permitted the artist a maximum of flexibility so that the figures could be freely worked and details could be refined through scraping and carving. As with the mold for bronze, stucco sculpture exemplified by the Widukind tomb (pl. 13), represents considerable versatility because it, too, was both modeled and carved. The material, a mixture of gypsum and either lime or sand, had to be shaped initially by the artist's hand. The surface, however, had to be smoothed by abrasion, and decorative details such as the hem ornaments on the Widukind figure had to be carved or incised after the stucco had set. On the other hand, ivory, represented by the Mainz Virgin, the "Ada Group" plaque, and the late-eleventh-century Würzburg book cover (pls. 9, 10, 18), was fully carved. This material permitted the most astonishing feats of technical virtuosity, especially in the degree of detail

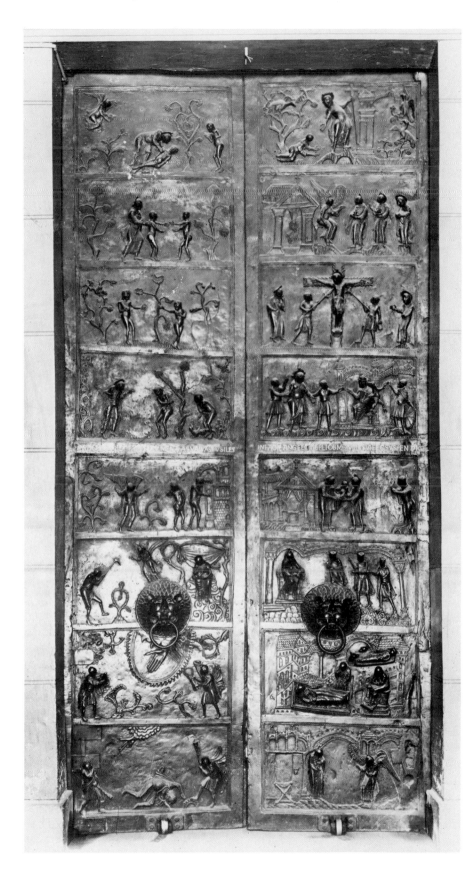

16. Bronze door with scenes of Genesis and of the life of Christ, made for Bishop Bernward, c. 1015, St. Michael's, Hildesheim. (Bildarchiv Foto Marburg)

17. Bronze "altar of Krodo," supported by atlas figures, late 11th century, Goslar. (Hirmer Fotoarchiv)

and the depth of carving. Figures were frequently carved with limbs, such as the legs exposed beneath a short tunic on the Würzburg relief, completely in the round and free of the relief ground. The drapery folds reveal the disposition of the body underneath to an extent unrivaled by any other medium of medieval art prior to the twelfth century. Finally, although wooden figures, such as the Imad Virgin (pl. 12), were seldom employed in circumstances in which the same degree of liveliness was appropriate, their production called for sensitive carving on a large scale. Both modeling and carving, then, and even combinations of the two were requisite skills in the Carolingian tradition of sculpture.

The variety of skills required to produce sculpture in the several media raises the issue of the degree of versatility which can be attributed to an individual artist. Because of the randomness of survivals, it is easy to assume that the work in each medium was produced by some sort of specialist, the scope of whose training remains undefined. A view of the whole tradition, however, tends to indicate otherwise, that a significant overlap exists both in the application of the various media and in the techniques required to produce them. Among the media, gold seems to have been the common denominator. On book covers and reliquaries, ivory plaques or figures were frequently set into gold

frames; wooden crucifixes and reliquary figures were often sheathed in gold or silver. The smaller objects cast in bronze, such as candlesticks, were sometimes gilded. And both gold and silver are known to have been applied to stucco decorations.[45] Regarding technical production, positive modeling was required to make the master image for bronze casting as well as stucco figures, while negative modeling was employed to fashion gold repoussé sculptures. Carving skills were needed for ivory and for wood sculptures and also for some details of stucco work. Thus for bronze and stucco work and for some objects made of two materials an overlap of techniques existed. Even if more than one artist was involved in creating a single object it is unlikely that a separation of technical duties was a permanent condition as the master artist had to know how to guide the entire project. While it is not possible to trace a single artistic hand from one sculptured object to another in a different medium, we can, through stylistic comparison, identify objects of various materials as coming from the same artistic centers, implying technical overlapping.[46]

This combination of circumstantial evidence suggests that the sculptor in the Carolingian tradition was basically a goldsmith, trained to work in a variety of media. Obviously, accidents of patronage and career opportunities may have frequently resulted in de facto specialization but that could scarcely have been foreseen during the period of training. Leo of Ostia, at the end of the eleventh century, seems to have been speaking of such a versatile training when he recounted that Abbot Desiderius (1058–1087) of Monte Cassino selected monks to be trained in the techniques not only of mosaic and laying mosaic pavements but also of silver, bronze, iron, glass, ivory, wood, alabaster, and stone.[47] Moreover, a manual of techniques written in the eleventh or early twelfth century by a certain Theophilus includes information for working in gold, silver, bronze, copper, tin, iron, enamel,

18. Ivory plaque with the martyrdom of three saints, late 11th century, Franconia, Universitätsbibliothek, Würzburg. (Hirmer Fotoarchiv)

ivory, bone, glass, and even for wall painting and book illumination. Theophilus did not identify his artistic profession by name, but we assume he was a metalworker because the greater part of his treatise is devoted to this craft. What is more, he was almost certainly a German,[48] so his information probably

[45] This combination was noted by Agnellus of Ravenna in the ninth century, *Liber Pontificalis ecclesiae Ravennatis*, in Holder-Egger, ed., *Monumenta Germaniae Historica, Scriptores rerum langobardorum* (1878), 288–289, cited by Deschamps, "Etude sur la renaissance... romane," 22. See also Michelangelo Cagiano de Azevedo, "Stucco," *Encyclopedia of World Art*, XIII, 634, 635.

[46] See Beutler, *Bildwerke, passim*; and Rudolf Wesenberg, *Frühe mittelalterliche Bildwerke: Die Schulen rheinischer Skulptur und ihre Ausstrahlung* (Düsseldorf, 1972), *passim*.

[47] Leo of Ostia, *The Chronicle of Monte Cassino*, III, trans. Herbert Bloch, cited in Davis-Weyer, *Sources and Documents*, 138.

[48] Theophilus, *The Various Arts* (*De diuersis artibus*), Introduction by C. R. Dodwell (London, 1961), xxxiv–xxxix.

applies directly to the Carolingian tradition. With hindsight from the Italian Renaissance, we have learned that versatility in sculptural media or a combination of sculpture and panel painting has its origins in artists whose professional identification (Ghiberti), apprenticeship (Donatello), or early training (Verrochio) was that of a goldsmith.

It is difficult to know precisely whether the medieval goldsmith was typically a lay professional or a cleric with a manual vocation. To be sure, most of the documentary evidence relating to this question tends to suggest the latter, but then the majority of such documents were written by clergymen. The chronicle of Leo of Ostia, cited above, explicitly states that the artists trained at Monte Cassino were monks who were "eager" to be selected. Theophilus himself was a Benedictine monk, as was the famous twelfth-century goldsmith Roger of Helmarshausen who has sometimes been identified with Theophilus.[49] And Bernward of Hildesheim was so eager to be associated with the bronze doors that their actual authorship is not completely dissociated from him.[50] On the other hand, in the mid-ninth century, Emperor Louis the Pious sent a serf who was a goldsmith to Archbishop Ebbo of Reims and let him work there all of his life.[51] So it is clear that from the early period of the Carolingian tradition at least some of the goldsmiths were laymen. Moreover, by the tenth century some such works were surely made outside of monasteries because holy orders would have made peripatetic craftsmanship very nearly impossible. Thus the distinction between cleric and lay craftsman is difficult to draw for the period prior to 1200.

It is highly probable, in any case, that the professional goldsmith had some degree of education. First of all, treatises like that of Theophilus would have had little value if the craftsman could not read. And, too, the lettering of inscriptions on works of gold, foremost, and secondarily on ivory is so beautifully executed that it is difficult to doubt the literacy of the artist. Furthermore, the complex and subtle nature of the figural iconography required a full understanding of the subject matter, a comprehension more complete than a spoken description or sketch could have conveyed. Although Scriptural scholarship on the part of the artist was probably not involved, the ability to comprehend written directions was virtually a necessity.

The versatile art of the goldsmith, then, comprised the only significant sculptural activity in the Carolingian tradition.[52] Even if, as Leo of Ostia implied, his oeuvre included work in marble and stone, there is almost no evidence to support the supposition of a widespread or continuous practice of stone carving within this cultural milieu. Nevertheless, when the demand for stone carving reappeared, the goldsmith was the only craftsman whose fund of experience could provide the requisite skills.

[49] *Ibid.*, xxx–xxxiv, xli–xliv.

[50] This association of Bernward with the actual production was mentioned in his biography, the *Vita Bernwardi*, discussed by Rudolf Wesenberg in *Bernwardische Plastik* (Berlin, 1955).

[51] Jean Adhémar, *Influences antiques dans l'art du Moyen Age français* (London, 1939), 150.

[52] Since this chapter was written, Thomas W. Lyman, in "Arts somptuaires et art monumental: Bilan des influences auliques," *Les Cahiers de Saint-Michel-de-Cuxa*, IX (1978), 115–124, has set forth additional and different evidence of the relationship between the work of goldsmiths and that of sculptors of stone.

CHAPTER 2

The Eleventh-Century Origins:
Capitals and Relief Slabs

Capitals

The first signs of a new tradition in figural stone sculpture appeared in the eleventh century in the context of architectural decoration. This new sculpture was located inside the churches, on the capitals of the shafts and colonnettes that articulated the structure. The capital, as a structural member, serves as the point of transition between the load of arches and the support of piers. Visually, it occupies a critical point in the rationale of the structure, so that despite its relatively small size it qualifies as a significant field for decoration. In this light the sculptured capital has long been regarded as the forerunner of the great portal and facade compositions that epitomize the achievements of Romanesque sculpture. Among the earliest examples of the eleventh century, Henri Focillon identified several different strains of decoration, initiated in eastern and central France, which are categorized as geometric, foliate, animal, fantastic, and figural compositions.[1]

The earliest application of figures to capital decoration predates the Romanesque period by many centuries. Masks, faces, and even some whole figures were interspersed among the acanthus leaves of Hellenistic and Roman Corinthian capitals. Although this practice did not survive beyond Antiquity, it is interesting to note that the most characteristic Romanesque essays in sculptured capitals occurred on the Corinthian type. There is no evidence that this repetition was a revival, or even a survival, of the antique practice.[2] Rather, in both

Antiquity and the Middle Ages, the structure of the Corinthian capital—with its successive rows of acanthus leaves around an inverted bell-shaped core, its volutes at the corners which effect a transition from the round base to the square top, and its medallions at the top of the central axis of each face—lends itself very readily to transmogrification. Also, the Corinthian was readily available: its use had survived the barbarian invasions and continued, albeit in an increasingly corrupt form, in Italy, France, Spain, and Germany right through the tenth century. The survival of the Composite capital, though of secondary importance, played a relatively prominent role in the development of Romanesque historiated capitals. The Composite was similar to the Corinthian, but with Ionic corner volutes drooping from the top so that the roundness of the bell was unobscured for most of its height.

The Romanesque application of figures to decorated capitals is quite distinct from that of earlier medieval practices. Visigothic Spain had already produced, in the late seventh century, capitals at San Pedro de la Nave (pl. 1) on which figural images of explicit religious subject matter were composed with distortions to conform to the shape of the field. One, Daniel in the Lions' Den, shows the prophet as

[1] Focillon, "Recherches récentes sur la sculpture roman en France au XIe siècle," *Bulletin monumental*, XCVII (1938), 57ff.

[2] Eugen von Mercklin, in *Antike Figuralkapitelle* (Berlin, 1962), has traced copious examples from ancient Egypt to Constantinian

Rome which were carved with human figures, fantastic creatures, and beasts, but almost none of the motifs from the Greco-Roman tradition appear in Romanesque capitals. Moreover, although the motifs in late antique Corinthian capitals are generally disposed so as to conform to the structure of the frame (e.g., capitals with human and fantastic creatures, pls. 773, 774, 781, 782; and with beasts, pls. 945, 981, 1039), in the eleventh-century Romanesque tradition, as we shall see later, a distinction was made and only decorative themes were formulated in this manner: figural compositions were not. Finally, the motifs on antique examples, unlike on Romanesque capitals, are subjected to a minimum of distortion.

19. Stone capital with unidentified themes, c. 1029, the crypt of Saint-Aignan, Orléans. (Bildarchiv Foto Marburg)

a praying orans, on the vertical axis, standing between facing lions. Because the lions stand on the sloping sides of the capital frame, their hindquarters are elevated to the level of Daniel's head, clearly an unnatural disposition. However unlike a Romanesque capital, the images are carved in shallow relief with a linear chip-carving technique and are limited to a framed flat surface.

A useful contrast is provided by one of the earliest-known Romanesque capitals which has the same figure grouping although not the same subject. Located in the crypt of Saint-Aignan at Orléans (pl. 19) and dated variously between 989 and 1029,[3] its

figures are carved with an emphatic sculptural roundness, with linear graving employed only to create hair textures. As at San Pedro de la Nave, the human figure stands on the vertical axis of the main face, but, unlike San Pedro, the Saint-Aignan lions are situated diagonally on the corners of the capital. The Saint-Aignan lions are more unnaturally distorted than at San Pedro because they stand on their hindquarters, backsides exposed, with their heads turned to face outward. The figures replace the decorative elements of a Corinthian capital: the lions' heads, the volutes; the human figure's head, the central medallion; all the bodies, the acanthus foliage. It was one thing to arrange the figures to conform to the contour of the Visigothic capital and quite another to integrate them into the structure of the Romanesque capital so that they assumed its form. But at Saint-Aignan a greater purpose than mere accommodation to the frame has been served: the formal integration of structure and image endows the image with a sense of relating to the whole architectural setting, allowing it to transcend its small size, giving it a monumental impact. In this essential aspect the Saint-Aignan capital represents the basic aesthetic achievement of eleventh-century architectural sculpture, but its sudden appearance without an extant evolutionary background leaves the origin of this mode unexplained.

Although the lions of the Saint-Aignan capital were distorted and the human figure fixed within the capital structure, it was necessary that this figure remain largely undistorted in order to preserve his (unknown) meaning. There was, however, no such limitation imposed on the use of purely decorative or fantastic motifs. It appears that the integration of these thematic categories into the structure of the capital offered the first opportunities for the development of stylistic abstraction. The most impressive early examples are found in the rotunda of the outer crypt of Saint-Bénigne at Dijon, c. 1016.[4] Only four of the rotunda capitals were carved, two of which remain unfinished (pls. 21, 22). The completed pair indicate that the plain in-

[3] Focillon, in "Recherches récentes," 68, assigned the date to the period between 1010 and 1029 on the basis of documentary evidence that the church was constructed during the reign of Robert the Pious. F. Lesueur, in "Saint-Aignan d'Orléans, l'église de Robert le Pieux," *Bulletin monumental*, cxv (1957), 169–206, reviewed the chronological studies and opted for the same date. He also indicated, with photographs, that the theme is not Daniel in the Lions' Den, as Focillon thought, but an unknown

subject with three related but different nude figures on each face (191). See also J. Bathellier, "Observations sur la crypte de Saint-Aignan d'Orléans et ses chapiteaux," *Revue archéologique*, XXXIX (1952), 192.

[4] Jurgis Baltrušaitis, *La stylistique ornementale dans la sculpture romane* (Paris, 1931), 83–85; Louis Grodecki, "La sculpture du XIe siècle en France: Etat des questions," *L'information d'histoire de l'art*, III (1958), 107–108.

20. Stone capital with grotesques, c. 1016, the crypt of Saint-Bénigne, Dijon. (James Austin)

verted bell shapes were intended to be carved with a basically Corinthian composition but with human and monstrous figures substituted for all of the foliage components (pl. 20). On the completed capitals, a monster represented only by head and legs on the vertical axis of each face sits crowded between two other monsters seen in profile facing the corners. These lateral figures meet those on the adjacent faces at the corners, where they coalesce on the diagonal to prey variously upon human and animal figures. The Corinthian capital structure has been respected, but the metamorphosis of foliate into animate forms is total. No figure is represented as a complete form, yet the ensemble of fragments is believable as whole. The composition is so compacted that the figures no longer retain the illusion of arrangement in a pictorial space. Instead, the image and its framework become identical: the image exists in the sculptural space delimited by the front plane of relief.[5] It is credible as a figure, then, only within its formal context.

The west porch capitals of Saint-Benoît-sur-Loire, probably carved in the 1080s,[6] demonstrate

[5] Erwin Panofsky, "Perspective as Symbolic Form," trans. anon. (Institute of Fine Arts, New York University, n.d.), 11–12, from *Vorträge der Bibliothek Warburg* (1924–25).

[6] The controversy revolves around the issues of (1) whether the tower porch and its capitals should be dated to conform to the reference, in a document of the time of Abbot Gauzlin (1004–1030), to a tower deemed worthy to be a model to all Gaul; (2) whether the structure and its decoration belong to the documented construction which took place under Abbot Guillaûme (1067–1080) and after; or (3) whether the ensemble should be dated between those two periods to harmonize with very similar decoration in a structure loosely dated to the middle of the eleventh century. The most complete account of this controversy is found in a subchapter devoted to Saint-Benoît-sur-Loire, by Marilyn Low Schmitt, in *The Abbey Church of Selles-sur-Cher*

21. Unfinished stone capital, c. 1016, the crypt of Saint-Bénigne, Dijon. (James Austin)

22. Unfinished stone capital, c. 1016, the crypt of Saint-Bénigne, Dijon. (James Austin)

graphically, although long after the earliest instances, how the process of substituting animate for foliate forms took place. Significantly, the substitution occurred simultaneously with the revival of a more nearly Roman version of the Corinthian capital. At Saint-Benoît there are several such Corinthian capitals with no animate decoration except on the impost above the capital proper (pl. 23). There are, in addition, several others on which only the axial medallion on each face has been displaced. One notable example has the figure of a man, contorted in a manner that can only be described as acrobatic (pl. 24). Even though other capitals in this group have less distorted figures, the stance here, in itself, is not the most salient feature: which is, rather, that the man is contorted to fit the square field on which he is carved. On still another capital, all the foliage has been replaced by lions, human busts, and masks

(pl. 25). The masks occupy the position of the medallion; the lions, of the volutes; other lions and the human busts, of the rows of acanthus leaves along the base. It would be a mistake, however, to construe this extent of substitution to be the result of gradual evolution. Instead, these examples demonstrate that while any amount of figural or fantastic subject matter could be substituted for the traditional foliage it was the structure of the Corinthian capital that controlled the disposition of forms.

The importance of the Corinthian capital structure and of fantastic motifs for the development of abstraction in Romanesque capitals seems to be underscored by the absence of both this structure and distortion in the religious historiated capitals that were formerly in the church of Saint-Germain-des-Prés in Paris. Although often dated in the early eleventh, or even the late tenth, century, the remainder of their original architectural setting suggests a date in the middle of the eleventh century,[7] well after the capitals of Saint-Aignan and

(Ph.D. diss., Yale University, 1972; Ann Arbor, 1973), 122–135, in which Schmitt supports a date toward the end of the eleventh century. Another recent account is that of Frédéric Lesueur, "La date du porche de Saint-Benoît-sur-Loire," *Bulletin monumental*, cxxvii (1969), 119–123. Dom Jean-Marie Berland, the present abbot of Saint-Benoît-sur-Loire, in "Le problème de la datation du clocher-porche de Saint-Benoît-sur-Loire," *Etudes ligériennes d'histoire et d'archéologie médiévales* (Auxerre, 1975), 45–59, is the last remaining adherent of the earliest possible date, c. 1030 in the abbacy of Gauzlin. In my opinion, Schmitt's analysis is the most convincing.

[7]Grodecki, "Etat des questions," 103 and n. 38, has surveyed the literature for a date of 990/1024 and for the late eleventh

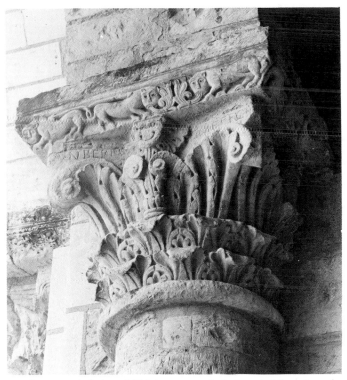

23. Stone capital signed "Unbertus me fecit," probably 1080s, the ground floor of the tower porch, Saint-Benoît-sur-Loire. (James Austin)

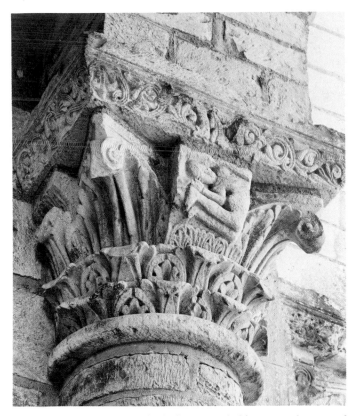

24. Stone capital with acrobatic figure, probably 1080s, the ground floor of the tower porch, Saint-Benoît-sur-Loire. (James Austin)

Saint-Bénigne. Beside a group of timid foliate capitals of the most corrupt Corinthian type from the same church, the figural capitals pose a striking contrast. Their basic shape, round at the bottom and square at the top, suggests no precise antique type but most nearly resembles a corrupt Composite capital without volutes. On such a Composite capital the foliate decoration can be so various that it imposes no guiding structure other than the basic inverted bell shape. One of the Saint-Germain-des-Prés capitals has Christ enthroned in a mandorla on the main face, framed on the corners by columns that slant outward at the top in conformity with the capital shape, and flanked by angels on the side faces (pl. 27). But here conformity to the capital frame is a compositional accident; the structure is not expressed by the image. Three other capitals, all dam-

aged, have figures representing unidentified but apparently religious themes. Although it may be argued that the figures are disposed according to the shape of the capital—one to each of three faces and one to each of two corners—yet they communicate with each other in a manner that suggests a frieze wrapped around the capital (pl. 28). They stand upright and, like the figures of the Christ capital, undergo no distortion. The figures correspond to no projecting structural elements and perhaps for this reason the relief carving is not so deep as on the capitals with a Corinthian format, but the style is equally plastic in conception.

Another example of capitals that indicate a distinction of stylistic treatment according to the type of theme is in the porch of Saint-Benoît, where the grotesque and the religious figural capitals are all carved on a Corinthian structure. Unlike what we find in the grotesques, the only distortion introduced in the religious images is on the corners where figures replacing the volutes bow their heads outward to respect the projection of the volute scrolls.

century. In course lectures delivered in the University of California at Berkeley, which I heard in 1965, Jean Bony set forth convincing evidence that the nave of Saint-Germain can scarcely be dated before c. 1050 and is not likely to have been much later. The most salient features of this nave are angle rolls in the main arcades and vertical bay-division shafts, both of which appeared together elsewhere about 1050 in the nave of Mont-Saint-Michel.

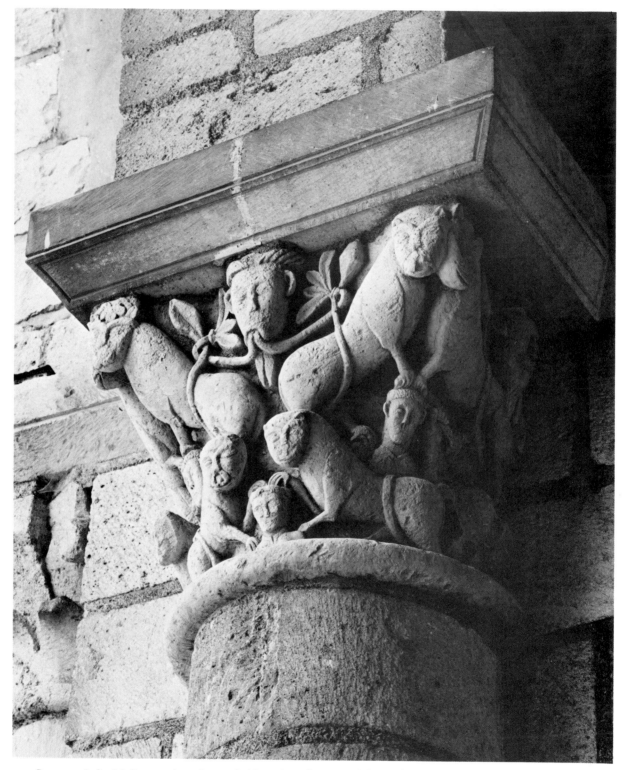

25. Stone capital with lions and masks, probably 1080s, the ground floor of the tower porch, Saint-Benoît-sur-Loire. (James Austin)

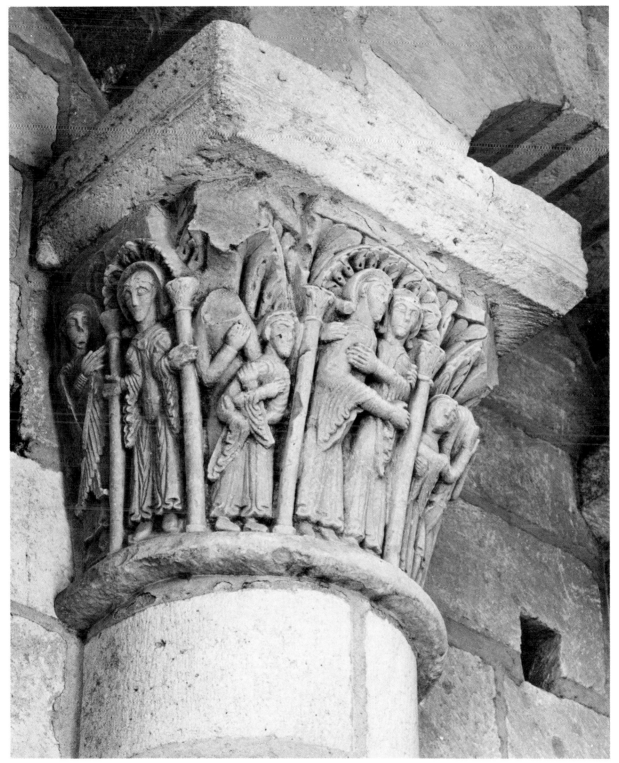

26. Stone capital with the Annunciation and Visitation, probably 1080s, the ground floor of the tower porch, Saint-Benoît-sur-Loire. (James Austin)

27. Stone capital with Christ Enthroned flanked by angels, c. 1050, from Saint-Germain-des-Prés, Paris, Musée Cluny, Paris. (Courtauld Institute—M. F. Hearn)

28. Stone capital with unidentified religious theme, c. 1050, from Saint-Germain-des-Prés, Paris. Musée Cluny, Paris. (Courtauld Institute—M. F. Hearn)

The relationship of the figures to the capital structure is otherwise tentative and the religious images follow almost as many schemes as there are examples. For instance, on the capital decorated with the Visitation of the Virgin to Elizabeth (pl. 26), the figures are arranged in a repetitive row of vertical forms. The figures on the front face are framed by an arch that separates them from those on the corners, but the same type of arch is used in the Annunciation scene on the left face to frame the Virgin asymmetrically. The maintenance of the Corinthian structure, then, is more apparent than real because the composition was determined by the subject matter itself and none of the figures was distorted to accommodate the field. In the Panteon de los Reyes in León, formerly dated to the 1060s but now placed near the end of the eleventh century,[8] the same dichotomy of treatment occurs. In the decorative capitals, the fusion of form and motif is total, but in the historiated capitals, such as that representing the Raising of Lazarus, (pl. 29), the figures are arranged in a frieze composition. Throughout the eleventh century, then, it appears that the abstraction and deformation of images in order to integrate them into the structure of the frame was typical of decorative and fantastic capitals but not of religious capitals.

The plasticity of conception and the depth of carving found in Romanesque capitals, beginning with the earliest examples, seem at first to be qualities which resulted from the substitution of nonreligious decorative motifs for the foliate motifs on the Corinthian capital structure. Indeed, the most salient characteristic of the Corinthian capital is the sculptural quality of its structure. However, the preceding examples demonstrate that all the early capitals were not based on the Corinthian format. Another such example, among the earliest of all figural capitals, is that from the early-eleventh-century parish church of St. Martin, Zyfflich (pl. 30), thought to be spolia from the church of St. Pantaleon in Cologne, dating from 970 to 980.[9] Two

[8] John Williams, in "San Isidoro in León: Evidence for a New History," *Art Bulletin*, LV (1973), 170–184, has demonstrated that the tower porch, with its capitals, was added to a church of the 1060s (which had a different plan from the present early-twelfth-century church) and is about three decades later than it has been traditionally dated.

[9] Rudolf Wesenberg, "Die fragmente monumentaler Skulpturen von St-Pantaleon in Köln," *Zeitschrift für Kunstwissenschaft*, IX (1955), 1–28; and *Frühe mittelalterliche Bildwerke: Die Schulen rheinischer Skulptur und ihre Ausstrahlung* (Düsseldorf, 1972).

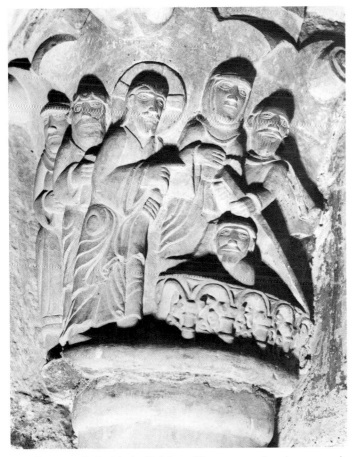

29. Stone capital with the Raising of Lazarus, end 11th century, in the Panteon de Los Reyes of San Isidoro, León. (Archivo Mas)

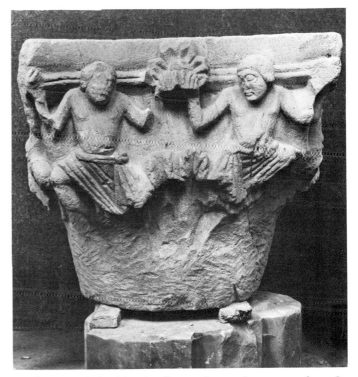

30. Stone capital with atlas figures, late 10th century, from St. Martin, Zyfflich, reused from St. Pantaleon, Cologne (?), Rheinisches Landesmuseum, Bonn. (Landeskonservator Rheinland, Bonn)

atlas figures are carved on its front face and two similar figures on each side. The carving is damaged on the lower half but there is no indication in the remaining portion of conformity to any kind of structural scheme. The seminude figures express to a considerable degree a sense of natural freedom and they are carved on a framework that does not impose compositional limitations. In sum, they look like elements that have been made separately and applied to the core of the capital. The significance of this difference from the norm of Romanesque capital compositions may be explained by comparing a very similar capital of the mid-eleventh century, located in the transept of Saint-Rémi at Reims.[10]

[10]Grodecki, in "Les chapiteaux en stuc de Saint-Rémi de Reims," *Stucchi e mosaici alto medioevali: Atti dell'ottavo Congresso di studi sull'arte dell'alto Medioevo*, 1 (Milan, 1962), 201, remarks that the essential difference between this capital and those of Saint-Benoît-sur-Loire is that its highly plastic figures do not conform to the frame.

The Saint-Rémi capital (pl. 31) has only two atlas figures, situated on the corners with their arms raised to support the central medallions of the front and side faces. Together with the fan of acanthus foliage that fills the space between them, the atlas figures largely express the format of a Corinthian capital. But the soft sculptural roundness of the modeling implies not a transformation of plastic Corinthian forms but the fullness of a figure that has been shaped independently and then applied to the relief ground. At Saint-Rémi the appearance is literally factual for the sculpture is made of stucco and was actually attached to the stone core. Such an example suggests that the Zyfflich capital was carved to imitate the plastic technical effects of stucco work. And although a direct influence of the Saint-Rémi capital here is impossible (it is predated by the Zyfflich), it does seem likely that this stone capital is the earliest surviving evidence of a still earlier practice of decorating capitals with figural compositions modeled in stucco. If this hypothesis is correct, the sculptural quality and depth of relief in the images of Romanesque capitals are due more

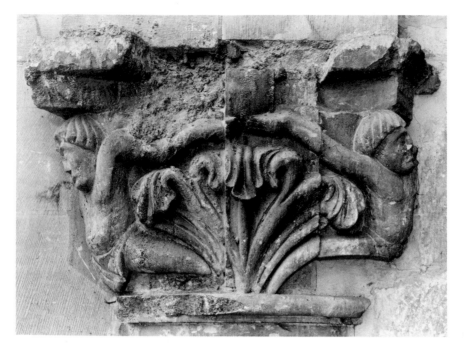

31. Stucco capital with atlas figures, mid-11th century, Saint-Rémi, Reims. (Bildarchiv Foto Marburg)

to the technique used in the first ornamented capitals than to the character of the Corinthian capital.

There are many indications that the earliest practice in capital decoration may have been the work of artists trained in the figural tradition and related media of the goldsmith. The Zyfflich capital's figural style has been most closely compared with the Luithard group of ivories.[11] Regarding the capitals of Saint-Germain-des-Prés, Focillon suggested that both the subject matter of the Christ capital and the style of all the figural capitals seemed to be borrowed from the tradition of gold or stucco retables, and Louis Grodecki compared the figural style to that of Ottonian bronzes.[12] The execution of the Saint-Germain-des-Prés capitals is a strange blend of sophistication and naivete, perhaps engendered by the difficulty of working in the unfamiliar medium of stone. Certainly the figural style, especially in the drapery, indicates a high degree of knowledge of the Carolingian tradition (pls. 11, 18). Moreover, the abnormally enlarged hands that gesture emphatically are reminiscent of the art of ivory

carvers working on a very small scale or of the figures in the Reichenau school of Ottonian illumination.

Yet, in contrast with these earliest capitals, the advance of the eleventh century saw figural style become more and more crude, witness especially the Saint-Benoît capitals (pl. 26), while stone-carving technique became ever more daring and expert. It appears that later sculptors no longer came from a highly developed figural tradition, but that they continued to seek the effects of applied decoration in deep relief carving. An excellent example is the capital at Saint-Benoît decorated with lions and masks (pl. 25). The lions, with their front legs carved completely in the round, are so deeply undercut that they appear to have been modeled and attached to the capital. And the vine motif that spews from the mouth of the central mask and entwines itself around the lions appears to be so free of the capital block that it, too, seems applied. The evidence suggests, then, that while the plasticity of sculptured Romanesque capitals originated in stucco work by artists trained in the Carolingian mainstream tradition of figural art, it was continued and developed by sculptors outside that tradition who imitated the technical effects of stucco work without absorbing the essential nature of that figural style.

Focillon observed, comparing the roughly con-

[11] Wesenberg, *Bildwerke*, 96. Significantly, two later German examples in the outer crypt of St. Luidger in Werden (c. 1060) are capitals with masks carved in the same hand as the fragments of a shrine or altar that appears to be the work of a goldsmith (see 54–58).

[12] Focillon, "Recherches récentes," 66; Grodecki, "Etat des questions," 104.

temporaneous examples of the golden altar of Basel (pl. 11), the marble lintel of Saint-Genis-des-Fontaines (pl. 5), and stone capitals like that at Saint-Aignan (pl. 19), that the differences in style are due to differences in craftsmen with unrelated artistic backgrounds.[13] Meyer Schapiro made a similar observation concerning distinctions between the style and technique of eleventh-century capitals and the marble antependium fragment in Rodez.[14] The disappearance of highly expert hands after the original experiments in decorating capitals with other than traditional foliate motifs indicates that the services of highly trained artists were not available everywhere for architectural decoration. It is significant that the extant early capitals that represent the high tradition of figural art were made in Cologne, Reims, and Paris: all three cities were important art centers from the reign of Charlemagne on. Otherwise, the carving of figural capitals seems to have been taken up by the artisans who already carved foliate capitals and who undoubtedly belonged to the architectural workshop.

We know that sculptors functioned as members of architectural workshops because work from specific hands appears in different churches of the same tradition or technical orientation. In the basin of the Loire River, for example, capitals related to those of Saint-Benoît-sur-Loire have been found at Saint-Hilaire of Poitiers, Maillezais, Corméry, Beaulieu-les-Loches, Méobec, and Selles-sur-Cher, all dating from the period between about 1040 and 1120. Similarly, in Burgundy the capitals of Charlieu and Anzy-le-Duc belong to another distinct workshop.[15] And when the architectural influence of Saint-Aignan of Orléans is identified in another region, Saint-Sernin of Toulouse, the capitals also show a remarkable likeness.[16]

Toward the end of the eleventh century and in the early twelfth, similarities in capitals in dissimilar churches suggest that the sculptors moved about, attaching themselves to various architectural workshops as their services were needed.[17] They were not just anonymous masons, however, for we have numerous instances of their signatures, from the both the eleventh and twelfth centuries.[18] Among the capitals already discussed in this chapter, the notable example is that of Saint Benoît-sur-Loire, where the inscription UNBERTUS ME FECIT is found on the right-hand capital of the central arch of the porch facade (pl. 23). Although such a signature seems to imply that the sculptor and others like him were literate, the relative crudeness of the lettering in each case (compared with the inscriptions on the more fluent figural sculptures of the twelfth century and with all other media in the eleventh) very likely betrays the copying of a signature written for the sculptor by a cleric.

The unfinished capitals of Saint-Bénigne at Dijon, left in several states of preparation, afford a rare glimpse of the sculptor at work. On the least finished (pl. 21), a few forms, still virtually abstract, have been blocked out symmetrically along the vertical axis, indicating the fundamental structure intended for the decoration. Diagonals correspond to Corinthian volutes and an oval form, representing the medallion, surmounts a subdivided shape on the lower part of the bell where acanthus leaves would be expected. The intentions for these forms are revealed on the adjacent capital where the carving is in a more advanced state (pl. 22). The central medallion is a crude human face, the diagonals are arms that extend from the base of the capital to the hands in the upper corners, and the space between the head and arms is occupied by the first indications of a draped torso. The intended motif on both capitals, then, would have been a truncated atlas figure. Beneath the hands on the corners are rudimentary articulations of foliage clusters which add nothing to the meaning of the subject but serve to fill out the structural form. The design of each face of the capital was conceived to coordinate with

[13] Focillon, "Recherches récentes," 56-57.

[14] Schapiro, "A Relief in Rodez and the Beginnings of Romanesque Sculpture in Southern France," *Romanesque and Gothic Art, Studies in Western Art: Acts of the Twentieth International Congress of the History of Art, 1960* (Princeton, 1963), I, 64-65.

[15] For the churches along the Loire and its tributaries, the most painstaking account of similar capitals is that provided by Schmitt, *Selles-sur-Cher*, 104-119. For a different pattern of dissemination among most of the same churches, see Grodecki "Etat de questions," 106-108. For the churches in Burgundy, see Eliane Vergnolle, "Recherches sur quelques séries de chapiteaux romans bourguignons," *L'information d'histoire de l'art*," XX (1975), 55-79.

[16] Schmitt, *Selles-sur-Cher*, 120-121; and Lesueur, "Saint-Aignan," 201.

[17] Thomas W. Lyman, in "The Pilgrimage Roads Revisited," *Gesta*, VIII (1969), 30-44, traces such examples on both sides of the Pyrenees, particularly the capitals of Saint-Sever and Saint-Gaudens and their relationship to the capitals of Saint-Sernin of Toulouse and of Santiago de Compostela. In Italy, another instance is found in the similar capitals of Sant'Ambrogio, Milan, and of San Michele, Pavia, located in dissimilar churches.

[18] F. de Mély, "Signature de primitifs: De Cluny à Compostelle," *Gazette des Beaux Arts*, X (1924), 1-24.

the others: the hands of the figures meet at the upper corners and the foliage clusters at the lower corners. Consequently, while the figures are centered on the faces, the foliage clusters are centered on the diagonal, creating a total integration of the image around the capital. The details of the motif would have been gradually refined until the capital structure was fully articulated and the decorative forms assumed a life of their own within the framework. This graphic example of procedure from an abstract pattern to a recognizable image led Jurgis Baltrušaitis to propose that abstract design was the underlying principle of the aesthetic of Romanesque capitals and indeed of Romanesque sculpture in general.[19] But in so doing he mistook the means of creation for the source of inspiration.[20]

In actual labor, the initiation of figural stone carving in architecture, where there was only a negligible amount of prior activity and where the mode of carving was new, may not have been so formidable a venture as it is often made out to be. To be sure, there is a distinct improvement in all technical aspects of carving over the course of the eleventh century. But the earliest capitals reveal an astonishing degree of virtuosity, suggesting that fairly sophisticated tools were available from the beginning. Gervase of Canterbury (1180s), in comparing the capitals of the Romanesque and Gothic choirs of Canterbury Cathedral, attributed the difference to tools—to the use of an ax in the former and a chisel in the latter.[21] But, Gervase notwithstanding, the completed capitals of Saint-Bénigne (pl. 20) give evidence not only of the chisel (in the depth of their relief) but also of the drill (in the completely detached arms of the corner monsters). Similarly at Saint-Benoît, the acanthus leaves of the Corinthian

capital clearly were drilled (pl. 23) and the legs of the lions are completely detached from the relief ground of the lion and mask capital (pl. 25). In terms of carving technique, there was nothing more daringly executed in the most sophisticated capitals of the twelfth century. Although they were isolated from the artists of other media, the capital-carvers in the architectural workshops were remarkably skilled even from the earliest years of their activity. To explain their skill, though, there is no basis for supposing that they came to this work from a prior sculptural tradition. In all likelihood they were, initially at least, recruited from among the masons in the architectural workshop, especially those who carved the corrupt Corinthian capitals. They were obviously artisans who were chosen because they could work in stone, however naively they reproduced the images they were given to copy.

The images on the capitals appear to have been borrowed from many disparate sources, none of which can be specified but most of which correspond to types found in other media. The religious themes, when they can be identified, seem to be straightforward formulaic images for which the common fund was a wide variety of illuminated manuscripts, as, for example, on the Annunciation-Visitation capital of Saint-Benoît. Others, such as the capital with Christ Enthroned from Saint-Germain-des-Prés, seem to have been adapted from sculptured objects like gold retables. A few capitals, for instance, those with atlas figures in Zyfflich and Saint-Rémi, suggest imitation of antique sculpture fragments. The motifs of birds and animals could have widely various sources, but capitals with confronting and addorsed beasts may well have been copied from precious textiles imported from the Near East, as Emile Mâle suggested.[22] On the other hand, examples with biting animals and interlaced foliage may have been influenced by the Celtic and Nordic traditions which had been assimilated throughout much of Europe by the eleventh century,[23] especially in manuscript decoration. Less familiar in earlier me-

[19] Baltrušaitis, *Stylistique ornementale*, see esp. 83–86.

[20] For the most cogent argument against Baltrušaitis's theory see Meyer Schapiro, "On Geometrical Schematism in Romanesque Art," in *Romanesque Art* (New York, 1977), 265–284, originally published in *Kritische Berichte zur kunstgeschichtlichen Literatur* (1932–33).

[21] For the Latin text, William Stubbs, ed., *The Historical Works of Gervase of Canterbury* I (London, 1879), 27. Comparing the new Gothic choir to the old Romanesque one, Gervase wrote: "In the old capitals the work was plane; in the new ones the chisel work is subtle.... There, the arches and everything else had been made flat, as though done with an axe [*secure*] and not with a chisel [*scisello*]" (trans. quoted from Paul Frankl, *The Gothic: Literary Sources and Interpretations through Eight Centuries* [Princeton, 1960], 30). That this distinction in tools is inherent in the difference between Romanesque and Gothic architecture was suggested by Walter Oakeshott, *Classical Inspiration in Medieval Art* (London, 1958), 81–82.

[22] Emile Mâle, *L'art religieux du XIIe siècle en France: Etude sur les origines de l'iconographie du Moyen Age* (Paris, 1924), 342–359.

[23] The Celtic, Nordic, and Frankish background of the Romanesque sculpture has been treated in varying degrees by R. Bernheimer, *Romanische Tierplastik und die Ursprünge ihrer Motive* (Munich, 1931); Marie Durand-Lefebvre, *Art gallo-romain et sculpture romane: Recherche sur les formes* (Paris, 1937); and André Varagnac and Gabrielle Fabre, *L'art gaulois*, La Nuit des Temps (La Pierre-qui-vire, 1964).

dieval art are the fantastic creatures (beasts or figures that combine parts of different species) and the bicorporates (beasts or figures that combine two bodies under one head), many of them contorted in unnatural positions. Vilhelm Slomann, in an extensive study of bicorporate motifs, demonstrated that the close similarity between many Romanesque capitals and ancient Sumerian works of art cannot be entirely fortuitous, but he was unable to advance a plausible theory for the transmission of these motifs to Europe. Nevertheless, despite the much earlier diffusion of many of these images (for example, chimeras) into the Greco-Roman world and also (for instance, biting animals) into the art of the migratory tribes of pre-Roman Europe,[24] there does seem to have been a fresh wave of influence from ancient Oriental art in Europe in the eleventh and twelfth centuries.

These sources, however, are only conjectural, for virtually no prototypes can be exactly identified. Baltrušaitis thought that many of the motifs on capitals were simply invented in the course of blocking out designs on abstract patterns that could be imposed on the Corinthian format.[25] Certainly this seems to have been the case with the majority of early capitals carved with foliate and abstract ornament. On the other hand, the more distinct the identity of the motif and the clearer its form, the more nearly it resembles images that existed earlier in other media. It is interesting to note that, with the exception of the precocious monsters of the Saint-Bénigne capitals, the more elaborately imaginative formulations and fantastic motifs did not appear until near the end of the eleventh century or in the twelfth. Some of the capital designs may well have been invented by the sculptors, but the more impressive ones were probably adapted from preexisting images. This reliance on models for such images leads us to question the circumstances under which the decoration of capitals began: was this new sculptural activity initiated by the artisans themselves or was it ordered by the patrons, with some or all of the motifs specified?

In their researches into the sources of the motifs and the process of creation, Mâle and Baltrušaitis discussed sculptured capitals only in terms of the artist.[26] Indeed, a case for the initiative of the artist could be readily made by the circumstances surrounding the creation of some of the earliest known examples, the capitals of the crypt rotunda of Saint-Bénigne of Dijon. Only a few of the capitals were carved and two were left unfinished, suggesting that the introduction of carved ornament was an ad hoc decision on the part of the artisans and insufficiently important to the patrons to delay the dedication of the crypt in order to complete the carving. Moreover, the lack of concerted thematic programs wherever large groups of capitals remain in situ, as in the porch of Saint-Benoît, implies that the decoration of capitals was an arbitrary activity left to the discretion of the carver. From the wide variety of sources attributed to the motifs we can surmise that the sculptors looked everywhere for images to appropriate. Indeed, the similarity of motifs in capitals found over a wide geographical range but carved in different styles suggests that the sculptors made and copied sketchbooks in order to collect a wide variety of patterns and images.[27] However, the existence of such sketchbooks has never been proven. Also, the assumption of artistic autonomy on the part of the sculptors exaggerates the historical role of artisans who seem to have been isolated from the Carolingian tradition, the mainstream of artistic production. And too, the immediate, widespread, and consistent deployment of this kind of decoration in churches of the last quarter of the eleventh century suggests that the introduction of sculptured embellishment was not casually left to the initiative and taste of the artisans.

But there are weightier arguments for the other side of the question. When considering the types of objects from which the motifs on the capitals were ostensibly copied, we must keep in mind that illuminated manuscripts, vestments, relics (and their textile wrappings), and objects used to decorate the altar were highly restricted in access. Although any worshiper might see them fleetingly during services, they were otherwise always locked away, or located in areas of the church reserved for the clergy. It would be difficult, then, for an artisan—be he a

[24] Vilhelm Slomann, *Bicorporates: Studies in the Revivals and Migrations of Art Motifs* (Copenhagen, 1967), I, 171–177. Slomann's theory—that pilgrims to the Holy Land following the First Crusade brought back plaster casts of Sumerian reliefs, believing them to be related to early Christianity—is too fanciful to be accepted. See also Jurgis Baltrušaitis, *Art sumérien, art roman* (Paris, 1934), for the theory of Oriental influence behind the fantastic motifs of Romanesque capitals.

[25] Baltrušaitis, *Stylistique ornementale*, 83–85, and *passim*.

[26] Mâle, *L'art religieux du XIIe siècle*, 340ff, and *passim*; and Baltrušaitis, *Stylistique ornementale, passim*.

[27] George Zarnecki, *The Early Sculptures of Ely Cathedral* (London, 1958), 29–30.

laymen or even a lay brother in a monastery—to see these objects close at hand unless they were shown to him on purpose, a situation that would most likely be initiated by the clerical patrons of a project. It is more plausible in this case that the sculptor would be provided with sketches made by a monk or canon who deemed these motifs suitable for the embellishment of the church. Also, there seems to be a more than coincidental connection between the appearance of the earliest examples of capitals imaginatively carved in a plastic manner and architecture constructed of smoothly cut ashlar masonry, a Roman technique which was newly revived in eleventh-century France. Indeed, Saint-Aignan of Orléans, Saint-Benigne of Dijon, Saint-Germain-des-Prés of Paris, Saint-Benoît-sur-Loire, and Saint-Rémi of Reims are all the earliest surviving examples of ashlar construction in their respective regions. This correlation indicates a situation in which the patron was the dominant force in the project. As Louis Grodecki has observed, the earliest capitals with figured sculpture in both Burgundy (Saint-Bénigne) and Normandy (Bernay) appeared in buildings erected by the same patron, William of Volpiano.[28] Neither the capitals nor the churches have medieval prototypes in Italy, but the size and complexity, as well as the technique, of the new architecture suggest that it was conceived to rival that of ancient Rome. The capitals, too, may have been inspired by such an ideal, without any intent to make direct copies of ancient examples. Significantly, the spread of sculptured capitals was apparently related only to the spread of the new architecture because it was certainly not dependent upon artistic filiation. The inception of stone sculpture on capitals, then, was probably based on a particular aesthetic taste, whether or not the patrons actually prescribed all of the designs for individual capitals.

In order to understand the function of this decoration it is necessary to examine it within the context of medieval culture and art. Fortunately, for this purpose there is at least one important document related to the decoration of capitals, a passage in the *Apologia* to William of Saint-Thierry (c. 1125), written by St. Bernard of Clairvaux.[29] Albeit negative in tone, much evidence for a positive appreciation of Romanesque sculpture can be gleaned from this passage condemning the fantastic art represented by capitals:

> But in the cloister, under the eyes of the brethren who read there, what profit is there in these ridiculous monsters, in that marvelous and deformed beauty, in that beautiful deformity [*mira quaedam deformis formositas ac formosa deformitas*]? To what purpose are those unclean apes, those fierce lions, those monstrous centaurs, those half-men, those striped tigers, those fighting knights, those hunters winding their horns? Many bodies are seen there under one head, or again, many heads to a single body. Here is a four-footed beast with a serpent's tail; there, a fish with a beast's head. Here again the forepart of a horse trails half a goat behind it, or a horned beast bears the hind-quarters of a horse. In short, so many and so marvellous are the varieties of shapes on every hand, that we are more tempted to read in the marble than in our books, and to spend the whole day wondering at these things rather than in meditating the law of God. For God's sake, if men are not ashamed of these follies, why at least do they not shrink from the expense?[30]

Although St. Bernard did not explicitly mention capitals, his reference to "marble"[31] and to the location of this art in the cloister leaves no doubt that he meant stone sculpture in an architectural setting. And the type of sculpture he described is found primarily on capitals, especially those of cloisters. This memorable description, recounted from an unspecified locale but directed in general against Cluniac practices, is drawn from a context in which St. Bernard clearly acquiesces to the use of art in nonmonastic churches, deploring its presence only in monasteries. Elsewhere in the *Apologia* he makes a further distinction between "beautiful" images of saints and other sacred figures, of which he approves

[28] Grodecki, "Etat des questions," 106.

[29] John Gage, in "Horatian Reminiscences in Two Twelfth-Century Art Critics," *Journal of the Warburg and Courtauld Institutes*, XXXVI (1973), 359–360, has set forth evidence to support the argument that St. Bernard was referring here to the opening passage of Horace's *Ars Poetica*, in which the poet was ridiculing similar fantastic creatures as hypothetical examples of excessive poetic license.

[30] Quoted from Meyer Schapiro, "On the Aesthetic Attitude in Romanesque Art," *Art and Thought*, ed. Bharatha Iyer (London, 1947), 133–134. For an English translation of the whole letter, see G. G. Coulton, *Life in the Middle Ages* (Cambridge, 1930), 72–76; most of the letter is quoted in Elizabeth Gilmore Holt, *A Documentary History of Art*, 1, *The Middle Ages and the Renaissance*, rev. ed. (New York, 1957), 19–22. The original Latin text is found in Migne, *Patrologia Latina*, CLXXXII, cols. 914–916.

[31] There are no known cloister sculptures, especially capitals, within the region of Burgundy (the region most familiar to St. Bernard), that are carved of marble. Instead, they are all carved from limestone. St. Bernard's reference to marble was a poetic term for stone sculpture.

for nonmonastic use, and the "deformed beauty" of fantastic capitals. As Meyer Schapiro has pointed out, St. Bernard's sensibility to these capitals, even his ability to describe them so accurately, attests to his awareness of the aesthetic intentions behind their creation.[32] Specifically, St. Bernard's objection to the diverting images among the cloister sculptures was directed toward their lack of moral utility, which made them unnecessary. Indeed, their very superfluity (a quality in decoration that was condemned later not only by the Cistercian Order but also by others, including Abelard) led, he thought, to *curiositas*, the interest in and love of the world which was the first step into the deadly sin of Pride.[33] But this protest represents the negative viewpoint of an aesthetic impulse that can be stated positively and would have been by those who sponsored its expression.

The great variety of motifs employed on the capitals was particularly striking to St. Bernard. As Schapiro has so aptly observed, the capitals of Romanesque architecture, carved with their highly various designs, mark the first pervasive instance of such consistently individualized ornament on repeated architectural elements.[34] Nevertheless, this differentiation was not exploited in the eleventh century for didactic purposes in the representation of sequential religious themes. On the contrary, the nonreligious motifs have no explicit meaning, as St. Bernard implies when he questions their purpose and adds that they are but "follies" that serve only to provoke wonderment.[35] If they have no definite or programmatic meaning, then their purpose is primarily decorative, even as decoration for its own sake. Schapiro recognized that such a function denotes an aesthetic attitude in which the visual attractiveness of art is regarded as valid in itself, an attitude clearly reflected in the enthusiastic observations

about other works of nonreligious or purely decorative art recorded by a number of twelfth-century observers.[36] Not only was decoration admired but, as St. Bernard's complaint about the cost suggests, it was also sufficiently desirable that patrons were willing to bear the additional expense it required.

The purpose of sculptured capitals as architectural decoration was parallel to that of the marginal embellishment of medieval art in general. More often than not, this embellishment consisted of motifs unrelated to the basic theme of the work of art. Typical eleventh-century examples are the borders with various birds and beasts found on the famous ivory holy-water bucket preserved at Aachen, on the Flabellum of Tournus (a liturgical fan), and on the Bayeux Tapestry.[37] Indeed, nearly every sumptuous work of medieval art has a similar border or frame of decoration, be it floral, animal, figural, or abstract in design. The contrast between the main theme and the decoration, often very marked, served to heighten the meaning and visual effectiveness of the principal subject. From this widespread practice it is safe to infer that the contrast was intended to make the work of art more striking and more impressive.[38]

A similar inference can be drawn from the abstract style of the nonreligious motifs on capitals. Although Baltrušaitis attributed the invention of this style to the procedure of carving, beginning with an abstract pattern imposed upon the structure of the capital, it is noteworthy that such a stylistic formulation was not entirely new. As far back as the Hiberno-Saxon manuscripts of the eighth century, for instance on the carpet pages of the Lindisfarne Gospels, we can find elaborate designs which not only conform to the frame and fill the available space completely but also rigorously follow an underlying abstract pattern.[39] In succeeding centuries the most apposite parallel occurs in illuminated initials where the norm is that nonreligious decoration conforms to the shape of the letter or the spaces inside it. Apparently, then, there was a notion throughout the Middle Ages that ornament that contributed to the splendor of a work of art rather than to its meaning

[32]Schapiro, "Aesthetic Attitude," 135–137.

[33]Edgar de Bruyne, *Etudes d'esthétique médiévale* (Bruges, 1946), II, 135–141; and Schapiro, "Aesthetic Attitude," 134–135.

[34]Schapiro, "Aesthetic Attitude," 131–132.

[35]Mâle, *L'art religieux du XIIe siècle*, 340; and Schapiro, "Aesthetic Attitude," 131–132, 137. St. Bernard's denial of iconographic significance in these decorative motifs was not a novelty but an echo of a traditional attitude in the Christian philosophy of images. Nicephoras, in his *Antirrheticus* III (*Patrologia Graeca*, c, col. 376) of the early ninth century, referred to similar decorations surrounding images of Christ and affirmed that they neither shared the sacred meaning of the latter nor merited the pious veneration of such holy images. See André Grabar, "L'esthétisme' d'un théologien humaniste byzantin du IXe siècle," *L'art de la fin de l'Antiquité et du Moyen Age* (Paris, 1968), I, 60–69.

[36]Schapiro, "Aesthetic Attitude," 138–142.

[37]Lilian M. C. Randall, *Images in the Margins of Gothic Manuscripts* (Berkeley, 1966), 3, n. 3; and see Peter Kidson, *The Medieval World* (New York, 1967), pl. 13, for the Aachen situla.

[38]Randall, *Images*, 3–20, *passim*.

[39]For an analysis of one of the Lindisfarne carpet pages see Gerard LeCoat, "Anglo-Saxon Interlace Structure, Rhetoric and Musical Troping," *Gazette des Beaux Arts*, LXXXIII (1976), 1–3.

should be subordinated to the shape of its frame.

It is significant that St. Bernard describes both the variety of motifs on the capitals and their deformed beauty with the same adjective, "marvelous" (mira), albeit with a slightly pejorative tone in this context. Other medieval writers frequently employed the same term in an entirely positive sense to convey an appreciation of fine workmanship or of the splendor and dignity conferred upon a work of art by its decoration.[40] So, likewise, did St. Bernard in an earlier passage of the Apologia when he referred to bronze candelabra "fashioned with marvelous subtlety of art."[41] But in his usage, the application of the term "marvelous" also to subject matter and to style denotes a specific aesthetic quality which they share. Since the description of capitals focuses on fantastic motifs, which are purely imaginative and artificial, his characterization of both content and form as "marvelous" implies that the style is equally imaginative and artificial. Presumably it was this very quality of artifice that endowed an object with the aesthetic nature deemed appropriate to sumptuous decoration by those who fostered it.

The consistency with which highly artificial designs were applied to the vast majority of capitals attests to the primacy of such an aesthetic notion as the motivating and justifying force that inspired their production throughout Western Europe. Despite the similarity in the types of motifs and, to a slightly lesser degree, in technique and style, no pattern of direct influence has emerged that could account for the proliferation of sculptured capitals through the independent agency of the sculptors themselves. Primary responsibility for the development of sculptured capitals, then, seems to rest with the patrons. Moreover, the speed with which the fashion spread in the latter half of the eleventh century (most notably throughout much of France, the Rhineland, Lombardy, and northern Spain) suggests that the aesthetic notion on which this type of decoration was based was easily communicated among patrons.

Within each region and in general, there was little evolution either in the type of subject matter or in style throughout the eleventh century. A marked advance in figural capitals occurred around 1100, in both Burgundy and Languedoc, but only where there is definite evidence of an intervention of artistic effort from sources other than the architectural workshop. The advance was sudden and embraced new levels of technique, style, and subject matter all at once, accompanied by other formats that were truly monumental. Nevertheless, alongside these privileged examples, the architectural workshop tradition of capital carving continued throughout the twelfth century, especially in areas where monumental stone sculpture was least developed. The character of both the change of 1100 and the continuation of the eleventh-century tradition elsewhere clearly indicates that sculptured capitals were not the matrix of the twelfth-century revival. They were simply the harbingers, staking out a claim in the architectural setting for the introduction of monumental figural sculpture.

Relief Slabs

Aside from sculptured capitals, there was another fresh beginning in eleventh-century stone sculpture, centered in Germany. Emerging suddenly about 1050, this sculpture comprised large-scale figural reliefs that seem to signify a genuine revival of the medium. More than forty reliefs and fragments constituting at least seven monuments or ensembles remain from the decades before 1100, and there are undoubtedly others that have now vanished.[42] A great majority of these reliefs are rectangular slabs carved with single figures, varying between eighteen inches and nearly five feet in height. Others, incorporated into church furniture or serving as tombs, have even larger formats. All of them share at least three important characteristics: regardless of the actual depth of relief they are carved with a remarkably plastic conception of the figure; they represent a fluent expression of the most expert figural style then prevailing; and they are the products of artists who were fully equipped to execute iconographic subtleties. Both by these qualities and the basically new formats, they are distinguished from earlier stone sculpture. Examination

[40] Schapiro, "Aesthetic Attitude," 138–142.

[41] Quoted from Holt, Documentary History, I, 20. See also a similar use of the term relative to the cathedral of Santiago in Jeanne Vielliard, ed. and trans., Le guide du pèlerin de Saint-Jacques de Compostelle (Mâcon, 1938), 90–93; cited by Schapiro, "Aesthetic Attitude," 141–142.

[42] Eleventh-century German sculpture has been treated in numerous articles on individual pieces, but in the context of German sculpture as a whole, the three principal studies are those by Herbert Beenken, Romanische Skulptur in Deutschland (11. und 12. Jahrhundert) (Leipzig, 1924); Erwin Panofsky, Die deutsche Plastik des 11.–13. Jahrhunderts (Munich, 1924); and Rudolf Wesenberg, Frühe mittelalterliche Bildwerke: Die Schulen rheinischer Skulptur und ihre Ausstrahlung (Düsseldorf, 1972).

of a few of the most striking examples provides an adequate basis for assessing this phenomenon.

As figural stone sculpture, the most significant examples by far are the three limestone reliefs of Christ Enthroned (pls. 32, 33) and of St. Dionysius (pl. 34) and St. Emmeram installed above the doorway in the vestibule of St. Emmeram in Regensburg. Generally accepted as the earliest manifestation of the new development in sculpture, these reliefs are dated by association with the inscription around the donor bust beneath the figure of Christ: ABBA REGENWARDUS HOC FARE IUSSIT OPUS ("Abbot Regenwardus had this made for him"). Abbot Regenwardus ruled over the abbey of St. Emmeram between 1048 and 1064, and the sculptures are usually dated about 1050.[43] The figures of all three reliefs, each forty inches high, are remarkable for their full-bodied roundness and the extent to which their composition eschews the pictorial movement and extension of limbs found in the ivory and metal sculptures of the period. Both qualities bespeak a sensitive distinction between the monumental decorum of large stone sculptures and the more pictorially expressive one of small-scale reliefs in precious materials. The degree of relief, carved from three sides, has its most striking parallel in an earlier ivory of the Virgin in Majesty (pl. 9), now preserved in Mainz.[44] The style has been compared to manuscript illuminations, most particularly the late-tenth-century work of the Gregory Register Master.[45] Whether or not these reliefs were originally intended for their present position above the door, they are in no way related to the configuration of the architectural setting and could as readily have served as a three-part retable. In format, they are more closely related to church furnishings than to later architectural sculpture.

The nineteen limestone reliefs, all in rectangular framed formats, from the former Benedictine abbey of Brauweiler represent in half-figures Christ Enthroned (pl. 35), two cherubim, and seven Apostles; a standing figure of Christ Victorious; the Lamb of God; and seven emblematic images of beasts and figures which undoubtedly represent signs of the Zodiac (pl. 36). In the most recent study of these reliefs, Rudolf Wesenberg divided them stylistically into three groups: one comprising the Zodiac signs;

[43] Beenken, *Romanische Skulptur*, 26; Panofsky, *Deutsche Plastik*, 81; Wesenberg, *Bildwerke*, 53.

[44] Wesenberg, *Bildwerke*, 58, figs. 430, 431.

[45] Carl Nordenfalk, "Der Meister des Registrum Gregorii," *Münchner Jahrbuch der bildenden Kunst* 1 (1950), 73ff.

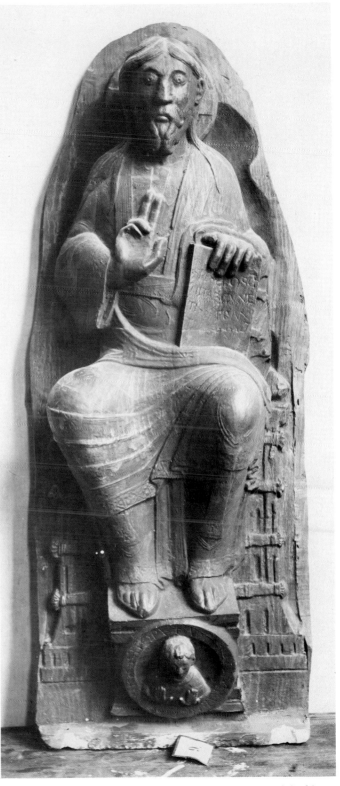

32. Cast of stone relief of Christ Enthroned, c. 1050, original is set above the doorway of St. Emmeram, Regensburg. (Bildarchiv Foto Marburg)

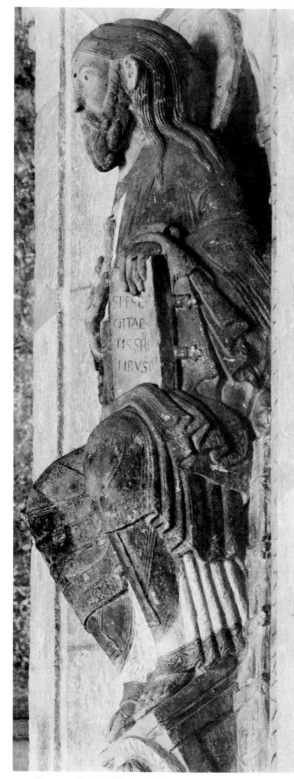

33. Stone relief of Christ Enthroned, c. 1050, set above the doorway of St. Emmeram, Regensburg. (Bildarchiv Foto Marburg)

34. Stone relief of St. Dionysius, c. 1050, set adjacent to the Christ relief above the doorway of St. Emmeram, Regensburg. (Bildarchiv Foto Marburg)

another, the Christ Victorious and the Apostles; and the last, all the others. These groups may signify different ensembles since their sizes do not always correspond to those of reliefs in a different hand but similar format. And too, their arrangements in three locations on the church exterior until recent decades did not necessarily represent their intended disposition. They have been compared variously to Byzan-

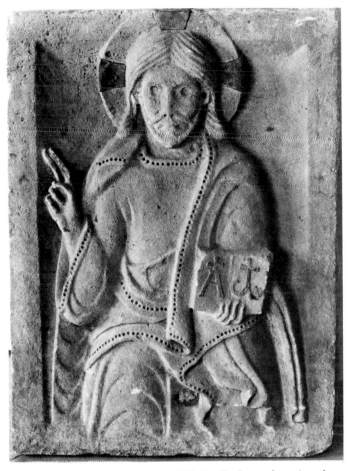

35. Stone relief of half-figure of Christ Enthroned, 1060s, from Brauweiler. Rheinisches Landesmuseum, Bonn. (Landeskonservator Rheinland, Bonn)

36. Stone relief from Zodiac group, 1060s, from Brauweiler. Rheinisches Landesmuseum, Bonn. (Landeskonservator Rheinland, Bonn)

tine ivories, to Ottonian bronze and gold work, and to the "late style" of Cologne illuminated manuscripts, which taken together indicate a date of 1060/1070.[46]

Technically, there are several points about the reliefs worthy of specific notice. Although carved against a concave background, the relief of the Christ Enthroned (pl. 35) and of the Apostles is relatively shallow, but it does not prevent a superlatively plastic and supple modeling of both faces and drapery, remarkably like gold repoussé work (pl. 11). The holes drilled into the area of the missing face and nimbus of Christ Victorious imply that these portions were made of metal and attached to the stone ground. These factors suggest that two of the style groups were executed by goldsmiths. Four

[46] Wesenberg, *Bildwerke*, 63–67.

of the Apostle figures retain traces of color, so it is likely that all of the reliefs were originally painted. Finally, the Zodiac group shows a different carving technique (pl. 36) in which the smaller-scaled figures stand out in significantly deeper relief, so that the limbs of both beasts and figures are cut completely free of the relief ground. Such work indicates the technique of an ivory carver (pl. 18).

Toward the end of the eleventh century, three reliefs, probably originally from the east tower of the monastery of canons of St. Mauritz at Münster, demonstrate both the continuity of the plaque format with a single large figure and the close stylistic relationship of stone sculpture to the media of gold, ivory, and book painting. Two represent warrior saints and the third a female saint, or perhaps the

Virgin (pl. 37).[47] They are striking not only for their size, about three feet high, but also for their sculptural technique. The features of the faces are very finely worked, and the relief, contrasted against a concave field—by then a typical practice—once again permits the carving of the warriors' legs fully in the round. These examples do not add new dimensions to this tradition of stone sculpture. Indeed, to the contrary, they demonstrate that no significant progress occurred throughout the course of this phenomenon in Germany. But they ratify the accomplishments of the Brauweiler reliefs and reflect the similar ones of the six reliefs at Trier and two others at Xanten which date from the intervening years between 1070 and 1090.[48]

Besides the technical advance over any previous stone sculpture in medieval European practice which these reliefs represent, there is also another distinguishing characteristic in their format as framed plaques carved with single figures. They do not represent any previously existing genre and therefore probably were made to serve an unprecedented purpose. Both their framed format and their subject matter recall that of Byzantine relief icons. Information about Byzantine sculpture is difficult to obtain because so little work remains, but Reinhold Lange has demonstrated that carved icons did exist about the beginning of the eleventh century.[49] Several of them survive even in the western outposts of the Byzantine Empire, in Venice, Ravenna, Ancona, and Torcello. As Lange has pointed out, the inspiration—if not the same meaning—of such icons in the German sculptures is suggested by the punning inscription on the frame (pl. 33) of the Regensburg Christ relief: CUM PETRA SIT DICTUS STABILI PNOMINE XPC ILLIUS IN SAXO SATIS APTE CONSTAT IMAGO ("Since he was called Petra in spite of his confirmed praenomen XPC his likeness in stone is completely appropriate"). Lange regards this as a justification for creating an image in stone.[50] Although many of the direct comparisons which can be made with Byzantine icons involve monuments dated later than the German reliefs, we cannot exclude the likelihood of earlier, now lost, Byzan-

37. Stone relief of female saint or the Virgin, late 11th century, St. Mauritz, Münster. (Landesamt für Denkmalpflege, Münster)

tine prototypes. Of particular interest are the similarities between the half-figure icons, the warrior saints, and the standing Virgin orans icons and the reliefs of Brauweiler, Xanten, and Münster.[51]

[47] Ibid., 80–81.

[48] Ibid., 83–84, 74–75.

[49] Reinhold Lange, Die Byzantinische Reliefikone (Recklinghausen, 1964), 23–25, 31–36.

[50] Lange, Reliefikone, 31. I am indebted to my colleague William Panetta of the Classics Department, University of Pittsburgh, for the translation of this inscription.

[51] Lange, Reliefikone, figs. 1–5, for the Virgin orans; figs. 19, 36, 40, for half-figures, and figs. 28, 29, for warrior saints. The Anastasis relief preserved in Bristol Cathedral and usually dated to the mid-eleventh century (see Lawrence Stone, Sculpture in Britain: The Middle Ages, 2d ed., Pelican History of Art [Har-

38. Stone fragment with seated female figures, 1050s, probably from the crypt shrine of St. Luidger, Werden. Rheinisches Landesmuseum, Bonn. (Landeskonservator Rheinland, Bonn)

The anomalies in their location in or on the church of both the Byzantine and German sculptures make impossible any comparison of function or even a justification of the use of sculpture instead of painting. However, the universal association of the German sculptures with exterior placement suggests that such images invited devotion, in the Western sense of the use of images, outside the church.

Still other monuments suggest additional motives for the production of large-scale sculpture in the eleventh century. Of these, the most important was that incorporating the various fragments from the former Benedictine abbey of St. Luidger in Werden. These limestone fragments consist of five reliefs about one foot high and of varying lengths with figures seated under an arcade (pl. 38), one similar relief with arcades and no figures, two reliefs a little over two feet high with figures standing under arcades (pl. 39), and a gabled lintel about five feet long with a lion chasing a stag (pl. 40). They were undoubtedly all carved by the same sculptor. Wilhelm Effmann associated them with either an altar or the

former shrine of St. Luidger (died 859) which was located in the outer crypt of the church, built by Abbot Gero (1050–1063), where the columns of an altar table bore an inscription by his successor Abbot Adalwig (1066–1081).[52] Enlarging upon Effmann's conclusions, Rudolf Wesenberg has proposed a tentative reconstitution of the fragments, attributing the five reliefs with seated figures to the actual shrine. Because two of the reliefs with female figures have fluted pilasters on the right end (pl. 38), he assumed that they represented fragments of two similar compositions. Because the pilasters are wide and have substantial bases, he also assumed that these fragments represented the bottom row of two-tiered compositions with female figures on the bottom row and male figures on the top. The fragments with seated figures, then, would have composed the two long sides of a sarcophagus. Since all the twelve female figures hold books and the two male figures hold either a book or a scroll and none has a halo, Wesenberg inferred that they represented sibyls and prophets, with six of each on either side of the shrine.[53] One iconographic difficulty is

mondsworth, 1972], 39, 41, pl. 24) would appropriately fall into the category of Feast Cycle icons and represent a provincial example of this German phenomenon; so, likewise the twelfth-century Virgin in Majesty at York exemplifies the Virgin icon (75, pl. 55).

[52] Effmann, *Die Karolingisch-ottonische Bauten zu Werden*, 1 (Strasbourg, 1899), 102ff.

[53] Wesenberg, *Bildwerke*, 54–58. Wesenberg estimated that with a suitable base and lid the sarcophagus would have been four feet high.

39. Stone relief of standing male in clerical garb, 1050s, probably from the crypt *fenestrella*, St. Luidger, Werden. Rheinisches Landesmuseum, Bonn. (Landeskonservator Rheinland, Bonn)

ject matter cannot be precisely reconciled with the reconstitution, these fragments certainly belonged to an ensemble which could be classified as church furniture.

Regarding the other Werden reliefs, the two tall standing figures (pl. 39), identified tentatively as deacons since they also have no haloes, have been accepted as framing images for a *fenestrella*, or window, which opened from the church into the crypt to offer a view of the shrine. The lintel (pl. 40), now placed over the sacristy door, was originally set elsewhere, probably over an entrance to the crypt, but that exact location has not been identified. In addition to these reliefs there are two capitals in the outer crypt with masks carved on their faces which are almost certainly by the same sculptor who made the reliefs. The sculptor's figural style has been compared to the ivory plaque on the book cover of Abbess Theophanu, to the Werden Psaltar, and in its details to a host of other objects in ivory and metal.[55] His technique most closely resembles that of repoussé work (pl. 11) but there are also hints of an ivory carver's mode of working, especially in the hands. At any rate, the artist belonged to the tradition of the liturgical arts. In view of this association, and since all of the Werden sculptures are associated with the decoration and furnishing of the outer crypt, this ensemble marks the first instance in which a goldsmith can be specifically identified with the carving of architectural decoration. It is important to note, however, that his architectural sculpture (pl. 40) is purely decorative, even grotesque, and that the figural carving with religious content was reserved for the putative shrine and the supposedly related *fenestrella*.

The grave slab of Widukind, Duke of Saxony, in the former monastery of St. Dionysius at Enger, is the largest single figure in eleventh-century sculpture, about six feet long (pl. 13). Although the figure is actually made of stucco, both modeled and carved, it is attached to a sandstone backing and hence represents an exceptional use of the stucco medium. In format it is closely related to a similar tomb slab in bronze, commemorating King Rudolf of Swabia (died 1081) in Merseburg Cathedral (pl. 14). While the modeling is more plastic than in the bronze relief and the drapery folds much more complex, Wesenberg has dated it slightly earlier, to the 1070s, on the basis of similar stylistic details in the

encountered, however, in the number of sibyls, who were counted as ten rather than twelve until the late fifteenth century.[54] Nevertheless, even if the sub-

[54] Reiner Hausherr, in *Rhein und Maas, Kunst und Kultur, 800–1400* (Cologne, 1972), 194. Archaeologically, there may be yet other problems in the attempt to relate the fragments to a specific location in the reconstitution.

[55] Wesenberg, *Bildewerke*, 54–58.

40. Stone lintel with animal motifs, 1050s, probably from the crypt door, St. Luidger, Werden. Rheinisches Landesmuseum, Bonn. (Bildarchiv Foto Marburg)

frescoes and the stone reliefs of Xanten and an ivory and manuscripts from Cologne, all placed approximately in the same decade.[56] Technically, however, it is more closely related to the bronze tomb relief precisely because a similar version in plaster would have necessarily preceded a bronze casting. It may well be that since the Enger tomb was not intended to be cast in bronze, the sculptor could afford to make the stucco figure more plastic and more complex in its modeling and decoration.

Assuming that the Werden fragments do represent a sarcophagus shrine, as Wesenburg thought, and that the Enger tomb slab originally had framing columns on the sides which made the arch a canopy, as Beenken proposed,[57] the fact that both were made of materials unusual for such formats in eleventh-century Germany may relate to their meaning rather than a presumed economy of precious materials. A sarcophagus with two rows of figures under arcades more nearly resembles an antique model than it does any known Ottonian example. A tomb figure, represented as if standing under an arch rather than recumbent, more nearly resembles an antique funeral stele[58] than it does any earlier medieval tomb, although the crown and scepter are

later attributes, from the Carolingian period.[59] In both cases, neither the style nor the specific choice of subject matter (or its attributes) is antique but the general format recalls premedieval models. It is possible, then, that the use of limestone or stucco was intended to recall the sculpture of the Roman era and to confer the prestige of Roman culture upon these monuments.

Two important conclusions can be drawn from these examples of eleventh-century German culture. First, in every case both the figural style and the technique of carving clearly implies that the sculptors were artists who usually worked in other materials—specifically gold, ivory, bronze, and stucco. Second, there is no continuity in the stone-carving tradition. Although some of the sculptures resemble others in small details, the similarities are due to the general relationship of all the monuments except Regensburg to the art of Cologne. Indeed, the larger number of the sites are within the old archdiocese of Cologne. None of the monuments resembles another to any significant degree nor can any of the sculptors be said to be the follower of another. The creation of stone sculpture within the Holy Roman Empire was therefore an incidental practice, one that continued well into the twelfth

[56] *Ibid.*, 79.
[57] Beenken, *Romanische Skulptur*, 46.
[58] Wesenberg, *Bildwerke*, fig. 497.

[59] See Chapter 1, second section, for the ninth-century stucco figure of Charlemagne.

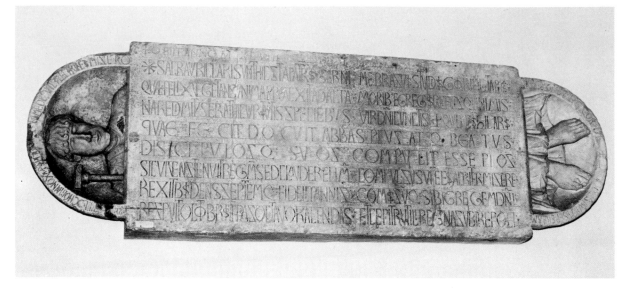

41. Plaster cast of stone tomb of Abbot Isarn, c. 1050, Abbey of Saint-Victor, Marseilles. Musée Borély, Marseilles (plaster cast in Musée de l'Homme, Paris). (Courtauld Institute—M. F. Hearn)

century but without any direct influence elsewhere. As with the sculptured capitals produced in the architectural workshops, the German reliefs did not generate the true revival of monumental stone sculpture. In every respect they foreshadowed the French and Italian developments in sculpture in the years around 1100, but in the actual historical process they were only prophets.

Among large relief sculptures of the eleventh century, those produced in Germany were by far the most important. But an account of this new phenomenon would be distorted without due notice of a few similar examples made in other places. The most conspicuous ones are found in Provence and the old kingdom of León. The marble sarcophagus lid of Isarn (pl. 41), abbot of Saint-Victor in Marseilles (died 1050)[60] precedes even the Widukind tomb of Enger in its implication of a life-size figure. It is only an implication, though, because the deceased is carved as if lying in a coffin with only the head and feet extending beyond a long inscription tablet. No extraordinary genius was required to carve such an illusion, but the relief is so high against the concave background and the modeling so supple that the sculpture bespeaks an expert artist. The face of the abbot, regardless of technical limitations, is no stock type and surely represents in part an attempt at portraiture. The texture of the hair and drapery is subtle and complex, suggestive of considerable experience in carving, while the face and feet indicate an equal experience in modeling. The combination of these technical effects in one work is comparable only to stucco work (pl. 13). The careful lettering of the inscription corresponds in sculpture only to metalwork (pl. 11). Although the sculptor, once again, seems to have come from the liturgical arts tradition, the composition does not: Jean Adhémar discovered a crude but close prototype in a Gallo-Roman tomb preserved at Saulieu.[61]

In Spain, the earliest known attempt to produce a plastically carved relief is the stone baptismal font (pl. 42) of San Isidoro of León, dated about 1060 or before,[62] which is now preserved in the cloister. Badly battered and apparently crude from the start, the obscure or confused subject matter indicates that the sculptor was either not familiar with the crafts in which figural art flourished or was not a highly skilled practitioner. However, Adolf Goldschmidt's stylistic comparison of the font to a Spanish ivory,

[60] Arthur Kingsley Porter, *Romanesque Sculpture of the Pilgrimage Roads* (Boston, 1923), I, 32–33.

[61] Jean Adhémar, *Influences antiques dans l'art du Moyen Age français* (London, 1939), 236, fig. 87.
[62] Arthur Kingsley Porter, in *Spanish Romanesque Sculpture* (Paris, 1928), I, 45–47, proposed very tentatively a date of 999/1028.

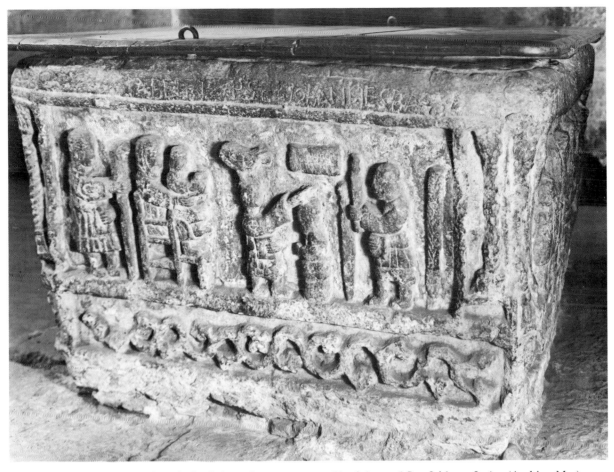

42. Stone font (?) with unidentified religious theme, c. 1060s (?), cloister of San Isidoro, León. (Archivo Mas)

dated about 1000, is very convincing.[63] Discounting the obscurity of the subject matter, which may be only our incomprehension, this sculpture could be the painful effort of an ivory carver whose tools, patience, and skill were inadequate for the task. Because the tower porch capitals have been redated from the 1060s to the 1080s, at the earliest,[64] we know there was no tradition of architectural sculpture with figures in high relief from which the sculptor could have come.

The second Spanish sculpture, a marble sarcophagus lid from Sahagún (pls. 43, 44) now preserved in Madrid, belonged to the tomb of Alfonso Ansurez (died 1093),[65] a young nobleman whose father was a close ally of King Alfonso VI. Since Sahagún is otherwise noted only for the Romanesque church of San Benito, the family connection with León is probably indicative of the artistic origin of the tomb. The slightly gabled, trapezoidal form of the lid falls well within the range of contemporary Spanish sarcophagi. But the use of sculptured decoration is a divergence from this tomb tradition, and its style, emphatically plastic and simply modeled with a smooth, rounded surface, marks a sharp departure from the earlier font. The figural composition and its subject matter, showing the deceased and the Evangelists and archangels, are original inventions for sarcophagus decoration. Although Evangelist symbols are common enough in liturgi-

[63] Adolf Goldschmidt, *Die Elfenbeinskulpturen aus der Zeit des karolingischen und sächsischen Kaiser, VIII.-XI. Jahrhundert* (Berlin, 1918–1926), IV, 24–25, and pl. XXII, c, catalogue item 80.

[64] See n. 8.

[65] Arthur Kingsley Porter, *Leonesque Romanesque and Southern*

France (New York, 1926), 245; Manuel Gomez-Moreno, *Catalogo monumental de España, Provincia de León*, 1 (Madrid, 1925), 348–349.

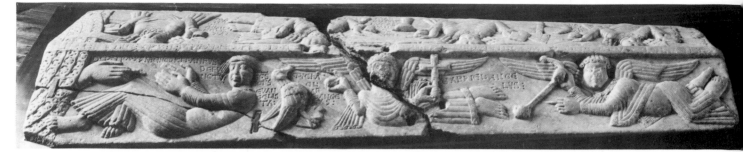

43. Marble lid from the sarcophagus of Alfonso Ansurez, c. 1093, from San Benito, Sahagún. Museo Arqueologico, Madrid. (Archivo Mas)

cal objects of late-eleventh-century León, no other object known to me represents all of them in human form. However, the shrine of St. John the Baptist and St. Pelayo in the treasury of San Isidoro (c. 1060) does have an ivory plaque with the three archangels, and such funerary objects are most likely to have inspired the subject matter of the sarcophagus lid. Nevertheless, none of the extant examples of funerary and liturgical art suffice to explain the artist's figural style. The figures have been made as large as possible, at the expense of considerable distortion and with a remarkable correspondence to the frame of the lid, but there is no evidence of influence from any known architectural sculpture of the region. The drilled curls of the Archangel Gabriel and indentations at the corners of the bulging eyes hint of imitation of antique sculpture. These details, as well as the general appearance of the figures, suggest that the sculptor's customary technique was carving. At this date (probably before 1100), his primary medium was probably ivory.

All three of these monuments indicate that the sculptors were accustomed to working in other materials than stone, namely stucco, metal, and ivory.

As in Germany, each of them is an isolated example of stone carving, exceptional within its artistic center and exerting no influence. By coincidence each of them appeared where the Ottonian tradition prevailed. The abbey of Saint-Victor was located inside the boundaries of the Holy Roman Empire. And in León, both the style and the media of the liturgical arts provide such a singular concentration of artistic activity outside the Empire that one may assume a point of direct contact. On the other hand, these sculptures do not imitate the formats of contemporary objects in the same or other media. In this respect they are more truly prophetic of the imminent revival of monumental stone sculpture, with the imitation of a late antique example in the case of the Isarn tomb and with their originality in the case of the Spanish examples. Only the Werden fragments (if they composed a shrine) indicate in Germany a similar urge to create objects in stone because of the inherent worth of making stone sculpture.

On the whole, the new tradition of relief sculpture in the latter half of the eleventh century simply indicates the versatility of the goldsmith to work in stone when the occasion required. The

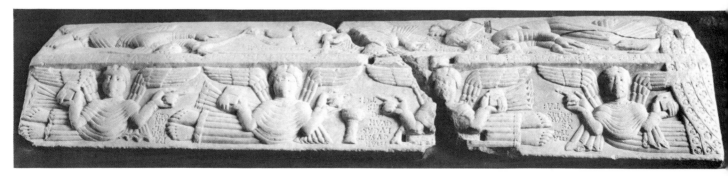

44. Adjacent face of the marble sarcophagus lid from Sahagún. (Archivo Mas)

ability to produce the revival already existed, then, but the conservative culture of the Holy Roman Empire did not require any fundamentally new types of monuments in which this ability might have been exploited. Until patrons could conceive projects which required formats and purposes unprecedented in the Carolingian tradition, the production of stone sculpture would remain haphazard and incidental.

The Crucial Monuments (circa 1100): Sanctuary Sculpture

The sculptures that proved to have been the starting points for continuous activity in monumental stone carving were all made within a few years before or after the year 1100. Widely scattered in France and Italy, each of them was apparently created without reference to the others and all but two had no (known) direct relationship of any kind. Their formats are as various as their geographical origins, but they all share the purpose of embellishing some portion of a sanctuary with sculptural images that have religious significance.

Although many sculptures have been dated about 1100 at one time or another, only a few of these attributions have withstood critical examination. The most drastic revision applies to the sculpture of Spain, where very few of the many monuments once dated before or about 1100 can now be regarded as earlier than the second decade of the twelfth century.[1] Some sculptures in France and Spain retain their dates in this period but must be excluded from this chapter because they were not the first important monument in the region,[2] because they did not mark the beginning of continuous activity,[3] or because they belong to an older tradition.[4] The monuments that remain as the examples crucial to the real revival of monumental stone sculpture are the table-altar and ambulatory reliefs of Saint-Sernin in Toulouse (1096), the archbishop's throne of San Nicola in Bari (1098), three reliefs on the facade of Modena Cathedral (1106), the ambo of Sant'Ambrogio in Milan (1100/1110), and the hemicycle capitals of Cluny Abbey (1088/1118). While it is difficult not to assume that other similar

[1] The following Spanish monuments can no longer be dated to this period: (1) The Tomb of Doña Sancha from Santa Cruz de los Serros, now preserved at Jaca. Marcel Durliat, in *L'art roman en Espagne* (Paris, 1962), 65–66, has redated from shortly after 1097 to somewhere near the middle of the twelfth century with relationship to the sculpture fragments from Vich. (2) The cloister of Santo Domingo de Silos has been dated to 1068/1084 by Porter and to similar early dates by Spanish scholars, but its archaeological relationship to fragments of the twelfth-century church and to Romanesque sculpture in general dictates a date well into the twelfth century, perhaps c. 1135/1140, where Durliat (*Espagne*, 30, 72, 149) has placed it. For a review on the literature, see Raymond Oursel, *Floraison de la sculpture romane*, La Nuit des Temps (La Pierre-qui-vire, 1973), 1, 335–339. (3) The tympanum and historiated capitals of Jaca Cathedral. The discovery by Serafin Moralejo-Alvarez ("Une sculpture du style de Bernard Gilduin à Jaca," *Bulletin monumental*, CXXXI [1973], 7–19) that one of the corbels on an eastern apse of the church is related to the school of Bernardus Gelduinus, post-1096, suffices to demonstrate that this church could not have been begun in 1063 and completed toward 1100, as tradition would have it, but was begun around 1100 and completed some decades later. The tympanum and

capitals, by different sculptors, should be placed, I believe, no earlier than c. 1120 and c. 1110 respectively, thus pushing almost all the sculpture in Navarre to the second decade of the twelfth century and later. (Since this book was written, the work of Serafin Moralejo-Alvarez, in "La sculpture romane de la cathédrale de Jaca: État des questions," *Les Cahiers de Saint-Michel-de-Cuxa*, x [1979], 79–106, indicates dates closer to 1100. It is entirely possible that the sculpture of Navarre ought to be considered as one of the earliest regional traditions, but even so it never became an important one.) (4) The Puerta de las Platerías of Santiago Cathedral has been redated from c. 1103–1109 to 1111–1116 by John Williams, "'Spain or Toulouse?' A Half Century Later: Observations on the Chronology of Santiago de Compostela," *Actas del XXIII Congreso internacional de historia del arte*, *Granada, 1971* (Granada, 1973), 1, 557–567. In addition to the Spanish monuments, an Italian sculpture, the tomb of Sant' Alberto of Pontida, who died 1095, was dated shortly after this year by Arthur Kingsley Porter (*Lombard Architecture* [New Haven, 1912], III, 295–296, and pls. 189–192), but this attribution has not been accepted.

[2] The Moissac cloister (1100) is derived from the Toulouse sculptures of 1096; see first section of Chapter 4.

[3] The inner tympanum of the porch of the abbey at Charlieu, normally dated 1094, did not initiate continuous activity in Burgundy; see second section of Chapter 4.

[4] The tomb of Alfonso Ansurez from Sahagún, c. 1093, has already been discussed in the context of eleventh-century sculpture; see Chapter 2, second section.

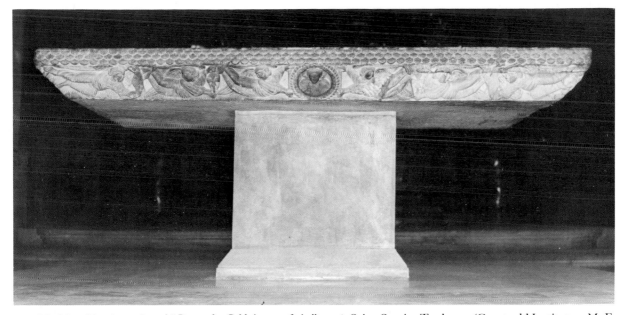

45. Marble table-altar, signed "*Bernardus Gelduinus me fecit*," 1096, Saint-Sernin, Toulouse. (Courtauld Institute—M. F. Hearn)

monuments existed from the years around 1100, there are no other early centers of sculptural activity for which one must hypothesize a lost initial sculpture.

The Table-Altar and Ambulatory Reliefs of Saint-Sernin in Toulouse

The collegiate church of Saint-Sernin in Toulouse possesses eight marble slabs with impressive figural carving which signal the earliest securely datable work of this important new stage in the development of monumental sculpture. These slabs consist of a table-altar and seven large reliefs, the former now located at the west end of the choir and the latter set into the wall of the raised crypt in the ambulatory.

The table-altar (pl. 45) is decorated on the top with an elaborate lobed border and inscribed around the edge with a legend that recounts its dedication to St. Saturninus (the patron of the church), its patronage by the confraternity of St. Saturninus, and its production by Bernardus Gelduinus.[5] Each of the

four sides is carved with images in relief on a slanted surface beneath a cornice of scalelike imbrications. The front face (pl. 46) shows a clipeated bust of Christ, held by two angels and flanked by two more on each side. The two end faces (pls. 47, 48) each have a series of seven medallion images, some of Apostles, some unidentifiable, some damaged beyond recognition, but on both, the central portrait seems to be of Christ. The rear face is decorated with pairs of confronting birds in vine foliage. Because the inscription states the dedication to St. Saturninus, the altar is universally accepted as that dedicated by Pope Urban II on May 24, 1096.[6]

The seven reliefs in the ambulatory consist of three pairs of single figures and a Christ in Majesty. On the Majesty slab (pl. 49), a beardless Christ sits on a cushioned throne, surrounded by a mandorla and the symbols of the Four Evangelists, arranged

[5] + IN NOM . . . IXV XPI HOC ALTARE FEGERUNT CONSTITVI CONFRATRES BEATI MARTIRIS SATURNINI IN QUO DIVINV CELEBRATVR OFFICIV AD SALVTE ANIMARV SVARV ET OMIVM DE FIDELIV AM +

SATVRNINE DEI CONFESSOR ET INCLITE MARTIR NOMINE PRO XPI QVI TAVRO TRACTVS OBIISTI VRBE TOLOSANA DV CORRIPIS ACTA PFANA VOTA TVAE PLEBIS FER AD AVRES OMPTIS VT . . . GRATIS QVOD IN HAC ARA CELEBRATVR BERNARDVS GELDVINVS ME FEC.

[6] For the text of the *Chronicon* and discussion of its interpretation see Jean Cabanot, "Le décor sculpté de la basilique Saint-Sernin de Toulouse," *Bulletin monumental*, CXXXII (1974), 101. This major article relates the full state of the question on Saint-Sernin and also recounts the discussions of the sixth international colloquium of the Société française d'archéologie which met in Toulouse, October 22–23, 1971.

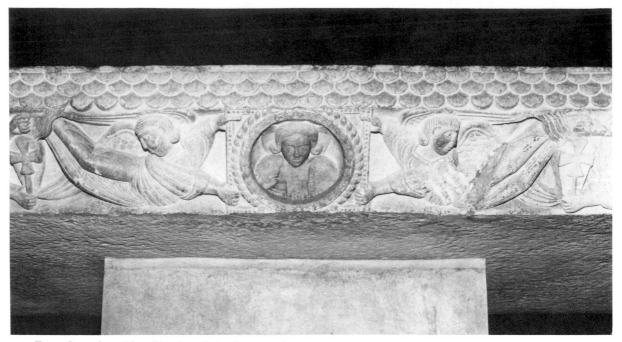

46. Front face of marble table-altar, Saint-Sernin, Toulouse. (Courtauld Institute—M. F. Hearn)

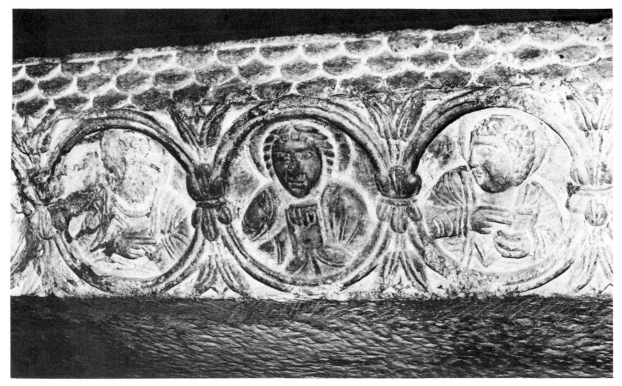

47. South end of marble table-altar, Saint-Sernin, Toulouse. (Courtauld Institute—M. F. Hearn)

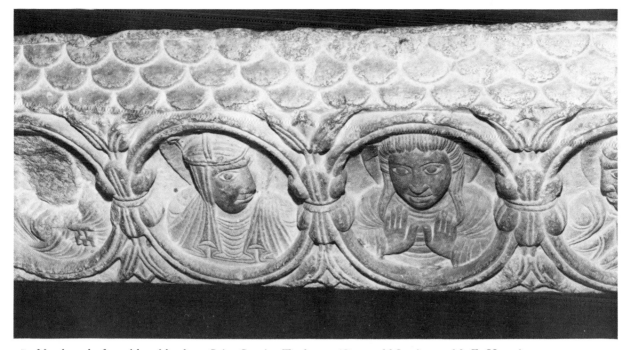

48. North end of marble table-altar, Saint-Sernin, Toulouse. (Courtauld Institute—M. F. Hearn)

clockwise from the upper right-hand corner—a winged man (Matthew), a winged lion (Mark), a winged ox (Luke), and an eagle (John). Christ holds an open book, inscribed PAX VOBIS, in his left hand and raises his right in blessing. Flanking the sculpture of Christ in the ambulatory and related to it in size, are two reliefs with a winged figure standing beneath an arch and looking toward Christ. Inscriptions on the arches identify them by their relation to the figure of Christ, a cherub to the right (pl. 50) and a seraph to the left (pl. 51).[7] Each holds a phylactery, inscribed E[T] CLAMANT: S[ANCTU]S, S[ANCTU]S, S[ANCTU]S, ("And crying: Holy, Holy, Holy") in the hand nearest Christ and a staff cross in the other. On a much larger scale are two reliefs of angels (pls. 52, 53), also standing beneath arches. Each of them looks to one side and points with the hand on that side to the opposite direction, while the other hand holds a staff cross. Related in size to the angels are two reliefs of frontal figures, most likely representing Apostles or saints standing beneath arches (pls. 54, 55). Each of them holds a book—one open, one closed—in the left hand and raises the right hand in blessing.

The possible relationship of these seven reliefs is

an important issue: on it hinges the single or multiple authorship of the sculptures, the original function of the ambulatory slabs, and the extent of the first sculptural project at Saint-Sernin. The variations in execution have frequently raised questions about authorship. Clearly there are different physiognomic types among the relief figures, the Christ and the two saints representing the extremes. Also, the treatments of hair—as flowing strands, as rumpled locks, as abstract versions of tight curls, and in different lengths—strikingly point up the variety of the images, a variety also reflected in the types and arrangments of clothing. More important, the eyes of all the figures on the altar and on the three small relief slabs are smooth and bulging while those on the four larger slabs all have pierced irises. This technical distinction is underlined by the fact that the Christ relief is carved from three sides, so that the figure stands out from the relief ground, while the other six reliefs are carved only from the front so that the figures are recessed behind the surface plane.

Yet there are more numerous similarities among the sculptures which suggest a single authorship.[8]

[7] Cherub: AD DEXTRAM PATRIS CERVBIM STAT CVNCTIPOTENTIS; Seraph: POSSIDET INDE SACRAM SERAFIN SINE FINE SINISTRAM.

[8] These observations were first made by Etienne Delaruelle, "Les bas-reliefs de Saint-Sernin," *Annales du Midi*, XLI (1929), 49–60.

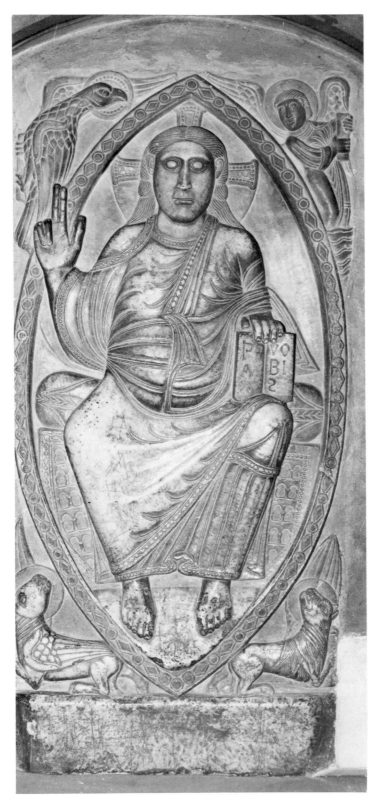

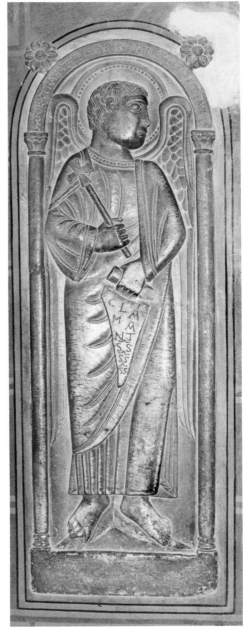

49. (*left*) Marble relief of Christ in Majesty, c. 1096, Saint-Sernin, Toulouse. (Courtauld Institute—M. F. Hearn)

50. (*above*) Marble relief of cherub, c. 1096, Saint-Sernin, Toulouse. (Courtauld Institute—M. F. Hearn)

52. (*right*) Marble relief of angel looking to the right, c. 1096, Saint-Sernin, Toulouse. (Courtauld Institute —M. F. Hearn)

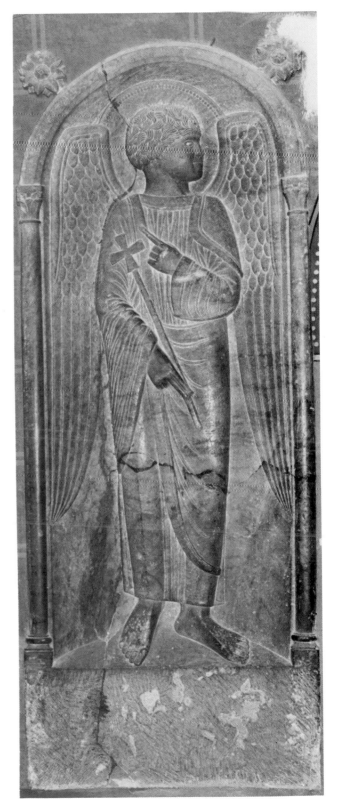

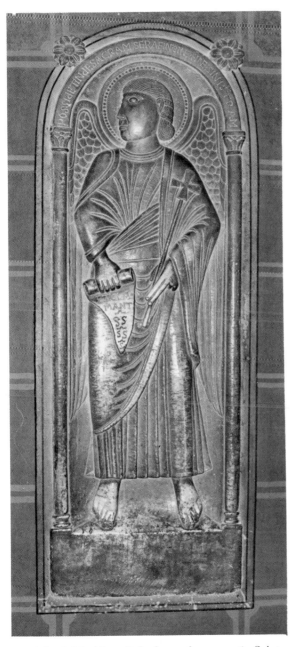

51. (*above*) Marble relief of seraph, c. 1096, Saint-Sernin, Toulouse. (Courtauld Institute—M. F. Hearn)

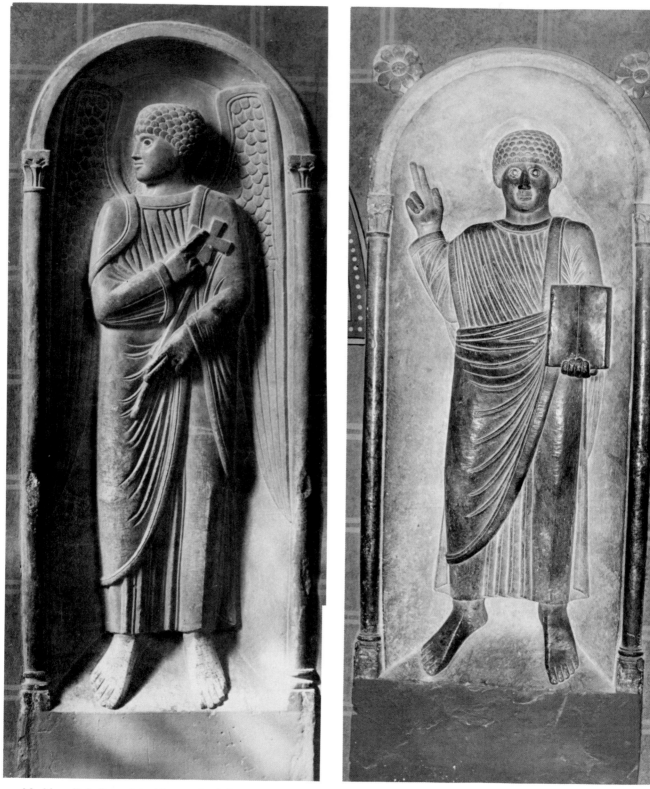

53. Marble relief of angel looking to the left, c. 1096, Saint-Sernin, Toulouse. (Courtauld Institute—M. F. Hearn)

54. Marble relief of saint holding an open book, c. 1096, Saint-Sernin, Toulouse. (Courtauld Institute—M. F. Hearn)

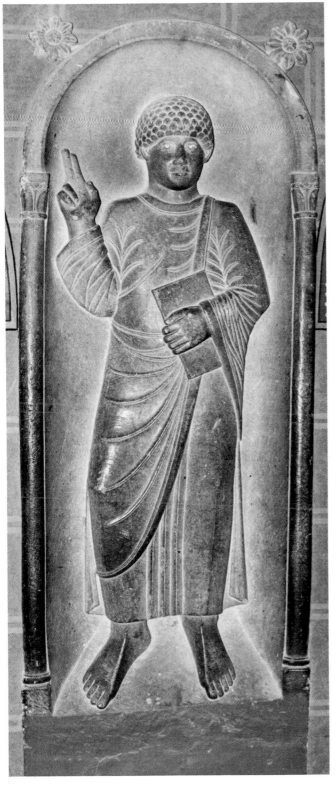

55. Marble relief of saint holding a closed book, c. 1096, Saint-Sernin, Toulouse. (Courtauld Institute—M. F. Hearn)

The three pairs of reliefs in the ambulatory are all framed under similar arches with identical capitals and bases on the colonnettes. All save one have rosettes carved in the spandrels above the arch and on that exceptional slab they have most likely been chiseled away. The same rosettes are found on the top of the altar. Despite the physiognomic differences, each type of face can be found on the altar also, as well as approximations of all hair treatments except the cap of rumpled locks. And despite differences in clothing, the drapery folds on all of the figures, on both altar and slabs, are carved as raised ridges between two lines: most characteristic of the Toulouse sculptures is the uniform technical mannerism of suppressing the curved folds where the body protrudes beneath the clothing. All wings are carved exactly alike, with the upper portion enclosed in a continuous border and with the upper feathers represented as scalelike imbrications, like those on the altar, and the lower feathers as parallel ribbons. Another peculiarity of all the standing figures is that each has one leg carved with a shin ridge showing faintly beneath the clothing. Similarly, all the faces have a rounded jaw line with full cheeks, a straight upper lip and full lower lip, deeply articulated nostrils, and a flared brow line. These similarities transcend the differences because they signify the technical mannerisms peculiar to one artistic personality. For this reason, the ambulatory slabs and the altar should all be attributed to the hand of Bernardus Gelduinus, or at least to his direct guidance.[9]

Iconographically, the relationship of these slabs amplifies that seen in the similarities of technique and format. The inscriptions above the cherub and seraph refer to the Christ in Majesty. Since the cherub (15 1/2 × 46 7/8") and the seraph (16 5/8 × 48 3/4") are similar in height to the Christ relief (23 1/2 × 49 1/2")—the differences occurring in the height of the bases—the three small reliefs were undoubtedly placed in immediate proximity. The angels (27 × 76", facing left; 29 3/4 × 77 1/2", facing right) also refer to the Christ relief, pointing upward in opposite directions appropriate to a flanking pair. The saints (29 1/2 × 79", closed book; 27 1/2 × 75 3/4",

[9] Cabanot, "Décor," 135, n. 8, makes a very good case for Gelduinus's having done all of the detail work after an assistant prepared the slabs and some of the first carving. I think it is likely that there was such an assistant and that he was gradually given a larger role in the project, finally completing some of the details (see Chapter 4).

open book) alone are not fixed with reference to the Christ figure. However, their similarity of format and size to the angels makes them compatible in the ensemble. Indeed, the fact that the angels face in one direction and point in the other suggests that they are addressing the saints and introducing them to Christ. The seven reliefs, then, comprise a related group with no extraneous subjects and with no parts missing. It is reasonable to conclude that the group is complete and that all seven sculptures were used together.

Whatever its form, the conception of the project which included the slabs was a matter of considerable initiative. No marble sculpture with figural carving is known to have been made in southwestern France since the mid-eleventh century altar frontal of Rodez which, together with its predecessors in the Pyrenean churches (pl. 5), belongs technically to a tradition already extinct long before the end of the eleventh century. Even if such examples were accepted as precedents, the format and scale of the Saint-Sernin sculptures and the plasticity of their figures are without parallel in that region since the decline of Antiquity. The impulse to make monumental marble sculpture at Saint-Sernin was corollary to its purpose.

Suggestions for the original disposition of the reliefs have included cloister pier decoration, as at Moissac (pl. 85);[10] a doorway with tympanum and flanking reliefs in the jamb zone, again as at Moissac (pl. 127);[11] a facade with reliefs placed above the doorways as at Marcilhac, or in the spandrels above the portals, as on the Porte des Comtes of Saint-Sernin;[12] a retable or antependium for an altar;[13] a choir screen;[14] a ciborium;[15] a tomb;[16] and a crypt portal,[17] but none of them has been pursued with a

[10] Willibald Sauerländer, "Das sechste internationale Colloquium der 'Société française d'archéologie': Die Skulpturen von Saint-Sernin in Toulouse," *Kunstchronik*, XXIV (1971), 344; Cabanot, "Décor," 136. There are several clear objections to their deployment in a cloister. First, only the large reliefs could have a natural placement there, on the piers. Second, these reliefs are much too thick to apply to a pier because there would be problems of joining them at the corners. Third, there is no way that the angel reliefs, each pointing to a figure beyond the slab on which it is carved, would make sense iconographically on a cloister pier.

[11] Delaruelle, "Bas reliefs," 56; Raymond Rey, *La sculpture romane languedocienne* (Toulouse and Paris, 1936), 37-40; and Cabanot, "Décor," 136, mention several possibilities for a portal arrangement, including one with the small reliefs in the tympanum and the large reliefs on the flanking jambs. However, no exterior doorway at Saint-Sernin could have accommodated such a composition. Moreover, no tympanum in Languedoc was ever composed of rectangular reliefs and the bases on these reliefs would be inappropriate in this situation anyway.

[12] Rey, *La sculpture*, 37-40. To arrange the reliefs in a pyramidal composition like that of the crude figure reliefs above the

south portal at Marcilhac would be iconographically appropriate, but such a composition would be much too large for any plausible facade setting. For the Marcilhac portal see Marguerite Vidal's essay in *Quercy Roman*, La Nuit des Temps (La Pierre-qui-vire, 1959), 183-185. As for installing the Saint-Sernin reliefs in the spandrels of the actual double portals of the transept or nave facades, they could not be arranged in that zone without violating their inherent iconographic relationship.

[13] Arthur Kingsley Porter, *Romanesque Sculpture of the Pilgrimage Roads* (Boston, 1923), I, 206-208, Henri Focillon, *L'art des sculpteurs romans* (Paris, 1931), 68; Etienne Delaruelle, "Le problème des influences catalanes et les bas-reliefs de Saint-Sernin," *Annales du Midi*, XLV (1933), 240-244; and Rey, *La sculpture*, 40. The stylistic relationship of the altar and the reliefs suggests that any such arrangement would have involved that altar. Yet there is no way to associate these reliefs as a retable with an altar carved on all four sides in order to be freestanding. Also, it is unlikely that such an altar would have been placed against a wall or pier. As for use as an antependium, there is no sign of grooving beneath the altar, as at Rodez, to indicate their former installation there.

[14] Geza de Francovich, "Wiligelmo da Modena e gli inizii della scultura romanica in Francia e in Spagna," *Rivista del Reale Instituto di archeologia e storia dell'arte*, VII (1940), 264. Choir screens with stone sculpture have not even been tentatively identified for a period before the second quarter of the twelfth century (if, indeed, fragments so identified in England—at Chichester and Durham—were really parts of choir screens. See George Zarnecki, *English Romanesque Sculpture, 1066-1140* [London, 1951]; and *idem, Later English Romanesque Sculpture, 1140-1200* [London, 1953]. Also it is difficult to imagine the Saint-Sernin reliefs in a composition both suitable and large enough to serve as a choir screen. Certainly more pieces would be required and there is no real evidence to suggest additional reliefs.

[15] Cabanot, "Décor," 136; see also Robert Mesuret, *Evocation de vieux Toulouse* (Paris, 1960), 470, cited by Thomas W. Lyman, "Notes on the Porte Miègeville Capitals and the Construction of Saint-Sernin in Toulouse," *Art Bulletin*, XLIX (1967), 30, n. 28. No known ciborium, extant or documented, had marble reliefs on the canopy. These reliefs are both too large and too heavy for that purpose and, again, the iconography would not permit a suitable arrangement. Examples of ciboria in various materials are: in stucco, Civate and Sant'Ambrogio in Milan (see Geza de Francovich, "Arte carolingia ed ottoniana in Lombardia," *Römisches Jahrbuch für Kunstgeschichte*, VI [1942-1944], 116-137, 139-145.); in painted wood, Saint-Michel de Cuxa (documented in Marcel Durliat, *Roussillon roman*, La Nuit des Temps (La Pierre-qui-vire, 1954), 41); in repoussé metal and enamel, Santiago de Compostela (documented in *Le guide du pèlerin de Saint-Jacques de Compostelle*, ed. and trans. Jeanne Vielliard [Mâcon, 1953; orig. ed., 1938], 112-115).

[16] Rey, *La sculpture*, 40, n. 2. Rey suggested a mausoleum in sarcophagus form. In view of the extant Gallo-Roman sarcophagi with figures standing beneath arcades this would seem to be a most sensible theory. However, the reliefs are so large that any likely composition would be grossly out of scale with the sarcophagus format.

[17] The suggestion of a crypt portal has been made informally by Thomas W. Lyman. Since such a portal could be composed in several different ways this possibility cannot be lightly dismissed on the grounds of size, format, or iconography of the reliefs. However, to locate and compose such a portal exactly, much less to reconcile its probable dimensions with those of the church, is very nearly impossible.

serious attempt at reconstitution. Consequently, there has been no evaluation of the technical and iconographic characteristics of the reliefs which would preclude their use in most of these situations. Although each possibility merits consideration in a discussion of the development of Romanesque sculpture, the fact that the pieces retain a high polish and show no sign of weathering obviates the likelihood of an exterior use.[18] On the other hand, while the format and iconography of the reliefs plausibly point to a function as church furniture, the relatively tall bases as well as the great size and weight of the larger reliefs preclude use in a tightly organized furniture composition.

Any reconstitution of the original disposition of the reliefs depends on the iconographical relationship of the figures. As we have seen, these seven slabs are interrelated in such a way that the reconstitution must include the entire ensemble and in close proximity, preserving much the same arrangement as the present one in the ambulatory but in correct order. Étienne Delaruelle proposed such a disposition of the reliefs in the sanctuary around the altar.[19] He did not propose a specific reconstitution scheme, but the implication is that the large reliefs would have been placed on the hemicycle piers around the apse with the small reliefs at the center of the group composing a retable above the altar. Such an arrangement, however, would place the reliefs so far from each other that the iconographic relationship of the ensemble would be virtually lost. Unless the reliefs could more likely serve another function in the sanctuary than any yet proposed, it is reasonable to hypothesize that they were used in the crypt and in connection with a shrine of St. Saturninus. Since the church was being built in honor of this saint it would be surprising if such a shrine had not existed. This sacred purpose also explains most plausibly the preservation of the sculptures after the shrine was dismantled, probably in the thirteenth century, when a shrine of gold made for the choir and when the crypt was remodeled.[20]

The most straightforward reconstitution yet advanced is one in which the reliefs could be set in their natural order, without regard for slight variations in size, and in connection with a shrine in the crypt.[21] This reconstitution accords best with Marcel Durliat's report of excavations in the crypt.[22] First, the crypt wall itself had been built around the remainder of the apse wall of the earlier brick church. This brick wall had been left standing several feet high, to the level of the windows that opened from the new crypt to the ambulatory. Second, a plaque inscribed with a cross had been carefully left in place on the floor at the apex of the original apse when the crypt was remodeled in the thirteenth century. Third, the original apse wall continued around almost to the present south door of the crypt (the likely location of the door in the late eleventh century). Fourth, the remains of a *fenestrella* at the east end of the crypt represented limited access to the apex of the apse when the crypt was locked, indicative that something of interest to pilgrims was located behind it.

Reconstitution of the sculptures in a crypt ensemble would be based on the following assumptions: that the floor plaque represented the location of the original shrine of Saint Sernin, which probably still survived in 1095 and was most likely in sarcophagus form; that the seven slabs were mounted around the shrine in the brick wall of the earlier apse, itself preserved as a relic; and that the table-altar was placed west of the shrine in the center of the apse. Thus, the three small reliefs—Christ, the seraph, and the cherub—would have been placed in the brick wall above the sarcophagus and below the *fenestrella* as a retablelike composition on a visual axis with the altar. The tall angels would have flanked these figures beyond the ends of the sarcophagus, pointing at Christ and looking toward the saints. The saints would have faced each other from the north and south sides of the old apse, in line with the altar. If this reconstitution has any validity, the identity of one of the saints as Saturninus may be safely assumed. From the *Chronicon Sancti Saturnini* we know that the altar was dedicated not only to him

[18] Henri Graillot, "Compte rendu de '*La basilique de Saint-Sernin de Toulouse*,' A. Auriol et R. Rey," *Annales du Midi*, XLIV (1932), 84ff.

[19] Delaruelle "Bas reliefs," 59; and *idem*, "Influences catalanes," 40–44.

[20] Marcel Durliat, "Les cryptes de Saint-Sernin de Toulouse, bilan des recherches récentes," *Les monuments historiques de la France*, n.s., XVII (1971), 25–40; Marcel Aubert, *L'église Saint-Sernin de Toulouse* (Paris, 1933), 57–58, 72.

[21] Gillian Cannell, "A Reconsideration of the Problem of the Bas-reliefs at Saint-Sernin in Toulouse" (M.A. thesis, University of Pittsburgh, 1976). Research for this study was begun in my seminar on Romanesque sculpture, Fall Term, 1974, for which I defined the problem to the point of attempting to reconstitute the reliefs as a shrine in the crypt. See the summary, published under the same title, in *Studies in Art History Presented at the Middle Atlantic Symposium in the History of Art*, 1974–1976 (College Park, Md., 1976), 13.

[22] Durliat, "Les cryptes," 25–40.

but also to another martyr, Ascisclus, and that relics of both were placed in the altar.[23] Hence the second saint is almost certainly Ascisclus. Altogether, the shrine ensemble would have consisted of a sarcophagus, the table-altar, the slabs, and the old apse wall. The composition of the ensemble would have occupied the whole of the old apse and could have been screened with an iron grille from the rest of the crypt, providing security for the relics if or when the crypt was open to pilgrims. This reconstitution has the virtues of employing all the sculptures, including the altar, and of respecting the limitations imposed by their size, format, and iconography. Moreover, it provides the only rational explanation for preserving the old apse wall.[24]

The meaning of such an ensemble resides primarily in the iconographical relationships between the various relief slabs, which were fixed, as we have seen, by the inscriptions on the seraph and cherub and by the stance and gesture of each of the angels. Assuming a similar arrangement of the sculptures in the choir and noting the variety of heavenly types—saints (who could represent both martyrs and confessors), angels, cherub, and seraph— Etienne Delaruelle suggested that the reliefs presented a visual representation of the majestic hymn, the *Te Deum*.[25] However, for a proper *Te Deum* it would be necessary to include several additional categories of heavenly beings and to distinguish them clearly. Moreover, there is no readily discernible motive for representing a hymn in sculpture. Instead, the presentation of the two saints by the angels to a Christ in Majesty who is flanked by a cherub and a seraph indicates a heavenly court scene. Such a theme belonged to a tradition stemming from late Antiquity and found in important monuments such as the church of San Vitale in Ravenna. In that sixth-century Ravenna mosaic, two angels in court dress present St. Vitalis and Archbishop Ecclesius (who had the church built) to Christ, who, dressed in royal purple, sits enthroned on a globe. Like the proposed arrangement of the Saint-Sernin reliefs, the San Vitale scene takes place in the apse just behind and above the altar. At Saint-Sernin, the heavenly court scene celebrating

the spiritual triumph and reception into glory of Saturninus and Ascisclus was an appropriate way to incorporate images of two sacred personages who were related only by the fact that their relics were preserved in the church.

The use of marble sculpture in shrine decoration in the crypt has a parallel in the stone sculpture fragments assigned by Rudolf Wesenberg to the outer-crypt shrine of St. Luidger in Werden, dated some three decades earlier.[26] Both crypts probably had a *fenestrella* permitting visual access to the shrine when the crypts were locked. Also, the composition of rectangular reliefs set into the wall is reminiscent of the format of Byzantine relief icons and especially of their ostensible adaptations in the stone sculpture of late-eleventh-century Germany. Indeed, no project other than the shrine of St. Saturnius is more likely to have prompted the revival of monumental sculpture in Toulouse. The style of the reliefs at Saint-Sernin, however, reflects virtually nothing in the eleventh-century art of the Holy Roman Empire.

Almost every scholar who has written about the Saint-Sernin sculptures has noted that their composition, motifs, and style recall the late antique sculpture of Roman Gaul. The composition of the slabs, with the figure standing beneath an arch, recalls many types of late antique art, most notably sarcophagi, funerary stele, and ivory plaques. The addition of rosettes in the spandrels is expressly similar to ivories of the fifth and sixth centuries.[27] Friedrich Gerke,[28] who has studied this matter in greatest detail, has observed that although the table-altar with a lobed border stemmed from a tradition that still survived in southwestern France, the addition of figural carving revived a late antique version of the table-altar which was not a part of the more recent tradition. Gerke also traced the major motifs of the altar—for instance, the clipeated portrait of Christ framed in a wreath and held by angels

[23] Cabanot, "Décor," 101, n. 3.

[24] Cannell has adduced considerably more evidence to substantiate this composition in contemporary apse paintings. However, that evidence, which was not related to my hypotheses, must await her own publication.

[25] Delaruelle, "Bas-reliefs," 53–55.

[26] See Chapter 2, second section.

[27] The most conspicuous example is the early-sixth-century ivory of the Archangel Michael, preserved in the British Museum, for which see John Beckwith, *Early Christian Art*, Pelican History of Art (Harmondsworth, 1970), pl. 68. The continuation of this motif into the Carolingian tradition is represented by the ivory cover of the Lorsch Gospels, ninth century, for which see Peter Lasko, *Ars Sacra, 800–1200*, Pelican History of Art (Harmondsworth, 1972), pl. 72.

[28] Gerke, "Der Tischaltar des Bernard Gilduin in Saint-Sernin in Toulouse," *Akademie der Wissenschaften und der Literatur, Abhandlungen der Geistes und sozialwissenschaftlichen Klasse*, VIII (1958), 494–508.

as well as many of the decorative details—to Gallo-Roman sarcophagi. In the three paired reliefs, also, he has traced both a general stylistic similarity and specific details, such as treatments of hair and facial features, to the same type of sources, most often in examples from the early fifth century. To this list of correspondences may be added the staff crosses[29] held by the angels, the cherub, and the seraph as well as the togalike garment of the saint holding an open book. The wide dispersion of comparisons does not demonstrate that Gelduinus sought inspiration in many different examples but that the one or few models he used (perhaps including the original fifth-century sarcophagus of St. Saturninus) are now lost.

The relief of Christ in Majesty has always been associated with a Carolingian or Ottonian model. It is very similar to an image of Christ Enthroned found in the Carolingian Godescalc Gospels, a book in the possession of the canons of Saint-Sernin when this sculpture was carved.[30] It is closer still to an Ottonian ivory plaque of about 900 (pl. 10), attributed to the Ada Group. Neither may have been the exact model, but it is certain that the image relates to art of that period. The explanation for this inconsistency of sources in Gelduinus's work surely resides in the necessity of finding an image required for the new project which was not supplied by the principal model. Since the Christ figure was part of a retablelike composition and since retables were unknown in pre-Carolingian times, no earlier model could have sufficed.

The ancient models for the shrine decoration cannot have been arbitrarily chosen. Even for funerary art, more recent images and formats existed in other materials and other styles. The choice of marble for the material and of much older models for the images suggests the desire to embellish the shrine in a manner reminiscent of the era of St. Saturninus. Following his martyrdom, about A.D. 250, at the Capitol in Toulouse, the remains of the saint were translated to the site of the present church in 403.[31]

The new decoration, then, was likely planned to be an authentic extension of the original shrine, but on a large scale and in a more complex composition. For that reason, not only the motifs but also the styles of the models were faithfully reproduced in the sculpture. For that reason, too, the new table-altar was decorated with motifs from funerary models, an otherwise incongruous source for an altar of this format.

The shrine purpose for the sculptures relates the altar and the reliefs as parts of a single project within which it is difficult to single out one piece as having been the first carved. This factor is of interest because it involves the circumstances under which the sculptures were conceived. Because the altar stands at the end of a two-century-old tradition in southwestern France of carving table-altars with a lobed border on the top,[32] it would be easy to infer that Bernardus Gelduinus was part of that tradition and that his addition of figural decoration was simply a significant step in an evolutionary process. The reliefs would mark another step in this evolution following his success in carving the altar. Instead, it is important to recognize that his altar marks a sharp break with recent tradition, and that the addition of religious imagery to the altar is intimately related to the circumstance that he had also been commissioned to make the reliefs. The realization of this project depended not upon the timely appearance of an artist capable of producing it but upon the necessity of finding an artist who could fulfill such a requirement. The tradition of lobed altars offers no evidence that such an artist existed within its context.

In order to determine the provenance of Bernardus Gelduinus, a distinction should be drawn between those aspects of his style that were determined by the models provided and those that were determined by the technical habits of his artistic background. In the latter connection, the smooth finish of the polished marble sculptures suggests a prior experience in ivory carving. Certain ornaments, such as the carved pearl border around the clipeated portrait of Christ on the front face of the altar (pl. 46), are frequent in metalwork and suggest

[29] See Wolfgang Friedrich Volbach, *Early Christian Art* (New York, 1962), for examples in mosaic and ivory: Mausoleum of Galla Placidia, Ravenna, pls. 146, 147; plaque with Adoration of the Magi, British Museum, pl. 222, and a diptych panel, Ravenna—all dated to the fifth or sixth century.

[30] Florentine Mütherich and Joachim E. Gaehde, *Carolingian Painting* (New York, 1976), 24, pl. 1. See also J. Hubert, J. Porcher, and W. F. Volbach, *L'empire carolingien* (Paris, 1968), 78.

[31] Elie Griffe, *La Gaule chrétienne à l'époque romaine*, 2d ed. (Paris, 1964), III, 228, n. 28.

[32] Paul Deschamps, "Tables d'autel de marbres executées dans le Midi de la France au Xe et au XIe siècle," *Mélanges d'histoire du Moyen Age offerts à Ferdinand Lot* (Paris, 1925), 137–168; Marcel Durliat, "Tables d'autel à lobes de la province ecclésiastique de Narbonne (IXe–XIe siècles)," *Cahiers archéologiques*, XVI (1966), 51–75; and Lyman, "Porte Miègeville Capitals," 33.

a familiarity on his part with that medium.[33] More specifically, the throne of Christ in Majesty (pl. 49), articulated with several rows of arcades, is an extremely rare feature which is found previously only on the silver Arca Santa, made in León about 1075.[34] The drapery with folds composed of a raised ridge, falling longitudinally along the axis of a sleeve or curving around the bulge of a torso or limb and dissolving at the point of pressure from the body (pl. 52), is found earlier only in the ivory Last Supper relief of the Arca de San Felices of San Millan de la Cogolla, made in León about 1094.[35] So, likewise, the jeweled border on the garments of Christ in Majesty is found on the same ivory. The wings of the angels, seraph, and cherub, with their border outline, their scalelike upper feathers, and their ribbonlike lower ones, are adumbrated by a Leonesque ivory book cover of the late eleventh century,[36] now preserved in the Louvre. These features do not necessarily demonstrate that Gelduinus was Spanish, but they do suggest the strong possibility that he had been working previously in León. They also imply that the effects he sought in marble are those normally associated with other media. The name—Bernardus Gelduinus—more readily suggests an origin in Germanic areas than in France or Spain.[37] The sudden appearance of sophisticated

metal- and ivory work in the area of León in the last decades of the eleventh century suggests cultural contacts with the Holy Roman Empire and perhaps an infusion of Germanic artists. Gelduinus may have been such an artist who had worked in León and then been sought out by the canons of Saint-Sernin for the shrine-decoration project. As we have already seen in connection with stone relief sculptures of the eleventh century, it is unlikely that any other type of artist could have undertaken such a commission to work, without prior experience, in the medium of marble.

The Throne of San Nicola in Bari

The archbishop's throne in the church of San Nicola in Bari (pls. 56, 57) is at once one of the most precocious and mysterious of the early sculptures in Italy. Carved from a single block of marble, the throne has a gabled back and sloping armrests which continue the slope of the gable. The corners of the chair and the middle of the back are articulated as posts topped with finials. The side panels are pierced to create screens with a geometric flower pattern. The chair is supported by a triangular pedestal, deeply recessed from the sides, and by columns at the back corners; the whole rests on a squarish octagonal plinth. On the flat front side of the pedestal, three figures, carved almost in the round, appear to carry the seat. On the angled back side, a lion and lioness, equally articulated, crouch over human heads. The richly plastic carving of these figures and beasts contrasts sharply with the flat decoration on the chair itself. The exterior faces of the corner posts and armrests are variously embellished with star and vine motifs; the front edge of the seat, with diverse animals inscribed in a diagonal lattice framework. The importance of the throne for the beginning of Romanesque sculpture is signaled chiefly by the unprecedented inclusion of supporting human figures.

Fortunately, the date of the throne can be fixed rather precisely. Carved on a band around the sides and back of the seat is the following inscription: INCLITVS ATQVE BONVS SEDET HAS IN SEDE PATRONVS

[33] Paul Deschamps, "Etude sur la renaissance de la sculpture en France à l'époque romane," *Bulletin monumental*, LXXXIV (1925), 89–90, stresses the relationship to metalwork, while Cabanot, "Décor," 134, emphasizes ivories. The ornament on the mandorla and garments of Christ in Majesty suggests gems set in metal. A translation of this motif into marble in what were probably similar circumstances had already occurred in the Rodez altar relief, as Durliat, in "Tables d'autels," 195–196, has observed.

[34] Cabanot, "Décor," 134, n. 5, cites this observation from Antonio Vinayo-Gonzales, *L'ancien royaume de Léon romane* (Saint-Léger-Vauban, 1972), 195–196, fig. 101.

[35] Manuel Gomez-Moreno, *El arte romanico español* (Madrid, 1934), 26, pl. xxxi.

[36] *Ibid.*, 24, pl. xxi. Note especially the angels on the lower sides of the book cover. Barbara Branon kindly called this example to my attention.

[37] Although the names Bernardus and Gelduinus are both Germanic in origin, Marie-Louise Morlet, in *Les noms de personne sur le territoire de l'ancienne Gaule du VIe au XIIe siècle*, I, *Les noms issus du germanique continental et les créations gallo-germaniques* (Paris, 1968), 53, 109, has shown that both had been thoroughly assimilated in France by the mid-eleventh century. Nevertheless, although he did not treat the name Gelduinus, Ernst Wilhelm Förstmann, in *Altdeutsches Namenbuch* (Bonn, 1900–1916, repr. Munich, Hildesheim, 1966–1967), III (twelfth century), showed that the predominance of names beginning with Gel are in general from Flanders or Lotharingia. Gelduinus's apparent prior experience as a goldsmith would tend to make his origin in the region of the Meuse more likely, an attribu-

tion Thomas W. Lyman suggested to me. Since this chapter was written, Lyman has published his arguments for identifying Gelduinus as a goldsmith from the Holy Roman Empire in "Arts somptuaires et art monumental: Bilan des influences auliques," *Les Cahiers de Saint-Michel-de-Cuxa*, IX (1978), 115–124.

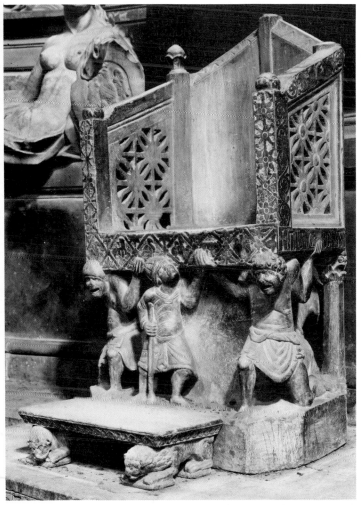

56. Marble throne made for Archbishop Helias, 1098, Bari Cathedral. (Alinari/Editorial Photocolor Archives)

PRESVL BARINVS HELIAS ET CANUSIMUS. ("As renowned as he is good, seated in this chair [is] our patron, Helias, Bishop of Bari and Canossa.") It identifies the prelate for whom the throne was made, Helias, archbishop of Bari and Canossa, whose tenure extended from 1098 to 1105. The Chronicle of the Anonymous of Bari contains, moreover, a reference to a throne made for Archbishop Helias which permits a more exact dating within this seven-year period.

A. 1098, venit papa Urbanus cum plures Archiepiscopi et Episcopi etc.—et suscepti sunt cum magna reverentia—et praeparavit Domino Helia nostro archiepiscopo mirificam sedem intus in ecclesia Beatissimi Nicolai Confessoris, et fecit ibi synodum. ("In the year 1098, Pope Urban came with many archbishops and bishops etc.—and they were received with great reverence—and [he] prepared for Lord Helias our archbishop a splendid throne, installed in the church of the most blessed Nicholas, Confessor, and held here a synod.")[38]

Because this record expressly located the throne in the church of San Nicola, and not the Cathedral of Bari, it is highly unlikely that it refers to any other throne made for Helias, so a date of 1098 can be confidently assigned to the monument under discussion.

Compared with the sculpture of a century later, the human figures of this throne are crude, but compared to everything in stone sculpture from the preceding five centuries in Italy, they represent a virtual revolution in the quality of figural representation. They are carved almost in the round and with a solid, swelling plasticity. The figures have an organic sense of movement and vitality; the side figures, especially, strain against the weight of their load and their facial expressions reflect this exertion. Their various hair treatments indicate an attempt to make them individually distinctive and to recreate effects found in antique sculpture. Certainly this work does not come close to the beautiful proportion, the muscular articulation, and the expressive vitality of classical antique figures, but in its deviations (or are they shortcomings?) from this ideal, it has much in common with late antique sculpture. Even beside the somewhat abstractly schematized style of the late antique tradition, this work may appear a bit clumsy and naive, but a similar mixture of natural imitation and of artificiality was achieved in both. For this reason, the Bari throne figures suggest an attempted revival of late Antiquity.

The iconography of the throne, on the other hand, is very puzzling. Of the three supporting figures on the front, the two on the corners are only half-clad, grimacing expressively under the strain of an attempt to lift the throne on their shoulders. They are highly reminiscent of atlas figures in antique art. The central figure, by contrast, is fully clad and, since he stands while the others kneel, is carved on a smaller scale. His peaked cap suggests the customary medieval emblem for a figure of oriental origin and his staff implies that he may represent a personage of high status. André

[38] Cited from Martin Wackernagel, Die Plastik des XI und XII Jahrhunderts in Apulien (Leipzig, 1911), 40. I am indebted to my colleague John Haskins for his assistance in the translation of this passage and of the inscription on the throne as well.

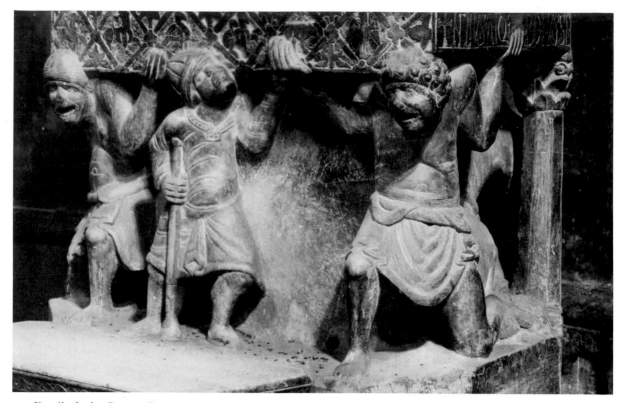

57. Detail of atlas figures, Bari throne. (Alinari/Editorial Photocolor Archives)

Grabar,[39] who has studied the problem of this iconography more exhaustively than anyone else, believes that these three figures represent different ethnic groups who were associated as alien to Christianity. The central figure may signify any oriental group, perhaps the Moslems, and the tight curls of the right-hand figure may denote the Ethiopians who symbolized the exotic heathen for the Middle Ages. To these suggestions may be added the possibility that the left-hand figure with straight hair could be identified with Asia. In any event, Grabar has determined, the figures can only represent peoples who were regarded as non-Christian. The lion and lionness preying on human heads are traditional symbols of the defeat of enemies. The heads they prey on also seem to represent different ethnic types. Together, then, the figures seem to signify the enemies of Christianity subjected to a symbol of its power, the throne.

Grabar has traced both the imagery and its context to ancient tradition. Thrones carried by beasts were a standard symbol of power in the ancient Near East. The theme filtered through Hellenistic and Roman culture and was eventually adopted in Byzantium as the "throne of Solomon." Although lions are the usual supporting beasts, elephants were also regarded as appropriate. The latter motif was adapted for the archiepiscopal throne of Canossa in the second half of the eleventh century.[40] But the use of human figures and preying beasts in this context at Bari is an anomaly. The themes of vanquished enemies forced to serve their conqueror and of beasts devouring enemies are frequent in Roman art, particularly in funerary monuments of rulers. Although no example related to a throne has survived, Grabar believes that such a conjunction is so apposite that it surely existed. Both the themes themselves and the Roman character of the half-clad figures, the lions, and the heads suggest a conscious revival based on antique models. Despite the imprecision of this iconographic derivation, the consistency of these two themes, together with their place in the composition of the throne, makes it difficult to

[39]Grabar, "Trônes épiscopaux de XIe et XIIe siècles en Italie méridionale," *Wallraf-Richartz Jahrbuch*, xv (1954), 12.

[40] *Ibid.*, 8.

accept the subject matter as anything other than a forceful statement of power.

The motive behind such a composition can at least be glimpsed in the circumstances surrounding the creation of the throne. Although the inscription leaves open the possibility that Helias had the throne made for himself, its highly complimentary reference to him suggests otherwise. Indeed, the specific prescription that Helias was the one to be seated on it and its location in a church other than his cathedral indicates that the throne was primarily intended for a particular great occasion. Because the inscription refers to Helias as "patron," it implies that Helias was the host for the occasion. The Chronicle—sometimes misread as meaning that Helias, not Urban, is the subject of the long and convoluted sentence and hence was the patron of the throne—definitely states that the throne was made at the order of Pope Urban for Archbishop Helias. Moreover, it was made for him in connection with the synod's having been convened in Bari. But because it was made for the church of St. Nicholas, where the synod was held, its purpose seems to have been more pointed than that of a guest's gift to his gracious host (in which case it would more likely have been sent to the cathedral). Apparently the pope's intention was that Helias, as host, would be seen by the other bishops at the synod as the beneficiary of something having to do with the theme of the throne, ostensibly a theme of temporal power.

The significance of a theme of temporal power for Helias was undoubtedly related to the purpose of convening the Synod of Bari. Unhappily, the motive behind the synod can only be inferred, for the official records of the proceedings no longer exist. All that has been recorded is contained in Eadmer's *Vita Anselmi* and William of Malmesbury's *Gesta pontificum*, recounting the activities of Anselm of Canterbury at the synod. Chiefly it is known that Anselm made an eloquent argument concerning the *Filioque* clause of the Nicene creed.[41] The *Filioque* clause states that the Holy Spirit proceeds from the Father *and* the Son, the position of the Roman Church, rather than from the Father *through* the Son, the position of the Byzantine Church. The difference refers to the ancient dispute between the orthodox and Arian parties of the church over the

nature of Christ—in the West, both divine and human; in the East, divine in human guise. The issue, then, concerned the theological division between the Western and Eastern branches of the Church. Since the synod was held in Bari, most of the eighty-five prelates present were probably from southern Italy. Apulia had been part of the Byzantine Empire until the conquest of Bari by the Norman dynasty under Robert Guiscard in 1071. The majority of the prelates, then, were Byzantine and it was precisely the *Filioque* clause that separated them from the Roman Church. The urgency in addressing this question after seventeen years of coexistence had much to do with the fact that the First Crusade, called by Urban in 1095, was then underway and was threatening to distintegrate into an adventure of secular conquest. In order to regain moral control of the Crusade, Urban needed behind him a powerful and united Church in Italy to sway the Norman rulers whose various relatives were leaders of the Crusade. The *Filioque* clause represented the crucial dogmatic issue that had to be settled in order to bring the Byzantine bishops into the Roman Church. (Indeed, in the long run, Urban hoped to effect a reunion between the Eastern and Western Churches.)[42] In order to convince the Byzantine prelates that they should make this doctrinal compromise he was prepared to offer blandishments. And he had something attractive to offer in the form of increased ecclesiastical power, emanating from his own claim to supremacy. By 1098, Urban had already consolidated this claim, initiated by his recent predecessor, Gregory VII (1073-1085), in a sweeping reform movement in the Church. The Bari throne presented to Archbishop Helias was a silent reminder to the members of the council of this offer of increased power.[43]

That the throne departed from the usual formula of episcopal thrones in southern Italy, by substituting human figures for supporting beasts, vividly underlined its special character as a symbol of power. Also, that the themes were revived from Roman Antiquity has a striking parallel in the nature of the Gregorian reform as a *renovatio* of the Church of Gregory I (590-604), which itself exercised considerable secular power and claimed even

[41] Charles-Joseph Hefele, trans. Dom H. Leclercq, *Histoire des Conciles*, v (Paris, 1912), 459-461.

[42] Robert S. Hoyt and Stanley Chodorow, *Europe in the Middle Ages*, 3d ed. (New York, 1976), 317-322.
[43] Grabar, "Trônes épiscopaux," 50-52, hints at the same line of reasoning.

more. It seems likely, then, that Urban may well have conceived the throne himself as propaganda for the purpose behind the council of Bari. Although it may have been normal for episcopal thrones to be made of marble, only a few survive from an earlier date and none approaches the richness and complexity of the Bari throne. It may be significant to recall that Urban had dedicated the marble sculptures of Saint-Sernin when he was in Toulouse only two years earlier. The relationship of their material, themes, and style to the art of the patristic age of Christianity could scarcely have been lost on him since the program was almost certainly based, at least partly, on the original shrine of St. Saturninus. In sum, the unusual character of the Bari throne, with its style and iconography based on associations with late Antiquity, tends to ratify the attribution of direct patronage by Urban II, whose political aims and artistic experiences were consistent with such a commission.

That the throne was carved under the patronage of Urban II is an assumption that Grabar made but did not follow up. To pursue its implications, it is reasonable to question whether or not the throne was made in Bari. Because most of the surviving thrones from the eleventh to the thirteenth century in Italy are in the southern provinces, it has always been taken for granted that the Bari throne was made in Apulia. No throne outside southern Italy is sufficiently similar in composition to establish an external relationship for it, but then only one other south Italian throne has a gabled back, at Monte Sant'Angelo (c. 1043),[44] and no other has sloping armrests. Nevertheless, Grabar,[45] as well as others, has insisted upon assigning the flat decorative carvings on the chair to the influence of Islamic art, be it direct or indirect. This interpretation is based not only on the flatness of the carving and the abstract quality of the motifs but also upon the fact that the relief ground chipped away around the designs was filled with colored mastic, a practice that Grabar associates most particularly with Islamic art. Such influence presumably could be exerted only in southern Italy where there were numerous Moslem trading communities. Curiously enough, though, no earlier throne has mastic coloring and both the thrones of Monte Sant'Angelo and Canosa have plastically carved decoration. On the whole, the

Bari throne seems to fit into the south Italian context precisely because it is located in Bari; because, indeed, it is such a striking monument that in our perceptions its qualities are transferred to other monuments. A much more plausible provenance, however, is the city of Rome.

Because nothing comparable to the Bari throne survives from this period in Rome, it is easy to regard that city as a sculptural void. But if Urban II did conceive and commission the throne, as seems most likely, he probably had it made in Rome and sent to Bari. Of course he could also have dispatched an artist to Bari to carve it on site, but even so, the artistic provenance would still not be Apulian. Regardless of which option he might have chosen, it is important to remember that no Apulian work of art anticipates the figural sculpture of the throne nor even the ability to produce it. Moreover, there is nothing in Apulia which suggests that it exercised any immediate influence.[46] (The much-vaunted similarity to portal fragments at Monopoli, usually dated 1107, is based on dubious stylistic and technical comparisons, the more questionable because the fragments are radially oriented voussoirs that have no counterparts in Romanesque sculpture until the 1120s and 1130s. The portals of the churches of Trani and Bari are no earlier than the 1140s and probably later.)[47] So even if he worked in Apulia,

[44] *Ibid.*, 7.
[45] *Ibid.*, 36–37.

[46] By coincidence, the only other Italian throne with comparable atlas figures—albeit they are arranged very differently—is in the north. Located in the cathedral of Parma, it is associated with the twelfth-century work of Benedetto di Antelami.

[47] Wackernagel, *Die Plastik*, 43–44, initiated the false relationship of the Bari throne and the Monopoli fragments. For the Trani and Bari portals, see Robert Crichton, *Romanesque Sculpture in Italy* (London, 1954). Pina Belli d'Elia, "La Cattedra dell'Abate Elia precisazioni sul romanico pugliese," *Bolletino d'Arte*, LIX (1974), 1–17, has proposed a redating of the throne to the middle of the twelfth century. The argument is based on a stylistic comparison of the Bari throne with other Apulian works of c. 1100 in which the incongruity of the throne is used as the reason for discounting the validity of both the inscription and the documentary notice in the Anonymous of Bari as criteria for dating the throne. Similarities to architectural sculpture in the church itself, decoration that is generally dated close to the middle of the twelfth century, are cited as the justification for the new date. Although this conclusion has the virtue of simplicity, it also has the defects of ignoring clearer evidence for documentation than is normally available for any Romanesque sculpture and of violating all points of concordance between the Bari throne and Romanesque sculpture elsewhere in Italy and France. That the throne should have been a source of inspiration in the architectural sculpture of the church, when it was eventually made, is not surprising, but the imitation need not have been immediate. The important issue is that the Bari throne is out of context in the Apulia of 1100, and that issue, I believe, is addressed better in my formulation of the problem.

the sculptor of the Bari throne disappeared as suddenly as he appeared. Although the circumstances of patronage suggest that the throne was made by an artist working in Rome, the lack of evidence there for any sculptural activity implies that the artist himself originated in yet another center.

A satisfactory explanation of the provenance of the sculptor depends upon a careful examination of the style and technique of the work itself. No eleventh-century sculpture in the whole of Italy offers a counterpart to the depth of relief, the expertness of surface treatment, the physical articulation, and the expressive musculature and faces of the Bari throne figures. If the Canossa throne elephants are similarly carved almost in the round, they are also stiff and lifeless. If the stuccoes of the Milan and Civate ciboria[48] are equally well articulated, they have nothing of the expressiveness nor of the full plasticity found in the Bari figures. If the Amalfitan ivories of the Salerno antependium[49] approach the expressiveness of the Bari figures, they are carved in very flat relief. Similarities to a combination of these qualities can be found nowhere in stone and only outside Italy in other media. The suavely finished surfaces, the very deep relief with some limbs carved completely in the round, the expert level of figural articulation, and to some degree the muscular expressiveness can be found in late-eleventh-century German ivories, most notably a book cover from Franconia now preserved in the Würzburg Universitätsbibliothek (pl. 18).[50] A close approximation to the half-clad atlas figures, except for the muscular and facial expressiveness, can be found in the bronze "Krodo Altar," also late eleventh century, which is preserved in the museum at Goslar (pl. 17).[51] Also, the grille-work carving of the side panels of the chair has its closest surviving counterpart in the ninth-century bronze grilles of the Palace Chapel in Aachen.[52] Such bronze work may have been made in Germany into the eleventh century,

although no examples can be cited. While none of these comparisons should be regarded as work by the Bari artist nor as sources for his motifs, they do demonstrate where and in what context the ability to undertake the task posed by the Bari throne already existed. The original background of the Bari sculptor must, I believe, be assigned to Germany in the versatile profession of the goldsmith.

In the Rome of the newly renascent papacy, where there was no flourishing indigenous sculptural tradition, goldsmiths from the Holy Roman Empire would have been in considerable demand for their customary services. Indeed, it is far more likely that an artist sufficiently versatile to produce marble figural sculpture should have been in Rome and available to the papacy than in provincial Apulia. While in Rome such an artist would not have been unaware of novel technical developments emerging around him. In this light, it is reasonable to suggest that the flat carved decoration on the seat of the Bari throne may have been an adaptation of the Cosmati work in inlaid marble which appeared in Rome about this time.[53] This explanation justifies the apparent inconsistency between the flat and plastic carving techniques on the throne more plausibly than that of a combination of antique and Islamic sculptural influences, especially since no other Apulian throne exhibits this inconsistency. The novel aspect of the Bari sculptor's style, the expressive vitality of the bodies and faces, does suggest a debt to Antiquity, due not to random borrowing but to a faithful translation of the putative thematic models that Grabar has suggested. Within the known pattern of artistic centers just prior to 1100, the Bari throne is most reasonably explained as a creation twice removed from Apulia, by virtue of papal patronage in Rome and of technical background in Germany.

The Incunabula of Sculpture on the Facade of Modena Cathedral

The sculptures on the west facade of the cathedral of Modena (pl. 58) comprise the most impressive ensemble of early-twelfth-century stone carving in Italy. They include a long frieze in four parts, the

[48] See de Francovich, "Arte carolingia ed ottoniana," 116-137, and 137-145.

[49] Peter Lasko, Ars Sacra, 800-1200, The Pelican History of Art (Harmondsworth, 1972), 144-146; pl. 146, has associated these ivories with the Bari throne and the sculptures at Modena. For the ivories, see Robert Paul Bergman, The Salerno Ivories (Ph.D. diss., Princeton University, 1972; Ann Arbor, 1972), esp. 171-210 and 254-278.

[50] Adolf Goldschmidt, Die Elfenbeinskulpturen aus der Zeit der Karolingischen und Sächsischen Kaiser, VIII.-XII. Jahrhundert (Berlin, 1918-1926), II, 45, and pl. XLII, cat. item no. 148.

[51] Lasko, Ars Sacra, 137, pl. 145.

[52] Karl der Grosse, Exhib. Cat. (Aachen, 1965), 29-30.

[53] Edward Hutton, The Cosmati: The Roman Marble Workers of the XIIth and XIIIth Centuries (London, 1950), 6, and pls. 26, 45, 57.

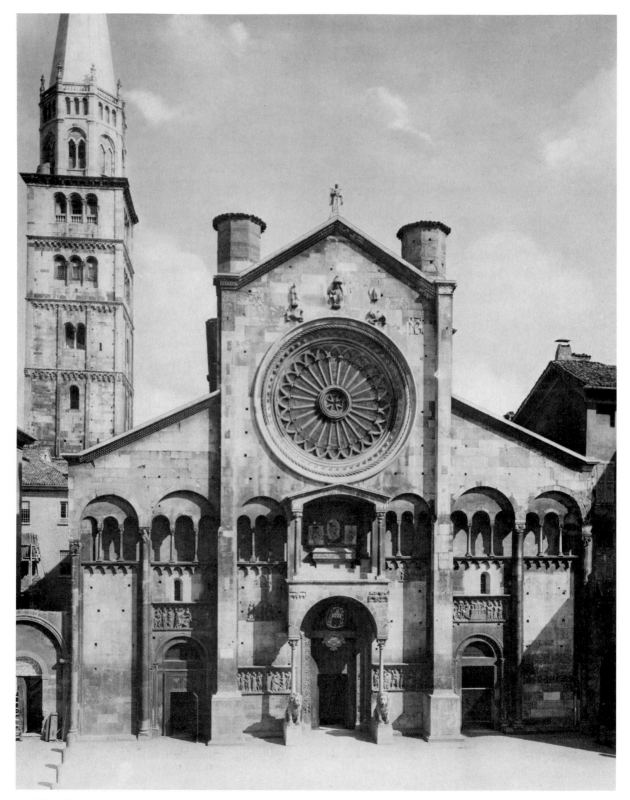

58. West facade of Modena Cathedral, begun 1099. (Alinari/Editorial Photocolor Archives)

59. Marble relief of Eros figure (with a bird), c. 1106, set in the facade of Modena Cathedral. (Carlo Orlandini)

central portal, and three relief slabs set into the facade high up on either side of the portal. The frieze is devoted to a narrative representation of scenes from the Book of Genesis, from the Creation of Man through the survival of Noah from the Flood. The portal jambs, lintel, and archivolt are embellished with an inhabited vine scroll on the outer face and the jambs are carved with figures of twelve prophets on the inner face beside the actual doors. Covering the portal is a ciboriumlike porch, supported on the front by two columns set on the backs of lions. Among the three relief slabs is a related pair, each carved with a winged nude figure holding a lowered torch (pls. 59, 60). The third slab, the largest of the three, has two figures holding an inscription plaque (pl. 61). The figures are labeled Enoch and Elias and the inscription recounts the beginning of the cathedral on June 9, 1099. At the bottom of the inscription and in a different type of lettering is a Leonine verse

in praise of the sculptor, Wiligelmus.[54] The consistency of style among these various sculptures is sufficiently obvious that they have been universally ascribed to the same hand. They have also been long acknowledged as the first important Romanesque sculptures in northern Italy.

However, the sudden appearance of such expert figural sculpture and the origins of Wiligelmus have never been satisfactorily explained. Also, a precise justification for a date soon after the building program began has never been determined. One of the principal reasons for this vagueness is that no one has ever seriously attempted to establish the chronological sequence in which the sculptures

[54]DV GEMINI CANCER CURSV CONSENDIT OVANTES/ IDIBVS IN QVINTIS IVNII SVP TPR MENSIS/MILLE DEI CARNIS MONOS CENTV MINVS ANNIS/ ISTA DOMVS CLARI FVNDATVR GEMINIANI/ INTER SCVLTORES QVANTO SIS DIGNVS ONORE/ CLARET SCVLTVRA NVC VVILIGELME TVA.

60. Marble relief of Eros figure, c. 1106, set in the facade of Modena Cathedral. (Carlo Orlandini)

were made. Accordingly, the circumstances of their creation remain obscure.

The obvious starting point for the investigation is the Genesis frieze (pls. 62, 63, 64, 65), which is not only the most conspicuous element of the sculptural program but also the most unusual in the context of Romanesque sculpture. As architectural embellishment it is less related to the format of its setting than any other major sculptural monument. Moreover, the second and third segments of the frieze, which flank the central portal, are awkwardly installed. Both of these frieze segments are a few inches too long for the space, with the result that the ends farthest from the door extend right into the vertical wall buttresses. This awkwardness, together with the arbitrariness of the frieze format in relation to its setting, inspired Arturo Quintavalle[55] to doubt its original function as an architectural decoration. Instead, he hypothesized that the frieze was

[55]Quintavalle, *La Cattedrale di Modena: Probleme di romanico emiliano* (Modena, 1964-1965), I, 184-200, figs. 19-24.

made as a sculptured balustrade to enclose the western end of the raised choir inside the cathedral. On the face of it, this hypothesis has much merit because the total length of the four segments (36 feet, 7 1/4 inches) is almost exactly the length of the present balustrade in that location (36 feet, 9 inches).

It should be noted, however, that each end of each frieze segment is terminated by a carved frame so that the narrative sequence was not continuous. Such frames imply divisions that would signify points of articulation, for instance, the natural location of the supporting columns beneath the balustrade. The present sculptured balustrade stands above three arches that lead to the crypt and is supported by four columns set on lions of early-twelfth-century date. But contrary to this apparently original format of supports, the three intermediate columns implied by the articulation of the facade frieze would then be located on the central axis of the crypt entrances, a most awkward and unlikely disposition. This contradiction indicates that the frieze was not usable as a balustrade. More-

61. Marble inscription plaque signed by Wiligelmus, c. 1106, set in the facade of Modena Cathedral. (Carlo Orlandini)

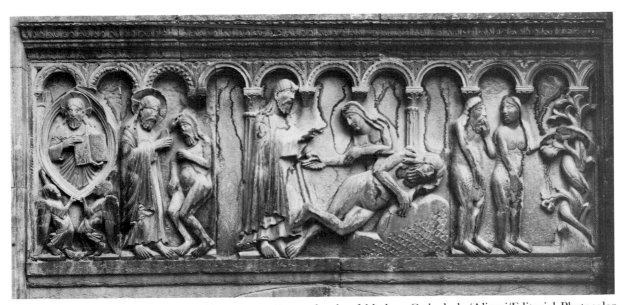

62. First segment, marble Genesis frieze, c. 1106/1110, facade of Modena Cathedral. (Alinari/Editorial Photocolor Archives)

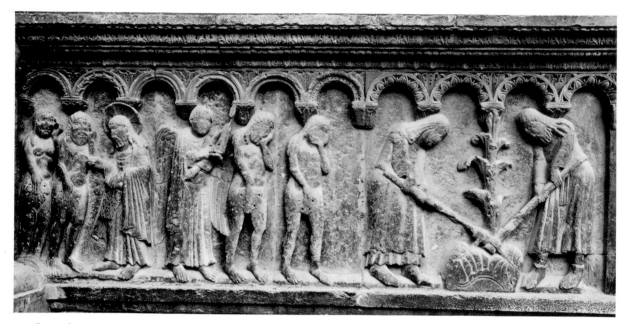

63. Second segment, marble Genesis frieze, c. 1106/1110, facade of Modena Cathedral. (Alinari/Editorial Photocolor Archives)

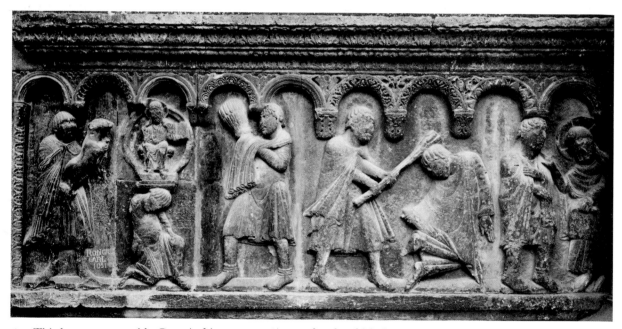

64. Third segment, marble Genesis frieze, c. 1106/1110, facade of Modena Cathedral. (Alinari/Editorial Photocolor Archives)

over, Eric Fernie[56] has pointed out two archaeological factors that indicate that the frieze was made for

the facade. First, the cornice above the frieze is carved with foliage exactly like that on the frieze itself, a resemblance so close that both elements have to be attributed to the same hand. Second, the cornice segments adjacent to the central portal are

[56] Fernie, "Notes on the Sculpture of Modena Cathedral," *Arte Lombarda*, XIV (1969), 88–93.

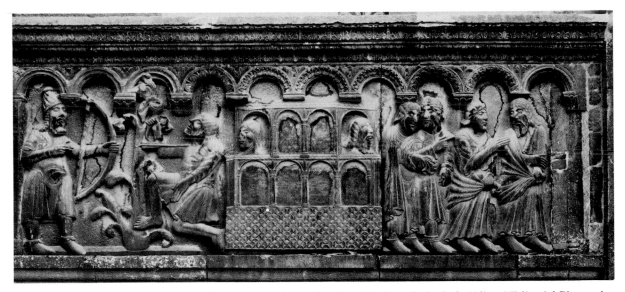

65. Fourth segment, marble Genesis frieze, c. 1106/1110, facade of Modena Cathedral. (Alinari/Editorial Photocolor Archives)

carved on stones that are integral with the door jamb, signifying that the cornice and portal have to be contemporaneous. The cornice, of course, would have no meaning without the frieze and so cannot be an independent element. The frieze, then, was made for the facade and its installation occurred when the facade was erected.

Fernie has also explained that the facade could not precede the dedication of the crypt, in 1106, because, as excavations show, the previous church was located over that area. Since the old church would have been needed until after the crypt was available for services, its destruction was almost certainly later. The crypt had been dedicated as soon as it was completed, at the insistence of the architect, Lanfranc, who apparently wanted to insure continuation of the building campaign. With the relics of the patron saint, Gimignano, installed, he would not have to fear a lack of support for the new construction. Such a tactic, which is fully documented,[57] implies also that he would then have proceeded to dismantle the old structure and build the facade in order to commit the patrons to complete the entire structure. Consequently, the facade was most likely begun soon after the translation of the relics in 1106. Since the frieze had to be ready by the time it was installed it was probably the first element of the facade program actually executed. That it does not fit exactly implies that it was prepared for planned measurements that were modified in the course of actual construction. The portal decoration also had to be ready in advance but could not be carved until the measurements of the portal were already fixed by actual foundations. Its execution was necessarily related to that of the cornice, which also had to fit the actual facade measurements. Therefore, the frieze was almost certainly made before the portal decoration but in conjunction with it.

Although Quintavalle's reconstitution of the frieze is incorrect, it raises an important issue, that the sculpture of Wiligelmus is highly suggestive of marble church furniture. This issue is clearly apposite to the three relief slabs set into the facade on either side of the porch. Despite their undeniable authorship by Wiligelmus, they have received only perfunctory notice in studies on the Modena sculptures. The subject matter of the inscription relief is self-evident, but it is important to note that the winged nude figures holding lowered torches (pls. 59, 60) are imitations of a theme common in late antique sarcophagi, the Eros-Thanatos theme signifying Sleep and Death. Regarding the physical location of the slabs in the facade, three factors—their random placement, the lack of congruity between their formats and the architectural setting, and the lack of relevance between the subject matter and that of the facade program—indicate that they

[57] Arthur Kingsley Porter, *Lombard Architecture* (New Haven, 1917), III, 11, 16.

were originally placed elsewhere. Since they are incongruous in all respects to any of the other architectural decoration at Modena and to any known programs of architectural sculpture elsewhere, it is reasonable to conclude that their original location was inside the cathedral. Apparently on the basis of such an inference, Quintavalle initiated interest in these reliefs by incorporating them into his proposed reconstitution of a shrine-altar of San Gimignano, associated with the documented translation of the saint's relics in 1106. According to Quintavalle's proposal, the three reliefs were set on the front and sides of a shrine receptacle under a table altar supported by four columns.[58] This theory has the virtue of providing a suitable setting for the imitation of antique sarcophagus motifs and fixing the date when Wiligelmus worked in Modena. Indeed, the installation of these reliefs on the facade implies a sacred association that prompted preservation after disuse for reasons other than their decorative character. However, a more critical and detailed analysis of the three reliefs and of Quintavalle's reconstitution leads to a much more precise understanding of the sculpture.

On the inscription relief (pl. 61), the images of Enoch and Elijah represent the two Old Testament figures who were taken into Heaven without experiencing death. They signify the theme of neverending life which can be appropriate to a shrine-altar. Physically, though, there is a slight disparity in the scale of the figures which makes them incompatible for the same ensemble. Moreover, the inscription itself celebrates the foundation of the new church, not the translation of the saint's body. Also, the verse in praise of Wiligelmus carved at the bottom of the inscription is not appropriate to an altar, unlike a mere signature or a donor acknowledgment. It seems more likely, then, that the inscription relief was an independent piece, related to the church fabric rather than the shrine-altar. It may well have been placed in the crypt but in a wall, apart from the freestanding shrine-altar.

Of the two other reliefs, the one to the left of the porch is about 23 inches high and 34 inches wide (pl. 59). It has an odd overall shape, with the upper corners cut away, but it is framed on all sides and appears to be complete. While it is clearly related to the other relief in size and subject, it is different in format. The relief to the right of the porch, about 27 inches high and 28 inches wide, has a bottom frame like the first but none on the sides and top (pl. 60).

This format implies that it was part of a continuing composition. Since one cannot assume that the formats were arbitrary, the three reliefs cannot be associated as compatible units of a three-part composition, as in Quintavalle's reconstitution. Nor can the two small reliefs be regarded as antique spolia installed in a Romanesque setting because both figures have the physiognomy characteristic of Wiligelmus's work.

Nevertheless, these figures holding lowered torches unmistakably represent the Eros-Thanatos theme which belongs to antique funerary sculpture. Typical examples of the Early Christian use of this Hellenistic motif are found in the Capitoline sarcophagus and in the Palazzo Farnese sarcophagus, both of the late third or early fourth century.[59] That Wiligelmus could have had access to such examples is manifest in the fragments found at Modena and in its vicinity at Carpi.[60] Even the framing of one figure under an arch can be justified by the Carpi fragment and the Salona sarcophagus of the late third century.[61] It is likely then, that Wiligelmus actually copied this theme from antique Roman sarcophagi.

It is also likely that the two reliefs belonged to a sarcophagus composition that served as both shrine and altar (pl. 66). First, the Eros-Thanatos theme is exclusively related to a funereal purpose: there could scarcely have been any mistake about the purpose of the object from which it was copied nor, consequently, about its original meaning. No other type of Romanesque liturgical furniture—font, ambo, pulpit, throne, screen, or ordinary altar—could be appropriately decorated with it. Second, the formats of the two reliefs suggest that one was an end piece and the other was part of the front. The composition of the front fragment (which is about 28 inches wide) implies a complementary piece and the two would require a center relief, probably slightly wider. A plausible motif for the center is that of two genii holding an inscription plaque, or, less likely, a clipeated portrait of San Gimignano.[62] Together

[58] Quintavalle, *Da Wiligelmo à Nicoló* (Parma, 1966), 32–33.

[59] Joseph Wilpert, *I sarcofagi cristiani antichi*, 3 vols. for 5 codices (Rome, 1929–1936), I, 92, and pls. LXXI, fig. 4 (Farnese), and LXXXVI, fig. 6 (Capitoline).

[60] Roberto Salvini, *Wiligelmo e le origini della scultura romanica* (Milan, 1956), 89–91, figs. 48, 50.

[61] Wilpert, *Sarcofagi cristiani*, I, 134, and pl. CXXXII, fig. 1.

[62] The motif of erotes holding an inscription plaque, particularly on the front edge of the lid, was common throughout the third and fourth centuries (see Wilpert, *Sarcofagi cristiani*,

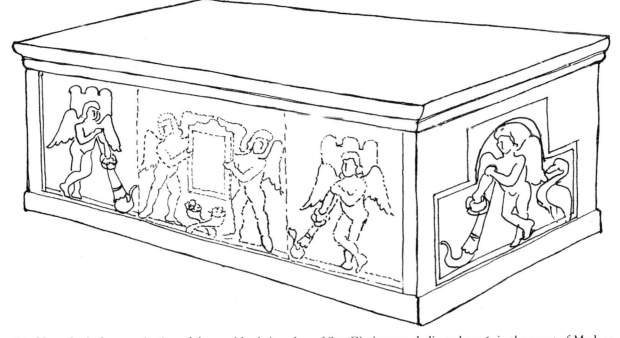

66. Hypothetical reconstitution of the marble shrine-altar of San Gimignano, dedicated 1106, in the crypt of Modena Cathedral. (M. F. Hearn)

with a frame at the edges, the length of the composition would be about 8 feet. The width of the end piece (about 34 inches) together with a frame would indicate a total width of about 3½ feet. These dimensions are entirely within the size limits of an altar in sarcophagus form.

That such a shrine-altar is likely to have been made in pieces rather than carved from a single block is suggested by the fragments in Werden, dated to the third quarter of the eleventh century, which Rudolf Wesenberg has reconstituted as the shrine of St. Luidger.[63] The overall composition of the Modena shrine-altar could have been that of a table-altar or mensa, as Quintavalle suggested, with the sarcophagus set within the perimeter established by the supports. That the altar slab was regarded as a mensa is certified by the *Translatio corporis Sancti Geminiani*, which describes the translation.[64] How-

ever, the altar need not have been in table form to be termed a mensa. Indeed, the illustration of the exposition of the relics in the same early-thirteenth-century document actually indicates a sarcophagus form.[65] Because the text description of the event required the illuminator to include soldiers guarding the new shrine, their location at the bottom of the composition precluded any opportunity to show the sculptural decoration. Nevertheless, when the form was depicted it was probably based on that of the actual shrine-altar.

Such a reconstitution of the two reliefs with the Eros-Thanatos motif revises that by Quintavalle in form but not purpose. The function of the altar as the shrine of San Gimignano necessitated the presence of Wiligelmus in Modena at a time sufficiently prior to the originally intended date of the translation, April 30, 1106, in order to carve it—that is about 1105. This theory also provides a motive for the revival of the late antique style which is blatant in these reliefs and strongly evident in the frieze. Imitation of the antique style was not a precondition for making marble sculpture: no matter how new

passim). Specific examples of erotes holding a portrait—either clipeated in a crown of glory or being unveiled—and flanked by Eros-Thanatos figures are preserved in Rome (see Wilpert, *op. cit.*) in the crypt of Lucina, II, pl. CLXXXIII, fig. 1; in the Terme Museum, III, pl. CCLXXIV, fig. 7, and in the cemetery of Praetextatus, III, pl. CCLXXV, fig. 1.

[63] See Chapter 2, second section.

[64] Before the ceremony, soldiers and citizens took oaths to guard the relics while they were exposed: "After that, the stone and the lid of the sarcophagus were raised with all reverence

[*Levatur ergo lapis, & mensa superposita magna cum reverentia*]." Cited from Porter, *Lombard Architecture*, III, 12, 14.

[65] *Ibid.*, pl. 141, fig. 4.

this medium was to Wiligelmus he could not learn to carve marble by looking at older marble sculpture. Rather, the antique revival must be due to the nature of the commission itself. St. Geminianus was a fourth-century bishop of Modena who died about 348. According to tradition, he was enshrined by Teodolo, his successor, and was venerated after the middle of the fourth century.[66] The comparisons with antique sarcophagi indicate that Wiligelmus's model or models could belong to that date. The combined circumstances suggest that the patrons of the cathedral fabric desired to have a copy of the saint's original tomb that could be regarded as authentic in format, theme, and style. However, the repetition of the Eros-Thanatos theme in my reconsititution is unknown in actual Early Christian sarcophagi. Also, the use of a bird (a pelican or an ibis?) in the fully framed relief (pl. 59) is incongruous with this theme. Therefore, it appears that Wiligelmus was in fact using fragments as models, fragments that well may have been preserved because they were thought to have belonged to the original tomb. In any event, it is likely that the purpose of the sculpture as decoration for the shrine-altar of San Gimignano dictated the use of antique models.

The importance of the imitation of antique fragments becomes apparent when considering the chronological place of the shrine-altar in Wiligelmus's work at Modena. Most scholars have ignored this question or have simply implied that either the central west portal or the Genesis frieze was first or that the inscription relief was last.[67] But these suggestions have been justified solely by subjective assumptions about stylistic development. The Eros-Thanatos reliefs have never figured in this discussion. However, since the shrine-altar had to be in place in the crypt before the translation of the relics in 1106, it is almost certainly the first work of Wiligelmus at Modena. The inscription relief would most likely have been inspired by this ceremonial occasion and, since it would be equally appropriate in the crypt as in the facade, was probably next.

The significance of placing the shrine-altar first is that Wiligelmus's initial activity must be associated with church furniture and not with architectural decoration. Indeed, the shrine-altar bears no relationship in either style or technique to any earlier architectural sculpture and has no precedents in that area of stone carving. The purpose of carving the shrine-altar, then, is likely to be the real reason he was called to work in Modena and the architectural sculpture followed only because his success in the first project inspired his patrons to commission this unprecedented facade program. Since there was no tradition of carving figural stone sculpture when these projects were executed, how can the sudden emergence of such work be explained? As we have seen, the antique influence in Wiligelmus's style was apparently determined by the models prescribed by the patrons at Modena. His technique as a marble sculptor, however, is a distinct factor that must be pursued separately.

No exact prototype for the Modena sculptures has ever been located, but scholars are almost unanimous in finding general or vague comparisons in the sculpture of other media in eleventh-century Germany. The Genesis scenes of the bronze doors of Hildesheim (pl. 16) comprise the nearest precedent to a plastic representation of this narrative subject. These doors are too early (c. 1015) to be related to Wiligelmus's own career and even a prior exposure to them was not likely to have been a factor in the Modena program because the subject matter there was undoubtedly prescribed by the patrons. Moreover, the iconography of the two monuments is identical in only a few particulars (such as the Offering Cain and Abel, pl. 64) and the figural style is markedly different. But the Hildesheim doors do indicate the artistic context that could produce a sculptor capable of executing the Modena program. Technically, the Modena sculptures are remarkably precocious, not only because of the very plastic modeling and depth of relief but also because the legs of some of the figures (pls. 62, 64) are carved completely in the round and free of the relief ground. A precedent existed in a late-eleventh-century stone relief at Brauweiler (pl. 36), but the ability to produce it was indigenous to ivory carving, as in the contemporaneous Franconian ivory plaque (pl. 18). With respect to specific details, the acanthus foliage of the Modena frieze cornice (pl. 63)

[66] Société de Bollandistes, *Bibliotheca hagiographica Latina antiquae et mediae aetatis*, I (Brussels, 1898–1899, repr. 1949), 329–330; and Porter, *Lombard Architecture*, III, 7.

[67] Salvini, *Wiligelmo*, chap. 4, places the oeuvre of Wiligelmus in the following order: portal, Genesis relief, Eros-Thanatos slabs, inscription slab, others. This order is either stated or implied by Toesca, *Storia dell'arte italiana*, III, *Il Medioevo* (Torino, 1927), 756–758; and Robert Crichton, *Romanesque Sculpture in Italy* (London, 1954), 7. Other scholars, such as Porter, *Lombard Architecture*, III, 30 ff, have placed the frieze first, then the inscription relief and the portal, without explicit attention to the Eros-Thanatos reliefs.

and the inhabited vine scroll on the outer face of the portal jambs (pl. 67) resemble nothing more than the decorative borders of eleventh-century German ivories and metalwork. Of the former, the Franconian ivory is an example; of the latter, the border of the golden altar of Basel (pl. 11) is a notable instance. Finally, the composition of the inscription relief (pl. 61), with Enoch and Elijah holding the inscription plaque, is a very rare formulation. Albeit such a composition may have been the central motif on the shrine-altar, any antique precedent would have suggested nude genii. The use of two clothed, Old Testament figures is a very different theme. Such an example exists earlier to my knowledge only in a German psalter from Mainz, c. 1025.[68] At Modena, the compositional format of the inscription relief, if not the choice of the figures, may well have been determined by the sculptor. Wiligelmus, then, is most plausibly identified as a Germanic goldsmith.[69] As has been noted before, his very name denotes a German origin.[70]

Admittedly, this evidence constitutes an indefinite case for an identification of the artist's background. The parallel with that applied to the Bari sculptor, however, is very striking and the evidence for each case provides mutual reinforcement for the identifications. In this similarity, though, there is more than coincidence because the figural style of the Bari throne is remarkably like that of the Modena sculptures.[71] To be sure, there are significant differences also. In making a comparison these distinctions should be acknowledged first.

The Bari figures (pl. 57) are carved virtually in the round while the Modena figures are all in only moderately high relief. The Bari atlas figures have faces charged with intense expression, mouths open in a pained grimace; most of the Modena figures (pl. 65) display no facial expression at all. The musculature of the Bari atlas figures virtually ripples from their physical strain, but all similar opportunities at Modena (the atlas figures in the first and third relief segments and at the base of the portal jambs, pls. 62, 64, 67, 68) are avoided by representing fully clothed the figures in a posture of support. None of the decorative motifs used at Bari appear at Modena. Indeed, except that the dates of each clearly place the Bari throne earlier, it would ordinarily be considered the more advanced work and of a later date than the Modena sculptures. However, the sculptures of Bari and Modena are also very different in format. The throne could be carved with figures virtually in the round while the relief slabs of Modena could not. The Bari atlas figures carry their load unwillingly, hence appropriately uncomfortable in expression and undignified in demeanor and dress. The supporting figures in the Modena frieze support the image of God the Father and an altar, hence willingly, but the atlas figures in the jambs do strain and grimace. The differences, then, are differences of propriety in the format and subject matter and the similarities far outweigh them.

At both Bari and Modena the figures are remarkably plastic in conception and share the same stocky proportions. The facial types at Modena vary, but the round Bari physiognomy with a soft jaw line appears there several times, (for example, the sons of Noah in the fourth relief segment, pl. 65), as well as the soft bulging abdomen (for example, the atlas figures on the jambs, pl. 68). The eyes, with irises in relief, and the heavy lips are the same.

[68] The MS. is Paris, B. N. lat. 2751, fol. 4. I am indebted to Carl Nordenfalk for this example, the certification of which he provided.

[69] De Francovich, "Wiligelmo," 258, revived by implication the earlier assertions that Wiligelmus was a German goldsmith by virtue by comparisons to bronze church furnishings of the eleventh, twelfth, and thirteenth centuries. Since this article was published, Salvini, in *Il duomo de Modena e il romanico nel modenese* (Modena, 1966), 109, has asserted that Wiligelmus was working in the tradition of the bronze doors at Hildesheim and the wooden doors of Sta.-Maria-im-Kapitol, Cologne, but emphasizes instead a greater relationship to the sculpture of the Moissac cloister (114). Quintavalle, in *Da Wiligelmo à Nicoló*, 21, places Wiligelmus in the German Imperial tradition but does not distinguish his metier. Everyone else has assumed that Wiligelmus was always a sculptor of stone who was inspired by variously hypothesized wide travels. Emile Mâle, *L'art religieux du XIIe siècle en France*, 2d ed. (Paris, 1924), 43ff, predictably—even perversely in this case—thought that Wiligelmus was French by training and probably by origin.

[70] Wiligelmus's German origin, including his name, was initially advanced by M. G. Zimmerman, in *Oberitalische Plastik im frühen und hohen Mittelalter* (Lipsia, 1897), 37, 50–51. Geza de Francovich, "Wiligelmo," n. 73–75, has collected references from other scholars who accepted that attribution. Ulysse Chevalier, *Répertoire des sources historiques du Moyen Age: Bio-bibliographie* (Paris, 1905–1907), II, 1914, does not equate Wiligelmus to the Italian name Guglielmus. Although he does not treat the name Wiligelmus, names beginning with Wile, Wili, and Willi are all associated with Germanic territories or with Anglo-Saxon England.

[71] Almost no one has missed the obvious similarity of the Bari throne and Modena sculpture. However, a kind of superstition against asserting an actual relationship has prevailed (see Toesca I, *Il Medioevo*, 833–834; Francovich "Wiligelmo," 258–259; Crichton, *Romanesque Sculpture in Italy*, 8, 153), largely in the belief that the Bari throne is too "developed" to be a predecessor of Modena.

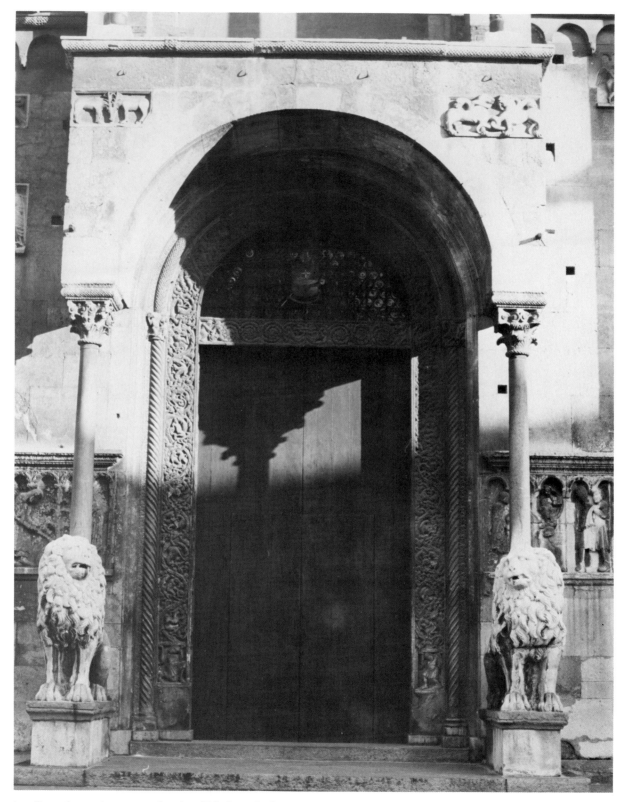

67. Central portal, c. 1110, facade of Modena Cathedral. (Courtauld Institute—M. F. Hearn)

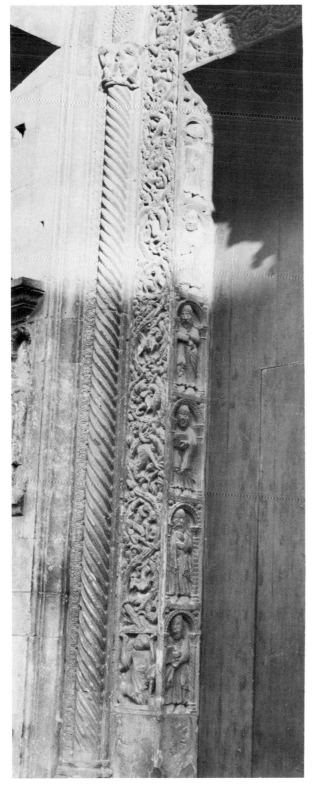

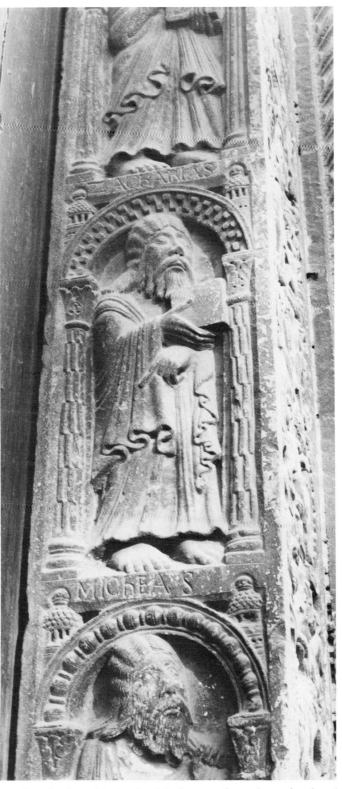

68. Marble jamb of central portal, facade of Modena Cathedral. (Courtauld Institute—M. F. Hearn)

69. Detail of marble jamb with figures of prophets, facade of Modena Cathedral. (Courtauld Institute—M. F. Hearn)

Drapery folds, hemlines, and hair styles are not identical but are sufficiently close to exclude possible relationship to any other earlier monuments. The stance of the atlas figures can be matched, detail for detail, although not fully in any single figure. The degree of anatomical plausibility is equivalent, particularly in the articulation and (dis)proportion of limbs. The mannerisms of carving and similarities of figural style are sufficient to relate the sculptures; the differences are no greater than the range of style observed in the works attributed to the hand of Bernardus Gelduinus.

That Wiligelmus could have worked at Rome or Bari and at Modena is a tempting conclusion in light of the technical and stylistic resemblances between the two monuments. If he was indeed a German and a goldsmith by training, the manifestation of his hand in the Bari throne is all the more plausible if the original locus of his activity in Italy was Rome. Since the pope (then Paschal II, 1099–1118) cannot have been unaware of the institution of a new cathedral in Modena for the purpose of enshrining San Gimignano (indeed it was he who actually dedicated the shrine on October 8, 1106), it is all the more probable that an artist who had presumably made the Bari throne under papal patronage would have been recommended for the Modena shrine. It is, after all, only through hindsight of Wiligelmus's subsequent work in Modena and his influence throughout Emilia that it seems natural for such a man to have been working in this region.

The Ambo of Sant'Ambrogio in Milan

The marble ambo in the church of Sant'Ambrogio in Milan (pl. 70) introduces a somewhat different type of sculpture into this series of monumental church furnishings. The quality of its figural style is at once both less impressive and more typical of eleventh-century art in general than the monuments of Toulouse, Bari, and Modena. An investigation into the artistic background of its creation helps to explain why the ambo was exceptional and why it was also less likely to be as influential as the other works in the development of Romanesque sculpture.

The ambo is situated at the eastern end of the nave on the north side, presumedly its original location. Its purpose was to provide a raised platform from which the Gospels were read in the celebration of the Eucharist, hence its location on the north, or Gospel, side of the high altar. The platform rests on an arcaded base supported by columns and is enclosed by a balustrade. The base, three bays wide and two bays deep, measures approximately eight by twelve feet and the whole composition is about twelve feet high. The necessity for two supporting columns within the perimeter of such a structure is obviated by the insertion of two Early Christian sarcophagi, one above the other, as a support beneath the two northeastern bays. The underside of the platform is groin-vaulted, so that the space above the sarcophagi is filled in and faced with lunettes. The Romanesque sculpture of the ambo is found, then, on the lunettes, on the capitals, spandrels, and cornice of the arcade, and on one section of the balustrade, facing the north aisle.

Ostensibly, the ambo was damaged when some of the vaults of the church fell in 1196.[72] This event is normally accounted the explanation for the plain balustrade on the front and sides. Normally, also, it is assumed that the sarcophagi were inserted as supports when the ambo required reconstruction. This is an important point because it involves the issue of whether or not the lunette sculptures and even the section of carved balustrade were part of the original project. Arthur Kingsley Porter, the only scholar to give this matter any explicit attention, simply assumed that the sarcophagus arrangement implied a makeshift repair and that the balustrade fragment (as well as the lunettes, which he did not mention) was part of an early-thirteenth-century restoration.[73] However, a careful comparison of the figures, the foliate motifs, and the animals on the two zones of the balustrade fragment with the spandrels of the base leave little doubt that the same hand was involved in both areas (pls. 71, 72). The physiognomies of the human and animal faces, the stiff articulation of bodies, the crudely linear drapery folds, and even the technical nicety of inserting a dark stone in the irises of eyes, are exactly the same. A comparison of the lunettes and spandrels reveals a parallel similarity. Moreover, the insertion of the sarcophagi in the base need not have been later; indeed, they provide an element of stability to the heavy ambo structure which may well not have been sufficient with the use of interior columns. There may even have been a specific reason, unrelated to

[72] Porter, *Lombard Architecture*, II, 570–572.
[73] *Ibid.*, 592–593.

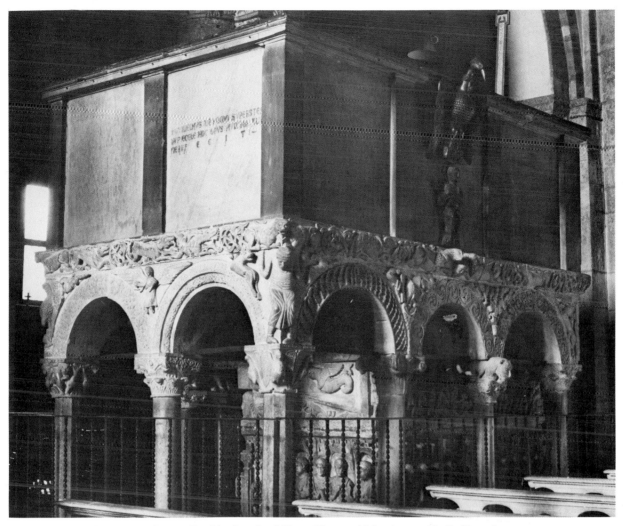

70. Marble ambo, c. 1100/1110, Sant'Ambrogio, Milan. (Courtauld Institute—M. F. Hearn)

the ambo, for placing the lower sarcophagus in that particular location. All factors considered, it seems likely that the ambo has not been altered except to replace damaged portions of the balustrade.

The loss of the greater part of the carved balustrade, which is clearly implied by the survival of one fragment, complicates any attempt to understand the iconographical program of the ambo. Since the upper register of this balustrade fragment (pl. 72) apparently represents the Last Supper, despite a deficient number of Apostles, it is most plausible that the balustrade originally contained a christological cycle, probably with scenes of the Passion. Although no earlier example can be found in medieval stone sculpture, its existence on later Italian pulpits as a standard theme of embellishment sup-

ports this idea. And like the surviving fragment, the lower register was probably filled all around with grotesque animal and foliate decoration.

The iconography of the spandrels (pl. 70) is very obscure.[74] Most of the figures are animals or grotesques, but the figural vignettes are close enough to standard images of religious themes that the animals may also have a symbolic character. One of these themes may be the Flight into Egypt, although none of the three figures is astride the donkey. One bird, labeled PELICANUS, may be a symbol of God the Son (as the Pelican in her Piety). These hints of religious content seem to inform the meaning of the most conspicuous human figure now left on the ambo. On

[74] *Ibid.*, 592.

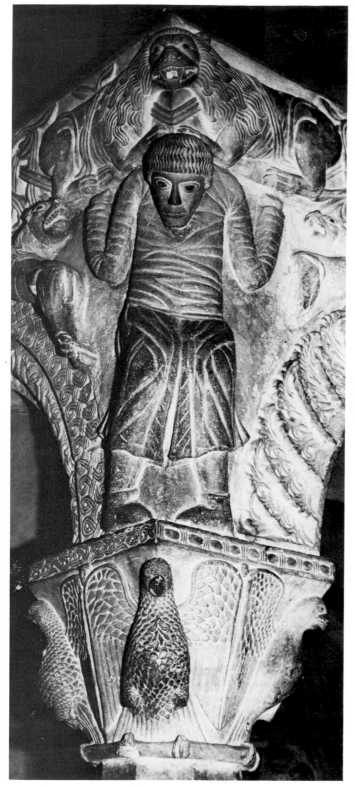

71. Atlas figure (Daniel in the Lions' Den?) on marble ambo, Sant'Ambrogio, Milan. (Courtauld Institute—M. F. Hearn)

the southwest corner of the base, the one most clearly seen from the nave, is a figure apparently occupied with holding up the cornice between the base and the balustrade (pl. 71). He has been explained as a reinterpretation of an antique atlas.[75] Nevertheless, he is fully clothed and flanked by two lions, suggesting that he is not a decorative pagan quotation at all but Daniel in the Lions' Den. Although his stance is like that of a praying orans, a frequent formula for Daniel in medieval iconography, he is clearly trying to support the cornice. But support of a christological cycle by this prophet is appropriate and the scene may be a conflation of the orans formula with the concept of such a symbolic purpose. For the rest, the capitals, arch faces, and the cornice are carved with purely decorative elements. The lunettes, however, are embellished with easily identifiable themes: the Magi before Herod, the Adoration of the Magi, the Labor of Adam and Eve, and two birds drinking from a cup symbolic of everlasting life. Even so, these scenes bear no relation to the carvings on the Early Christian sarcophagi. On the whole, then, the iconography of the ambo appears to be random and obscure and probably had no fully programmatic character except on the balustrade. Nevertheless, if surviving Italian marble church furniture from earlier periods accurately represents the range of previous possibilities, the Milan ambo signals an unprecedented attempt at religious sculptural embellishment in this context.

The figural style of the carving offers little promise of the development of monumental sculpture. As was mentioned above, the articulation of the figures is stiff and awkward and the modeling is simple and crude. The factors of the ambo sculpture that justify discussion in the context of important early monuments are the quality of plasticity in the figures, and the attempt—unprecedented in Lombardy—to represent religious subject matter in stone carving. There is, in fact, a curious inconsistency in the carving technique. The spandrel figures and the balustrade scene are carved in very bold relief, with the contours deeply undercut, as if the figures were modeled separately and applied to the relief ground. The purely decorative motifs, on the other hand, are carved in very shallow relief— witness the arch faces and the cornice.

[75] René Jullian, *L'éveil de la sculpture italienne: La sculpture romane dans l'Italie du nord* (Paris, 1945), 22.

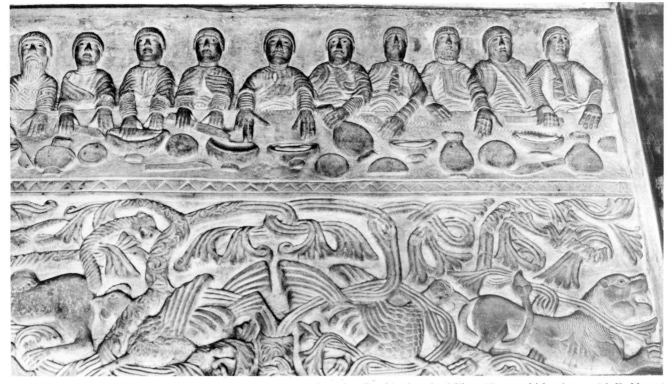

72. Balustrade relief (The Last Supper) on rear side of marble ambo, Sant'Ambrogio, Milan. (Courtauld Institute—M. F. Hearn)

The carving of marble church furniture and the nature of the nonfigural decoration on the Milan ambo belong to a north Italian tradition then already several centuries old. The intertwined vine foliage, carved in shallow relief with parallel rows of lines and triple-pointed leaves, and the various kinds of interlace and vine-scroll patterns on the arch faces appear frequently in church furniture and architectural decoration (principally arch faces and not capitals), in both marble and stucco, from the eighth century on.[76] The character of the carving style and decorative motifs is identical in both marble and stucco and indicates that this embellishment was made by a group of artists, peculiar to northern Italy, who specialized in church decoration, but without any apparent connection to architectural workshops. Curiously, on the rare occasions when they made figural compositions, such as the late-eleventh-century lunette scenes in the crypt at Civate[77] or the slightly earlier fragments at Aulla,[78]

the material was stucco. While nonfigural carving was always shallow and linear, regardless of material, the stucco figures were boldly plastic and in high relief. This juxtaposition of both techniques in marble occurs for the first time in the Milan ambo. In support of this interpretation, the lunette reliefs beneath the ambo platform appear to be actually made of stucco.

In contrast to Bernardus Gelduinus and Wiligelmus, the sculptor of the Milan ambo seems to have been involved in carving marble from the beginning. His background also bears little relationship to the sophisticated figural tradition of the Holy Roman Empire. But like his contemporaries, he was undertaking a novel commission that required him to go beyond the boundaries of prior experience. In doing so, he also left traces in his work of technical effects he normally expected to produce in another medium. But because the ambo was a departure from prior practice, it is very difficult to date precisely (in the absence of documentation) on the basis of its advanced qualities. The closest resemblance between the ambo and other sculpture occurs in the animals on the capitals and the cornice. Both in style and technique, the lions and birds are remarkably

[76]Paolo Verzone, *L'arte preromanica in Liguria; ed i relievi decorativi dei "secoli barbari"* (Turin, 1944), 53–55, pl. XXVI.

[77]Roberto Salvini, *Medieval Sculpture* (Greenwich, Conn., 1969) 314, pl. 33.

[78]Verzone, *L'arte preromanica*, 53–55, and pl. XXVI.

similar to the capitals in the nave of Sant'Ambrogio itself.[79] The grotesque decoration also matches that on the door frames at the western entrance to the nave. Because the church was begun in 1087 and nearing completion in its first state shortly after 1100, it seems reasonable to accept the traditional date for the ambo, the first decade of the twelfth century.[80]

Nothing in the circumstances of its creation suggests a motivation for the specific format and decorative scheme employed in the Milan ambo. Because the style represents current practice in this specific context, it is not feasible to hypothesize a late antique model. It may be significant, however, that the church itself revived the Early Christian atrium, a feature that was then being revived also at Monte Cassino. There could have been a desire on the part of the patrons to have the one new piece[81] of conspicuous furnishing embellished with marble sculpture as an association with the glorious period of their patron saint, Ambrose (c. 340–397), whose remains were enshrined beneath the high altar.

The Hemicycle Capitals of Cluny

The capitals and other sculpture fragments that survived the destruction of the abbey church at Cluny—the greatest building and the most important monastery of Romanesque Europe—are both the most original and the most puzzling of all the early monuments of the sculptural revival. Among the capitals, the coordinated group of eight that embellished the hemicycle of the main apse and, among the fragments, the pieces from the central western portal represent fundamentally new developments in style, iconography, and format. These factors alone make their study one of the most difficult problems in the history of Romanesque sculpture, but the effort is further complicated by the loss of their setting, the church itself.

As at Modena, it is necessary to determine which of the Cluny sculptures was made first in order to identify the most telling manifestation of their artistic background. The sequence of production among the hemicycle (pls. 73–81) and portal fragments (pl. 83) can be established to a fairly reliable degree because of their stylistic and technical similarity. Among the figures the qualities they share are the expert articulation of bodies and an unprecedented sense of vitality and movement. The technical similarities include drapery folds, carved as a series of overlapping planes, and hair styles, carved as a series of parallel lines with collected strands sometimes ending in a small, tight curl. But within this group of related sculptures there is a clearly discernible evolution in the technical execution of certain details, especially in the faces. On the capitals, the facial features are rather small and tightly concentrated along the central axis. The wide, flat cheeks extend from well beneath the ears and the jaw continues in a virtually straight line to the chin. The eyes have a nearly straight upper lid, a deeply curved lower lid, eyeballs articulated in the socket by distinct indentations at each corner, and irises pierced with a tiny hole. The top of the noses interrupts a flared brow line. The small, narrow mouths have thin, slightly rounded lips which are terminated on each end with a vertical crease to suggest a cheek muscle. The hair usually falls low on the forehead while the chin is long and straight. In the portal fragments, the same technical mannerisms recur but are more subtly modeled. The eyeballs, cheeks, and lips are more supply rounded and all the facial features are relatively larger, more widely spaced, and more carefully articulated. This evolution might be ascribed simply to the larger format of the portal fragments were it not for the appearance of the same hand in some of the later nave capitals in the abbey church of Vézelay (for instance, the Mystic Mill [pl. 122], Moses and The Golden Calf, Adam and Eve [pl. 123], and The Avenging Angel Killing Pharoah's Son).[82] These later works also show the refinements of the Cluny portal fragments and they are smaller even than the Cluny hemicycle capitals. Within the activity of this artist, identified as the Cluny Master, the hemicycle capitals may be confidently accepted as the earliest work.

There are, however, other capitals and portal fragments at Cluny which appear to be the work of another hand. Two pilaster capitals, one with the Accusation of Adam and Eve (pl. 82) and the other

[79] Salvini, *Medieval Sculpture*, 317, pl. 53.

[80] Porter, *Lombard Architecture*, pls. 118, fig. 2, 3; 119, fig. 3, 4; 122, fig. 2.

[81] The others are the remarkable gold and silver gilt altar frontals by Wolvinius, c. 850, and the stucco ciborium, late eleventh century or earlier.

[82] The identity of this hand as that of the Cluny Master was pointed out by Porter, *Pilgrimage Roads*, 1, 95, and accepted by Francis Salet, *La Madeleine de Vézelay* (Melun, 1948), 153.

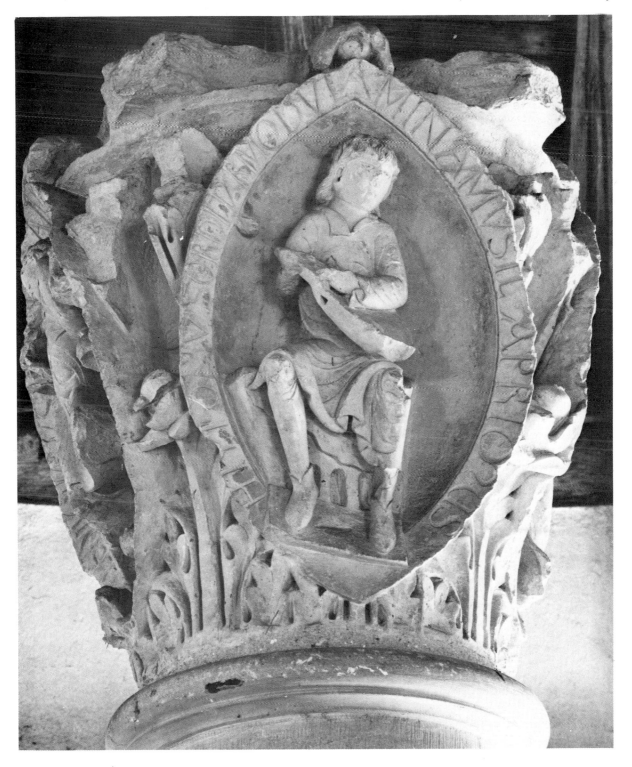

73. Stone capital from the apse hemicycle, the first four Tones of the Plain Chant, c. 1088/c. 1110, Cluny Abbey. Musée du Farinier, Cluny. (James Austin)

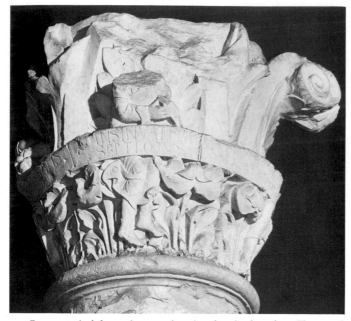

74. Stone capital from the apse hemicycle, the last four Tones of the Plain Chant, c. 1088/c. 1110, Cluny Abbey. Musée du Farinier, Cluny. (James Austin)

with the Sacrifice of Isaac, have been associated by Kenneth John Conant (the foremost scholar of Cluny) with the hemicycle capitals while Francis Salet attributes them to another part of the church. Both agree, though, that despite the clear influence of the Cluny Master on the former, it is by a different sculptor.[83] In comparison with the Cluny Master's style, the faces are basically oval in composition with prominent features widely spaced. The eyeballs are more rounded but there are no identations at the corners and the irises are cut with a deep hole. The sweeping brow line continues into the contour of the nose and the curving lips are sensuously full. The face is modeled with a hint of high cheekbones and the chin is subtly rounder. The proportions of the figures, however, are less attenuated, their stances are stiffer and less graceful, and the composition lacks the neat clarity of those by the Cluny Master. Among the portal fragments are small heads (pl. 84) that repeat the physiognomy of the Adam and Eve capital and with a degree of

evolutionary refinement parallel to that of the Cluny Master, but the sculptor's style is at once starker and less detailed. Because this capital reflects the influence of the Cluny Master, most particularly in his singular type of foliage carving as well as in the general type of the figures, and because the portal fragments are all related to marginal parts of the program (that is, the archivolt figures[84]), it is reasonable to conclude that the second sculptor was an assistant trained by the Cluny Master. George Zarnecki has traced the assistant's hand to the sculpture of Autun Cathedral, where he is identified as the famous Gislebertus.[85] Thus the first figural carving at Cluny is the work of the Cluny Master and his earliest efforts are represented by the hemicycle capitals.[86]

In addition to the vivacious, elegantly carved figures, the distinguishing characteristic of the hemicycle capitals, each about three feet high, is the variety of their composition in the context of a basically Corinthian format. One is purely Corinthian, with no figural decoration (pl. 81). Two have figures only at the corners, superimposed upon the volutes but not otherwise interrupting the scheme of acanthus foliage (pls. 79, 80). Another has a similar composition except that an inscription band girds the entire capital at the midpoint of the figures' height (pl. 74). On three others (pls. 73, 75–77) the figures are isolated from the Corinthian frame within large almond-shaped or elongated hexagonal medallions carved on each of the four faces of the capital. On only one capital (pl. 78) do the various motifs completely replace the acanthus foliage, with figures at the corners and symbolic flora on the faces. Even so, the flora do not follow the configuration of the acanthus foliage. It seems the hemicycle capitals signal a marked divergence in figural style,

[83] Kenneth John Conant, "The Apse at Cluny." *Speculum*, VII (1932), 35, and *idem, Cluny: Les églises et la maison du chef d'ordre* (Mâcon, 1969), 92; "K. J. Conant, *Cluny: Les églises et la maison du chef d'ordre*," *Bulletin monumental*, CXXVII (1969), 185. The crude style of the Sacrifice of Isaac capital makes it unrelated to the sculpture of the Cluny Master.

[84] Conant, *Cluny*, determined the placement of these fragments on the basis of size and iconography and compared them (pl. LXXXIV) to the Adam and Eve capital (pl. LXXXV, fig. 193) to demonstrate their common authorship.

[85] Denis Grivot and George Zarnecki, *Gislebertus, Sculptor of Autun* (London 1961), 175. Conant, *Cluny*, 28n., has accepted this attribution.

[86] In this discussion of the distinction and evolution of individual sculptors at Cluny, I have adopted some of the observations made by Richard Paley, a student in my seminar on Romanesque sculpture, Fall Term, 1974. The fragments of a presumed Psychomachia cycle of capitals, ostensibly located in the ambulatory, show exactly the same style and technique as the hemicycle capitals and were probably an extension of the hemicycle program. For an illustration, see Conant, *Cluny*, pl. LXXVII, fig. 174.

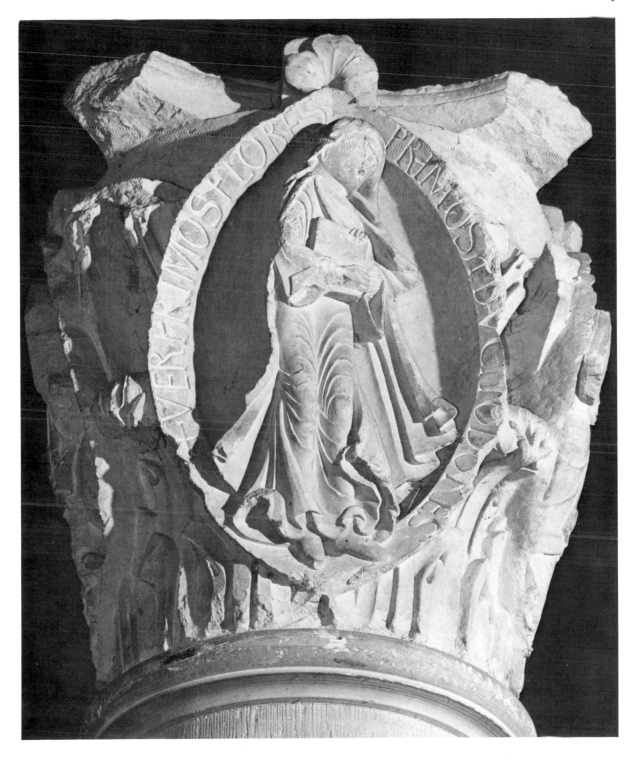

75. Stone capital from the apse hemicycle, Prudence (the Cardinal Virtues), formerly identified as "Spring," c. 1088/c. 1110, Cluny Abbey. Musée du Farinier, Cluny. (James Austin)

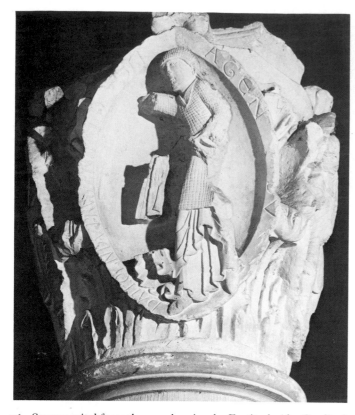

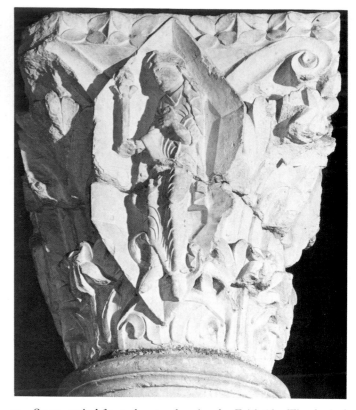

76. Stone capital from the apse hemicycle, Fortitude (the Cardinal Virtues), formerly identified as "Avenging Prudence," c. 1088/c. 1110, Cluny Abbey. Musée du Farinier, Cluny. (James Austin)

77. Stone capital from the apse hemicycle, Faith (the Theological Virtues), c. 1088/c. 1110, Cluny Abbey, Musée du Farinier, Cluny. (James Austin)

in technical finesse, and in composition from the tradition of the eleventh-century capitals. This divergence must be interpreted either as a strikingly original beginning or as the high point in the evolution of sculptured capitals, depending on their date.

Few questions in the history of Romanesque sculpture have provoked more heated or protracted controversy than that concerning the date of the Cluny hemicycle capitals. Because Urban II and his suite are known to have dedicated the high altar and several other altars on October 25, 1095, Conant and Porter assumed that the choir, probably begun in 1088, was already completed by that date and that the carved capitals were already in place.[87] Paul Deschamps, on the other hand, placed the capitals around 1130, based on his perception of an evolutionary stylistic development in Burgundian

Romanesque capitals and without reference to the chronology of the church structure itself.[88] Archaeological factors within the capitals themselves or within the excavated remains of the church have inspired attributions to intermediate dates.[89] Among these factors two are definite determinants. First, the capitals could not have been incorporated into the structure still uncut because there are fully carved details at the top of some of them which were necessarily covered by the impost blocks when they

[87] Kenneth John Conant, "Medieval Academy Excavations at Cluny, The Date of the Capitals," *Speculum*, v (1930), 77-94; Porter, *Pilgrimage Roads*, I, 80-81.

[88] Deschamps wrote several articles on the question: "Note sur la sculpture romane en Bourgogne," *Gazette des Beaux Arts*, ser. v, 10 (1922), 61-80; "Les débuts de la sculpture romane en Languedoc et en Bourgogne," *Revue archéologique*, ser. v (1924), 163ff; "A propos des chapiteaux du choeur de Cluny," *Bulletin monumental*, LXXXVIII (1929), 514-516; and "L'âge des chapiteaux de Cluny," *Revue de l'Art*, LVIII (1930), 157-176 and 205-218.

[89] Marcel Aubert suggested a date within the abbacy of Pons de Melgueil (1109-1122) and probably between 1113 and 1120: "Cluny," *Congrès archéologique de France, Lyons*, XCVIII (1935), 503-522. Francis Salet, in "Cluny III," *Bulletin monumental*, CXXVI (1968), 235-292, proposed a date of 1118-1120.

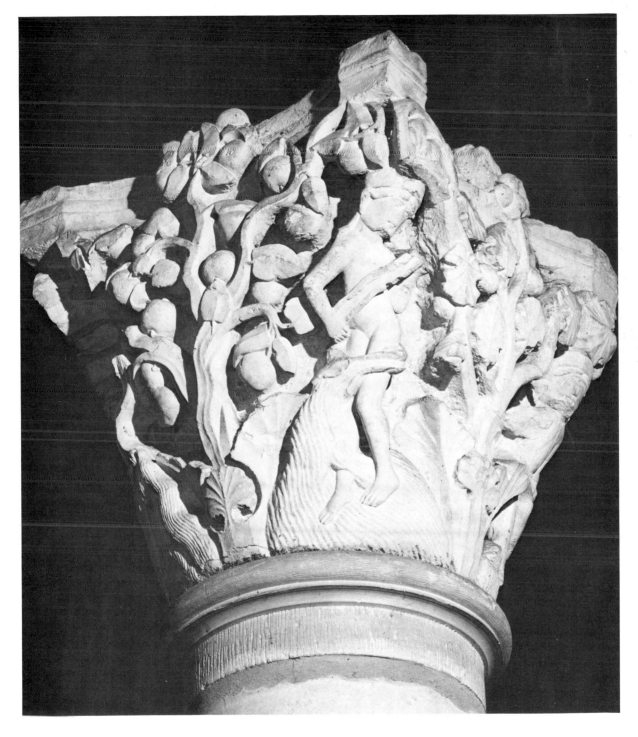

78. Stone capital from the apse hemicycle, the Four Rivers of Paradise (symbols of the Four Evanglists or the Gospels), c. 1088/c. 1110, Cluny Abbey. Musée du Farinier, Cluny. (James Austin)

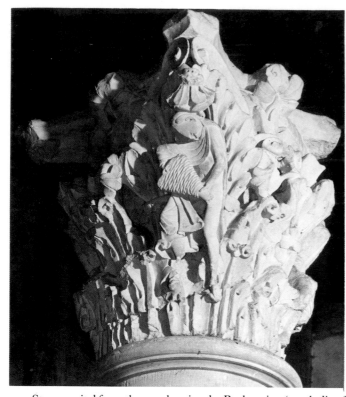

79. Stone capital from the apse hemicycle, Beekeeping (symbolic of the Virgin), c. 1088/c. 1110, Cluny Abbey. Musée du Farinier, Cluny. (James Austin)

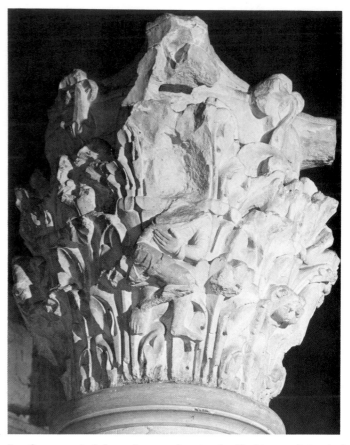

80. Stone capital from the apse hemicycle, Emblems of classical culture (symbolic of Reason), formerly identified as "Palestra" or spiritual gymnasium, c. 1088/c. 1110, Cluny Abbey. Musée du Farinier, Cluny. (James Austin)

were in place.[90] Second, in the excavated foundations the articulation of the ambulatory bays is not coordinated with the placement of the hemicycle columns, indicating that the columns were erected after the ambulatory wall was built.[91] The reason probably has to do with acquisition of the columns. We know from the remains of the church that six of the eight hemicycle columns were made of marble and we are informed by tradition that these marble column shafts were brought from Rome.[92] Presumably, construction of the hemicycle was delayed to await delivery of the marble shafts. And in the meantime the plan was altered to increase the number of hemicycle columns from six to eight, necessitating the compromise of material which resulted in using two limestone piers. Since the eight capitals make a homogeneous group it would appear that they were carved after this change in plan was decided.

Francis Salet, who has scrutinized these archaeological factors most carefully, places the capi-

tals as late as possible in the building campaign, that is about 1118/1120.[93] One justification is that some of the inscriptions on one capital were not completely carved or were even painted,[94] ostensible signs of haste in preparation of the capitals for installation. As we shall see later, though, these inscriptions were more likely tardy afterthoughts, added years after the capitals were carved but before they were set into place. In view of the elaborately correlated mensuration of the church,[95] it is implausible that the diameter of the columns was not known from the time they were ordered, so the capitals could have been made while the structure was still being set out. This is all the more likely considering

[90] Conant, "Date," 77.
[91] Salet, "Cluny III," 251–252.

[92] Kenneth John Conant, "The Iconography and the Sequence of the Ambulatory Capitals of Cluny," *Speculum*, V (1930), 279.
[93] Salet, "Cluny III," 273–281.
[94] Conant, "Iconography," 283; see also Joan Evans, *Cluniac Art of the Romanesque Period* (Cambridge, 1950), 113–114.
[95] Conant, *Cluny*, 77–80.

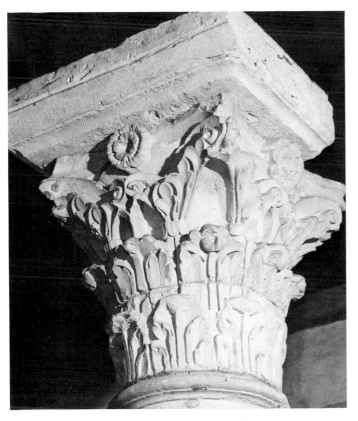

81. Stone capital from the apse hemicycle, Corinthian design, c. 1088/c. 1110, Cluny Abbey. Musée du Farinier, Cluny. (James Austin)

the highly unusual coincidence that the capitals were all carved with the astragal on a separate block so that any discrepancy between column and capital diameters could be easily accommodated. Consequently, the Cluny hemicycle capitals can still fall within a wide chronological range (c. 1090–c. 1120) with reference to the abbey church itself. But compared to other monuments their position in the context of Burgundian Romanesque sculpture remains exactly where Conant and Porter placed them. The degree of their stylistic maturity clearly distinguishes them from the entire eleventh-century tradition, including late examples at Anzy-le-Duc and Saint Benoît-sur-Loire.[96] But the tracing of artistic hands also demonstrates that they stand before all the twelfth-century historiated capitals in Bur-

gundy, such as those at Vézelay, Autun, and Saulieu. Regardless of their absolute date the Cluny hemicycle capitals must be seen relatively as the germinal monument of the Burgundian tradition of Romanesque sculpture.

The iconography of the hemicycle capitals has proved to be virtually as elusive as their date, but it has received much less attention because it has not been treated as a factor inseparable from the style of the figures. The subjects are generally recognizable as quaternities of personified abstract concepts, but all the quaternities and all the individual figures have not been convincingly identified. That is, no attempt at full identification has produced a complete and coherent iconographical program. Concerning five of these capitals there is no controversy at all. Two of them represent the Eight Tones of the Plain Chant, one Tone on each face of the two capitals (pls. 73, 74). Another clearly represents the Four Rivers of Paradise and four similarly symbolic flora—a grape vine, an apple tree, an almond tree, and a fig tree (pl. 78).[97] The fourth certainly represents the Three Theological Virtues—Faith (pl. 77), Hope, and Charity—with a fourth Virtue not clearly identified but probably intended to relate to the other three. The fifth is indisputably a plain Corinthian capital for which no specific symbolic value is assumed. The problem with the subject matter concerns three capitals, one identified by Conant as representations of two Seasons (pl. 75) and two manifestations of Prudence (pl. 76) and two others that represent respectively scenes of beekeeping and four obscure figures who may be "athletes." This problem is exacerbated by the severe damage which has been incurred by some figures, especially those on the last two capitals.

As Joan Evans has indicated,[98] among the three capitals with inscriptions—the Eight Tones of the Plain Chant, "Prudence and the Seasons"—only the inscriptions identifying the Eight Tones are unambiguous. On the third capital, two inscriptions (those of "Spring" and "Avenging Prudence") were fully carved, one ("Summer") was partially carved and partially painted, and the fourth ("Warning Prudence") was simply painted.[99] Not only are the

96 For a recent study of the capitals of Anzy-le-Duc, see Eliane Vergnolle et al., "Recherches sur quelques séries de chapiteaux romans bourguignons," L'information d'histoire de l'art, XX (1975), 55–79; for the choir capitals of Saint-Benoît-sur-Loire, see Dom Bénigne Defarges, Val-de-Loire roman, La Nuit des Temps (La Pierre-qui-vire, 1965), 104–106.

97 Evans, Cluniac Art, 112–113.
98 Ibid., 113–114.
99 The inscriptions are: Spring: VER PRIMOS FLORES PRIMOS PRODVCIT ODORES; Summer: FALX RESECAT SPICAS RER[VENS] QVAS DECOQVIT AESTAS; Avenging Prudence: DAT COGN[OSCE]NDU[M] PRVDENTIA Q[V]ID SIT AGENDV[M]; Warning Prudence: DAT NOS MONENDV[M] PRVDENTIA Q[V]ID SIT AGENDVM.

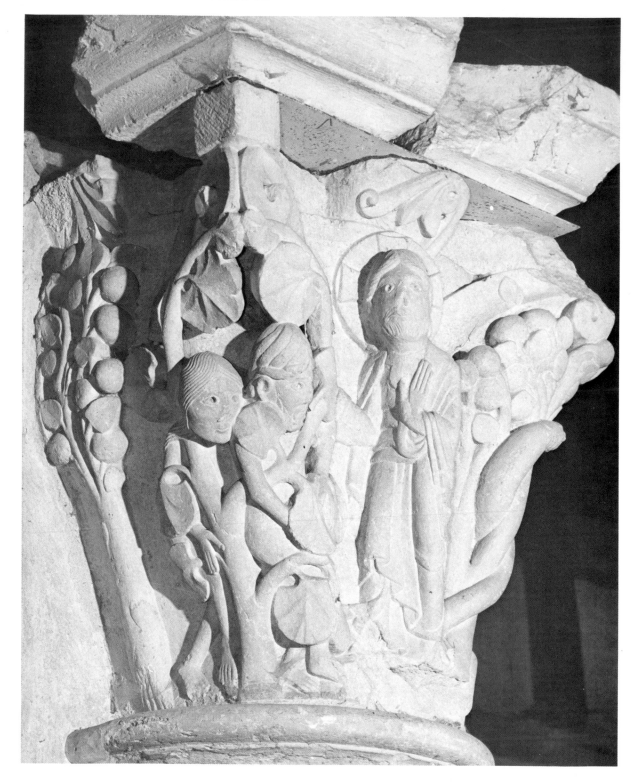

82. Stone capital from engaged half-round shaft, Adam and Eve, c. 1088/c. 1120, Cluny Abbey. Musée du Farinier, Cluny. (James Austin)

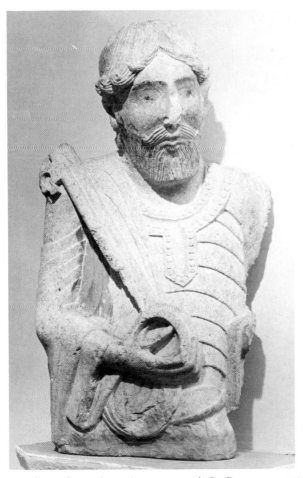

83. Stone figure from the west portal, St. Peter, c. 1088/
c. 1112, Cluny Abbey. (Museum of Art, Rhode Island
School of Design; Museum Appropriation)

84. Head from stone figure on the west portal, c. 1088/c. 1112,
Cluny Abbey. Musée Ochier, Cluny. (Pierre Bonzon)

inscriptions incomplete, but they also do not seem to
correspond to the figural representations they sur-
round. Evans points out that the figure of "Warning
Prudence," who seems to be chastizing a small fig-
ure, now lost, would easily have been identified as
Avenging Justice before Conant discovered traces of
the painted inscription in 1928.[100] With similar
skepticism, Adolf Katzenellenbogen questioned the
representation of "Spring" as a figure carrying a
book, of "Summer" bowing to a destroyed figure,
and of "Prudence" clad in the armor (pl. 76) nor-
mally associated with Fortitude.[101]

When these incongruities have been subsequently

investigated,[102] disregarding the inscriptions al-
together and seeking the traditional images of Jus-
tice, Fortitude, and the other Cardinal Virtues of
Prudence and Temperance, surprising results have
emerged. In this light, it is "Spring" (pl. 75), a
female figure carrying a book, who represents Pru-
dence.[103] "Avenging Prudence," dressed in a long

[100] Evans, *Cluniac Art*, 113–114; and Conant, "Iconography,"
283.
[101] Katzenellenbogen, *Allegories of the Virtues and Vices in Me-
dieval Art* (London, 1939), 53, n. 1.

[102] I am indebted to George Rugg for sharing this information
which he investigated in a term paper written for my colleague,
John Williams, in the Winter Term, 1975. Since this study is not
available to other scholars, Mr. Rugg has kindly permitted me to
cite the supporting evidence for his conclusions and this is set
forth in n. 103–109. The rest of the revised iconography and all
the conclusions are my own.
[103] James Hall, *Dictionary of Subjects and Symbols in Art* (London,

robe with a tunic of chain mail and carrying arms (destroyed on the capital but implied by the figure's stance and position), is indeed Fortitude[104] as Katzenellenbogen suspected. "Summer" is very heavily damaged but she seems to have held a large object carved virtually free of the relief ground. This object could well have been the scales of Justice.[105] "Warning Prudence" is also badly damaged but she seems to be threatening (with a whip?) a small figure, now virtually missing. She ought to be Temperance, a Virtue represented in many different ways in medieval art. This particular version, if correctly reconstituted, corresponds to a description by Theodulph of Orléans, c. 800.[106] With these apparent correspondences, it is difficult to interpret the images consistently as anything other than the Cardinal Virtues. The inscriptions, then, could only be the result of a mistake and a mistake so grievous is more likely to have been made well after the figures were carved rather than at the same time. Assuming that this identification of the figures as the Cardinal Virtues is correct, the capital would make a natural companion to the capital of Theological Virtues. The fourth of the Theological Virtues, now completely destroyed, is far more likely to have been Humility than "Justice" (Conant's attribution).[107] In such a case, there would have been none of the inconsistencies and repetitions of Virtues found in previous attempts to identify the iconographical program. Moreover, the capitals with two types of Virtues would be a proper parallel to the two capitals with the Eight Tones of the Plain Chant.

The motif of the capital with damaged figures who are apparently employed in beekeeping (pl. 79) has been identified on the basis of comparison to a similar capital at Vézelay. And it has been noted that bees were illustrated in a special kind of manuscript, the exultet roll, which was devoted to the liturgical poem for Easter Saturday. They were appropriate because they produced the beeswax of which the Paschal candle was made.[108] But the beekeeping scenes on the Cluny capital were probably intended to represent the Virgin. The association is altogether likely because medieval belief ascribed the reproduction of bees to parthenogenesis, hence a parallel to the virginity of Mary.[109] Such an interpretation of the meaning of the Beekeeping capital is harmonious with the probable meaning of the Four Rivers of Paradise capital (pl. 78). Curiously, none of the attempts to discern the iconographical program has included the observation that the Four Rivers traditionally represent the Gospels.[110] The meaning of the Four Trees on the same capital is less obvious, but it is entirely possible that the vine, the fig, the apple, and the almond, could also be associated with the Gospels in much the same way as the Evangelist symbols of winged man, winged lion, winged ox, and eagle. Any other interpretation of the general meaning of this capital would have to digress from the mainstream of Christian iconographical tradition. Allegorically allusive to the Virgin and the Four Gospels, the Beekeeping and Four Rivers capitals could form a pair representing the means of access to God—Intercession and Scriptural Knowledge.

Of the last pair, the Corinthian capital (pl. 81) and the heavily damaged capital (pl. 80) that Conant associates with an allegory of the monastery as a spiritual gymnasium, or "Palestra,"[111] I think it extremely likely that they are increments to the originally intended program, inserted when two additional piers were added to the hemicycle plan. The Corinthian capital is undoubtedly purely decorative and without iconographical significance; the other probably supplements the original program of six capitals. The figure that Conant interpreted as a "discobolus" is such an obvious quotation from classical sources[112] that, in the company of a

1974), 254; Engelbert Kirschbaum, ed., *Lexikon der christlichen Ikonographie* (Freiburg, 1968), IV, 366; Katzenellenbogen, *Virtues and Vices*, 33.

[104] Hall, *Subjects and Symbols*, 255; and Emile Mâle, *Religious Art in France in the Thirteenth Century* (New York, 1913), 133.

[105] Katzenellenbogen, *Virtues and Vices*, 55.

[106] Kirschbaum, *Lexikon*, IV, 366; cf. other devices in Hall, *Subjects and Symbols*, 255.

[107] Katzenellenbogen, *Virtues and Vices*, 33.

[108] J. Banchereau, "Travaux d'apiculture sur un chapiteau de Vézelay," *Bulletin monumental*, LXXVII (1913), 403-411; Evans,

Cluniac Art, 115, cites the other literature on this identification as well as the connection with exultet rolls. Although an Italian exultet roll may well have been at Cluny, this symbolism was known well enough that no visual model was required.

[109] Kirschbaum, *Lexikon*, I, 299.

[110] Louis Réau, *Iconographie de l'art chrétien* (Paris, 1958), III, 1, 477; Kirschbaum, *Lexikon*, IV, 459. The flora—grape vine and apple, fig, and almond trees—could be symbolically associated with the Gospels or with the conditions of life: apple and temptation, fig and sin, grape and life, almond and resurrection.

[111] Conant, *Cluny*, 88; and *idem*, "Apse," 30-31.

[112] This quotation of the Discobulus is less likely to have been inspired by visual knowledge than by references to it in ancient literature. The most readily accessible source would have been Pliny's *Natural History*, in which he discussed Myron as the sculptor (of an athlete) who "only cared for the physical form and

"reader," a nude "bather," and a "fighter," this capital could represent an allegory of the human wisdom found in classical learning. It would, then, enlarge the meaning of the pair of capitals devoted to the means of access to God to include Human Reason.

Altogether, I interpret this program as one which describes allegorically the vocation of the monastic life. The Eight Tones of the Plain Chant represent worship in the monastic offices. The Cardinal Virtues and the Theological Virtues represent the moral imperatives of the monastic discipline. The Virgin, the Four Gospels, and Human Reason represent the means of access to God. In such a program, the capital representing the Virgin would violate the general assumption that the iconography was based on a series of quaternities. I think, however, that the quadratic format imposed by the capitals has led to undue emphasis upon the quaternal aspect of the iconography at the expense of its more basic allegorical character. Also, this interpretation of the program as an allegory of the monastic vocation provides a cogent justification for the disposition of these subjects in the hemicycle around the matutinal altar. Such an iconographical relationship of the program to the purpose of the sanctuary also dissociates the capitals from their usual function of arbitrary decoration and places them squarely in the same context as the sculptured church furnishings in other regions.

The subtlety of the iconographical program and especially the intellectual abstraction of its motifs is equally as unprecedented in stone sculpture as the precocious technique and style. Indeed, the program should be regarded as the principal reason for the artistic originality of the capitals. In all other early stone sculpture there is no sign of capability to produce such work. Yet, as we have seen, there is no archaeological reason to place these capitals anywhere other than at the beginning of monumental sculpture at Cluny. That the carving technique signals a break in the tradition of sculptured capitals and implies the achievement of effects normally produced in other media was noted by Focillon and Conant.[113] In none of the capitals is the thematic decoration actually incorporated into the structure of the Corinthian framework. Although three of the capitals have figures on the corners in the place of volutes, the stance of the figures does not conform to the frame (pls. 74, 79, 80). Moreover, the medallions (pls. 73, 75–77) on the three capitals of the Tones and Virtues are so independent of the Corinthian composition that they appear almost to have been made separately and superimposed upon the framework. And while the Four Rivers capital (pl. 78) ostensibly represents a fully traditional replacement of acanthus foliage, with figures on the corners and symbolic trees on the faces, the undercutting is so deep and the forms are so free of the Corinthian compositional pattern that they, too, appear to have been applied to an unadorned surface. Such an approach to carving is reminiscent of stucco and metalwork, in which individual elements of a composition were frequently made separately and then applied to the composition. The expert handling of the figural carving and of the complex iconography has contemporary sculptural parallels only in those same media, particularly as they were practiced in the Holy Roman Empire.

In terms of the technique and figural style, the search for the background of an artist capable of executing such capitals leads inevitably to the Empire. The closest precedent in stone to the facial type and the drapery treatments of the figures is that provided by the fragments attributed to the shrine of St. Luidger in Werden (pl. 38). To be sure, the Werden figures have none of the vivacity of those on the Cluny capitals, but the physical articulation is nevertheless very close. This vivacity and freedom of movement, especially as seen in the medallion figures (pl. 73), has a parallel in stone only in the Brauweiler Zodiac reliefs (pl. 36) in which the figures are similarly in very deep relief against a concave ground.[114] As we have already seen, the Werden fragments are closely related to metalwork; the Brauweiler reliefs, to ivory carving.[115] The unusual composition of the capitals with medallions is also to be found previously only in the Empire. An almost exact analogue to the Cluny capitals exists on the

did not express the sensation of the mind." See the translation by Kenneth Jex-Blake, *The Elder Pliny's Chapters on the History of Art* (London, 1896), 45, 47. A much better source, but one not known to have been available at Cluny, would have been Quintilian's description of the Discobulus in his *Institutes*, II, xiii, 8–10, in which that author praises the curved stance of the figure for its expression of movement. See the translation by H. E. Butler, *The Institutia Oratoria of Quintilian*, Loeb Classical Library (Cambridge, Mass., 1969), 293, 295.

[113] Focillon, *The Art of the West in the Middle Ages*, I, *Romanesque Art* (London, 1963; orig. ed., in Fr., 1938), 120; and Conant, *Cluny*, 91.

[114] This comparison was made by de Francovich, "Wiligelmo," 266.

[115] See Chapter 2, second section.

bronze column (pl. 15) of Bernward at Hildesheim (1000/1020). Although this example is a bronze nineteenth-century replacement of a seventeenth-century wooden copy of the original, it is likely to be accurate in its general outlines.[116] These indications of a background in the Carolingian figural tradition have a parallel in the origin of the monk Hezelo, formerly a canon in Liège, who was apparently master of the works in the construction of the abbey church.[117] Conant believes that he was also largely responsible for the sculptural decoration,[118] although the nature of that responsibility is not clear. It is most likely that Hezelo procured the sculptor and that he sought the artist in the cultural context where such talent existed, in this case his native Meuse region where metalwork was flourishing.

If the Cluny Master was probably a goldsmith from the Meuse region in the Holy Roman Empire, the identification of his provenance still does not explain the new aspects of the figural style, the source of the specific motifs, or the conception of the general program. Curiously, prototypes for all three factors are remarkably absent. Meyer Schapiro is only one of several scholars who have pointed out how close the figural style of the capital is to contemporary Burgundian painting,[119] but no example adduced is sufficiently similar to be regarded as a model. Despite attempts to locate the motifs in a poem by Abbot Odo (927–c. 942), in a treatise by Radulfus Glaber who was a monk at Cluny in the time of Abbot Odilo (c. 993–1048), or in a letter to the abbey from Peter Damian (c. 1063),[120] not one of these documents contains even a substantial portion of the program. Only the poem by Abbot Odo, on the monastic life, suggests its general thrust.[121] These associations do have a certain degree of historical resonance, however, for there seems to be a certain kinship between these literary materials and the capitals. Even so, they do not account for the

singular originality of both the figural style and the iconographical program. Since both the style and the thematic program were equally unprecedented it is necessary to consider the possibility that the capitals represent a deliberate and original artistic invention, even though the aggregate of research into medieval art discourages the notion that such an invention was historically possible in the years around 1100. The plausibility of an original invention depends upon a unified relationship between content and form in which the style is a particularly appropriate expression of the program.

Had the program of the Cluny capitals been conceived as just an illustration of the monastic vocation, it would have been a simple matter to represent monks at worship, doing good deeds, reading Scripture, praying to the Virgin, and studying the arts. And in this case any sculptor's traditional style would have sufficed. But such an ensemble would be only mildly interesting and it would have no meaning beyond mere illustration, hence no inspirational impact. Moreover, it would be highly uncharacteristic of medieval culture. Conceived as an allegory of the monastic vocation, the program of the Cluny capitals veils each element under the guise of personifications that do not represent the literal meaning of the monastic imperatives. Such a conception is analogous to the medieval apprehension of the Scriptures, spelled out by St. Augustine in *De doctrina christiana* (a treatise that exercised a powerful and lasting influence in the Middle Ages).[122] More than once in this work Augustine points out that the Scriptures are not always to be read literally nor to be taken merely at face value because they are, for the most part, obscure and ambiguous, truth veiled as in allegory. This is so because "what is sought with difficulty is discovered with more pleasure." Some things are stated plainly to satisfy an urgent spiritual hunger but others obscurely so that immediate satisfaction does not produce disdainful indolence (II. vi. 7–8).[123] Quoting St. Paul, "For the letter killeth but the spirit quickeneth" (II Corinthians, 3:6), Augustine points out that "when that which is said figuratively is taken as though it were literal, it is understood carnally.... There is a miserable servitude of the spirit in this habit of taking

[116]Lasko, *Ars Sacra*, 120, and pl. 117.

[117]Jacques Stiennon, "Hézelon de Liège, architecte de Cluny III," *Mélanges offerts à René Crozet* (Poitiers, 1966), 345–358.

[118]Conant, *Cluny*, 77, 91–92.

[119]Meyer Schapiro, *The Parma Ildefonsus: A Romanesque Illuminated Manuscript from Cluny and Related Works* (New York, 1964), 55, 57–58.

[120]This literature is collected and summarized in Eliane Vergnolle, "Les chapiteaux du déambulatoire de Cluny," *Revue de l'art*, xv (1972), 99–101.

[121]Carol Heitz, "Réflexions sur l'architecture clunisienne," *Revue de l'art*, xv (1972), 89.

[122]D. W. Robertson, ed. and trans., *On Christian Doctrine: Saint Augustine* (Indianapolis and New York), 1958, Introduction, xii–xiii.

[123]*Ibid.*, 36–38.

signs for things, so that one is not able to raise the eye of the mind above things that are corporal and created to drink in eternal light [III.v.9]."[124] The concept of allegory as an attractive and inspirational manifestation of truth also had a wider meaning in which allegory was regarded as the principal instrument for understanding human experience in the world and the relationship of man to divine purposes. In the thirteenth century, St. Thomas Aquinas was to refer to this mode of understanding as the *sensus allegoricus*, but without the name it had already permeated Christian thinking since late Antiquity. For the *sensus allegoricus*, the beauty of the Scriptures and the world enveloped both in a veil of mystery, concealing their true meaning under images. Discernment of this veil revealed the relationship of all things to the moral order.[125] The allegorical program of the Cluny capitals, then, represents the typical medieval formulation of a theme that was intended to be spiritually inspirational.

However, as we have seen earlier, in order to produce this allegory of the monastic vocation it was necessary to compose it from previously unrelated motifs which had to be gathered from widely disparate sources. Since this collection was not artistically coherent, such an initiative required the formulation of a suitable style in order to unify the sequence of images as a related program. Such a formulation presupposes the existence of a theory of art that could provide the basis for a conscious selection or invention of styles. But because no body of evidence has yet been set forth that would explain such a style consciousness from the inside out (that is, in terms of theory), it is necessary to approach the problem from the outside in (that is, from observation of the sculpture itself). The style of the sculpture in general was aptly characterized when Arthur Kingsley Porter wrote: "The greatest glory of the capitals of Cluny is a quality that has been considered a defect. They are admirably mannered. Medieval art can show nothing comparable. In an age of manner, these are the supreme examples."[126] To be more specific, we can observe that the figures (pls. 73–80) are positioned in a stance of calculated grace. Most of them are shown in motion, with twists and turns of the body which endow them with an emphatic

vitality, elegantly expressed. On many of them, this vitality is enhanced by fluttering and clinging drapery. Yet in only two cases (the female dancer as the Second Tone of the Plain Chant and the figure of Temperance, whipping a boy [?], as a Cardinal Virtue) is movement or fluttering drapery inherent in the motif represented. Moreover, the technique of carving is equally extravagant. All the figures are carved in very deep relief, so that many limbs, draperies, and emblematic attributes stand completely free of the relief ground. Although the surfaces are not polished and the detail is not minute, the overall quality of the carving has an unparalleled finesse. Both formally and technically these characteristics of the Cluny style are not necessary to a visual representation of the several motifs. But the artifically elegant style is correlative in nature to the artificially allegorical thrust of the program as a whole. Its beauty attracts the viewer to the images just as discernment of their meaning attracts one to the truth they represent. The style, then, is a function of the iconography because it is appropriate to the iconography's purpose. Such a relationship of form and meaning cannot be merely fortuitous and should therefore be attributed to an original invention.

Significantly, the plan of the church itself was equally unprecedented, and documentary evidence survives which recounts the situation in which it was allegedly conceived. According to the monk Gilo, whose *Vita sancti Hugonis* was written at Cluny about 1120, St. Peter had appeared in a dreamlike vision to an aged and ailing monk, Gunzo, and commanded construction of the new abbey church, dictating the entire plan and even its gigantic dimensions. Having reluctantly agreed to obey the command, Gunzo miraculously recovered his health following the vision, as accorded with the promise of St. Peter. After Gunzo related this vision to Abbot Hugh and the monks of Cluny, the enormous project was undertaken, but the actual task of directing the work was apparently assigned to Hezelo.[127] This account was written at least three decades after the building project began, about 1088, so the story of the conception of the church may well have become a garnished legend in the interval. But whether or not this account was regarded as literally

[124] *Ibid.*, 84.

[125] Edgar de Bruyne, *Etudes d'esthétique médiévale* (Bruges, 1946), II, 320.

[126] Porter, *Pilgrimage Roads*, I, 80.

[127] For the Latin text and a French translation see Stiennon, "Hézelon de Liège," 354–355. See article as a whole, 345–358, for the role of Hezelo in the construction of Cluny III.

true, it implies that the scheme for the church was recognized as original. Such an original conception of the architecture would undoubtedly have included the major decoration, for instance that of the sanctuary and the main portal, because the thematic program of this decoration would have been considered inseparable from the meaning of the total scheme of the church. Indeed, this sort of justification was probably necessary, especially for the figural ornamentation, in order to bypass the tradition initiated by the *Libri Carolini* that artists should not invent images but seek good models.[128]

The validity of the assertion that the Cluny capitals represent an original artistic invention rests only partly on their style and the novelty in sculpture of their subject matter. In addition, there is no similar early example of a concerted program for a group of capitals, much less one so complex and sophisticated. The combination of all three factors suggests that these capitals could not be the result of merely gathering visual motifs from many sources. The sculptor, then, almost certainly could not have been the author of the conception, for it required a guiding intelligence that was educated well beyond the scope of an artisan. That Gunzo was capable of conceiving the program is hinted at in Gilo's description of him as a "remarkable musician" (*psalmista precipuus*).[129] This attribute suggests a personal motivation for selecting the Tones of the Plain Chant to represent monastic worship. But, more important, it also implies that Gunzo was accomplished in the theory of music. If so, he was almost certainly, a highly educated man. Whether or not he was an active scholar, he undoubtedly possessed the general intellectual and cultural background necessary to conceive the program. The various motifs, which do not exist together in any previous context, could easily have been assembled—even from memory—from the readings of a well-educated monk.[130] The ability to specify the style may also have been within his ken. In this regard, it is important to recall that Cluny at this time was the preeminent cultural center of Western Europe,

famous for its ritual, its art, and its learning. The great monastic library included not only most of the patristic and medieval works of scholarship but also nearly every ancient text known to the Middle Ages, including Vitruvius, Pliny, Horace, and Cicero.[131] Indeed, the monks of Cluny were well known for their knowledge of ancient literature, especially poetry.[132] That knowledge of ancient aesthetics may have determined the style is implicit in the striking similarity between the Cluny capitals and the nature of antique sculpture—a similarity that bears no hint of direct influence through imitation of actual works of antique art. Within the cultural context of Cluny, Gunzo could very plausibly have envisaged the program, its thematic components, and its style.

Even if Gunzo actually conceived the program in a dreamlike vision, though, its details were most likely articulated through conscious deliberation after he recounted his experience to Abbot Hugh and the other monks. No matter how precisely Gunzo may have imagined the images, his conception would probably have been expressed verbally. For this reason, it would have been necessary to provide the sculptor with models for the various figures, translations that may well have been made through drawings. Such drawings are most likely to have been executed by an artist in the Cluny scriptorium. Drawings made as iconographical guides are known for both manuscripts and mosaic cycles in the twelfth century[133] and are entirely plausible

[128]For a discussion of the relevant passage from the *Libri Carolini*, see Chapter 1, second section.

[129]Conant, *Cluny*, 62; and Stiennon, "Hézelon de Liège," 354–356.

[130]The very scattered nature of possible sources for the images is well exemplified by the search for models for the figures of the two capitals devoted to the Tones of the Plain Chant: see Kathi Meyer, "The Eight Gregorian Modes on the Cluny Capitals," *Art Bulletin*, XXXIV (1952), 75–94.

[131]Joan Evans, in *Monastic Life at Cluny, 910–1157* (London, 1931), 99–100, cites not only the general nature of the library holdings but also the literary accomplishments of various types. Conant, *Cluny*, 76–77, n. 18, cites a catalogue of the library, shown to Mabillon in 1682, which was reputedly over five hundred years old and listed nearly 1,800 titles. No catalogues are known before the middle of the twelfth century and certainly many of the books were acquired during the abbacy of Peter the Venerable (1122–1157), when Cluniac letters were at their summit. But this was not a sudden renascence and the evidence certainly represents a high proportion of books and literary activity during the abbacy of St. Hugh (1049–1109).

[132]The knowledge of ancient literature at Cluny was colorfully attested to in the famous "Dialogue between a Cluniac and a Cistercian" in which the Cistercian says: "By your speech, by your quotations from the poets, I recognize a Cluniac, for you and your brethen take so much pleasure from the lies of poets that you read, study, and teach them even in the hours which St. Benedict has definitely reserved for the reading of the Scriptures and manual labor." Although, the "Dialogue" dates from c. 1135 or later, it refers to a cultural milieu that had flourished at Cluny for many decades. Quoted from Evans, *Monastic Life*, 102.

[133]Ernest Kitzinger, "The Role of Miniature Painting in Mural Decoration," *The Place of Book Illumination in Byzantine Art* (Princeton, 1975), 109–121.

in this instance. If this was indeed the case, it would explain why the Cluny Master, who was probably not a French sculptor, adopted a figural style in stone that vaguely resembles the style of Cluny manuscripts. It would also demonstrate that the sculpture that initiated the Burgundian style was based on a visual model provided by the patrons—as were the sculptures by Bernardus Gelduinus and Wiligelmus. Moreover, this model would have been derived from antique culture (as were the models for Gelduinus and Wiligelmus) but indirectly through intellectual inspiration rather than directly from specific works of art.

There may well have been a significant lapse of time between the conception of the program and its execution. Although the putative model drawings were likely to have been made soon after the program was conceived, about 1088, the time of their translation into sculpture was probably predicated by exigencies related to the schedule of construction. In all likelihood, the capitals were carved a few years after 1100, and installed still later when the hemicycle columns were in place. In effect, then, the program may have three dates: that of design, that of execution, and that of installation (when the inscriptions on one of the capitals were hastily produced, some cut and some painted). Such a delay in the execution and installation of the capitals may account for the relatively late flowering of Burgundian sculpture outside Cluny. Nevertheless, the fact that Burgundian sculpture had its true origins in an architectural setting—albeit through a process that paralleled the origins of Romanesque sculpture elsewhere—testifies to the more advanced character typical of the sculpture of this region. In addition to the type of format, both the figural style and the manner of its conception were also more advanced and these factors loom large in the subsequent development of Romanesque sculpture and the dominance of France in that development.

Conclusion

For each of the artists who initiated the revival of continuous sculptural activity in stone, the task involved a skill in figural work that could convey the subtleties of complex subject matter. Judging from the lack of evidence of such a skill in architectural sculpture of an earlier date and from the abundance of evidence in these monuments of techniques normally applied to other materials, the artists had all been previously trained to work in precious metals, ivory, and stucco. In every case except that of the Milan sculptor, the closest parallels to their technical achievements are in eleventh-century art in the Holy Roman Empire, suggesting that these sculptors originated in that tradition. For the first time in medieval sculpture, the principal artists of this group—Bernardus Gelduinus, Wiligelmus, and the Cluny Master—derived a considerable amount of their stylistic expression from models unrelated to the context of their technical training. Each of their models was either directly or indirectly related to antique or late antique art. The ancient source of the models and the unprecedented nature of the various projects suggest that the monuments these artists executed were all inspired by a new cultural impulse that required elaborate sculpture, even if the medium virtually had to be reinvented.

The revival of monumental stone sculpture took place in the context of a new surge of advanced architectural activity which was resonant with echoes of and even direct quotations from Early Christian architecture. Each of these monuments was located in a church of major architectural significance in this new development. The parallel raises the possibility that the demand for marble and stone sculpture was prompted by the same urge that inspired architecture rivaling that of ancient Rome. In this connection, it is important to recall that Pope Gregory VII (1073–1085) generated a major reform movement in the Church based on the ideals propounded by his namesake, Pope Gregory I (590–604). As Gerhardt Ladner has demonstrated, Gregory VII intended his reform to be a *renovatio* of the Church in the patristic age, parallel to the *renovare* of Gregory I.[134] Significantly, the great architectural renascence of Europe flourished in the 1070s and the revival of sculpture occurred when the sanctuaries were sufficiently complete to be embellished or furnished.

Although the Gregorian reform may well have inspired the impulse to revive a type of art associated with ancient Rome, there is no reason to suppose that the revival was initiated by the papacy. Yet it is an interesting coincidence that each of the early sanctuary sculptures except the Milan ambo is associated with a papal visitation. As we have seen,

[134] Ladner, "Gregory the Great and Gregory VII: A Comparison of Their Concepts of Renewal," *Viator*, IV (1973), 1–27.

Pope Gregory's successor, Urban II (1088–1099), was at Cluny in 1095 after the church had already been planned and construction was underway. He dedicated the altar and presumably the shrine of St. Saturninus in Toulouse in 1096. He ordered the Bari throne to be made for Archbishop Helias in 1098, and his successor, Paschal II (1099–1118), dedicated the shrine-altar of St. Geminianus in Modena in 1106. As we shall see later, knowledge of the schemes for sculpture at Cluny may have been transmitted in this way to Toulouse and employed in later sculpture. The experience of seeing the Toulouse sculpture almost certainly had something to do with Urban's sponsorship of the Bari throne.

And the technical relationship between the Bari throne and the Modena shrine-altar may have an intermediary in the papacy. Certainly Urban II is the key figure, both in the continuation of the Gregorian reform and in the loose relationship of the sculptures. Since he ascended the papal throne after having been a monk at Cluny and just after the new church of Cluny was ostensibly planned, Cluny itself may be the ultimate point of origin. No firm significance can be attached to these coincidences, but they ought to be remembered alongside the apparently independent circumstances surrounding the revival of monumental sculpture within a decade in several widely separated centers.

CHAPTER 4

The Origin and Development of Architectural Sculpture

The First Adaptations of Monumental Sculpture to an Architectural Setting

Immediately after the important series of sanctuary sculptures was created in several separate centers of Italy and France there appeared in each of the same regions a new monument, very similar in figural style and technique to the first, in an architectural setting. These new sculptures at once enlarged both the scale and the scope of image carving in stone and extended the use of religious sculpture from the restricted sanctuary to the public exterior of sacred architecture. The earliest examples in the regions of Languedoc, Emilia, Lombardy, and Burgundy were, respectively, in the cloister of Moissac Abbey (1100 and shortly after), on the facade of Modena Cathedral (about 1110), on the portal of San Fedele in Como (about 1115), and on the portal of Cluny Abbey (executed about 1110, but planned earlier).

THE CLOISTER AT THE ABBEY OF MOISSAC

The Moissac cloister is the earliest surviving cloister with monumental sculpture,[1] and was probably the first. It was also certainly the earliest major example of monumental sculpture in an architectural setting in the southwest of France.[2] The

sculptural decoration consists of tall reliefs (pls. 85–90) on each of the two inner faces of the corner piers, similar reliefs on the inner face of the eastern intermediate pier and on the outer face of the western intermediate pier, and of seventy-six capitals, of which forty-five are historiated (pls. 91, 92) and thirty-one are purely decorative (pl. 93). The capitals are supported by single and paired columnar shafts, placed alternately in the cloister arcades so that the capitals themselves are of single and double format. Three-sided capitals supported by half-round shafts abut the corner piers.

The cloister is securely dated to the years around 1100 by an inscription plaque located on the inner face of the western intermediate pier. The inscrip-

[1] Raymond Rey, in *L'art des cloîtres romans: Etude iconographique* (Toulouse, 1955), 23–28, cites documents for possible earlier examples at Saumur, Cluny, and Saint-Bertin, but it is unlikely in view of the pattern of extant monuments that the sculptural decoration amounted to anything more than grotesque capitals.

[2] Thomas W. Lyman, in "The Sculpture Programme of the Porte des Contes Master in Toulouse," *Journal of the Warburg and Courtauld Institutes*, XXXIV (1971), 12–39, has proposed that

the first adaptation of figural sculpture to an architectural setting in Languedoc is the Porte des Comtes, the south transept facade of Saint-Sernin of Toulouse, which he dates c. 1090 to c. 1100. This ostensible program is made up of capitals on the columnar shafts that flank the two doors and of reliefs in the spandrels above the doors, one in the middle and one at each end. The capitals, carved with figures representing Luxuria and Avarice, are easily relatable to the pre-Gelduinus capitals of the choir of Saint-Sernin and belong to the eleventh-century tradition. The reliefs, so damaged that their figures are no longer discernible, are probably much later, however. All three reliefs are framed with arcades and have rosettes in the spandrels, like the Gelduinus reliefs. The central slab has an embossed inscription denoting its subject—SANCTUS SATURNINUS. The side slabs are not inscribed but portions of the drapery remain. The elaborate folds are far more expressive than in any example by Gelduinus or his followers and have counterparts only in later sculpture like the Moissac portal. Moreover, all these reliefs are carved in stone rather than marble. Except for capitals, nothing in the region is carved of anything other than marble until the sculptures of the north facade of Santiago Cathedral, as we shall see. Although there are no explicit signs of insertion of these slabs in the masonry, such a task could have been easily accomplished neatly. The Porte des Comtes, then, is probably only a simple project of decoration, composed of sculptures from c. 1090 and after 1120.

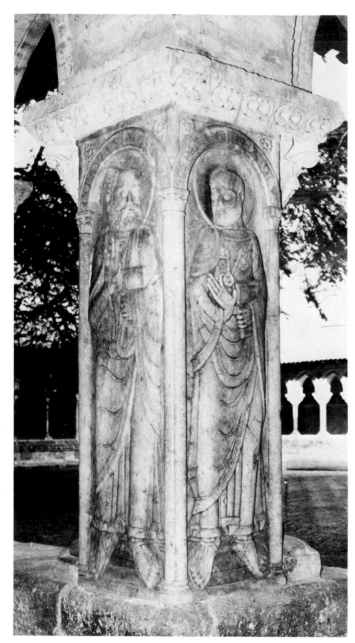

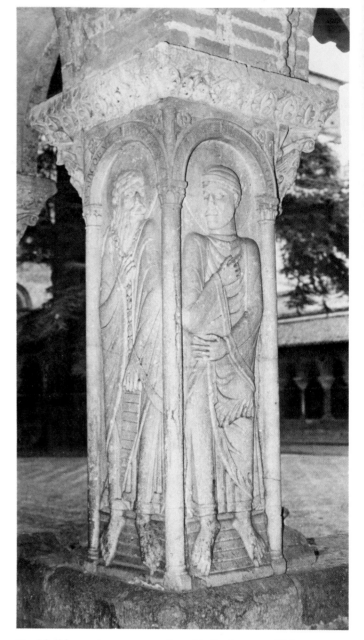

85. Marble southeast corner pier with Ss. Peter and Paul, c. 1100, cloister of Moissac Abbey. (Courtauld Institute—M. F. Hearn)

86. Marble northeast corner pier with Ss. James and John, c. 1100, cloister of Moissac Abbey. (Courtauld Institute—M. F. Hearn)

tion records that it was made *in* the year 1100, in the time of Abbot Ansquitil.[3] It is highly unlikely,

[3]The inscription reads as follows: ANNO AB I[N]CARNA / TIONE AETERNI / PRI[N]CIPIS MILLESIMO / FACTU[M] / CENTESIMO EST CLAUSTRU[M] ISTUD / TEMPORE / DOMINI / ANSQUITILLII / ABBATIS / AMEN / V.V.V. / M.D.M. / R.R.R. / F.F.F. The four lines of abbreviations at the end have recently been explained by Meyer Schapiro in the new edition of his Moissac cloister article in the collection of his works, *Romanesque Art* (New York, 1977), 258, n. 66.

however, in view of the stylistic unity of most of the sculptures, that enough sculptors were involved to have undertaken and completed all the work in one year. Although most scholars have assumed that the inscribed date signifies the completion, I think it is much more plausibly interpreted as the beginning, especially since the installation of the pier with the inscription would have taken place well before the

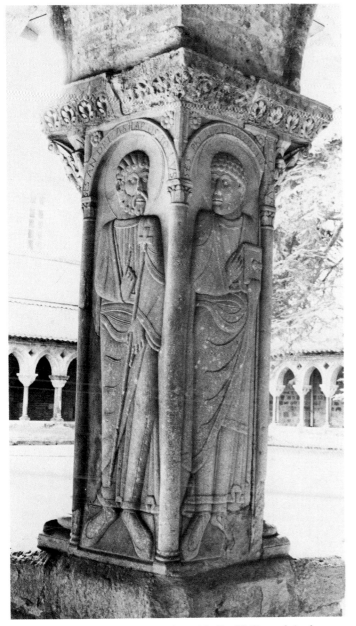

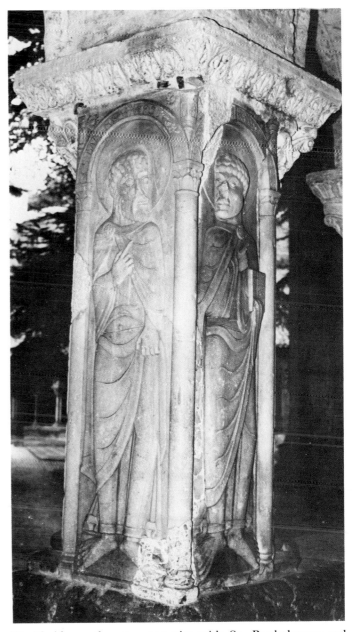

87. Marble northwest corner pier with Ss. Philip and Andrew, c. 1100, cloister of Moissac Abbey. (Courtauld Institute—M. F. Hearn)

88. Marble southwest corner pier with Ss. Bartholomew and Matthew, c. 1100, cloister of Moissac Abbey. (Courtauld Institute—M. F. Hearn)

arcade and roof of the cloister were built. For this reason, from a beginning date of 1100, completion should be placed around 1105.

The present state of the cloister is not that of the original construction. The brick arcades of pointed arches clearly indicate a rebuilding in the thirteenth century and it is known also that Viollet-le-Duc supervised a substantial restoration in the nineteenth

century.[4] It is possible that some of the capitals have been rearranged and that the relief on the outer face of the western intermediate pier is not in its original

[4] These and other possible alterations have been noted by Ernest Rupin, *L'abbaye et les cloîtres de Moissac* (Paris, 1897), 107, 354ff; and Meyer Schapiro, "The Romanesque Sculpture of Moissac, Part I," *Art Bulletin*, XIII (1931), 254, 258.

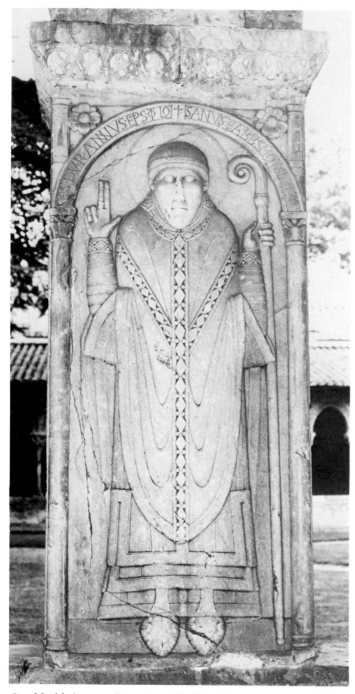

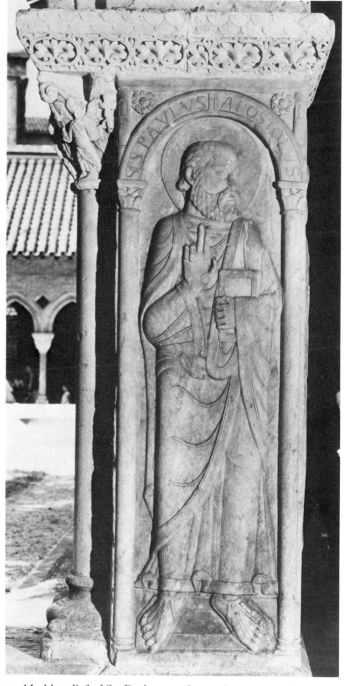

89. Marble intermediate pier with Abbot Durandus, c. 1100, cloister of Moissac Abbey. (Courtauld Institute—M. F. Hearn)

90. Marble relief of St. Paul on southeast pier, c. 1100, cloister of Moissac Abbey. (James Austin)

location, but all the other pier reliefs appear to be in their original places.

No other surviving cloister retains such a rich and

varied repertory of imagery. The forty-five historiated capitals represent a multitude of themes which may be grouped into four categories—scenes

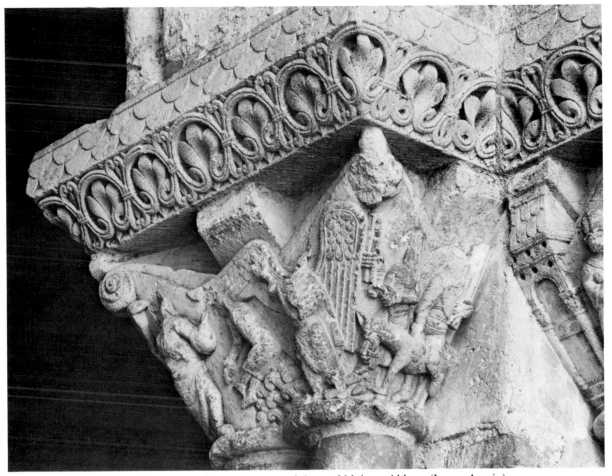

91. Stone capital with the Sacrifice of Isaac, c. 1100, cloister of Moissac Abbey. (James Austin)

from the Old Testament, the life of Christ, the Apocalypse, and the lives of the Apostles and other saints. Their locations, however, do not produce an orderly sequence, narrative or symbolic. This apparently random placement could be attributed to an extremely complex pattern of cross-references, but if so, the pattern has not been deciphered. It could also be attributed to a later rearrangement of the capitals. But the disposition of themes in the fixed locations of the engaged capitals, the sequence of themes on the alternating formats of single and double capitals, and the arbitrary interspersal of purely decorative capitals within this alternation defy the reconstitution of any rational order in the program. It seems the capitals were ostensibly intended to be observed or contemplated separately,

although related topics are usually represented on all four sides so that the viewer has to move from the cloister gallery to the open garth in order to see all four scenes. Since there was no orderly sequence of themes, the role of the capitals in the iconographical program was subordinate to that of the pier reliefs. Even so, they comprise the earliest large ensemble of historiated capitals.

The pier reliefs present half-life-size images of Apostles and a former abbot of Moissac, all shown standing beneath an arcade. The Apostles are grouped in pairs on the corner piers: Peter and Paul, southeast (pl. 85); James and John, northeast (pl. 86); Philip and Andrew, northwest (pl. 87); and Bartholomew and Matthew, southwest (pl. 88). The relief of Simon the Zealot is now attached to the outer face

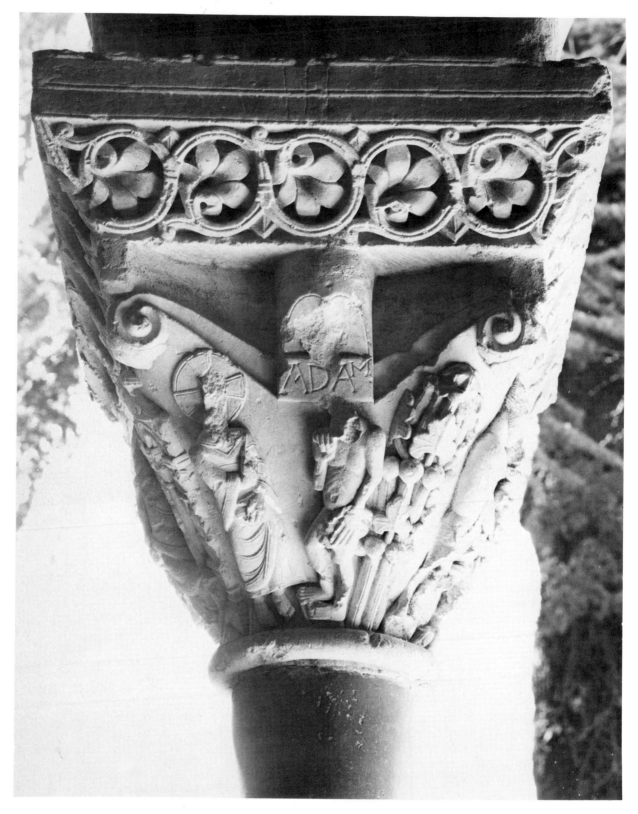

92. Stone capital with the Accusation of Adam and Eve, c. 1100, cloister of Moissac Abbey. (James Austin)

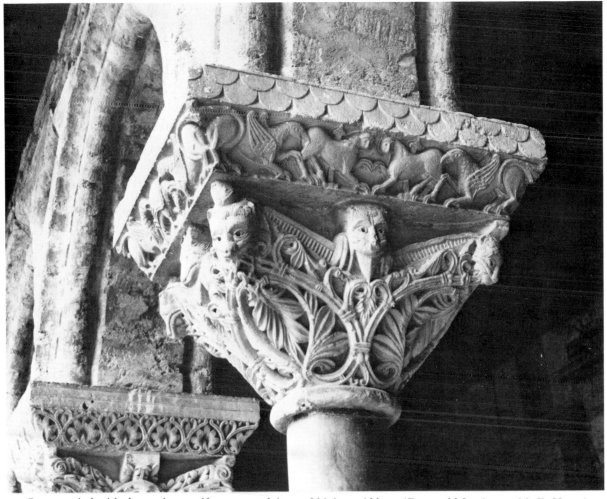

93. Stone capital with decorative motif, c. 1100, cloister of Moissac Abbey. (Courtauld Institute—M. F. Hearn)

of the intermediate western pier, which has the inscription on its inner face.[5] The relief of Durandus (pl. 89), abbot of Moissac from 1047 to 1071, is located on the inner face of the intermediate eastern pier, facing the chapter house where all monastic meetings were held. It is entirely possible that the program initially included Jude, Thaddeus, and James the Less, perhaps on the northern and southern intermediate piers and on the outer face of the eastern one, opposite Simon. Nevertheless, there was no overwhelming necessity to represent all twelve Apostles (with Paul as the replacement for

Judas) and it is significant that the three Apostles who are missing are also the most obscure ones.

The meaning of the program seems to reside in the fact that Abbot Durandus is represented in a format exactly parallel to that of the Apostles, with the sole distinction that he faces the viewer frontally while the heads of all the Apostles are turned in a three-quarter direction to the left or the right. This association of a former abbot of Moissac with the Apostles implies that he is a true successor, hence that monasticism is the proper heir of the apostolic vocation, a view widely held at the time in the order of Cluny.[6] The capitals function as amplifications of

[5] Schapiro, "Moissac," 258, n. 51, reports that the Simon relief was put in its present location by Viollet-le-Duc. The fact that the relief fits exactly makes this reconstitution more plausible than a theory that it was originally on the lavabo, located in the garth (Raymond Oursel, *Floraison de la sculpture romane* [Paris], 1, 1973, 276).

[6] Henri de Lubac, in *Exégèse médiévale* (Lyons, 1961), 578–579, cites Peter de Celle, *Patrologia Latina*, CCII, 1102 D. This interpretation of the iconographical program of the Moissac cloister was advanced by Gudrun Mower in my seminar on Romanesque sculpture of the Toulouse school, Winter Term, 1972.

such a program, authenticating the source, practice, and destiny of the monastic vocation. The location of the program in the cloister was entirely appropriate, since the cloister was the center of monastic life outside the church itself.

Every factor relating to Durandus, to the patron Ansquitil, and to Moissac as an abbey tends to corroborate this interpretation.[7] Moissac was a Cluniac abbey which enjoyed an official rank in the order of Cluny second only to the mother house. When the association with Cluny was established in 1047, Abbot Odilo of Cluny sent Durandus to Moissac to be abbot. Accordingly, the Durandus relief was an appropriate symbol of this affiliation, and its placement in the cloister opposite the chapter house, and in the company of the Apostles, conferred the aura of apostolic dignity upon all the monks. The particular situation that prompted the creation of the sculpture in Ansquitil's reign (1085–1115) was probably related to the circumstance that he, too, had been sent from Cluny to be abbot after Abbot Hunaud (1072–1085) had compromised the association of the two abbeys. The ostensible similarity between the theme of the cloister program and the theme of the Cluny hemicycle capitals may well signify more than mere coincidence. That the format of the Moissac program took a very different form, in a different part of the monastic complex, was most likely due to the lack of a suitable location for a new sculptural ensemble in the abbey church (dedicated in 1063, under Durandus). That it was also executed in a different style is undoubtedly related to the more mundane matter of availability of sculptors from a source closer than Burgundy. The decoration of the cloister with such an impressive program of sculpture transformed this normally utilitarian portion of the monastic complex into a sacred precinct.[8] As at Cluny, art integrated with the structure was employed as a permanent means of moral inspiration.

Since the sculptural program is rather loosely organized, using two formats of highly disparate scale and shape in a widely dispersed arrangement, and since the types of format were limited to those that could be accommodated by a cloister arcade, namely historiated capitals and pier reliefs, it is unlikely that the conception or composition of the program was based on a formal model. While the garments of the Apostles (pl. 90) hint of late antique types,[9] and their arcade frames remind us of the ivory plaques with Apostles on the eleventh-century reliquary of St. John the Baptist in León,[10] the prior appearance of similar costumes and identical frames on different images in the Saint-Sernin reliefs in Toulouse indicates that these features in the Moissac sculptures could have been merely an aspect of the master sculptor's design habits. If, as we shall see was the case, the same atelier of sculptors was involved with both projects, the design and execution of the Moissac pier reliefs required in addition to these formal habits only a knowledge of the Apostles' emblematic attributes in order to produce them. For the capitals (pl. 92) also, only traditional iconographic formulas were necessary. On the other hand, the portrait quality of the face of Durandus (pl. 89), as well as his stance, suggests that there was a specific model for this relief, probably his own funerary monument, in a form resembling the eleventh-century bronze relief of Rudolf of Swabia in Merseberg (pl. 14). The homogeneity of stylistic mannerisms in most of the capitals and all the reliefs, images from a wide variety of sources, suggests that any models for specific images were used primarily to assure iconographic authenticity. The design of the Moissac cloister program, then, seems to have required only the prescription of themes by the patrons and the assured personal style of an experienced sculptor.

Paul Deschamps pointed out long ago the intimate relationship between the Moissac sculptures (pls. 90, 91) and those of Saint-Sernin in Toulouse (pls. 50, 53).[11] Among the figures, the faces closely resemble the physiognomic types, especially the characteristic rounded jaw line; the drapery reveals the same type of curved line to represent folds; the shins retain the peculiar ridge line; and the wings have exactly the same pattern of feathering. The

[7] For a recitation of the historical facts cited in this passage, together with the sources of their documentation, see Schapiro, "Moissac," 252–254. See also H. E. Cowdrey, *The Cluniacs and the Gregorian Reform* (Oxford, 1970), 113–118.

[8] Marcel Durliat, "Le cloître historié dans la France méridionale à l'époque romane," *Les Cahiers de Saint-Michel-de-Cuxa*, VII (1976), 61–74.

[9] For instance, the stucco reliefs of the Apostles in the Orthodox Baptistery in Ravenna, consecrated c. 458, as illustrated in Wolfgang Friedrich Volbach, *Early Christian Art* (New York, 1962), pl. 143.

[10] Pedro de Palol and Max Hirmer, *Early Medieval Art in Spain* (New York, 1967), pls. 66, 67.

[11] Deschamps, "L'autel roman de Saint-Sernin de Toulouse et les sculptures du cloître de Moissac," *Bulletin archéologique* (1923), 239–250.

94. Marble impost of stone capital, with clipeated portrait of Christ supported by angels, c. 1100, cloister of Moissac Abbey. (Courtauld Institute—M. F. Hearn)

arcade frames of the pier reliefs have the same details, including the rosettes in the spandrels. And several of the impost reliefs (pl. 94) imitate the Saint-Sernin altar angels holding a clipeated portrait (pl. 46), sometimes substituting a symbol for the portrait. There are also differences, to be sure, but they are differences of degree rather than kind. Most of the Moissac sculptures present a more consistent and mature technical performance, but they are almost certainly the work of the Saint-Sernin atelier, probably including Gelduinus himself.

The importance of the Moissac sculptures, aside from their inherent value as an impressive artistic achievement, lies chiefly in the adaptation of a sophisticated figural style to an architectural setting and on a monumental scale equal to that of the large reliefs in Toulouse: the cloister thereby marks the transference of sculptural leadership from the milieu of church furniture to that of architectural decoration. The adaptation required no great conceptual feat; it consisted of the simple application of relief slabs to flat surfaces and enhancement of the role of historiated capitals. Nevertheless, the adaptation, especially in the pier reliefs, was precise and definite. The figures (pl. 90) fill almost the whole surface area on both the piers and the capitals, and the pier relief frames are composed to fit the structural setting exactly. Henri Focillon stressed this adaptation in his scheme for the development of figural style in monumental sculpture. Compared to the Toulouse reliefs (pl. 54), he noted, the figures are physically flatter and more abstractly schematized. Moreover, the frame is no longer used to define spatial volumes but simply to enclose the flat sculptural field.[12] In this putative application of the law of the frame to figural sculpture Focillon seems to imply that the pier reliefs had assimilated the aesthetic formulation of eleventh-century grotesque

[12]Focillon, *L'art des sculpteurs romans* (Paris, 1931), 244–249.

capitals, thereby establishing an apparent continuity of tradition between them. In this light, Gelduinus's Saint-Sernin sculptures appear to stand outside the mainstream of development, significant primarily as stylistic models. The prior adoption of his style in the south transept capitals at Saint-Sernin[13] would seem to reinforce such an interpretation. In this light, the style of the Moissac pier reliefs would indicate either that Gelduinus instinctively modified his accustomed mode when making architectural decoration, presumably in obedience to aesthetic principles inherent in that adaptation, or that it was not Gelduinus and his assistants who made them but an atelier of architectural workshop sculptors who had been influenced by his work.

However, several factors in the actual execution of the project explain the stylistic differences more precisely than the law of the frame and seem to settle the issue of Gelduinus's own participation at Moissac. The ostensible development toward crowding the relief field and filling the frame is more apparent than real. In both Toulouse and Moissac, the figures of the large reliefs stand in a setting that exceeds a height of five feet by four to six inches. But the typical width of the reliefs at Toulouse (pl. 55) is thirty inches while at Moissac (pl. 90) it is only twenty-one inches. The figures have approximately the same proportions in both cases, so the difference in the relation of size to background is due to the narrow dimension of the Moissac piers. The difference in relief depth has a similar practical explanation. Although the thickness of the Toulouse reliefs has not been measured, it is abundantly clear from simple observation that the slabs are much thicker than at Moissac. At Moissac, the two reliefs on each of the corner piers are indisputably carved on a single piece of marble, but each face of that marble is only about two inches thick. The actual pier is built of brick. More to the point, the intermediate piers (with the inscription and the Durandus relief) have three faces belonging to a single piece of marble which is also hollow and filled with brick. Especially in this latter case, there is no possible way that the available cutting techniques could have left the material that was carved from the interior in usable form, thereby justifying an economy of marble. Equally, there is no structural reason to

hollow out a large block. Both factors suggest that the relief slabs are reused late antique sarcophagi, then obtainable in great numbers in the south of France.[14] Specifically, it is likely that the corner reliefs are carved on the back and bottom of a sarcophagus, where the surfaces would have been least cut, and that the intermediate reliefs are carved on the back, bottom, and front, the former front reliefs having been shaved off. The size of the pier surfaces would make it possible to reduce almost any rectangular (that is, not trapezoidal) sarcophagus to achieve uniform dimensions. The use of sarcophagi is plausible also because the capitals, clearly by the same workshop, are carved of limestone and only a few imposts are marble; hence blocks of marble were not available for the decorative program. The flatness of the figural style in the pier reliefs, then, is due more to the thinness of the material available than to a stylistic change. Except for these differences, the stylistic and technical features can all be found in the Toulouse sculptures. That there is a degree of development, in the fluidity of the drapery fold S-curve and in the flared brow above the eyes, attests to the kind of evolutionary improvement one would expect to find within any artist's work.

The striking difference in carving between the capitals (pls. 91, 92) and the pier reliefs underlines the circumstantial origin of the pier relief style. Although the technical mannerisms in the capitals are the same as those in the reliefs, the capital figures are carved in very deep relief. Moreover, the composition of nearly every historiated capital ignores the structure of the capital itself: figures overlap each other in a pictorial manner and interact psychologically in a way that is antithetical to the eleventh-century grotesque style. Indeed, they are far freer than in the Saint-Sernin capitals that imitate the Gelduinus style. At the same time, the purely decorative capitals (pl. 93), attributable to the same hands by virtue of details, demonstrate that the sculptors could readily appropriate the aesthetic of the grotesque capitals where it suited the decorum of the situation. The style and technique of the sculptures, then, represent a break with the eleventh-century tradition rather than a continuation.

[13] Thomas W. Lyman, "Notes on the Porte Miègeville Capitals and the Construction of Saint-Sernin in Toulouse," *Art Bulletin,* XLIX (1967), 29-31.

[14] Oursel, *Floraison,* I, 276. This interpretation was originally suggested to me by Frank Guziewicz, in my seminar on the Romanesque sculpture of the Toulouse school, Winter Term, 1972, before Oursel's book was published.

Certainly more than one hand is to be detected at Moissac. One group of capitals, including Daniel in the Lion's Den, was clearly made by a sculptor whose style is only tangential to that of Gelduinus.[15] The others, according to Meyer Schapiro,[16] can be assigned to at least four hands. The pier reliefs also show some differences but, as Schapiro observed, the permutations and combinations of distinctions make it difficult to separate them into two or more groups, except, perhaps, for distinguishing the relief of Simon from the others. My own impression is that one sculptor guided the entire project and that he may have had one assistant who worked closely with him and others who carved only a few capitals each. The corner pier reliefs indicate how the labor may have been divided between the master and his principal assistant. Each of the pairs of Apostles has details that are distinctive to that pair alone. For instance, in one pair both Apostles stand barefoot on stairs (pl. 86); on another, barefoot on a flat surface (pl. 88); on another, they wear sandals and stand on stairs (pl. 85); on the last, they wear slippers and stand on a flat surface (pl. 87). Each pair also shares an equally distinct arrangement of garments, except that of James and John, and each pair shares a virtually parallel pose, differing only in the handling of attribute emblems. In contrast to this series of parallels, the figure on the left in each pair has a beard and a more elaborate hair treatment. It would appear, then, that two sculptors worked side by side, one under the guidance of the other and one more expert in hair treatments than the other. In view of the strong recollection throughout of the technical mannerisms of Gelduinus, it is difficult not to see him as the guiding sculptor. No evidence set forth thus far would justify identifying him as one or the other of the relief sculptors, but it is possible to ascertain a similar set of relationships between each of the pairs of relief slabs at Saint-Sernin. Therefore, Gelduinus may have had an assistant from the beginning. At this point it may seem far-fetched to assign the principal sculptures in the Gelduinus style to two sculptors working in an almost identical manner, but, as we shall see, this attribution gains considerable force in the light of evidence from subsequent monuments.

THE FACADE OF MODENA CATHEDRAL

The marble sculpture on the facade of Modena Cathedral (pl. 58) signals the first adaptation of large-scale figural ornament to an architectural setting in Italy. This ensemble consists of a frieze in four parts; a portal with carved jambs, archivolt, and lintel; and a ciboriumlike porch that frames the portal. As we have already seen in connection with the shrine-altar of San Gimignano, located in the crypt, the frieze as well as the portal was originally intended for this location. However, the awkward placement of the two outer segments of the frieze above the side portals, so that the continuity and visibility of the frieze are impaired, indicates that the original composition of the ensemble has been modified. Upon examination, the decorative details of the side portals reveal no relationship to those of the central portal. Instead, they match exactly the details of the great rose window high in the facade. Both the form of the window and its bar tracery are anachronistic for the early twelfth century and indicate a later remodeling, probably in the thirteenth century.[17] Moreover, there are scars in the masonry of the pilasters that flank the side portals, located exactly on a level with the two inner segments of the frieze. It is clear, then, that the frieze was not only originally intended for the facade but was also installed in a straight sequence flanking the central portal. Although the original presence of the porch has been doubted, both its decorative details and its structural relationship to the facade indicate that it was part of the intended facade ensemble,[18] along with the portal and frieze. As was demonstrated in connection with the shrine-altar, the frieze was probably begun soon after the dedication of the crypt in 1106 and was installed around 1110, when the facade was likely under construction. The decorative cornice above it and the portal sculptures were probably carved just prior to installation.

The subject of the frieze is the story of Genesis.

[15] Marcel Durliat, "L'atelier de Bernard Gelduin à Saint-Sernin de Toulouse," *Anuario de estudios medievales*, I (1964), 521–529. This sculptor was the same who made the first series of capitals for the cloister of La Daurade in Toulouse, probably after the Moissac cloister.

[16] Schapiro, "Moissac," 338–341.

[17] Quintavalle, *La Cattedrale di Modena: Probleme di romanico emiliano* (Modena, 1964), I, 168–172.

[18] *Ibid*, 66, and fig. 1, proposed that the facade was originally built without the porch. However, Roberto Salvini, *Il duomo di Modena e il romanico nel modenese* (Modena, 1966), 77–84, has marshaled sufficient archaeological evidence to build a convincing case for construction of the porch along with the facade.

The first segment (pl. 62) shows God initiating the Creation, the Creation of Man, the Creation of Woman, and the Temptation. The second segment (pl. 63) shows the Accusation of Adam and Eve, the Expulsion from the Garden of Eden, and the Labor of Adam and Eve. The third segment (pl. 64) shows the Sacrifice of Cain and Abel, the Murder of Abel, and the Accusation of Cain. And the fourth segment (pl. 65) shows the Death of Cain, the Flood, and the Thanksgiving of Noah and his sons for deliverance. The front face of the jambs, the archivolt, and the lintel are carved with an inhabited vine scroll, with atlas figures at the base of the jambs (pl. 68). The inner face of each jamb is carved with six prophets standing under arcades (pl. 69). On the left, reading from the bottom are Zephaniah (inscribed "Sofonius" on the jamb), Malachi, Jeremiah, Isaiah, Ezekiel, and Habakkuk. On the right, reading from the bottom, are Obadiah, Micah, Zechariah, Daniel, Aaron, and Moses. The original lions supporting the porch were Roman spolia.[19]

The entire figural program is made up of standard images, even more so than at Moissac, so that we cannot infer the use of special models that might reveal the nature and circumstances of its creation. The Genesis cycle can include many scenes, so that any abbreviated version, such as this one, involves a choice of themes. The scenes chosen for the Modena frieze do not correspond with those on any other well-known monument, but then there are almost no identical abbreviated cycles. The selection probably depended mostly upon which theological insights the patron wanted to emphasize. Although each of the segments of the Modena frieze may have an internal meaning within the cycle, that meaning is obscure. Rather, the cycle as a whole appears to represent the antetype of Christ's salvation, especially since it is combined with the prophets on the portal. Since the porch is part of the decorative program of the facade, it may well contribute to the meaning. Its ciboriumlike form makes an obvious reference to the type of canopy associated with an altar. No such ciborium is known to have occupied the sanctuary at Modena, but there were virtually contemporaneous ones at Milan and Civate. Associated with the frieze and portal imagery, the canopy may well signify the sacredness of the portal

that gives access to the altar. Thus, the portal itself could be regarded as a symbolic antetype of salvation, just as the Old Testament themes of the sculptures are antetypes of the purpose of Christ's mission on earth. There can be little doubt that the facade decoration as a whole, representing the human condition prior to the Incarnation, endows the facade itself with a sacred character.

Except for the porch, the elements of the program do not suggest the adaptation of specific precedents or types of objects. Indeed, the sculpture itself does not seem to lead to an explanation for the choice of an Old Testament theme. Certainly the Genesis cycle had already been associated with portals in eleventh-century Germany, at Hildesheim (pl. 16)[20] and Augsburg, but in a very different form and medium. Its use at Modena is apparently without precedent, but there can be no doubt that it was considered peculiarly appropriate in Italy, as it recurred throughout the twelfth century, albeit in the Modenese tradition of sculpture.

If the source of inspiration is obscure, the artistic authorship is unusually clear. There has never been any uncertainty that the sculptures were made by the same Wiligelmus whose name is recorded on the inscription relief. His style inaugurated what for Romanesque sculpture is a relatively realistic mode of figural representation. The plasticity, earthbound weight, and mobility of his figural style denote a quality alien to medieval art and reminiscent of Roman Imperial art. Although this quality was probably not inherent in his background, it was undoubtedly acquired in the experience of translating antique models in his first marble sculpture at Bari and Modena.

In adapting his figural art to an architectural setting, no stylistic compromises were required in the production of narrative scenes for the frieze. In terms of practicalities, the segments of the frieze are composed of several slabs and the disposition of figures is, in general, one scene per slab. When this was not possible, as in the Sacrifice of Cain and Abel, several slabs were used, but no figure extended beyond its slab. On the other hand, Wiligelmus was not concerned with filling the field of each slab with sculpture. Only the portal suggests any kind of allegiance to a law of the frame. There, the prophets do fill the space inside the arcades but

[19] Quintavalle, *Cattedrale di Modena*, I, 122–123. These were replaced by modern lions in the restoration of 1843; see Arthur Kingsley Porter, *Lombard Architecture* (New Haven, 1914–1917), III, 38.

[20] See Chapter 1, second section, for discussion of the bronze doors of Hildesheim.

95. Marble portal with grotesque motifs and Habakkuk and the Angel and Daniel in the Lions' Den, c. 1115, San Fedele, Como. (Alinari/Editorial Photocolor Archives)

without any hint of distortion, flattening, or schematization as a consequence. The fact that the vine scroll on the outer face of the portal elements does conform exactly to the frame underlines Wiligelmus's appreciation for the distinction between what was aesthetically appropriate for decoration and what was appropriate for figural carving. So, once again, as at Moissac, the incipient assimilation of the figural sculpture tradition by architectural sculpture tradition is only circumstantial and unintended.[21] Indeed, although the original as-

semblage of forms in this composition made a cohesive group and although the extension of the frieze across the facade did enhance the importance of the portal, the composition in no way suggests that it was predicated by the architectural setting.

THE PORTAL OF SAN FEDELE IN COMO

The eccentric portal of the former cathedral of San Fedele in Como (pl. 95) is the first essay in the adaptation of sculpture to an architectural setting in Lombardy. Located in the east wall of a vestibule in the corner between the north transept and the choir, the portal faces out onto a square. This unusual location and the decorative emphasis probably indi-

[21] The effect of crowding the figures in the frames was corrected in all subsequent portals made in the tradition of Wiligelmus, the most obvious example being the Porta dei Principe on the south flank of Modena Cathedral.

cates that it served as an important entry into the church, but there may have been formerly another such door to the south of the choir.[22] The door was placed off-center in the vestibule wall, bounded on the left by the apse of the church and on the right by a house, leaving more space to the left than to the right. The format of the portal consists of sculptured jambs, a triangular arch, and a large relief on the left side. The figural decoration is concentrated in this relief.

San Fedele has been little studied and its chronology is uncertain, but Arthur Kingsley Porter argued cogently that the church was probably begun about 1115 or slightly earlier.[23] The building began at the east end, with the vestibule as a part of the original scheme, so the setting of the portal would undoubtedly have been ready for its sculpture very early in the course of construction. The sculpture, then, reasonably may be placed around 1115.

The jambs are carved with large and elaborate grotesque biting animals. The figural relief to the left is divided into two areas, the larger and lower of which is occupied by a seated man flanked by lions, all framed by an arch. The spandrel area above the arch is occupied by a flying angel, pulling a man aloft by his hair. Traditionally, the imagery has been identified as Daniel in the Lion's Den and Habakkuk and the Angel,[24] and there seems to be no reason to quarrel with this interpretation. These themes were not frequently associated with a portal, but they were readily available within the iconographical and scriptural traditions of the Middle Ages. Both themes represent miraculous escapes in the Old Testament and as a class they signified antetypes of Christ's salvation. The purpose in choosing such themes for a portal is obscure. However, the obvious coincidence of the iconography with the type adopted at Modena indicates that Old Testament themes were the preferred subjects for portals in Italy.

Although the sculpture is rather badly weathered, we can still discern technical mannerisms that denote a close resemblance to the ambo of Sant'Ambrogio in Milan (pl. 72). The figural articulation is very stiff, the drapery is carved with ridge folds that crudely define the plasticity of the body, and the physiognomy has the same oval shape with large

schematized features. Moreover, the biting animals on the jambs are remarkably like those on the jambs of the west portals of Sant'Ambrogio, where the capitals, like those of the nave, are in the same style as the ambo. It seems altogether likely, then, that the Como sculptor is the same man who worked earlier in Milan. If so, although he was probably by training a sculptor of architectural decoration, his work at Como represents an attempt to work in a large scale in figural sculpture equally as unprecedented as that of the former goldsmiths at Moissac and Modena.

Despite the fact that the Como portal sculpture fills the wall area between the apse and the adjacent secular building, its composition is very hesitant and arbitrary. By no means can its adaptation to the architectural setting be regarded as an organic integration, except in the purely decorative jambs. The figural composition is simply a relief slab applied to the flat wall beside the portal, albeit enclosed in a frame determined by the structure of the portal. If the disposition of the figures on the slab conforms both to the external frame and to the internal division introduced by the arch, it is largely due to the sculptor's professional background in a tradition of architectural decoration. Unlike the other monuments, this portal does continue the eleventh-century mode characterized by the jamb reliefs at Sant'Ambrogio. In the final analysis, the San Fedele portal represents a tentative experiment, large in scale but not monumental in conception. It belongs to an artistic tradition that was ill-equipped to expand the significance of its activity, even with the aid of an imaginative patron.

THE WEST PORTAL OF CLUNY ABBEY CHURCH

The west portal of the abbey church at Cluny inaugurated the monumental adaptation of sculpture to an architectural setting in Burgundy—and with a format that was to become the chief prototype for Romanesque portals in France. Although it was destroyed on May 8, 1810, along with much of the church, the portal has been reconstituted in all but its smallest details through the researches of Kenneth John Conant and his colleague Helen Kleinschmidt.[25] The portal (pl. 96) was flanked by splayed jambs articulated with four or-

[22]Porter, *Lombard Architecture*, II, 328, 330.
[23]*Ibid.*, I, 334–335.
[24]*Ibid.*, 326, 327, 334.

[25]Conant, *Cluny: Les églises et la maison du chef d'ordre* (Mâcon, 1968), 103–104, pl. LXXXI, fig. 186.

96. Reconstitution by K. J. Conant of west portal, c. 1088/c. 1112, Cluny Abbey. Model in Musée du Farinier, Cluny. (Medieval Academy of America—K. J. C.)

97. Reconstitution by K. J. Conant of west portal tympanum, c. 1088/c. 1112, Cluny Abbey. (Medieval Academy of America—K. J. C.)

ders of decorated columnar shafts that corresponded to as many archivolts in the surmounting arch. Enclosed within this arched frame was a carved lintel above the open doorway and a carved tympanum (pl. 97) in the resulting lunette beneath the arch. The portal composition itself was enclosed by a tall rectangular frame, with sculptured figures in the spandrels above the arch. The rectangle was surmounted by an arcade of nine arches, the center one framing a window and the others framing flat painted images. On the basis of descriptions and drawings made before its destruction and of measurements taken from the excavated foundations, Conant has been able to determine the dimensions of the portal. The tympanum proper was 18 feet wide and more than 10 feet high. The lintel was 3½ feet high and the doorway itself was 18 feet wide and 21 feet high. With jambs, frames, and cornices, the entire composition was about 45 feet wide and 54 feet high. The tympanum and lintel were each made from single stones and the central image of Christ in the tympanum was about 10 feet high. The scale of this monument, then, outstripped everything that had gone before and rivaled nearly everything that was to come afterward. In addition to the splendor of its size and composition, the portal was further

embellished with brilliant colors of paint on all the sculptured areas,[26] the first such recorded instance in monumental Romanesque sculpture.

As with the hemicycle capitals at Cluny, the date of the portal is problematic. The difficulty, though, is parallel to that of the date for the capitals, discussed in the last chapter, and can be resolved on the same basis. The only difference is that the execution of the portal was probably somewhat later than that of the capitals, judging by stylistic comparison. Because the entire plan seems to have been laid out about the same time as the ambulatory (which, according to Salet, was constructed above the level of the foundations only after the south arm of the larger transept),[27] the west facade was probably not much later than the work on the interior of the choir.[28] On the other hand, lacking the confusion introduced into the dating of the capitals by the dedication of

[26]Helen Kleinschmidt, "Notes on the Polychromy of the Great Portal at Cluny" (written 1930), *Speculum*, XLV (1970), 36-39.
[27]Francis Salet, "Cluny III," *Bulletin monumental*, CXXVI (1968), 235-292. As K. J. Conant has kindly informed me, careful examination of the foundations has revealed no breaks between the south transept and the ambulatory.
[28]Conant, *Cluny*, 98.

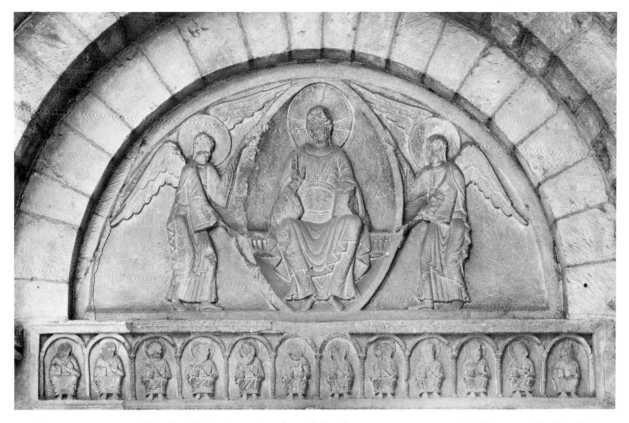

98. Stone tympanum and lintel with the Ascension–Second Coming, c. 1094, west portal of the nave, Charlieu Abbey. (James Austin)

altars in 1095, the issue of the portal date has been much less controversial. Conant's estimate of the chronology of the portal, then, fits well the situation of the capitals: the portal was probably designed when work began, about 1088; its foundation was probably laid out by 1100; the sculptures were probably executed around 1106/1109, and they were probably installed about 1108/1112.[29]

During the interval between the conception and installation of the Cluny portal, a smaller and simpler version of its composition was made elsewhere in Burgundy, thereby complicating the developmental pattern of this region's monumental sculpture. In order to keep straight the apparent sequence of events it is necessary to digress briefly to discuss this sculpture, the west portal of the abbey church at Charlieu (pl. 98). This portal, later enclosed beneath a porch, was part of a church known to have been begun toward the middle of the eleventh century and to have been consecrated (pre-

sumably finished) in 1094.[30] Only a small fraction of the size of the Cluny portal, that at Charlieu represents a simplified version of the Cluny iconography and format. Although there is some variation in style between the lintel and tympanum, the suggestion that the tympanum is later than the lintel[31] is untenable because the iconography of either element would be meaningless without the other. If the portal belongs to the date when the church was

[29] *Ibid.*, 101.

[30] Elizabeth R. Sunderland, "The History and Architecture of the Church of St. Fortunatus at Charlieu," *Art Bulletin*, XXI (1939), 68, 87–88.

[31] Arthur Kingsley Porter, in *Romanesque Sculpture of the Pilgrimage Roads* (Boston, 1923), I, 77, compared the lintel with the twelve Apostles to another at Châteauneuf that has no carved tympanum above it. The latter example has not been fully explored but it is extremely unlikely that it never had any tympanum decoration. Similarly, the suggestion that the center of the upper edge of the Charlieu lintel was cut back in order not to obscure the image of the Ascension makes no sense, first, because the portal is too small for the lintel to obscure a clear view of the tympanum and, second, because the indentation in the lintel border could not have been so neatly cut after the lintel was carved.

nearing completion, it could represent the earliest example of monumental scupture in an architectural setting and would precede any of the first-generation monuments elsewhere.

If Romanesque sculpture was developed largely through the initative of virtually autonomous artists, as many of the pioneering scholars seem to have assumed, and if its development was rooted basically in formal innovations, evolving from the simple to the complex, then Charlieu would have to be given pride of place. However, as we have already seen in the examination of other monuments and as we shall see again in the case of the Cluny portal, new forms were based on new ideas, new ideas were generated in great cultural centers, and the forms that expressed these ideas were neither timidly nor tentatively executed. The abbey of Charlieu was no cultural center and it was also a dependency of Cluny.[32] The execution of its portal before that of Cluny does not establish its priority as an invention. Instead, it is a reflection before the fact of the Cluny portal, based on a design already formulated at the mother house but yet uncarved.[33] That a sculptor was found who could produce the Charlieu portal is more important. The striking similarity of his style to that of late-eleventh-century stone reliefs in Germany, such as those at Werden (pl. 38) and Münster (pl. 37), suggests that his provenance was similar to that of the Cluny Master. However, his hand does not seem to reappear in Burgundian sculpture. Indeed, the very fact that the Charlieu portal did not influence any other monuments attests to the overriding importance of the Cluny portal after it was executed. In the end, Charlieu is significant only as an adumbration of the sculpture at Cluny, but its appearance between the conception and execution of the Cluny portal reinforces the interpretation of the circumstances surrounding the creation of the Cluny sculpture.

Through the labors of Conant and Kleinschmidt,

the imagery of the Cluny portal, at least in its basic themes, has been retrieved through sketches made before the destruction of the Church. These sketches also permit the reconstitution of the portal's format. The tympanum (pl. 97) was dominated by the central figure of Christ, seated on a throne in a mandorla of light, holding a book in the left hand and raising the right in blessing. The mandorla was supported by two angels and two other angels swooped below this group on either side. Flanking the upper portions of the mandorla and at the two lower corners of the tympanum were the signs of the Four Evangelists—the winged man, winged lion, winged ox, and eagle, reading clockwise from the upper right side. The lintel is recorded to have had twenty-three figures which, from various bits of evidence, Conant has reconstituted as three groups: the Three Marys at the Sepulcher; the Apostles, the Virgin and two Men in White at the Ascension; and Christ with the pilgrims on the road to Emmaus. The first archivolt had fifteen cusps with images of angels and God the Father. The second archivolt had twenty-five roundels which could have contained the Twenty-four Elders and the Deity, but because none of the heads retrieved in the excavations wear crowns, Conant has assumed that they were assorted Apostles, prophets, and patriarchs. A figure that seems to have come from the spandrels is definitely St. Peter. Because the abbey was dedicated to SS. Peter and Paul, Conant believes the figures that occupied the two spandrels were Peter and Paul, accompanied respectively by the Apostles James and John.[34]

The combination of the tympanum image of Christ supported by angels and the assembly of Apostles, Virgin, and Two Men in White on the lintel produces one of the standard formulas of Christian iconography of the Ascension described in Acts 2:9–11. From Early Christian times, an Ascension scene with Christ enthroned in a mandorla and surrounded by the Evangelist symbols denoted the conflation of this theme with that of the Second Coming, described in Revelation 4:2–5:10. The association of the two themes was also Scriptural, since the Two Men in White foretold the Second Coming at the Ascension. The ancillary scenes on the lintel simply amplify the meaning of the Ascension as the archivolt images amplify that of the Sec-

[32] Sunderland, "Charlieu," 64.

[33] Francis Salet, reviewing Sunderland's *Charlieu à l'époque médiévale*, using a different title (*Histoire monumental de l'abbaye de Charlieu*), in *Bulletin monumental*, CXXX (1972), 73–75, cast doubt on the completion of the church and portal as early as 1094. He did not advance an argument to support a later date, and it seems safer at present to hold to the traditional date until evidence for a new one is forthcoming. If the portal was later, though, then the Charlieu portal can be withdrawn from its central place in the problems concerning the origins of Romanesque sculpture in Burgundy.

[34] Conant, *Cluny*, 103.

ond Coming.[35] The spandrel figures could complement this program in several ways. The special appropriateness of this program for a portal, however, is revealed only in the context of its artistic background.

As Émile Mâle noted many years ago (before the Cluny portal had been reconstituted) with reference to the portal of Charlieu, the composition of Ascension in the tympanum strikingly recalls that of the apse paintings in Burgundian churches of the twelfth century.[36] Although the iconography of extant apse paintings does not reproduce exactly that of the Cluny portal, there is a remarkably similar image of Christ in the apse of the nearby chapel of the Cluniac grange at Berzé-la-Ville, dated to the same period as the portal. An image similar to the Second Coming aspect of the tympanum iconography, Christ in Majesty, had been a traditional theme in apse paintings for many centuries. An early example is the sixth-century apse at Bawit (Egypt), where the composition is parallel to that of the Cluny tympanum, lintel, and archivolt with roundels, with the same disposition of zones.[37] The Bawit formula entered Western art in the late eleventh century through the influence of the Byzantine tradition. For Cluny, the conduit of that influence was probably the Benedictine abbey of Monte Cassino, which Abbot Hugh had visited when it was still relatively new.[38] Indeed, the apse of Cluny itself had a Christ of the Apocalypse painting, although it may have been executed later than the door.[39]

The correspondence is more than one of formal similarity. There were very few subjects considered acceptable for an apse painting. The apse, as a semi-dome, was associated with the ancient concept of the Dome of Heaven. A figure represented under a canopy, a dome, an apse, or even an arch was endowed with the aura of divinity or a special sanctity.[40] It was precisely this meaning that made the apse an appropriate architectural form for the altar area of a church and which, in Early Christian times, helped to define the divinity of Christ in apse images. In the decoration of a Christian church only a scene with dogmatic significance was deemed appropriate for an apse. Variants of the Ascension, the Second Coming, or Christ in Majesty were suitable because they represented the triumph of Christ. Because of this association between the iconography and the apse, the appropriation of the form of an apse to a sculptured portal virtually dictated that the iconography be that of the conflated Ascension and Second Coming themes. Put the other way around, it was the decision to adopt for the portal a meaning formerly associated with the sanctuary that resulted in the innovation of applying sculpture to the lunette above a doorway. It is highly significant, then, that no reliably dated sculptured tympanum before the third decade of the twelfth century bears any theme not related to this concept: only after this portal composition had been assimilated into the routine practice of monumental sculpture did it become a formal convention that could accommodate many types of subject matter. This association of form and subject matter also accounts for the absence of any tentative prototypes for the sculptured tympanum.[41]

The meaning of the portal is not complete, however, without that of the rectangular frame and spandrel figures. Such a frame surrounding an adaptation of a painted apse is exactly like the "triumphal arch" at the sanctuary end of the nave which frames

[35] An early example of this conflation of the Ascension and Second Coming is found in a miniature of the Rabula Gospels A.D. 587.

[36] Mâle, L'art religieux du XIIe siècle en France: Etude sur les origines de l'iconographie du Moyen Age, 2d ed. (Paris, 1924), 32–37. One element of confirming evidence for the derivation of the tympanum from apse paintings is the fact that the background of the Cluny tympanum was painted cobalt blue (Kleinschmidt, "Polychromy," 38), the standard color for apse paintings.

[37] Mâle, L'art religieux du XIIe siècle, 34–35, fig. 34. For the general context of the frescoes at Bawit, see Charles Rufus Morey, Early Christian Art (Princeton, 1942), 87–89, 260–261, fig. 76.

[38] Two of the best discussions of the Italo-Byzantine influence at Cluny proper are in Meyer Schapiro, The Parma Ildefonsus: A Romanesque Illuminated Manuscript from Cluny and Related Works (New York, 1964), 41–50, and Walter Cahn's review of the book in Art Bulletin, XLIX (1967), 72–75.

[39] The literature on this painting is collected and summarized by Carol Heitz, "Réflexions sur l'architecture clunisienne," Revue de l'art, XV (1972), 89, and n. 52.

[40] Karl Lehman, "The Dome of Heaven," Art Bulletin, XXVII (1945), 13; and Earl Baldwin Smith, Architectural Symbolism of Imperial Rome and the Middle Ages (Princeton, 1956); 21–30, 107–131.

[41] Ivo Petricioli, "La scultura preromanica figurativa in Dalmazia ed il problema della sua chronologia," Stucchi e mosaici alto medioevali: Atti dell'ottavo Congresso di studi sull'arte dell'alto Medioevo, I (Milan, 1962), 369–370, has proposed the gabled lintel of San Lorenzo at Zara as such a prototype. To be sure, the subject matter resembles that of Charlieu and Cluny and the concept is certainly similar, but this portal had no influence, so the idea, if the same, died until it was reconceived at Cluny.

the view of the apse of an Early Christian basilica.[42] It is well known that such an association accrued to this arch in late Antiquity and it, too, was a proper field for images, especially those of saints. At Cluny, the figure of Peter and an equally likely one of Paul would have been appropriate as the patrons of the abbey. The identification proposed by Conant for the other two figures is pure conjecture, but it could as readily be St. Benedict and some other monastic figure as it could be the Apostles James and John. In either case, the spandrel figures would immediately endow the frame with the significance of a triumphal arch. This meaning would amplify that of the tympanum itself and would add a secondary meaning of the triumph of the patron saints of Cluny. In this light, the triumph of Christ could be interpreted as continuing through the triumph of Cluniac monasticism. The secondary meaning seems to be confirmed by the arcade above the frame, itself a symbol of a *palatium* (in this case, the palace of the Lord), which Conant reports enclosed flat painted images of the abbots of Cluny.[43]

The meaning of the portal as a whole reflects, appropriately enough, the meaning interpreted in the hemicycle capitals. The application of sculptured images to the main entry into the church transformed a utilitarian doorway into a sacred portal. The theme of the triumph of Christ, shared by monasticism, thus endowed the act of entering the church with the aura of participation in that triumph. In the apse with its hemicycle capitals, the worshiping monks were also reminded of the means to share that triumph, the monastic vocation. The apse painting above with its vision of the Apocalyptic Christ represented the consummation of the monastic vocation. The portal, like the hemicycle capitals, was an elaborate allegory and its conception was undoubtedly part of the same exercise in imaginative invention. Although it could be realized with images that already existed, it required a series of unprecedented associations and a translation from one medium to another.

Albeit the destruction of the portal precludes any detailed analysis of style, it is reasonable to assume that the immobile frontality and the exaggerated height of the Christ figure in the tympanum were influenced by the ultimately Byzantine character of the image in a model, such as a drawing. Moreover, when the design for the tympanum was made (pl. 97), it may have been adapted from the space-enclosing form of an actual apse. This sort of adaptation would likely have resulted in crowding the auxiliary figures of the apse composition around the axial central figures, into a smaller area than they would occupy in an actual apse. Consequently, figures originally positioned over a wide area became thinner and more compactly arranged toward the edges of the composition, except for the two Evangelist symbols at the bottom which would have lost their visual meaning if not inserted as if seen frontally. Such a process of translation, I believe, is the most plausible explanation for the crowded arrangement of the figures around the mandorla and for their strict coordination with the shape of the frame. By contrast, the lintel functioned as a region for undistorted narrative representation. The archivolt cusps (perhaps quotations from the marble altar dedicated in 1095 by Urban II, which could easily have been added to the design of c. 1088) do not seem to have restricted the disposition of the angels. The second archivolt with roundels is simply a series of clipeated portraits, imitated from the Byzantine convention for borders,[44] so it, too, imposed no restrictions. Moreover, the spandrel figures do not appear to have been influenced in any way by their setting. Adherence to the law of the frame, which formerly seemed to be such an important aspect of the development of the sculptured tympanum, appears once again to have been a coincidental factor in the sculptural style of the monument.

The sculptor who was chiefly responsible for the portal, the Cluny Master, had already developed his sculptural style in the course of translating the putative model drawings for the capitals into stone. This style was apparently reinforced by his using a similar model for the portal, presumably a drawing made about 1088 in the Cluny scriptorium, in a manner like that hypothesized for the capitals. The artist employed the same technical mannerisms in the portal sculpture, endowing the portal figures with a more solemn version of the graceful vitality he bestowed on those of the capitals. This quality,

[42] See Richard Krautheimer, *Early Christian and Byzantine Architecture*. Pelican History of Art (Harmondsworth, 1965), 35, and pls. 3, 15, for examples.

[43] Smith, *Architectural Symbolism*, 30–37; and Conant, *Cluny*, 104.

[44] Margaret English Frazer, "The Djumati Enamels: A Twelfth-Century Litany of Saints," *The Metropolitan Museum of Art Bulletin*, XXVIII (1970), 241.

associated with the vivid artifice appropriate to poetic allegory, was also apt for the allegory of the triumph of Christ, shared by Cluniac monasticism.

CONCLUSIONS

The ensembles of architectural sculpture that were executed by the first important masters of the revival—Bernardus Gelduinus, Wiligelmus, and the Cluny Master—signaled an important development in medieval culture. For the first time in post-antique Europe, figural stone carving on the exterior of buildings was employed to present complex programs of Christian themes to an entire monastic chapter or to a general public. This purpose of enunciating religious concepts endowed the sculpture with a function parallel to that of ancient Roman architectural sculpture, in which, for example, triumphal arches proclaimed political policy and interpreted historical events.

These new ensembles also marked a significant advance in the revival of the medium of monumental stone sculpture. Not only did the adaptation of sculpture to architectural settings multiply the formats and iconographic possibilities for sculptural creativity but it was also the means whereby sculpture regained its monumentality. A close formal relationship of the sculpture to the architectural setting was not an automatic result of the process of adaptation; indeed, the physical coordination of the two was initially either tentative, as at Modena and Como, or coincidental, as at Moissac and Cluny. But from the beginning, the sculpture was given a plastically articulated architectural frame that justified the placement of the carved images. For this reason the sculpture was seen in relation to the structural setting and so had the visual impact of being much greater than its actual size. Even when the figures were relatively small and nonmonumental in conception, as in the Modena frieze, the ensemble became monumental in effect. In this respect, as with its cultural purpose, the relationship of the sculpture to its architectural setting was parallel to ancient Roman usage.

Growth and Development of the Regional Schools

Once introduced into the artistic tradition of the twelfth century, architectural sculpture became the principal metier of the sculptor of stone images. Portals and facades with complex religious iconography appeared throughout much of western Europe during the second, third, and fourth decades of the century. The most significant advances in the revival of stone sculpture were made in the conception of new formats, the physical coordination of the sculpture to the architectural setting, and the professional activity of the sculptors.

It is possible to identify continuous activity of individual sculptors or closely related hands at various locations in a given region. Such clusters of related sculpture are customarily designated as "schools," a term that neutrally covers all situations related to unsettled attributions. The first such schools to emerge were those stemming from the centers in which activity has already been traced from the sanctuary to the exterior architectural setting. Many others appeared in the first half of the twelfth century, but to continue by tracing only the pioneering schools suffices to illustrate how regional schools developed.

LANGUEDOC AND NORTHERN SPAIN

The region of Languedoc, with its great cultural center in Toulouse, was the Continental foyer to the pilgrimage routes that led over the Pyrenees to the shrine of the Apostle James at Santiago de Compostela. In this region and along the Spanish pilgrimage roads flourished the most prolific and versatile school of sculptors among the early regional styles. Initiated in the table-altar and shrine at Saint-Sernin (c. 1096), the style of this region was first adapted to architectural sculpture in the capitals of the south transept at Saint-Sernin and in the cloister at Moissac (1100). From Moissac one of the principal sculptors went to Lavaur (c. 1105), where he made a marble table-altar similar to that at Saint-Sernin.[45] Another, who may have remained at Saint-Sernin all the while, made three historiated marble capitals, carved on all four sides, which were later installed in the Porte Miègeville. Because they correspond neither to the style of the other portal sculptures nor to the two-sided format appropriate

[45] Marcel Durliat, "La table d'autel de Lavaur," *Anuario de Estudios Medievales*, II (1965), 479–484. The top of the altar, instead of continuing the old tradition of a lobed border, was graven with a border exactly like that on the inscription relief in the Moissac cloister. The figural style on the front is very like that at Saint-Sernin but the iconography is different.

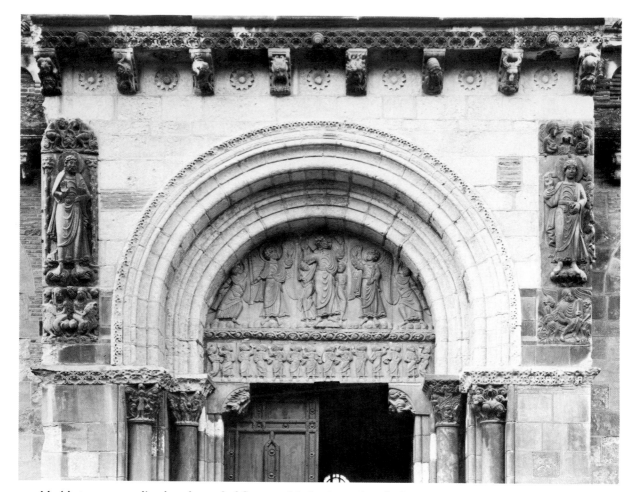

99. Marble tympanum, lintel, and spandrel figures with the Ascension, St. James, and St. Peter, c. 1110/c. 1115, Porte Miègeville, Saint-Sernin, Toulouse. (James Austin)

to portal capitals, they were probably made earlier for another purpose where they would be freestanding. Thomas Lyman has suggested that they might have been intended for a ciborium,[46] presumably in the choir. If so, the first two monuments made by the Gelduinus school of sculptors after the Moissac cloister were pieces of marble church furniture, with carvings on a miniature scale. The next major project undertaken, however, was the portal in which the capitals were enventually employed.

The Porte Miègeville at Saint-Sernin of Toulouse

Situated on the south flank of the nave of Saint-Sernin, in the eighth bay of the outer side-aisle, the Porte Miègeville (pls. 99, 100, 101) derives its name from the fact that it terminates the street that leads

[46]Lyman, "Porte Miègeville Capitals," 29.

directly from the center of Toulouse, where St. Saturninus was martyred. Because it is the most elaborately embellished entry into the church, its location at such an odd place can only be related to that geographical coincidence. The portal is mounted in a rectangular block that projects from the side-aisle. Its focal point is the carved marble tympanum on which Christ, standing in profile, is about to ascend into Heaven supported by two angels and flanked by four others. On the lintel beneath, the twelve Apostles stand looking upward, accompanied by the Two Men in White. This Ascension composition is framed by two molded archivolts, supported by columnar shafts and the aforementioned capitals, whose iconography is not an integral part of the program. In the spandrels there are marble reliefs of St. James and St. Peter, set between separate reliefs above and below which are carved

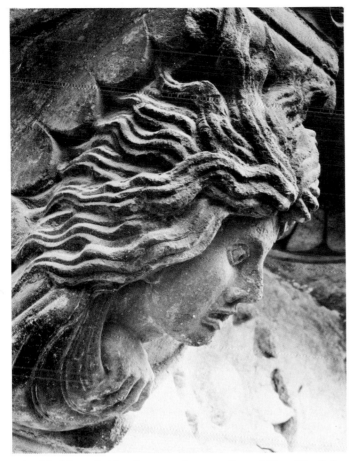

100. Marble corbel head, c. 1110/c. 1115, Porte Miègeville, Saint-Sernin, Toulouse. (Jean Dieuzaide)

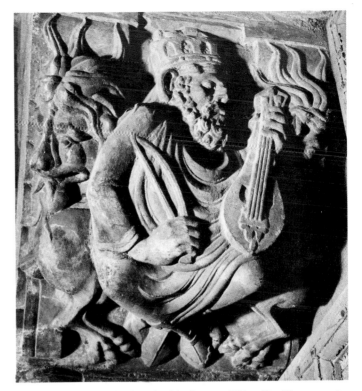

101. Marble corbel for lintel with figure of King David, c. 1110/c. 1115, Porte Miègeville, Saint-Sernin, Toulouse. (Jean Dieuzaide)

with antithetical motifs.[47] The basic theme, then, is the Ascension or the triumph of Christ. The location of St. James in the place of honor on Christ's right (our left) is apparently a reference to the great pilgrimage for which Saint-Sernin was a major station. In this context, the figure of Peter probably symbolizes the papacy, which in the previous century had rescued the canons of Saint-Sernin from displacement by Cluniac monks. The triumph of Christ, then, is associated with references to the pilgrimage, the papacy (of Gregory VII), and, by virtue of its location, to the martyrdom of St. Saturninus.

The date of the portal is linked with that of the nave itself, that is, between c. 1100, when the transept was completed, and 1118, when the nave was documented as nearly complete. No evidence has come to light to fix the date more precisely, but scholars generally agree that it should fall between 1112 and 1115.[48] This dating accords well with the portal's manifestation of the stylistic maturity of the Gelduinus mode. That it belongs to this artistic strain is clearly evident in the technical handling of wings, garment folds, hair types, and physiognomies. But the hemlines, with their succession of schematized undulations, specify exactly the precedent of Moissac. The quality of liveliness is new in the large figures but it can be traced through the lintel figures back to the Moissac capitals (pl. 91). The depth of relief in the spandrel figures, with

[47]The motif under St. James is not clearly identified but that under St. Peter is Simon Magus, associated with the sin of simony (the selling of ecclesiastical offices). The association with St. Peter is a pun on his real name, but as Mâle, in *L'art religieux du XIIe siècle*, 252, has observed, a beardless St. Peter seems to refer to his role as a cleric rather than as an Apostle. Thus the antithetical juxtaposition would be apt.

[48]Jean Cabanot, "Le décor sculpté de la basilique de Saint-Sernin de Toulouse," *Bulletin monumental*, CXXXII (1974) 140–144, discusses the literature on this question. Thomas W. Lyman, in "Raymond Gairard and Romanesque Building Campaigns at Saint-Sernin in Toulouse," *Journal of the Society of Architectural Historians*, XXXVII (1978), 71–91, has revised the chronology of construction but without changing the portal's date.

their heads carved virtually in the round, is a highly plastic translation of the Moissac pier reliefs. On the other hand, there are also manifestations of technique and style that have precedents only in the earlier Saint-Sernin sculptures. Technically, the carving of the spandrel reliefs from the sides as well as the front recalls the Christ in Majesty. Stylistically, one of the corbel heads (pl. 100) has an analogue only in the clipeated portrait of Christ on the altar (pl. 46). These details, together with the self-assured mastery of craft which bespeaks leadership in the sculptural production of this school, suggest the hand of Gelduinus himself.

Even if Gelduinus carved the Porte Miègeville, he is not likely to have devised its program. That aspect of the portal was the province of the patrons, the canons of Saint-Sernin. And the conception probably did not originate with them. The similarity of the format and theme to the Cluny portal (pl. 96) is obvious and the date is contemporaneous with the completion of the Cluny portal; yet the style and iconography are different. The representation of the Ascension with Christ standing in profile belongs to an entirely different tradition from the Cluny Ascension. The Toulouse formula goes back to an expressly Western Early Christian narrative image, common in southern France, in which Christ is pulled into Heaven by the Hand of God.[49] This version seems particularly at home in the quasi–late antique quality of the Gelduinus style and it may have been modeled on a very old image available in Toulouse. Also, we cannot be certain that a format like that of the Cluny portal could not have been devised independently in Toulouse. Yet the tympanum image does not belong to a type associated with apse decoration and the figures show no evidence of having been adapted from an apse composition. Moreover, the use of a portal composition that is so closely associated with Cluny suggests that when Urban II came to Toulouse from Cluny to dedicate the altar in 1096 he or someone with him may have discussed the new church of Cluny with the canons of Saint-Sernin. That the Cluny portal composition was standard in Burgundy and was not repeated in the school of Languedoc for a decade or so tends to confirm the suspicion that the Porte Miègeville was inspired by a verbal account of the scheme for the Cluny portal.

However conceived, the Porte Miègeville marked the introduction of ambitious architectural sculpture to doorways in Languedoc. Furthermore, the careful arrangement of its tympanum figures to conform to the limits of the five vertical slabs of marble came closer than in any previous monument to submitting to a law of the frame. In this respect, though, as with its format, the Porte Miègeville remained singular in Languedoc.

The Sculptured Facades of Santiago Cathedral

The cathedral of Santiago, as the putative resting place of the Apostle James, was the goal of the greatest pilgrimage in Western Europe in the Middle Ages. Consequently, it was also one of the most important churches in Christendom. Although far from Languedoc, the cathedral structure was patterned after Saint-Sernin, so the appearance in Santiago of sculptors from Toulouse would not be surprising. The monumental sculpture of Santiago has not fared well and all that remains of three great facade ensembles is to be found on the south transept facade, known as the Puerta de las Platerías (pl. 102).

The format of the decorated portion of the facade consists of a pair of portals and an ample spandrel area above them, bounded at the top by a cornice at the level of the interior gallery and framed on the sides by wall buttresses. Sculpture has been applied to every part of this composition, the jambs, tympana, spandrel area, and wall buttresses. Sadly, in its present state, this ensemble of carvings is a jumble only an archaeologist-connoisseur could love. Some of the sculptures were carved of marble and others from granite, the material of the cathedral, and they were made in highly various shapes by many different hands.

Two different types of evidence, however, aid the student of Romanesque sculpture in sorting out the pieces of this puzzle. The first is a unique document, commonly known as the *Pilgrim's Guide*, which is part of the *Liber Sancti Jacobi*. Written by a French monk named Aymery Picaud, between 1139 and 1152, the *Guide* provides eyewitness descriptions of the transept and nave facades as they then existed.[50] From the descriptions, the original location of many

[49] A famous example is on an ivory panel of c. 400, now preserved in Munich. See Volbach, *Early Christian Art*, 328–329, pl. 93.

[50] Jeanne Vielliard, trans. and ed., *Le guide du pèlerin de Saint-Jacques de Compostelle* (Mâcon, 1938; cited from 3d ed., 1963), xii–xiii, 97–105. For an English translation, see Conant, "New Studies on the Cathedral of Santiago de Compostella," *Art Studies*, III (1925), 154–163.

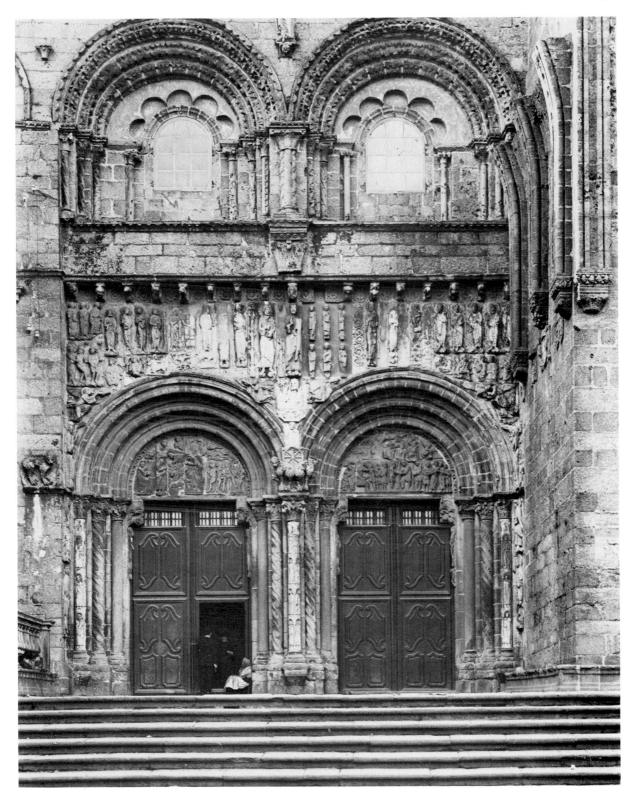

102. South transept facade, Puerta de las Platerías, c. 1111/c. 1116, Cathedral of Santiago de Compostela. (Archivo Mas)

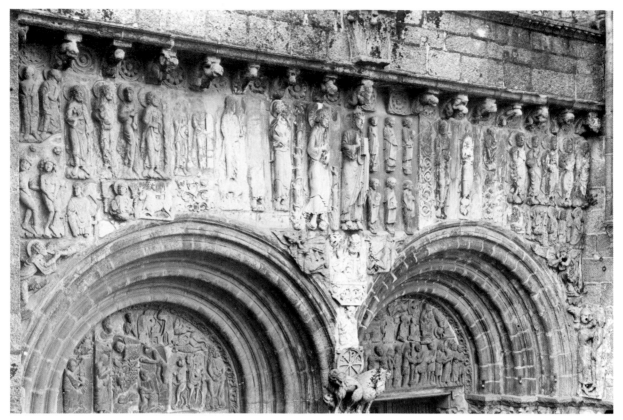

103. Spandrel area, Puerta de las Platerías, sculpture of various early-12th-century dates, Cathedral of Santiago de Compostella. (Archivo Mas)

of the pieces can be determined on the basis of their iconography. The second type of evidence is contained in the sculptures themselves, for they fall into several stylistic groups that are fairly easily identified. Ole Naesgaard has compiled a census of these groups which is accurate at least in distinguishing the major hands.[51] When the iconographic and stylistic groups are compared they coordinate smoothly. It then becomes possible to reconstitute the original state of the facade ensemble.

The Puerta de las Platerías today represents at least the sixth state of its existence, each version of which can be discerned by proceeding in reverse order. Sculptures that are clearly post–twelfth century or that do not relate to the reported iconographical programs probably represent fragments inserted into blank areas during restorations, most likely in the nineteenth and early twentieth centuries (sixth and fifth states). Others, which by virtue

of their iconography can be associated with the north transept facade, were probably installed in the early eighteenth century, when the exterior of the cathedral was sheathed in a rococo decor (fourth state). The marble figure of Christ in the center of the spandrel area (pl. 103) is a late-twelfth-century replacement of the original and represents a remodeling (third state). The tympana (pls. 104, 105), filled with fragments not consistent in theme, style, or format, cannot be considered original even though they were described by Aymery Picaud in exactly their present locations.[52] The collection of

[51] Naesgaard, *Saint-Jacques de Compostelle* (Aarhus, 1962), 103–106.

[52] Picaud was not an authoritative connoisseur. The fragments in the left tympanum which he claimed to have identified by an inscription as the Temptations of Christ are so uncoordinated in scale and format that their intended disposition cannot be determined. They are works from the same hand but they apparently were meant for a much larger setting. On the right tympanum, the wide horizontal slab with the Flagellation of Christ was described as including Christ before Pilate, but close examination verifies that the vignette could represent only the imposition of the Crown of Thorns. Moreover, almost all the themes in both tympana are narrative and thus inappropriate for that format. (Although themes such as the Adoration of the Magi or the

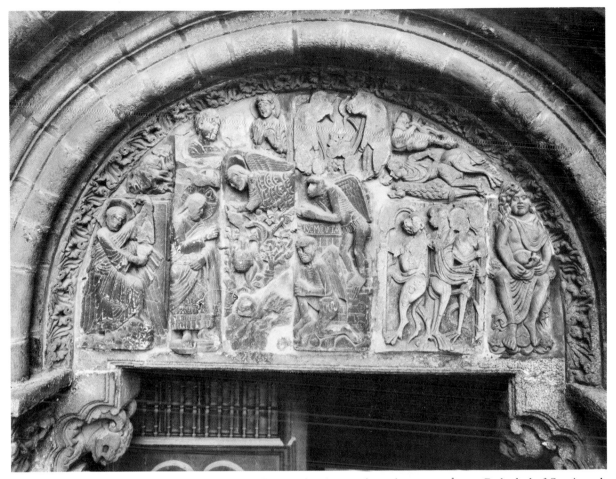

104. Left tympanum, Puerta de las Platerías, sculpture of various early-12th-century dates, Cathedral of Santiago de Compostella. (Archivo Mas)

such a meaningless jumble in the Romanesque period constitutes an unparalleled anomaly, but even so it can represent only a remodeling which took place before 1139, the earliest date when Picaud could have written. On the basis of stylistic comparison to other monuments, the filling of the tympanum areas can be dated around 1130 (second state).[53] The original composition of the facade pro-

gram, then, consisted of the marble Apostles and angels and some small decorative pieces in the spandrel area and the three marble colonnettes among the splayed jambs (first state).[54] And even though the colonnettes (pl. 106) may have been originally installed, the fact that they are carved all around indicates that they were initially intended as freestanding supports, probably for a ciborium.[55]

As for the other sculptures, the large granite reliefs (pls. 106, 107) set into the flanking wall buttresses correspond to the scale and format of the large

Deposition from the Cross were later to be used in tympana, they were not employed in a narrative sense.) Finally, and most telling, the format of the stones is not consonant with practice anywhere else for the cutting of tympanum stones. Elsewhere, tympana are monoliths, as in Burgundy, or they are cut in vertical slabs. Never, not even late in the Romanesque period, were they cut in horizontal slabs like that of the Flagellation.

[53] The Flagellation relief clearly was made by the sculptor who carved the great tympanum of Sainte-Foy at Conques. See Paul Deschamps, "Etude sur les sculptures de Sainte-Foy de Conques et de Saint-Sernin de Toulouse et leurs relations avec celles de

Saint-Isidore de León et de Saint-Jacques de Compostelle," *Bulletin monumental,* c (1941), 249-251. However, Deschamps surely erred in implying that Conques was earlier, because it is much more fluently carved than the Santiago relief.

[54] Naesgarrd, *Santiago,* 27-48.

[55] I am indebted to my colleague John Williams for this observation.

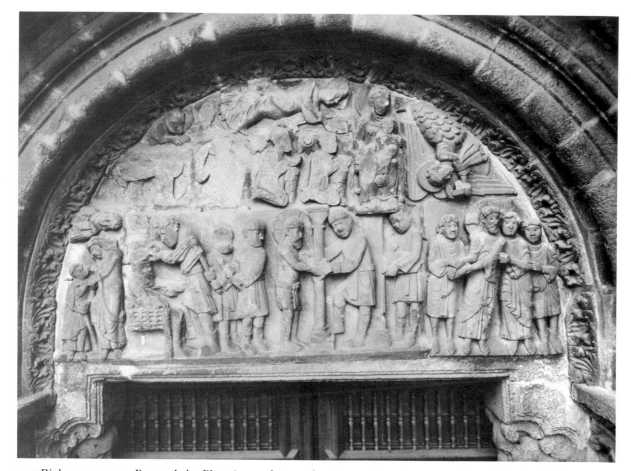

105. Right tympanum, Puerta de las Platerías, sculpture of various early-12th-century dates, Cathedral of Santiago de Compostela. (Archivo Mas)

marble Apostles and also to the reported iconography of the north facade, suggesting that they composed an ensemble on the north facade similar to that of the Apostles and angels on the Puerta de las Platerías. The stylistic affinity of some of the smaller granite reliefs to these sculptures and their reported inclusion in the north transept program also indicate that this composition was augmented on either side with horizontal bands of additional scenes that may well have completely filled the spandrel area. Hence the north facade was intended to be a more ambitious composition than that first executed for the south transept. There are yet other small granite reliefs from the same hand with subject matter that was reported to have been on the south transept. The combination of their format, material, and iconography suggests that the south transept program was to have been subsequently enlarged on

a scale equal to that on the north. Since the Platerías facade was apparently altered and since its altered form seems likely to have been modeled on the north facade composition which was presumably homogeneous, it is reasonable to conclude that the original program of the Platerías facade was the earlier of the two. However, when the Platerías program was expanded, these new sculptures were not installed in manner parallel to that envisioned on the north facade. Some of them had been placed in the tympana when Aymery Picaud described the facades sometime after 1139.

Following this archaeological pattern, the south transept program initially included marble images of Christ, six Apostles, and two angels in the spandrel area (pl. 103), together with assorted small decorative pieces, and, in the jamb area, the colonnettes carved with saints and angels. The north

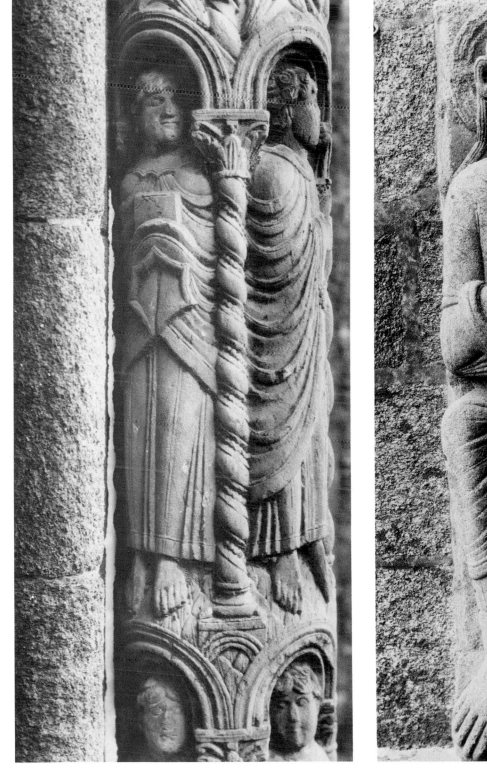

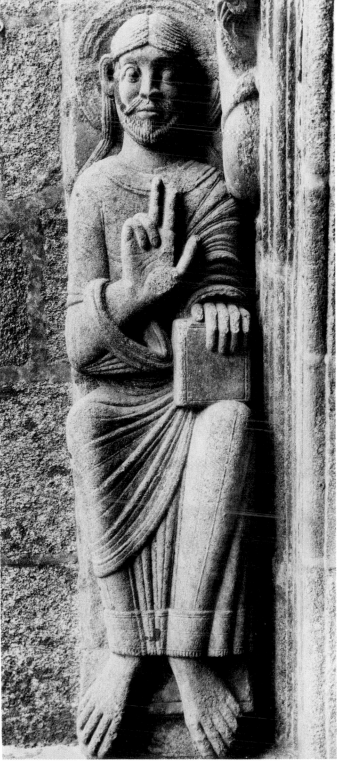

106. Marble colonnette, Puerta de las Platerías, c. 1110(?), Cathedral of Santiago de Compostela. (Archivo Mas)

107. Stone relief of Christ in Majesty, Puerta de las Platerías, after 1116, Cathedral of Santiago de Compostela. (Archivo Mas)

transept program[56] had a similar array of sculptures in the spandrel area. Flanking the Christ in Majesty (pl. 107, mentioned in the *Pilgrim's Guide*) were probably the large reliefs of David (pl. 108), God Creating Adam, God Creating Eve, the Sacrifice of Isaac, and other Old Testament subjects. Beyond these tall reliefs were smaller slabs with additional subjects related to the Creation (for example, the Expulsion of Adam and Eve [pl. 109] mentioned in the *Guide*) and perhaps the Incarnation (the *Guide* places the Annunciation in the left tympanum). The entire spandrel area may have been completely filled and possibly the tympana as well. Flanking the tympana were lions, and the jambs were embellished with figures of Apostles. The expanded south transept program probably was intended to fill the sides of the spandrel area with scenes from Christ's Ministry and Passion (for instance, the Temptations of Christ and the Betrayal). Flanking the portal arches were angels and lions and on the jambs were Apostles. The programs, then, appear to have been devoted to the Old Testament and Incarnation on the north and to the Passion and triumph of Christ on the south. The *Pilgrim's Guide* describes a program of similar composition, made of marble, on the west front (displaced by a later facade and the Puerta de la Gloria, completed 1188). It was apparently focused on the Transfiguration, the most important event in the life of Christ with which the Apostle James was explicitly associated.

The formal significance of these programs is that they marked the first occurrence of ambitious facade decoration in the school of Languedoc. Iconographically, they constituted the first effort anywhere to coordinate the decoration of multiple ensembles with parallel compositions. With respect to historical development, the Puerta de las Platerías was the most important of the three facades because the conception was realized there first. Its position in this development has not been properly appreciated, however, because of confusion about its date. An inscription plaque, set into one of the jambs cites a date corresponding to 1078 in the present calendar. Another, referring to King Al-

[56] This reconstitution is my own, but the north transept program has been studied by J. M. Azcarate, "La Portada de las Platerías y el programa iconografico de la catedral de Santiago," *Archivo Español de Arte y Arqueologico*, XXXVI (1963), 1ff; and S. Moralejo-Alvarez, "La primitiva fachada norte de la catedral de Santiago," *Compostellanum*, XIV (1969), 623–668.

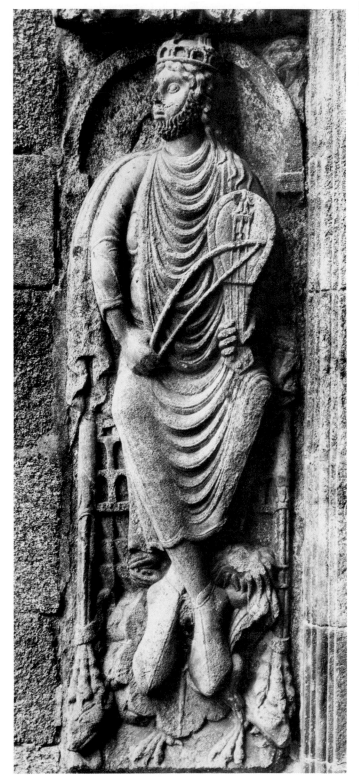

108. Stone relief of King David, Puerta de las Platerías, after 1116, Cathedral of Santiago de Compostela. (Archivo Mas)

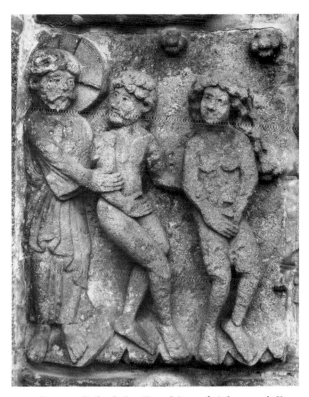

109. Stone relief of the Expulsion of Adam and Eve, Puerta de las Platerías, after 1116, Cathedral of Santiago de Compostela. (Archivo Mas)

fonso (ANF REX) on the marble figure of St. James (pl. 109), has been associated with King Alfonso VI, who died in 1109. Accordingly, because the Bishop of Santiago, Diego Pelaez, is known to have had a new building underway in 1080, and because there was a dedication of several chapels in 1105, it has usually been assumed that construction could already have advanced to the south transept facade by 1103 and that the sculptures could have been installed by 1105 and before 1109.[57] Reexamining published reports of excavations made in the choir in the 1950s, John Williams[58] demonstrated that the church of Bishop Pelaez had progressed very slowly and that only a few ambulatory chapels had been built when he was driven from office in 1088. As Williams argues, construction was resumed in the 1090s under Gelmirez, who became bishop in 1100.

Consequently, each stage of the early work should be redated to a few years later and the facade to after 1110. Two events, the coronation of Alfonso VII as King of Galicia in Santiago Cathedral, in 1111, and his triumphal entry into Santiago after fighting the Almoravides near Toledo, in 1116, could account for the inscription on the St. James relief. (The other inscription was presumedly in the choir and later removed to the portal jamb.) The facade decoration should then be redated to either c. 1111 or c. 1116, probably the latter.

The virtue of this redating is that a date just after the Porte Miègeville establishes a plausible reason for the duplication of unusual iconography and the close affinity in style between the marble St. James at Santiago (pl. 110) and the St. James on the Porte Miègeville (pl. 99), in addition to similarities in some capitals of the Santiago ambulatory to those in the Porte des Comtes.[59] The marked resemblance between this and other figures at Santiago and Toulouse no longer has to be based on lost common models or mysteriously similar impulses, made all the more mysterious by the absence of any prior monumental sculpture in Santiago or the whole kingdom of León and Galicia. Moreover, the plausible association of the reference to King Alfonso on the St. James sculpture with a triumphal event in Alfonso VII's life helps to explain the idea behind the composition of the sculpture above the double portal. As regards the design of the architectural setting, there can be no doubt that the format of the facade was determined by the plan of the church, in which the transept aisles were joined by a gallery of two bays (in conformity with the width of the transept) behind the facade: no scheme other than a double portal was feasible. But few people in the Middle Ages could have failed to notice that the composition, articulated by the portals, cornice, and flanking buttresses, resembled that of a Roman city gate, examples of which remained in many places throughout Europe. And the ancient iconographical associations of these gates with the ruler are well known.[60] Consequently, such associations could accrue to any special gate.

Cyril Mango[61] has studied this connection in de-

[57] K. J. Conant, *The Early Architectural History of the Cathedral of Santiago de Compostella* (Cambridge, Mass., 1926), 31.

[58] Williams, "'Spain or Toulouse?' A Half Century Later: Observations on the Chronology of Santiago de Compostella," *Actas del XXIII Congreso internacional de historia del arte, Granada, 1971* (Granada, 1973), I, 559–560.

[59] Naesgaard, in *Santiago*, 103–111, has collected most of the references in earlier scholarship to these similarities and their historical relationship.

[60] Smith, *Architectural Symbolism*, figs. 11–12.

[61] Mango, *The Brazen House: A Study of the Vestibule of the Imperial Palace of Constantinople* (Copenhagen, 1959), 21–22, 108–154.

tail with reference to the Chalkê, the ceremonial entrance to the Imperial Palace in Constantinople. Originally, Constantine had set his own image above the gate, denoting the theme of imperial victory. But by the sixth century, the image above the entrance gate was an icon of Christ. Destroyed during the Iconoclastic controversy, the icon was replaced in the ninth century and restored several times again in the course of the Middle Ages. The relationship between the Emperor and the Gate was expressed through the image of Christ which, if known copies are truly representative, was a standing figure much like that employed on the Puerta de las Platerías. Although Constantinople was not unknown to Western Europeans, especially after the First Crusade, it is unlikely that there was any intention at Santiago to imitate this specific example. Rather, the instance serves to demonstrate the currency of the triumphal association with the gate form in the early twelfth century. Indeed, at Santiago this association would have had special appropriateness in the image of St. James as well as that of Christ, for the aid of St. James was routinely invoked in the battles of the Reconquest of Spain from the Moors.[62] It was from such a battle that Alfonso VII returned in triumph in 1116. There was good reason, then, to carve the name of Alfonso on this relief: The program would thus represent the special role of St. James, subordinate to that of Christ, in Spain. It would not be seen as a topical reference to the victory of Alfonso but as a general proclamation of the joint mission of the Church and the king to reconquer Spain for the glory of Christ. The interpretation of the Puerta de las Platerías as an expression of this triumphal association may seem merely coincidental without explicit historical evidence that this tradition was known in northern Spain. However, the representation of Christ with Apostles and angels in a nonnarrative situation and without any of the appurtenances of theophany, such as a mandorla of light or the Apocalyptic beasts, reinforces the likelihood that the tradition was known and that the composition did have such a meaning.

Regardless of the originally intended meaning of the south facade sculpture, it almost certainly was not the meaning of the north facade program. The juxtaposition of a theophanic image (Christ in Majesty) with images representing precursors (David) and antetypes (Creation of Adam, Sacrifice of Isaac), and with narrative amplification (Expulsion of Adam and Eve) has a much more dogmatic character. The probable subsequent intention to expand the south transept program would similarly have transformed its nature to make it parallel with the north transept. The meaning of either type of program, though, depended only upon the selection of appropriate images and their juxtaposition or relationship to the setting. Nothing was required in the way of abstruse iconographical formulations and no actual model was needed. The sculpture suggests that none was used which did not already belong to the sculptors' prior artistic experiences and encounters.

The singular formulation of the marble St. James (pl. 110) standing between two tree trunks with their limbs cut off (identified as cypresses by the *Pilgrim's Guide*) immediately raises the issue of direct imitation from the Porte Miègeville (pl. 99). The images differ in only one particular: the Santiago St. James holds a book with both hands while the Toulouse version holds up the right hand in blessing. But while there is also a distinct affinity of style, the two works are clearly not by the same hand. Because he accepted an earlier date for the Santiago figure, Naesgaard[63] suggested that the stylistic antecedent was the ivory carving of the Arca de San Felices of San Millán de la Cogolla, dated in the 1090s. But he noted that the style was also remarkably close to that of the Moissac cloister sculptures, and detailed comparison reveals that the Santiago marble master had almost certainly worked there. Although the subtle modeling of the face and the relative fluidity of the drapery on the Santiago St. James (pls. 110, 111) make that figure seem at first to be far removed from the Moissac pier Apostles, the technical mannerisms are the same. Compared with the Moissac St. Paul (pl. 90), the St. James has identical feet and sandals, the same schematized undulations in the hemline (among the sinuous gathered folds), similar curved linear folds on the bulging right leg, identical articulation of sleeve hem and folds, parallel arrangement and type of garments, and a somewhat more developed version of the same hair and beard treatment. Even the remarkable articulation of eyeballs and the arched brow are foreshadowed in

[62] T. D. Kendrick, in *St. James in Spain* (London, 1960), relates the basic beliefs about St. James in Spain (13–24) and his role as the Moorslayer (34–40).

[63] Naesgaard, *Santiago*, 41–42.

110. Marble relief of St. James, seen from the right, Puerta de las Platerías, c. 1111/c. 1116, Cathedral of Santiago de Compostela. (Archivo Mas)

111. Marble relief of St. James, seen from the left, Puerta de las Platerías, c. 1111/c. 1116, Cathedral of Santiago de Compostela. (Archivo Mas)

the Moissac St. Paul. In addition, the mantle of the Santiago St. James has an ornamented border above his hand which is similar to those on the Moissac St. James and Durandus reliefs (pls. 86, 89). These mannerisms also exist in the other pier reliefs in varying degrees, but the St. Paul provides the most telling single comparison.

Compared with the Toulouse St. James, that of Santiago has a great richness of surface treatment and articulation of details and a somewhat less insistent concentration on solid plasticity. When both these reliefs are compared with the Moissac piers, (pls. 85–89), this difference of formal qualities is faintly suggested already in the differences between the (bearded) figure on the left in each pair and the (beardless) figure on the right. To identify the hands of both the Toulouse and Santiago masters, each distinct individuals, in the Moissac cloister pier reliefs, clearly implies that one was Gelduinus (as we have seen earlier) and the other was his principal assistant. Ostensibly, this assistant went to Santiago shortly after Gelduinus had presumedly carved the figures for the Porte Miègeville. Not only does this explanation account for all the similarities but it also reinforces the independent arguments for their respective dates of c. 1112/1115 and c. 1116.

In discussing the other sculptors at Santiago, Naesgaard aptly noted that the author of the south transept marble colonnettes (pl. 106) was not the same as the St. James master, but that he also seemed to be related to the sculpture of Moissac.[64] I agree with this attribution and suggest that he was one of the sculptors who made historiated capitals at Moissac. About the large reliefs I have assigned to the north facade, Porter noted that the carving of the David (pl. 108) manifests exact technical parallels to that on a corbel in the Porte Miègeville (pl. 101),[65] despite the radical differences in format. The shoes, shin ridge, drapery folds, viol, and crown are identical; the physiognomy and hairstyle and the extension of arms directly from the neck are similar. The relief of God Creating Eve and that of the famous Adulteress in the left tympanum (pl. 104) reveal other marked similarities to the Porte Miègeville sculptures. It appears, then, that the sculptor whom I identify as Gelduinus followed his old assistant to Santiago in order to carve the large reliefs of the north facade. The small reliefs (for example, Expulsion, pl. 109) seem to have been made by another assistant whose work reflects the Gelduinus tradition. This assistant's style reappears in the small reliefs presumedly made for the expansion of the south transept portal (for example, Betrayal), now located in the right tympanum (pl. 105). Naesgaard convincingly suggested that this sculptor was the one who made the marble colonnettes (pl. 106).[66] There were at Santiago, then, at least three sculptors whose work marks a continuation of the school of Languedoc. It is also noteworthy that during this project, for the first time in the sculpture of this school, Gelduinus and the colonnette master made figured reliefs from stone rather than marble.

Later Monuments: Toulouse and León

After the Puerta de las Platerías, the hand of the Santiago marble master does not appear. Gelduinus, however, seems to have returned once more to Toulouse where he made the enigmatic relief of two women holding small animals and presumedly also other reliefs which were applied to the west facade of Saint-Sernin,[67] probably around 1120. Then the primary sculptor of the (first) school of Languedoc seems to have vanished, for we find no more traces of his work.

However, the secondary sculptors of this group did continue the tradition in the portals of San Isidoro in León (after 1120),[68] located on the south flank of the nave (pl. 112) and at the end of the south transept. Both portals reflect the composition of the

[64] Ibid., 48.

[65] Porter, Pilgrimage Roads, I, 211.

[66] Naesgaard, Santiago, 77, 99.

[67] David W. Scott, "A Restoration of the West Portal Relief Decoration of Saint-Sernin in Toulouse," Art Bulletin, XLVI (1964), 271ff. Marcel Durliat, in Haut-Languedoc roman, Nuit des Temps (La Pierre-qui-vire, 1978), 122, recounts the legend attached to the inscription carved on this relief; the legend asserted that Toulouse had been anciently designated by astral portents as one of three holy cities, together with Jerusalem and Rome.

[68] Although a much earlier date was proposed by Porter, Pilgrimage Roads, and by others, the date of the León portals must follow the new chronology for the church implied in John Williams's redating of the earlier western tower porch, the so-called Panteon de los Reyes, to the last years of the eleventh century, in "San Isidoro in León: Evidence for a New History," Art Bulletin, LV (1973), 170–184. Williams has discussed the unusual iconography of the nave tympanum in "Generationes Abrahae: Reconquest iconography in León," Gesta, XVI (1977), 3–14, in which the basic theme of the Sacrifice of Isaac and the Lamb of God is related to the Reconquest. This parallel to the meaning imputed to the original program for the Puerta de las Platerías tends to reinforce the interpretation of the latter. For the spandrel reliefs, see Serafin Moralejo-Alvarez, "Pour l'interprétation iconographique du portail de l'Agneau à Saint-Isidore de Léon: les signes du zodiaque," Les Cahiers de Saint-Michel-de-Cuxa, VIII (1977), 137–174.

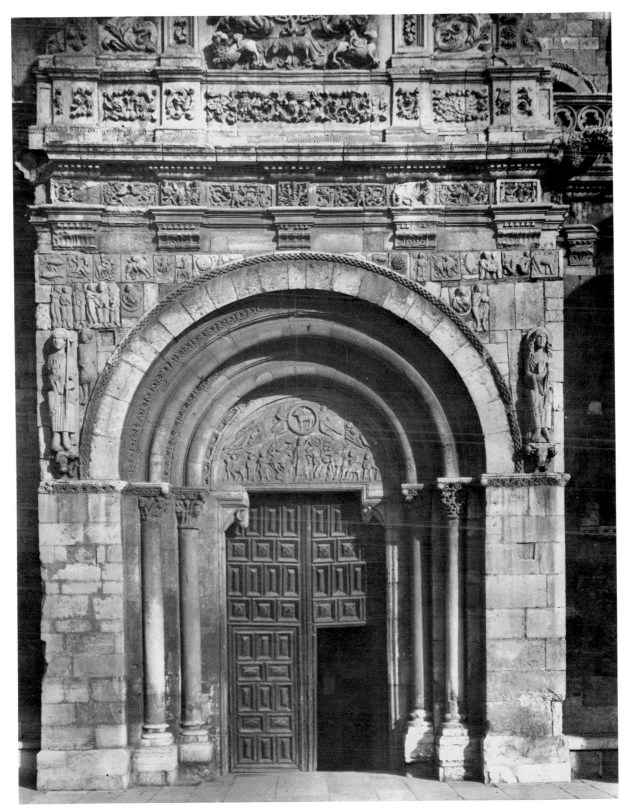

112. South nave portal, c. 1120, San Isidoro, León. (Archivo Mas)

113. Tympanum, south nave portal, c. 1120, San Isidoro, León. (Archivo Mas)

Porte Miègeville, the former very directly and the latter in the application of figures on either side of the tympanum. The influence was, however, evidently transmitted via Santiago, whence came the two, or possibly three, sculptors. Both of the tympana, the small spandrel reliefs on the nave portal, and the flanking figures of the transept door retain the basic characteristics of the Toulouse school style, now much evolved. The faces with round jawline and full cheeks, the vertical shin-line, the concentrically curving drapery folds (now fully modeled), the limbs plastically articulated beneath the drapery, and the ribbonlike wing feathers are still recognizable.

The author of the nave tympanum (pl. 113) was almost certainly the sculptor of the Santiago marble colonnettes (pl. 106). The transept portal was by another sculptor who had already carved some Apostle reliefs, original location unknown, now found in the spandrel area of the Puerta de las Platerías (pl. 103). The spandrel figures of San Isidoro and of another saint in the nave portal (pl. 112), however, were made by the sculptor who carved the Santiago Christ in Majesty (pl. 107) and God Creating Adam which ostensibly belonged to the north transept program. His rigidly composed figures with their softly rounded contours and emphatically plastic conception have only a slight affinity with the Toulouse style. Albeit influenced by the Gelduinus mode his work stands removed from it. As his hand does not appear in sculpture earlier than that at Santiago, he was likely of Spanish origin with training at Santiago. After León, the influence of the Toulouse school style becomes dim. As we saw in the Temptation and Flagellation reliefs of the Santiago tympana, the later work at Santiago seems to have marked the beginning of a second generation of sculptors.

NORTHERN ITALY

The hesitant quality of the Lombard monuments of Milan and Como was prophetic of the destiny of monumental sculpture in that region. No evidence remains of a subsequent project on the scale of the Como portal. The same style, perhaps even the same hand, recurred in the portals of two churches in Pavia, San Michele and San Pietro in Ciel d'Oro, both generally dated about 1120 or after.[69] The facade of San Michele contains three portals with splayed jambs, each embellished with an arbitrary sprinkling of religious and grotesque subjects on the jamb capitals and purely decorative ornament on the jambs and archivolts. The only large figures with religious significance, representing bishops, angels, and archangels, are carved on rectangular slabs that were simply inserted inside and above the three lunettes of the doorways. They seem to have no particular iconographical relationship to the rest of the program and they reflect nothing new in the development of style except a greater finesse in the carving of the faces and wings. The scale of the decoration scheme was enlarged by the insertion of four bands of grotesque beasts, now largely deteriorated, across the entire width of the facade between and above the portals. These bands lend a rather grand and unifying effect but they represent nothing essentially new in the development of monumental sculpture. At San Pietro in Ciel d'Oro, a single portal was decorated in the same manner as at San Michele. These modest achievements terminated the school of Lombardy which had been initiated by the ambo in Sant'Ambrogio of Milan.[70]

The school of Emilia, on the other hand, was both prolific and the longest-lived of all the regional styles. During the second and third decades of the twelfth century, a substantial number of portals were constructed using the format of the central west portal of Modena Cathedral. Characteristically, the portals were framed by a ciboriumlike porch, usually of two stories. The jambs, lintels, and archivolts were carved with small-scale sculpture and the tympana were left open. Two such portals were made in Modena, on the south and north flanks of

the cathedral and others were made in Cremona, Nonantola, Piacenza, and Sagra di San Michele.[71] The iconography was varied and figural compositions displaced much of the purely decorative carving which was so prominent in the original Modena portal. The figural style of Wiligelmus dominated this sculptural practice to such a degree that the sculptors must all be identified as members of his atelier. His own hand, however, cannot be reliably traced beyond the west facade of Modena Cathedral. Despite the most conscientious efforts of numerous scholars, this group of portals has defied classification of exact chronological order and identification of specific hands.[72] Although such a classification would be very useful in understanding more precisely the work of a major regional school of sculptors, it is not crucial to the present purpose as only one of these portals, at Cremona Cathedral, contributed anything new to the development of monumental sculpture in Italy.

The Portal of Cremona Cathedral

The west portal of Cremona Cathedral, although now much altered, is of considerable interest because it was the setting for the largest figural sculptures ever made in Italy in the Romanesque period. The portal composition clearly followed that of Modena but on a much larger scale so that the jambs and lintel were physically bigger fields for sculpture. The only figural carvings still in situ are the atlas figures supporting two freestanding colonnettes among the splayed jambs and the four figures of prophets set on the inner face of the door jambs. These prophets are Jeremiah and Isaiah, on the left

[69] Porter, Lombard Architecture, III, 209-211, 226.
[70] Ibid., 170-179, discusses evidence for a facade, much like that of San Michele, on the destroyed church of San Giovanni in Borgo, also in Pavia. He judged from the style of preserved fragments that it was probably later.

[71] On the sculptured images of the Nonanatola tympanum Christ Enthroned is flanked by two angels and surrounded by the Apocalyptic signs, much the same iconography that initially appeared in Burgundian portals. However, each of the images is carved on a separate rectangular slab and inserted into a ground of plain masonry. Although the program is clearly deliberate and appropriate to a tympanum, the pastiche technique of execution disqualifies this example as a genuine sculptured tympanum. Instead, it is simply a lunette with applied sculptures. See Arturo Carlo Quintavalle, Romanico padano, civiltà d'Occidente (Florence, 1969), 33-47. For Piacenza, see Quintavalle, "Piacenza Cathedral, Lanfranco, and the School of Wiligelmo," Art Bulletin, LV (1973), 40-57. For Sagra di San Michele, see Christine Verzár, Die romanischen Skulpturen der Abtei Sagra di San Michele: Studien zu Meister Nikolaus und zur "Scuola di Piacenza" (Bern, 1968), 37-104.
[72] Porter, Lombard Architecture, I, 269-287, II and III, passim; René Jullian, L'éveil de la sculpture italienne: La sculpture romane dans l'Italie du Nord (Paris, 1945), 110-178; Roberto Salvini, Wiligelmo e le origini della scultura romanica (Milan, 1956), 113-162; Arturo Carlo Quintavalle, Da Wiligelmo à Nicoló (Parma, 1966), 47-108.

(pl. 114), and Daniel and Ezekiel on the right (pl. 115), each holding a phylactery inscribed with a reference to his prophecy of the Incarnation.[73] Near the portal, under a loggia, are two reliefs (about eighteen inches high) carved with scenes of the Temptation and the Expulsion of Adam and Eve. Their size and format together suggest that they were originally attached to the now denuded lintel, comprising with the prophets an abbreviated version of the Modena facade program within the portal itself. However, the frame along the bottom of the two reliefs is not identical in each case and there are no other examples of lintel sculptures not carved on the lintel itself. A reconstitution of the basic program, then, must remain tentative.

The chief importance of this portal for our purposes lies in the technical achievement of carving the jamb sculptures. The pairs of prophets are each carved on a single piece of marble slightly more than twelve feet high (pl. 114, 115). Each prophet is just over six feet high and eighteen inches wide. Hence they are the first truly life-size figures in the sculptural revival. Because their disposition was very much limited to the block from which they were carved, their hands are necessarily pressed against their bodies. Even so, they are remarkably plastic in conception, considering the fact that the slab of the relief ground is just over two inches thick and that the projection of the prophets from this slab never exceeds five or six inches (pl. 116). Nevertheless, their grandiose size leads one to expect that surface details, such as drapery folds, hair, and facial modeling, would have been fully exploited, and they were not. Instead, the surface articulation is more schematized and abstract than in any of the other works of the Emilian school. This deviation from the school's stylistic norm has led some scholars to hypothesize artistic influence or models from the Near East, especially on the right-hand jamb where the feet of the figures are skewed sideways.[74] In my estimation, though, these qualities are directly attributable to the unprecedented scale of the figures in conjunction with the constraints imposed by the thickness of the slabs, as well as to the novelty, in Italy, of carving a relief from three sides rather than the front only. The deficiencies tolerated in the area of physical articulation, though, are compensated by the gain in monumentality achieved in these figures. The scale of the prophets is not only much more impressive than at Modena but is also in better relationship to the portal itself than at Modena.

Probably the most reliable evidence for determining the date and artistic authorship of this portal lies not in the portal itself but in a relief now located in the cathedral treasury. This relief, which appears to have been carved by the sculptor of the portal, shows Enoch and Elijah holding a plaque that commemorates the beginning of the cathedral construction in 1107.[75] The iconography, composition, and figural style are so similar to the Modena inscription relief signed by Wiligelmus that attribution of direct relationship is virtually unavoidable. Yet, while the figures display almost the same style traits, they differ sufficiently in technical details of physiognomy and hair treatments that it is not feasible to include them among the autograph work of Wiligelmus. Rather, they seem to come from the hand of a sculptor trained by the master at Modena. For this reason it would follow that the date is after that of the Modena sculptures but not necessarily so early as 1107, stated by the inscription. Although the cathedral was begun in that year, it was heavily damaged by the earthquake that shook much of northern Italy in 1117. Construction was apparently not resumed until 1126 and no dedication of any portion of the church prior to 1141 was recorded.[76] The style of the relief and the portal sculptures in the context of the whole Emilian school do not readily admit attribution to the second period of construction. The sculptures have usually been assigned to the period between 1107 and 1117, but since the relief and the portal clearly reflect knowledge of the completed Modena portal it seems likely than the sculptor did not leave for Cremona until after the Modena facade was installed, around 1110. Hence the date of the Cremona portal ought to be assigned to the last years before the earthquake, probably around 1112.

[73] Porter, *Lombard Architecture*, II, 386–387, has shown that these inscriptions are adapted from a sermon of St. Augustine (Migne, ed., *Patrologia Latina*, "Contra Judoeos, Paganos, et Arianos," [xi], XLII, col. 1123).

[74] The Cremona inscription: ANN D̄N̄ICO INCAR/ NACO. M̄. C̄. VII. INDI/ TIONE. XV. P̄SIDENTE/ DOMINO PASCALE/ IN ROMANA SEDE/ VII. K̄L SEP̄T̄B. INCEP/ TAĒ AEDIFICARI HEC MA/ IOR AECCL[ESI]S CREMONEN/ SIS [QVAE] MEDIA VIDĒT/

[75] Porter, *Lombard Architecture*, II, 373–376, 392.
[76] Jullian, *L'éveil*, 71–73.

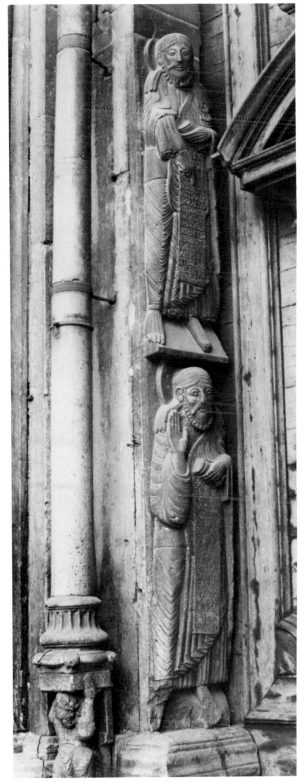

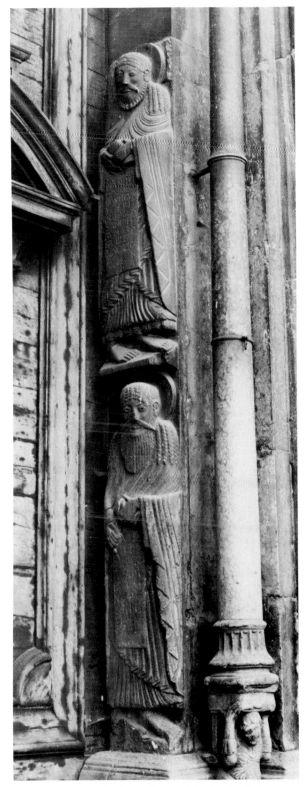

114. Marble relief of prophets, left jamb of the west portal, c. 1112/c. 1115, Cremona Cathedral. (Courtauld Institute—M. F. Hearn)

115. Marble relief of prophets, right jamb of the west portal, c. 1112/c. 1115, Cremona Cathedral. (Courtauld Institute—M. F. Hearn)

116. Marble relief of the prophet Isaiah, left jamb of the west portal, c. 1112/c. 1115, Cremona Cathedral. (Courtauld Institute—M. F. Hearn)

The Portals of Ferrara and Verona

The work of the Emilian school continued to flourish through the late 1130s, long after the original schools of Languedoc and northern Spain and of Burgundy had disappeared and given way to a second generation of sculptors. The most conspicuous monuments of this later period are the portals of Ferrara (c. 1135) and Verona cathedrals (c. 1139) and of the abbey of San Zeno in Verona (1139).[77] Continuing the basic format of the Modena portal, their compositions were more elaborate than those of their predecessors and endowed the sculpture with a closer relationship to the architectural setting.

In the nearly identical compositions of the Ferrara and Verona Cathedral portals (pls. 117, 118, 119), deeply splayed jambs and archivolts provide a monumental frame for the doorway beneath the traditional canopy-porch. In the angles between each of the five orders of rectangular jambs there are colonnettes, thus providing an alternation of round and pointed surfaces for sculptured embellishment. Consequently, all the portal surfaces that could be carved were articulated structural members. By contrast, the San Zeno composition is completely flat (pl. 120). Besides the lunette above the doorway, its principal decoration is located on large ensembles of small reliefs on either side of the porch (pl. 121). In principle, this was a highly conservative disposition of sculpture, without apparent integration into its structural setting. Both relief ensembles, however, are strictly limited on each side to the area bounded by the doorway and the wall buttresses flanking the nave and on the top by a blind arcade which extends across the entire facade at the level of the lintel. Moreover, the vertical division of the ensembles into two rows of reliefs corresponds to the pilasters that articulate the facade. Therefore, while the narrative character of figural scenes represented in each relief is not hampered by the frame, the composition as a whole is utterly integrated into the structural articulation of the facade. This contrast of compositions is all the more interesting because all three portals were signed by the same sculptor, Nicoló.[78] Such a diversity in the contem-

[77] All three portals are fairly reliably dated in association with documents related to the churches: see Porter, *Lombard Architecture*, II, 408, 422; and III, 479, 539.

[78] The inscriptions read as follows (cited from Porter, *Lombard Architecture*). Ferrara, Cathedral (II, 409): LI MILE CENTO TRENTA CENQUE NATO/ FO QTO TENPLO A.S. GOGIO. DONATO/ DA GLELMO CIPTADIN P[ER] SO AMORE/ E NE FO LOP[ER]A NICOLAO SCULPTORE;

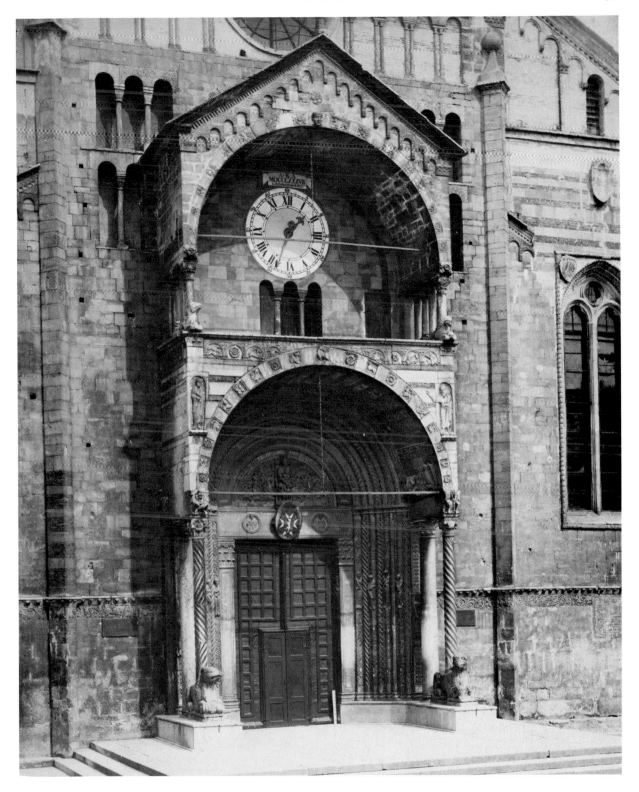

117. West portal, c. 1138, Verona Cathedral. (Alinari/Editorial Photocolor Archives)

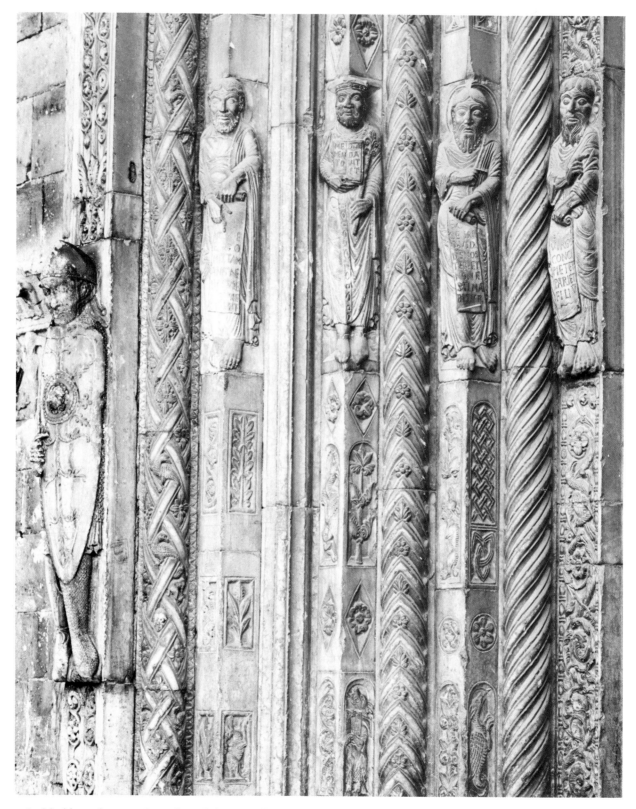

118. Marble sculptures of prophets, left jamb of the west portal, c. 1138, Verona Cathedral. (James Austin)

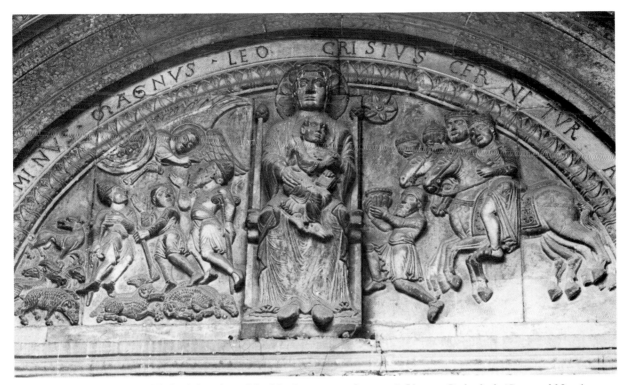

119. Marble tympanum with the Adoration of the Magi, west portal, c. 1138, Verona Cathedral. (Courtauld Institute—Julian Gardner)

poraneous works of one artist demonstrates conclusively that rote custom and formal evolution were not important factors in the designs he executed. Instead, it reflects Nicoló's ability to respond to the varying desires of different patrons rather than his exercise of artistic autonomy.

The innovations of these portals reside in the introduction into Italy of genuine carved tympana (pl. 119) and in the nature of the jamb figures on the two cathedral portals. At this late date, the tympana reflected the international adoption of the invention that had originated in Burgundy about four decades earlier. But by this time the tympanum had become merely a formal convention and no longer maintained the original association with the apse and its special iconography. Because it had no previous function in traditional Italian portal iconography, its

subject matter was not a climactic focal point of a hieratic program. Instead, it was employed to glorify the patron of the church (in Ferrara, St. George; in Verona Cathedral, the Virgin; in San Zeno, St. Zeno). These tympanum figures were in no way distorted to accommodate the frame, yet each example variously demonstrates a sensitivity to the shape of the frame which makes the composition apt for no other format. As for the jamb figures (pl. 118) on the two cathedral portals, those on the intermediate jambs were carved along the axis of the projecting corner rather than on a flat face. Although they were necessarily restricted in disposition to the shape imposed by the jambs, they were freed from the limitation of a frontal relief plane, thereby penetrating the real space of the portal embrasure. A similar effect was achieved in the tympana where the central figure overlaps the frame, suggesting the spatial projection of the figure beyond the frame and the relief ground. Since this relationship to real space occurs on unlike members of the portal it was undoubtedly intentional. It foreshadows a development that was widespread in the late 1130s, particularly in France, in which architectural

Verona, Cathedral (III, 474): ARTIFICEM GNARVM QVI SCVLPSERIT HEC NICOLAVM HVNC CONCVRRENTES LAVDANT PER SECVLA GENTES; Verona, San Zeno (III, 529): ARTIFICEM GNARVM QVI SCVLPSERIT HEC NICOLAVM OMNES LAVDEMVS CRISTVM. DNM Q ROGEMVS CELORV̄ REGNUM SIBI DONET VT IPSE SVP[ER]N̄V; and (*Ibid.*): HIC EX̄EPLA TRAI POSS̄VT LADS NICOLAI.

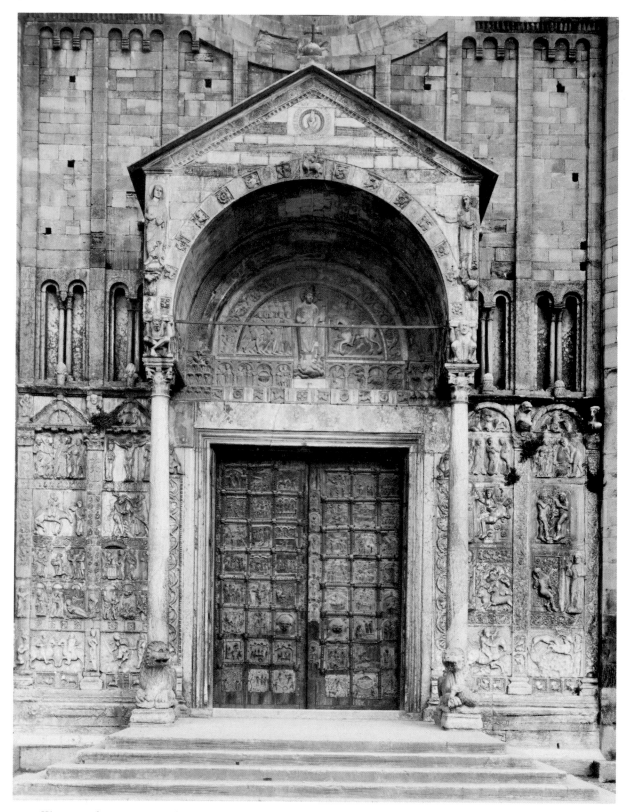

120. West portal, c. 1138, San Zeno, Verona. (Alinari/Editorial Photocolor Archives)

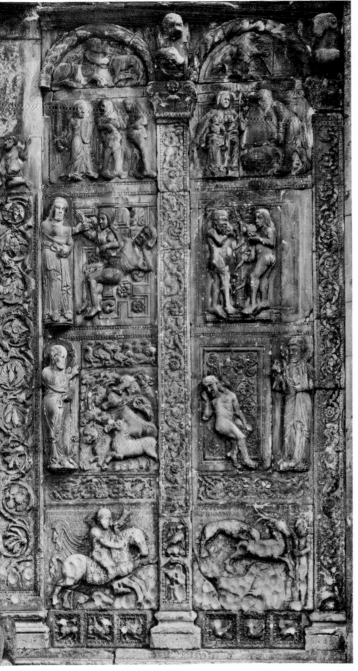

1. Marble reliefs of the Genesis cycle, right jamb of the west portal, c.
38, Verona Cathedral. (Alinari/Editorial Photocolor Archives)

sculpture cast off the limitations of a flat relief ground.

The figural style of Nicoló's sculpture clearly belongs to the school of Wiligelmus. However, the basic stylistic homogeneity of this school makes it necessary to begin with these signed late works in order to trace Nicoló's point of origin by reverse chronological order. The existence (or the record) of his signatures goes back as far as the Zodiac portal of Sagra di San Michele. This example, according to Porter, makes it possible to identify his hand at Piacenza Cathedral, an attribution accepted also by other scholars.[79] Any further definite attributions would require lengthy examination and comparison of the various portals, together with an exhaustive consideration of the dates of the structures in which they are found. But on the basis of technical mannerisms, such as those manifested in wings and facial features, it is possible to see the same hand at Nonantola, at Cremona, and even in the south nave door at Modena, the Porta dei Principe. I do not insist on the conclusiveness of this identification, but it appears highly likely that Nicoló was originally trained as an assistant to Wiligelmus in Modena and that he was primarily responsible for most, if not all, of the Emilian portals after the west facade of Modena. An active career of three decades is plausible and the number of monuments executed would probably not fill that period completely. We know from an inscription at San Zeno that he had an assistant, Guillelmus, who carved the New Testament panels on the left side of the portal.[80] It is possible that he had assistants in other portals but Nicoló seems to have remained the principal master until about 1140. In Emilia, then, as in other regions, the major monuments of the early schools were essentially the work of only a few sculptors.

BURGUNDY

The regional school of Burgundy, to judge from the extant monuments, manifested the least variety in its formats and (with the exception of the Cluny portal) the smallest scale in its sculptural ensembles, but it produced the largest number of themes among all the early regional schools. Portals were limited to miniature, simplified versions of the Cluny portal format, but not to the same iconography. Historiated capitals were produced in an unparalleled profusion, the majority of them with friezelike com-

[79] Ibid., III, 346-347; Jullian, L'éveil de la sculpture italienne, 110-113; and Quintavalle, "Piacenza" Art Bulletin, LV (1973), 40-57.
[80] Porter, Lombard Architecture, III, 532: Q[VI] LEGIS ISTA [PIE] NATVM PLACATO MARIE/ SALVET T ETERNV Q[VI] SCVLP[SE]RIT ISTA GVILLELMVM/ INTRANTES CONCTI/ [SV]CVRRANT HVIC PEREVNTI.

positions. The pattern of production is more complicated than in other regions: While the stylistic range is no greater than that in Languedoc and Emilia, there is less indication that all the various hands are directly related. The Charlieu Master, for instance, seems to have had no experience working with the sculptors of the Cluny atelier.

The flowering of the medium of stone sculpture on a continuous basis in the school of Burgundy is centered on the work of the Cluny Master and his assistants. Like the school of Toulouse, the Burgundian school reveals in its early sculptures the hands of two great masters—the Anonymous of Cluny and his chief assistant, Gislebertus of Autun. These two brought the work of the original regional school to an end almost simultaneously with their creation, respectively, of the great central portal of Vézelay and the west and north portals of Autun, about 1125 or shortly afterward. Later, a second generation of hands continued the tradition of the school of Burgundy in portals, such as those on the Charlieu narthex north facade and the west facade of Saint-Julien-de-Jonzy, and in historiated capitals, as in the nave of Saint-Andoche at Saulieu. However, none of this later work advanced the development of the medium of stone sculpture.

For the purposes of this book, the focus of interest is on the oeuvre of the Cluny Master and his atelier. Surely much of this master's sculpture and that of his assistants was lost with the destruction of Cluny Abbey church, for his hand has been detected there in fragments belonging to other than the hemicycle capitals and the portal.[81] In a short period around 1120, however, he seems to have been directly responsible for the small portals at Montceaux-l'Etoile and Perrecy-les-Forges, followed by an ambitious campaign of work at the abbey of La Madeleine at Vézelay, where he had several assistants.[82] The sculptor who apparently was the chief assistant at Cluny can be detected briefly at Vézelay and then appears at Autun, where he identified himself, with an inscription on his later work, as Gislebertus.[83] Through much of the third decade of the century, Gislebertus worked on the memorable capitals of Autun while the Cluny Master led his workshop on the more extensive project of capitals at Vézelay.

Simultaneously, or shortly before the sculpture of Vézelay, another assistant of the Cluny Master made the small portal at Anzy-le-Duc.[84] Among all these works, though, the only significant advancements in the development of stone sculpture were achieved by the Cluny Master at Vézelay.

The Nave Capitals and Small Portals of Vézelay

Aside from activity at the abbey of Cluny itself, the Cluny atelier was devoted principally to the nave capitals and portals of the great Cluniac abbey of St. Mary Magdalene at Vézelay. The church is known to have been dedicated in 1104 and damaged in 1120, when the nave was burned with twelve hundred people in it. The exact nature of the damage is unclear, but presumably a major repair was underway soon afterward. The reconstruction of the nave and the addition of the narthex are thought to have been completed only by 1132, when the consecration by Pope Innocent II took place. The interpretation of the evidence is a matter of considerable controversy, but relative to the development of Romanesque sculpture as a whole, the sculpture of Vézelay best fits the period between 1120 and 1132.[85]

There are scores of historiated capitals in the nave and its aisles, representing most of the symbolic and narrative themes known in medieval sculpture. There are scenes from the Old and New Testaments, from the lives of saints, and allegorical personifications of various kinds. Among the sculptors was the Cluny Master (pls. 122, 123),[86] who apparently also brought assistants with him from Cluny. The work of several of the artists is clearly not as skilled, especially in the carving of drapery and in physical articulation. Nevertheless, at least one detail in nearly every capital proclaims his influence. From this circumstance and from the certain identification of the Cluny Master's hand in the portals, it is reasonable to assume that he was still in charge of this atelier. The chief significance of these capitals for the development of Romanesque sculpture is

[81] Conant, *Cluny*, pl. LXXVII, fig. 174.

[82] Porter, *Pilgrimage Roads*, I, 120, 122; and Francis Salet, *La Madeleine de Vézelay* (Melun, 1948), 166–167.

[83] Denis Grivot and George Zarnecki, *Gislebertus, Sculptor of Autun* (London, 1961), 175.

[84] Carol Stamatis Pendergast, *The Romanesque Sculpture of Anzy-le-Duc* (Ph.D. diss., Yale University, 1974; Ann Arbor, 1974), 167–174, and 316–341; and Zehara Jacoby, "La sculpture à Cluny, Vézelay et Anzy-le-Duc: un aspect de l'évolution stylistique en Bourgogne," *Storia dell'Arte*, XXXIV (1978), 197–205.

[85] Salet, *Vézelay*, 66–67.

[86] The work of the Cluny Master among the Vézelay capitals was discussed in some detail by Porter in *Pilgrimage Roads*, I, 91–98. This identification has been accepted by Salet, *Vézelay*, 164, and generally by others.

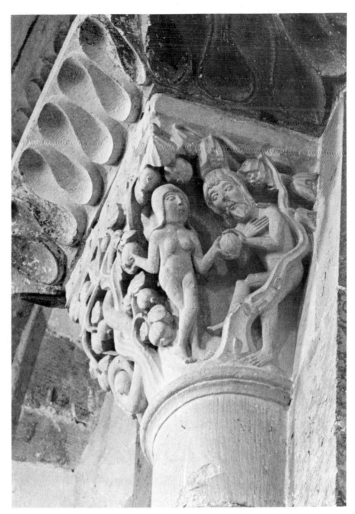

122. Stone capital with the Allegory of the Mystic Mill, after 1120, La Madeleine, Vézelay. (James Austin)

123. Stone capital with the Temptation of Adam and Eve, after 1120, La Madeleine, Vézelay. (James Austin)

that they mark among extant monuments the first instance of the use of historiated capitals throughout the structure of a church. They were not, however, arranged in a discernible programmatic sequence. Also, as with the historiated capitals at Cluny and Moissac, any conformity of the figures to the structure of the frame is merely coincidental.

The Cluny Master alone was responsible for the side portals of a group of three, located at the west end of the nave and now enclosed by an ample narthex. As on the other Burgundian portals, the sculpture was carved on the lintel and the monolithic tympanum. The portal to the right (pl. 124), which enters the south aisle, is devoted to scenes of the Incarnation on the lintel, culminating in the Adoration of the Magi on the tympanum. The

door to the left (pl. 125), which enters the north aisle, is devoted to post-Resurrection scenes on the lintel, culminating in the Ascension on the tympanum. Although the subject matter is basically narrative, and is arranged sequentially like a story, it was composed so that the scenes with dogmatic significance were placed on the tympana, thus preserving the special character of that format. The central portal (pl. 126) was carved with an extremely complex iconography, based on the Commission to the Apostles, and in a highly elaborate style that departs considerably from that of the side portals and capitals. It, too, has been identified as the work of the Cluny Master.[87] However, it poses a set of

[87] Salet, *Vézelay*, 162-165.

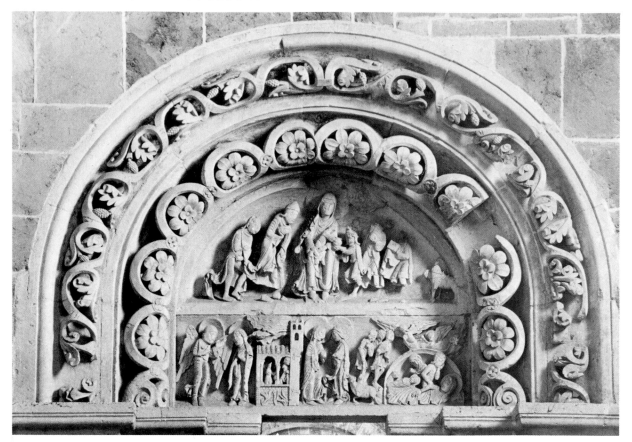

124. Stone tympanum and lintel with the Incarnation, right portal inside the narthex, 1120/1125, La Madeleine, Vézelay. (James Austin)

problems that are properly discussed in a later context and is mentioned here only because the significance of the side portals cannot be properly appraised without reference to the entire program of narthex portals.

This program marks the first instance in which three portals in juxtaposition are formally and iconographically related. The side portals present the complementary events that symbolize the life of Christ and justify the mystical import of the central portal's theme. The tripartite program itself, then, occasioned the use of the tympanum for themes other than the Ascension and Second Coming, transforming the meaning of this apselike shape into a formal convention. This program also created a situation that called for different stylistic treatments for different types of subject matter. Through these interruptions of accustomed practice, the creation of the Vézelay portals heralded the end of the original

Burgundian style and simultaneously led the way to the next important stage of development in monumental sculpture.

CONCLUSIONS

The regional schools of sculpture represent work that was continuous over the period of a generation, during which the revival of monumental stone sculpture became an accomplished fact. One of the most important aspects of the sculptural revival concerns the artists: the continuity of work signals the emergence of the full-time sculptor of stone, whose artistic orientation and technical abilities clearly separate him from the architectural workshop sculptor. Such an artist was unprecedented in the Middle Ages; he belonged to a new category of professional. In the first two decades of the twelfth century the number of these sculptors was remark-

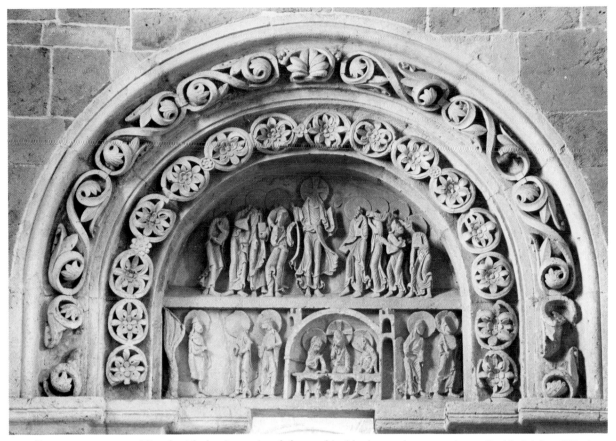

125. Stone tympanum and lintel with the Ascension, left portal inside the narthex, 1120/1125, La Madeleine, Vézelay. (James Austin)

ably small, considering the number of significant monuments that had been produced. As we have seen, each of the early regional schools initially had only one master who, in each case, had one principal assistant to share the important work on big projects. These masters probably had other assistants as well, who functioned in a more limited manner, like that of the earlier capital carvers, but we are concerned here with the sculptors of the monumental pieces. Within a decade or so after beginning to work, the principal assistants appear to have become masters in their own right and to have trained assistants of their own. With the proliferation of regional schools, the lines of filiation become hard to trace, but it is clear that the total number of artists involved in making the major monuments of Romanesque sculpture was never very large.

While some formats, such as the portal with sculptured tympanum and lintel, were apparently inherent in the iconographic ideas behind their conception, subsequent use of the same compositions for programs with different themes led to the conversion of these formats into formal conventions. However much this development may have diminished the iconographical impact of a format, though, it also led to the proliferation of thematic variety in sculpture. Throughout this period, ensembles of sculpture in structural settings were integrated into the architectural design with increasing clarity and boldness. Moreover, as the scope of plastic figural decoration increased, so also did the plastic articulation of architecture itself. All the advances of the sculptural revival which emerged in the work of the regional schools, including the ones noted earlier in connection with first adaptations of sculpture to an architectural setting, successively increased the striking parallels between Romanesque sculpture and the architectural sculpture of

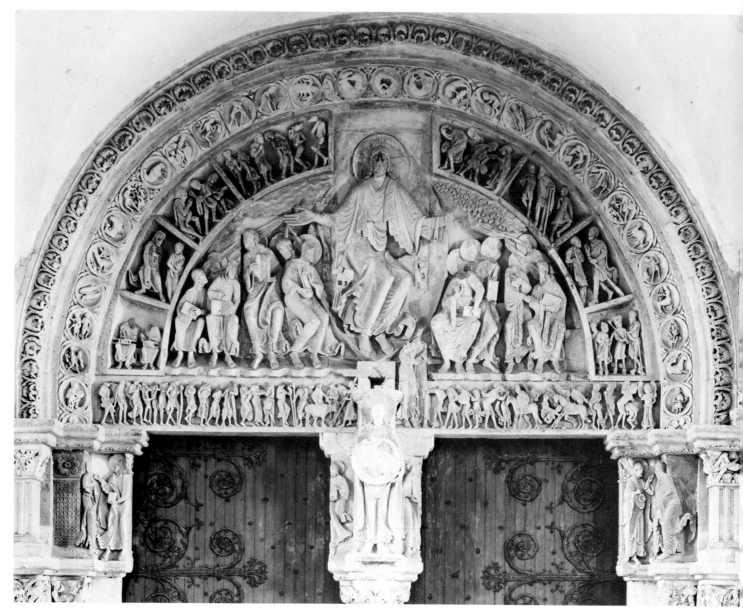

126. Stone tympanum and lintel with the Commission of the Apostles, central portal of the narthex, c. 1125, La Madeleine, Vézelay. (James Austin)

ancient Rome. In view of these correlations, it is clear that Romanesque sculpture has been very aptly named.[88]

[88] The aptness of the name, however, is an accident. The term "Romanesque" was applied because the sculpture is found in the architecture so designated (in a pejorative spirit) by Charles de Gerville in 1818. This style name was disseminated by scholars in France, such as Arcisse de Caumont, and in England, such as William Gunn, within the next few years. See Paul Frankl, *The Gothic: Literary Sources and Interpretations through Eight Centuries* (Princeton, 1960), 507–508, 519. The invention of the name was investigated by M. F. Gidon, "L'invention de l'expression 'architecture romane' par Gerville (1818)," *Bulletin de la Société d'archéologie de Normandie*, XLII (1935); cited by Frankl, 508n.

CHAPTER 5

The Great Portals

While the monuments produced by the early regional schools of sculptors revived the medium of monumental stone sculpture on a continuous basis, the style of these works was largely limited to that established by the first project in each region. Had the development of the medium continued solely in this manner, especially after the revival could be taken for granted and new regional schools began without special circumstances involving late antique models and the like, Romanesque sculpture would probably have come to resemble more and more the figural art in other media. However, about 1125, a different mode of conception, which increased the independence of stone sculpture from the artistic formulation of other media, became current in France, and it is in this area that the development of the medium continued to advance.

From the second quarter of the twelfth century on, French sculpture assumed decisive leadership through the increased size of the monuments and the complexity of their style, iconography, and format. These monuments are the great portals, the sculptures of which have always attracted the most attention. Because the portals have been much more methodically studied than the earlier monuments, it is no longer necessary to investigate the questions of date, original format, and subject matter in every case in order to discuss their place in the scheme of historical development. Hence the great portals can be conveniently studied in successive generational groups, of which there were three in the twelfth century. Because in each successive generation the range of formal variety narrows markedly, and the historical problems relevant to this book are more readily focused in a discussion of fewer examples, the number of portals examined will be reduced for the discussion of each new stage of development through the twelfth century.

The First Generation: Theophany in the Portal

The first generation of great portals comprises two distinct groups, one in Burgundy and the other in Languedoc. The chronological sequence is not a serious problem—Vézelay and Moissac respectively are accepted as the first in each group—but no precise date can be assigned to any of the monuments. The relative position of the later examples has been determined by varying interpretations of the developmental pattern of the Romanesque style. In the group stemming from Languedoc, the portals of Souillac and Beaulieu, as well as the facade of Angoulême, clearly follow Moissac, in no definite order, while the portals of Conques, Cahors, and Carennac have usually been either placed later (to honor a supposed modification of stylistic principles) or regarded as a contemporaneous subgroup with different stylistic filiations. In Burgundy, the portals of Autun, Neuilly-en-Donjon, and Charlieu (porch exterior) are generally accepted as being later than Vézelay, again in no particular order.

Although passionate advocates of earlier dates for Vézelay and Moissac are never lacking, both monuments are most safely placed around 1125 or shortly after, without a clear priority of one over the other.[1] Following the example set by these first

[1] The date of c. 1125 for the Vézelay central portal has been advanced by Francis Salet, *La Madeleine de Vézelay* (Melun, 1948), with reference to the documented rebuilding of the nave, beginning in 1120, which was presumably complete when the nave was consecrated in 1132. This date, accepted by most scholars, has been challenged by Christian Beutler, in "Das Tympanon zu Vézelay: Programm, Planwechsel, und Datierung," *Wallraf-Richartz Jahrbuch*, XXIX (1967), 7–30. Beutler, observing the intrusion of the *trumeau* figures into the composition of the lintel and tympanum of the central portal, suggested that the portal had been remodeled in the Romanesque period, a modification that he also thought he detected in the uneven setting of the stones in the tympanum. Because the iconography of this portal had been associated by Adolf Katzenellenbogen ("The Central Tym-

monuments, the most conspicuous masterpieces of this period were portals, usually enclosed by porches of various types. But other compositions, such as the sculptured facade, also played a significant role. It was in this format, beginning with the facade of Angoulême Cathedral, that monumental sculpture spread to the west of France. This first generation of great portals became outmoded in the years around 1140 with the appearance of a wholly new formulation for sculptural ensembles in regions where monumental sculpture had previously not existed, the Ile de France and Provence. The first generation of portals, then, comprises a coherent group of monuments, restricted in date to the short period between 1125 and 1140 and limited geographically to the southerly regions of France.

The great portals are distinguished from the earlier monuments of the French regional styles by several characteristics which they hold in common. Both in physical size and in scale of setting they are larger than any previous examples, with the exception of the west door of Cluny. They share a high degree of stylistic similarity, characterized by figures that are often extremely attenuated, are carved with a richly linear surface, and are animated by postures of exaggerated movement expressive of ecstatic spirituality. The figures, frequently distorted, are packed into densely crowded compositions, with striking contrasts of scale and expression. In sum, this style differs markedly from the mode of the regional schools initiated at Toulouse (Languedoc and northern Spain) and Cluny (Burgundy).

Technically, there are other new developments. In the carving the degree of undercutting is significantly greater so that the limbs and heads of most of the smaller figures are completely detached from the relief ground. Moreover, in contrast to previous practice, the stones of the tympana are not cut to contain either the whole composition or entire individual figures.[2] Instead, the largest figures may be carved on several stones, which may also include all or part of other figures. Although the compositions do conform to the shape of the tympanum—with the largest figures in the center and a diminution in size toward the sides—their execution defies the internal order of the masonry because the disposition of the figures does not correspond to individual stones. Altogether, there is a remarkable new degree of virtuosity in the carving and a new freedom from the individual slabs of stone.

The degree of artistic subtlety that can be discerned in the most ambitious monuments suggests that there was a process of elaborate premeditation behind the design. Meyer Schapiro has demonstrated this point amply in his lengthy formal analyses of the Moissac tympanum and the Souillac

panum at Vézelay," *Art Bulletin*, XXVI [1944], 141–151), with the scriptural text of the sermon preached by Urban II to initiate the Crusades, Beutler contended that a date just after the Second Crusade was preached at Vézelay (1146) was more likely for the modified state of the portal. Working backward, archaeologically and chronologically, he proposed that the first version of the door was a Pentecost with the Dove of the Holy Spirit at the center (rather than Christ) and that the date was of the 1130s. My own examination of the portal, however, leaves me convinced that the tympanum has not been remodeled nor could it have been in the manner Beutler proposed without extremely intricate piecing and patching, which manifestly has not occurred. The only reason Beutler's proposal could be taken seriously is that it might explain how the portions of the central tympanum that contrast most markedly with the style of the lateral doors could be attributed to stylistic evolution in the intervening years. There is no impediment, however, to a date in the 1120s, probably about 1125 to 1130. The dating of the Moissac portal, on the other hand, must be determined around a minor conflict between documentary and archaeological evidence expressly related to the portal. The chronicle of Moissac written by Aymery de Peyrac, about 1400 (recorded by Ernest Rupin, *L'abbaye et les cloîtres de Moissac* [Paris, 1894], 350–351), ascribes the portal to the time of Abbot Durandus (died 1085) and Abbot Ansquitil (died 1115). Recognizing the advanced character of the portal, scholars who give credence to this document assign the latest possible date (1115) to the sculptures. However, the interval of nearly three centuries between the carving of the portal and the writing of the chronicle leaves ample time for mistaken historical traditions to grow. On the south porch which frames the portal is the figure of a monk with a halo, inscribed ROGERUS BEATU[S] and universally accepted as a representation of Abbot Roger (died 1131). Hence completion of the portal certainly occurred after "Blessed Roger" died. An interval of seventeen years or so for production of the sculpture is not untenable, but so many changes occurred in the early twelfth century that a more precise date is needed for such an important monument. Because the porch setting of the portal overlaps the junction of tower narthex and nave, it is clear that this setting represents a modification in the original scheme for the church. And since there is some variation in style in the sculpture, the tympanum could have been made first for a different location, namely the west end of the nave, for which it is exactly the right size. The best estimates of the date of the tower narthex place its lower-story ribbed vault with canted responds at c. 1125, consonant with the other earliest known ribbed vaults with canted responds in France, in the Jumièges chapter house and the crossing bay of Duclair church. The tympanum, then, could be dated to c. 1125, and the side reliefs to the time when the south porch was added, c. 1130 and afterward. An earlier date is not likely but it would be entirely reasonable to ascribe the entire campaign to a brief period just after 1131.

[2] For diagrams of the stones in the various tympana see Raymond Oursel, *Floraison de la sculpture romane*, II, La Nuit des Temps (La Pierre-qui-vire, 1976), figs. 104 (Vézelay), 109 (Moissac), 110 (Beaulieu), 111, 112 (Autun) in contrast to fig. 101 (Toulouse, Porte Miègeville).

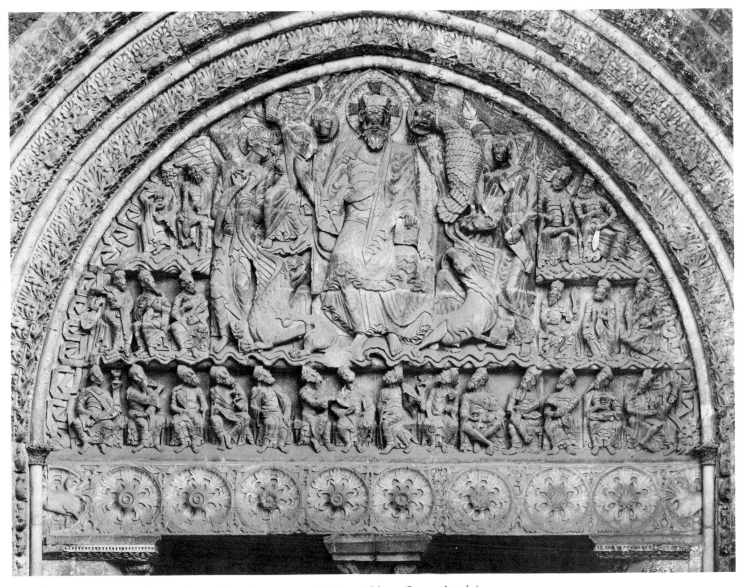

127. Stone tympanum with the Second Coming, c. 1125, Moissac Abbey. (James Austin)

fragments.[3] An example of the Moissac Master's exquisite sensibilities is illustrated by the Twenty-four Elders of the Apocalypse (pl. 127, 128). Faced with representing a large number of similar figures, all seated, he invented at least four completely different leg positions and then varied the repetitions sufficiently so that no two are exactly alike. These variations are combined with a greater number of arm positions so that finally every figure has an individual

appearance. There are further variations in beards, crowns, garments, and objects held, but the faces are nearly identical because the Elders after all do not represent personalities. This variety is controlled by and subordinated to a greater purpose of unity through the positions of the Elders' heads. Although each head is held at a different angle with a different axial relationship to the body, all look directly at Christ. The figures farthest from the center merely glance to the side or slightly upward while those in the middle lean backward to look directly up. This arrangement has the added advantage of increasing the sense of physical tension toward the

[3] Schapiro, "Moissac," 464–531; and *idem*, "The Sculptures of Souillac," *Medieval Studies in Memory of A. Kingsley Porter*, II (1939), 359–387.

128. Detail of stone tympanum with Elders of the Apocalypse, Moissac Abbey. (Courtauld Institute—M. F. Hearn)

center and thereby creating an emotional climax, amplified by the violent movement and tension of the tetramorph figures around the sharply contrasting, frontal, and immobile Christ. One can go much further, but the issue is already clear at this point: all the sculptures in this style will yield equal and different aesthetic delights, none of which could have been created by "primitive intuition" or rote tradition.

Finally, the great portals also introduced an unprecedented complexity into the subject matter represented. The former importance of the Ascension–Second Coming theme as the most appropriate for the sacred portal remained undiminished. But in the principal monuments the theme was usually weighted toward one aspect or the other and greatly elaborated. Detailed vignettes, or other themes related only by their abstract theological meaning, were added to the tympanum or juxtaposed in adjacent locations. In each of the portals the program was composed to present a very detailed and specialized interpretation of the basic theme. Indeed, each program is remarkable not only for the embellishment of its theme but also for the variety and singularity of its elaboration.

Since the meaning of the program was undoubtedly of paramount concern to those responsible for the creation of the sculpture, a concise examination of the subject matter is a fitting place to begin an analysis of the contribution that these portals made to the art of sculpture. Vézelay and Moissac, as the initiators of this new phenomenon, and Angoulême, as the first example of a strikingly new format, merit the larger share of attention. Only the most ambitious of the other portals will be treated and only to the extent that they serve to represent the variety and singularity of the programs.

More than three decades ago, Adolf Katzenellenbogen demonstrated that the central tympanum at Vézelay (pl. 126) represents an elaboration of Christ's Commission to the Apostles just prior to the Ascension.[4] On the tympanum proper, Christ bestows with visible rays of power the apostolic gifts of teaching, healing, and salvation of souls upon his

[4] Adolf Katzenellenbogen, "Vézelay," 141–151. For different interpretations of the iconography as a Pentecost, see the communications by Francis Salet to the *Bulletin de la Société nationale des antiquaires de France*, in the vol. for 1945–1946–1947, 62–69, 262, 267–268.

Disciples. Around them on the archivolt, varying incidents of conversion, teaching, and healing take place. Some figures reject the message of Christ, others are won over, and still others receive it willingly as if by anticipation. Those in need of the gifts of healing represent different types of physical, mental, and moral illness. Beneath the tympanum, on the lintel, is a procession of diverse peoples representing allegorically an assortment of nations and races, cultural archetypes, and professions to whom the Apostles must minister. The Apostles Peter and Paul stand on the lintel overlapping the tympanum, symbolic of the Church as intermediary between Christ and man. Around the whole composition are roundels representing the Labors of the Months and the signs of the Zodiac, symbols of temporal life in the world until the Second Coming. The composition rests on jambs and a central pier (the *trumeau*), where six Apostles flank the figure of John the Baptist. John holds the symbol of the Lamb of God, prophesying the mission of Christ which is to be perpetuated by apostolic succession in the Church. Thus the theme of the Ascension has been enlarged to combine Christ's triumph and the fulfillment of the promise of salvation with a moving explication of the nature and function of the instrument of salvation, the apostolic Church (see frontispiece).

Unlike the portals of Cluny and Toulouse, this composition is not merely the allegorization of a historical event and its accompanying prophecy in a setting symbolic of triumph, it is the image of a theological mystery, a visible manifestation of an invisible reality. As a composite image it presents simultaneously and in a comprehensible arrangement a series of concepts that would be both difficult and tedious to elucidate in a linear sequence of thoughts and words. And as an image it has a concrete reality both more explicit and more convincing than words. It is more than a sermon or even a manifesto; it is a revelation. The special nature of the central portal is underlined by the contrast with the lateral portals, representing the Incarnation on the right (pl. 124) and the Ascension proper on the left (pl. 125). All of the scenes represent specific moments in the life of Christ from the Gospels. The lintels are composed as narrative sequences, respectively the events of the Nativity and those immediately preceding the Ascension. The climactic events, the Adoration of the Magi and the Ascension, were reserved for the tympana, thus endowing them with dogmatic significance beyond their nar-

rative importance. Significantly in both cases, the tympanum compositions are arranged so that the Virgin and Christ are located on the vertical axis in a frontal position. The representation of scenes in the three portals therefore follows a strict hierarchy both in location and nature of the image from narrative to dogmatic to theophanic.

This subtle program of three coordinated doors marks the emergence of the triple portal composition, a formulation that acquired considerable significance in the next generation of great portals, especially at Saint-Denis, Chartres, and Saint-Gilles. That the three doors correspond to the three vessels of the interior, the nave and aisles, undoubtedly reflects a greater concern for functional utility than for formal rationality, for the lateral doors are placed off-center within their respective segments of the facade. However, the construction of lateral doors created apt new focal points for sculptural decoration. To be sure, the lateral doors of the original west facade at Cluny (pl. 96) were not included in the sculptural program, so it was not necessary to do so at Vézelay. But the decoration of three doors presented the opportunity to introduce iconographic pairs which could enhance by amplification or by contrast the theme of the central portal. Originally, as at Cluny, these portals punctuated a simple sectional facade (the narthex was added later, as was Cluny's), but, unlike at Cluny, the facade articulation seems not to have contributed to the meaning of the program. Instead, at Vézelay, the relationship of the sculptural program to the architectural form appears to reside primarily in the exploitation of the opportunity to incorporate three doors in a unified iconographical program.

At Moissac, a similar complexity obtains but in a very different kind of composition. The basic theme of the tympanum (pl. 127) of the south porch has always been recognized as the Second Coming. Christ Enthroned, in an auriole of glory, is accompanied by the Living Creatures and two seraphim and is adored by the Twenty-four Elders. As an Apocalyptic theme, this image has traditionally been associated with the illustration of the Book of Revelation and its source endlessly sought among the manuscripts of the Commentaries of Beatus on the Apocalypse, especially those of Spain and Gascony. The search, however, has been unrewarded and the true nature of the image was not perceived until 1963 when Louis Grodecki articulated the obvious: the various components are not to be found

together either in the Beatus Apocalypse illumina-tions or in the Scriptures.[5] The two seraphim repre-sent the vision of Isaiah (6:2) and Christ, enthroned and surrounded by the Living Creatures and the Elders, represents the Second Coming (Revelation 4:4, 7–8). The Living Creatures, however, are visualized not according to the Scriptural descrip-tion of the four beasts of the Apocalypse, but with books, as the symbols of the Four Evangelists. More-over, in Apocalypse illuminations, the scene with the Elders is represented with the Lamb enthroned rather than the figure of Christ. The figure of Christ in an auriole of glory does not even appear in these images of the Second Coming. Taken together, the components of the image of Christ—throne, auriole of glory, and the four Evangelists—comprise the image of Christ in Majesty, a theme of triumph. The seraphim signify that this appearance of Christ in Majesty is a vision. Grodecki concluded that the symbols of the Evangelists should be interpreted as symbolic representations of the Gospels; the Elders, of the Old Testament; and the whole as a vision of Christ in the midst of the Scriptures. As Yves Christe summarized this interpretation: "The ap-parition of the Son is then conceived as a revelation of the Holy Mysteries and of the hidden realities of which Scripture is only an allegorical transposi-tion."[6]

Nearly everyone who has studied the Moissac portal agrees that the tympanum may have been intended for a location beneath the tower porch at the end of the nave. Its size is exactly right and both the themes of the ancillary sculptures and the pre-sent setting of the portal suggest that the program of the tympanum was expanded shortly after it was carved. On either side of the portal there are com-plex relief compositions—on the right (pl. 129), the events of the Incarnation from the Annunciation to the Flight into Egypt; on the left (pl. 130), the vices of Luxuria and Avarice and the parables of the rich fool (Luke 12:16–34) and Dives and Lazarus (Luke 16:19–31). The juxtaposition of the two compo-sitions as parallel components suggests that the lat-ter is an allegory of the Last Judgment, balancing the former as the fulfillment of the Incarnation. The figures of St. Peter (pl. 131) and Isaiah, on the left and right outer jambs of the portal, would thus signify respectively the Church as the arbiter of salvation or damnation and the prophecy of salva-tion through the Incarnation. At the same time they also relate to the tympanum, along with the *trumeau* figures which are assumed to be St. Paul and Jeremiah (pl. 132), as symbols of the New and Old Testaments. It is important to note that since these images are not located in tympana they are repre-sented in narrative or allegorical formulations rather than in dogmatic ones. Thus the hierarchical princi-ple of image type and location is honored at Moissac as at Vézelay.

The setting of the Moissac portal (pl. 133) seems to reflect the sculptural program. In basic form it resembles a triumphal arch. Indeed, the lateral sculptures recall the placement of reliefs on the Arch of Titus in Rome, and such flanking attached col-umns are an indispensible element of a triumphal arch. Surmounted by figures, of a monk (St. Be-nedict?) on the left and the late Abbot Roger (Be-atus) of Moissac on the right, these columns recall those of the Roman Arch of Constantine. Other arches could have served as models, of course, but knowledge of Rome was sufficient among the Cluniacs to inspire emulation of the actual Roman monuments. Undeniably the composition was de-liberate since the portal structure awkwardly over-laps the juncture of the tower porch and the nave. The figures on the columns imply that monasticism itself shares in the triumph of Christ. The portal thereby extends the iconography of the cloister in a statement to the world outside the monastery.

After Vézelay and Moissac introduced the new type of great portal into Burgundy and Languedoc respectively, the creation of other portals in these regions was largely a matter of adaptation and varia-tion. Although their successors are great works of art, the investigation of which is rewarding to any-one interested in this sculpture, a full discussion of them is not needed in order to study the develop-ment of monumental stone sculpture. Nonetheless, an appreciation of the originality and singularity of

[5] Louis Grodecki, "Le problème des sources iconographiques du tympan de Moissac," *Moissac et l'Occident au XIe siècle: Actes du Colloque international de Moissac, 1963* (Toulouse, 1964), 59ff. (also in *Annales du Midi* LXXV [1963], 387–393). Since this chapter was written, a comprehensive survey of studies on the Moissac tym-panum iconography has been compiled by Noureddine Mézoughi, in "Le tympan de Moissac: Études d'iconographie," *Les Cahiers de Saint-Michel-de-Cuxa*, IX (1978), 171–200. While many different putative sources for the Moissac imagery have been suggested, none includes all its components. Stressing Lan-guedocien sources of the iconography, Mézoughi nevertheless gamely reports criticisms offered by Grodecki which emphasize the Burgundian character of the portal, hence also its lack of direct dependence on prototypes in art.

[6] Yves Christe, *Les grands portails romans: Études sur l'iconologie des théophanes romanes* (Geneva, 1969), 26.

129. Stone and marble reliefs of the Incarnation cycle, right side of the porch, c. 1125/c. 1131, Moissac Abbey. (Courtauld Institute—M. F. Hearn)

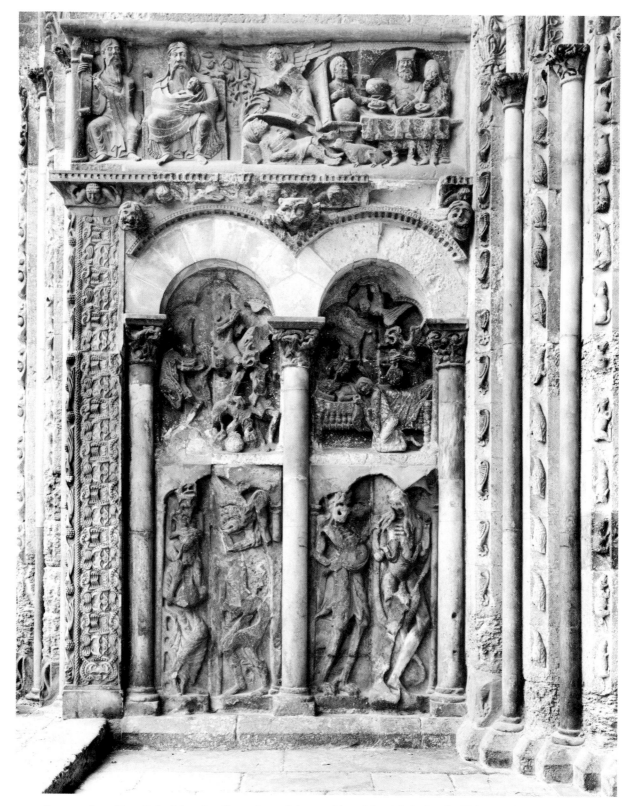

130. Stone and marble reliefs of Avarice, Luxuria, and the parables of the rich fool and of Dives and Lazarus, left side of the porch, c. 1125/c. 1131, Moissac Abbey. (James Austin)

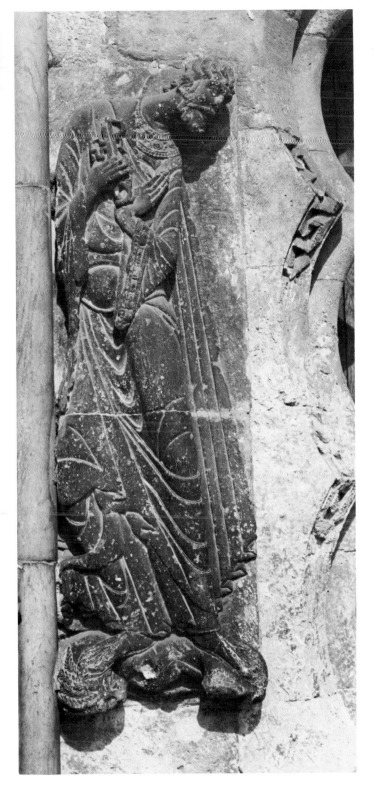

131. Stone relief of St. Peter, left jamb of the portal, c. 1125/c. 1131, Moissac Abbey. (Courtauld Institute—M. F. Hearn)

132. Marble *trumeau* with Jeremiah, west portal, c. 1125/c. 1131, Moissac Abbey. (Courtauld Institute—M. F. Hearn)

133. South porch portal of the west tower, c. 1125/c. 1131, Moissac Abbey. (James Austin)

their iconographical programs does contribute to a better understanding of both the style and the general conception of these portals, and it will be treated here for that purpose. As we have seen, the portals of Vézelay and Moissac initiated a thematic division between the Ascension and the Second Coming, with emphasis on one or the other for the tympanum image. In the succeeding portals at Beaulieu, Conques, and Autun, the Last Judgment, an aspect of the Second Coming, is emphasized.

Beaulieu (pl. 134), with the cross held by angels behind the figure of Christ, combines the Vision of

Matthew (14:30), in which "the Sign of the Son of Man" accompanies the Second Coming, with the Last Judgment. Indeed, as Yves Christe has observed, Christ does not participate in the Judgment and there is no separation of the good and the bad. Rather, Christ appears as in a Roman Imperial triumph with the instruments of the Passion borne as trophies by flying angels.[7] His appearance with the Apostles is likewise not Scriptural unless the

7 *Ibid.*, 123. The cross, represented as a gemmed processional cross, is explicitly in the tradition of the trophy of triumph.

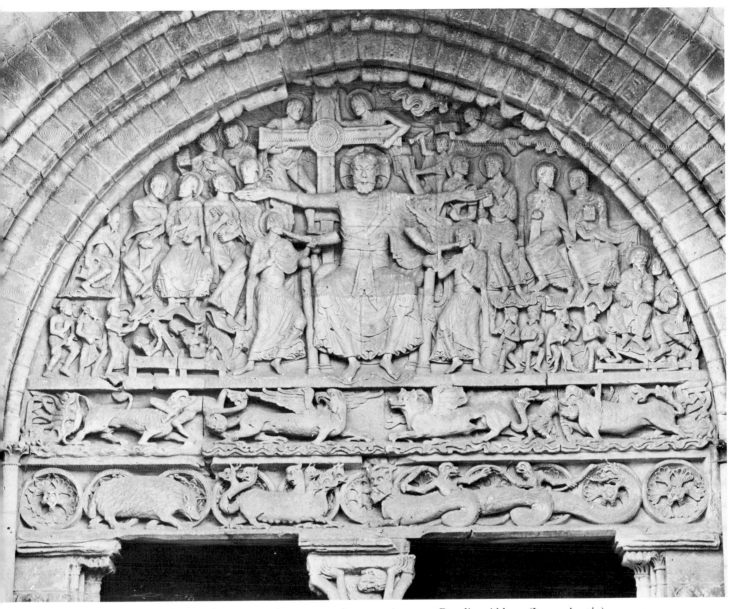

134. Stone tympanum with the Last Judgment, south nave portal, c. 1130/c. 1135, Beaulieu Abbey. (James Austin)

Apostles are symbolic of Christ's prophecy that when he returns in glory they shall sit beside him on thrones, judging the twelve tribes of Israel (Matthew 19:28). Only the angels blowing trumpets, symbolic of the Second Coming (Revelation 4:1), and the awakened dead (Revelation 20:12–13) expressly signify the Apocalypse. Even the resurrected mortals awaiting judgment (pl. 135) depart from traditional imagery in being clothed and in exotic costume at that. Their significance has been the subject of much conjecture, but in my opinion the best explanation is that they represent heretics of the type loosely labeled Albigensian. The costumes seem to represent those of heretical proselityzers who went about dressed incognito as jesters, hence the double- and triple-peaked hats. Their gestures correspond to the ritual of recantation prescribed by the Church.[8] Because the heretics denied the hu-

[8] This explanation was advanced in an unpublished paper by Roy Petre who, at my suggestion, investigated the possible relevance of the "Albigensian" heresy to the Beaulieu portal in my seminar on Romanesque sculpture in Summer, 1969. (The original paper is available to readers in the Frick Fine Arts Library.) For the early history of Albigensianism see Ignatius von Döl-

manity and Passion of Christ, the image of Christ showing his wounds and surrounded by the Instruments of the Passion assumes a very pointed meaning. As they also believed in an equality of God and Satan, the reference to the forces of evil as beasts, derived from Old Testament descriptions,[9] denies that equality. The lower side reliefs of the portal, which derived its general composition from Moissac, represent Daniel in the Lion's Den and the Temptations of Christ. The image of Daniel is at once an image both of miraculous escape through divine intervention and of the prophecy of Christ's Incarnation in human form; the Temptation scenes amplify the theme of his humanity. The whole composition, then, seems to be a representation of Christ's triumph at the end of time with an affirmation of his dual nature as both divine and human, triumphant over the forces of Satan. It functions simultaneously as a theophany, an affirmation of

orthodoxy, and as a message of hope to heretics who recanted.

At Conques (pl. 136), Christ in Majesty (enthroned, with auriole and Evangelists) is also in triumph, with the cross once again borne by angels. But this time he is accompanied by personified Virtues and the resurrected mortals, good and bad already separated. And this time also, he holds the Book of Life and raises his right hand in judgment. Below him, the Blessed are already in Paradise and the Damned in Hell. Of this tympanum Christe observed that the presence of Christ as Judge seems merely a pretext for moralizing about good and evil.[10] It is entirely possible that the theme was enlarged in side reliefs,[11] as at Moissac and Beaulieu, but if so, the portal was later remodeled to exclude them.

The portal at Autun (pl. 137) follows an established image for the Last Judgment, a formula of Byzantine origin transmitted to western Europe via Italy and Ottonian Germany.[12] Christ, enthroned in an auriole, is borne by four angels and flanked by the Virgin, enthroned on his right, and by Enoch and Elijah, on his left. Beyond these figures are angels on each side blowing trumpets; hence the image is identified as the vision of St. John in the Revelation. The Apostles hover on Christ's right, where St. Peter greets the Blessed at the Gates of Paradise, and the Judgment, dominated by the weighing of souls, takes place on his left. Beneath him, on the lintel, the mortals awake, apparently already apprehending their fate. But more than any earlier image of the Last Judgment, that of Autun is richly anecdotal. At the weighing of souls, a devil is trying to tip the scales but is overpowered by the resisting efforts of the Archangel Michael. On the lintel, three children touchingly clutch at the sleeves of an angel. As at Beaulieu, some figures of the resurrected are clothed in order to give them generic identity. Among them, one is a monk and two are pilgrims to Jerusalem and Compostela, specified by the badges on their cloaks which show a cross and a scallop shell. They are located just to the left of Christ's feet, looking up in antic-

linger, *Beiträge zur Sektengeschichte des Mittelalter* (München, 1890); Charles Lea, *A History of the Inquisition of the Middle Ages*, 3 vols. (New York, 1887); Jacques Maudale, *The Albigensian Crusade* (New York, 1967); C. Schmidt, *Histoire et doctrine de la secte des cathares ou albigeois*, 2 vols. (Paris, 1849); H. J. Warner, *The Albigensian Heresy*, 2 vols. (New York, 1967). For Albigensian beliefs and practices that required recantation and for the required acts of recantation, see Schmidt, *Cathares*, II, 189; Lea, *Inquisition*, I, 95; Denis de Rougement, *Passion and Society* (London, 1940), 95; Gertrude Jobes, *Dictionary of Mythology, Folklore, and Symbol* (New York, 1961), 63; A. Francis Davis, *A Catholic Dictionary of Theology* (London, 1962), I, 55; and Louis Réau, *Iconographie de l'art chrétien* (Paris, 1957), II, 402ff. For all aspects of the Beaulieu program other than the clothed mortals, the best study is that by Jean Marie French, *The Innovative Imagery of the Beaulieu Portal Program: Sources and Significance* (Ph.D. diss., Cornell University, 1972; Ann Arbor, 1973). She is fully aware of the implications of heresy for this program and has explored and explicated them in a very substantial way. Regarding the clothed mortals, however, she accepts the conclusion of Henry Kraus, "Anti-Semitism in Medieval Art," *The Living Theatre of Medieval Art* (Bloomington, Ind., 1967), 139–144, that these figures represent Jews who are presenting their claims for salvation. Kraus reached this conclusion on the basis of identifying the peaked caps of the figures as Phrygian caps, frequently used in medieval art to denote Jewish figures. He did not account, however, for the fact that most of the caps in question have two or even three peaks, hence are not Phrygian. French did not test Kraus's attribution in her study, even though the Jewish identification of the figures represents the only aspect of the program in which she did not find references to Christian (Petrobrusian) heresy. In all other respects, though, her study confirms Petre's reading of the Beaulieu portal program.

[9] Petre located the descriptions of the beasts as follows: bear, Daniel 7:5; seven-headed monster, Revelation 13:1–4, of which the four-headed monster may be a variant; griffon, Daniel 7:4; the mouth of hell and the lion as symbols of Satan, Réau, *Iconographie*, I, 110. No source was found to explain the fire-spitting monster, although Kraus, *The Living Theatre of Medieval Art*, 39, explains this figure as a symbol of the Devil.

[10] Christe, *Les grands portails*, 126–127.
[11] For a discussion of the original composition of the Conques portal, see L. Balsam and Dom Angelico Surchamp, *Ruergue roman*, La Nuit des Temps (La Pierre-qui-vire, 1963), 29–34. For all aspects of Sainte-Foy at Conques, see Christoph Bernoulli, *Die Skulpturen der Abtei Conques-en-Rouerge* (Basel, 1956).
[12] Christe, *Les grands portails*, 127–130, and *passim*.

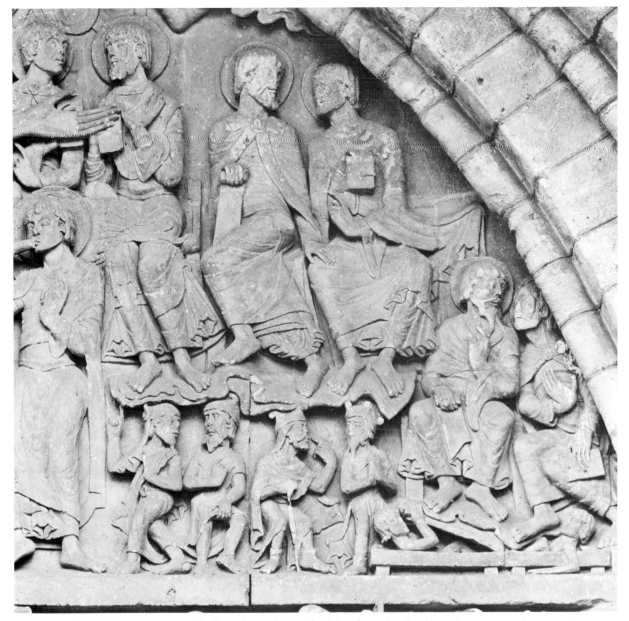

135. Detail of stone tympanum with Apostles and mortals rising from the dead, south nave portal, c. 1130/c. 1135, Beaulieu Abbey. (James Austin)

ipation of grace. The implication, clearly, is that they approach judgment with special advantages. The Damned, on the other hand, suffer terrible tortures at the hands of gruesome monsters. The message of the whole is emotionally gripping as it reveals the awesome terror of the last day.

Although the first great portals were set in porches, there were soon impressive achievements in other formats as well. Angoulême Cathedral marks the first instance in which a sculptural pro-

gram occupied the whole facade of a church (pl. 138).[13] Its most conspicuous element is the Ascen-

[13] The date of the Angoulême facade has never been firmly established. Because details on the interior (vault profiles, capitals) differ from bay to bay in the nave, the sequence of construction seems to have been from west to east, thus suggesting that the facade was the first work. The juncture of the facade block and the nave, however, does not appear to have been achieved without adjustments, so it is highly likely that the facade was built after the nave. The association of the beginning of construction with a dedication performed in 1110 by Bishop Girard cannot, by

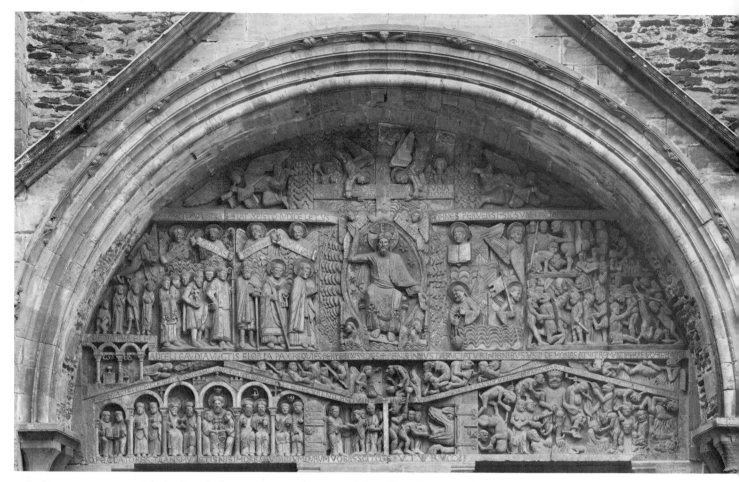

136. Stone tympanum with the Last Judgment, c. 1130/c. 1140, Sainte-Foy, Conques. (Hirmer Fotoarchiv)

sion[14] located at the top of the central axis with the Virgin and Apostles just beneath, but the Second Coming aspect of the theme is included in the program, signaled by the Elders, the Damned, and the Elect. The location of these various figures does not follow a precise order: There seems to have been

some arbitrariness in the placement of some figures (with more Elders on one side than on the other) and in the exposition of the theme (with the Elect beneath Christ and the Damned at the outer edges of the composition). Further confusion results from the loss of the original sculptures of the five tympana, located above the central door and in its flanking pairs of blind arches, and of the equestrian figures in the intermediate zone. Ostensibly the tympana enlarged upon the general theme with scenes of the Calling of the Apostles, and the equestrian figures apparently represented Christian emperors. Nevertheless, neither the assemblage of themes nor the quality of carving is equal in interest to the significance of this type of facade as an architectural setting for such a sculptural ensemble.

Disfigured by the nineteenth-century restoration by Paul Abadie, the facade now has twin towers, but formerly, and perhaps originally, it had a hori-

general agreement, apply to the sculpture. In a discussion of the dating problem, Charles Daras (*Angoumois roman*, La Nuit des Temps [La Pierre-qui-vire, 1961], 78, 86) accepted the clearly date for the facade and suggested that the sculpture was added later. But an examination of the manner in which the sculpture was installed and of the pattern of arcades that frames the sculpture clearly indicates that the sculpture could not have been added. The documents and photographs in Pierre Dubourg-Noves, *Iconographie de la cathédrale d'Angoulême, de 1575 à 1880* (Angoulême, 1973), *passim*, support the theory that the facade was built after the nave was well underway, so that a date of c. 1130 for the sculpture accords with both its style and the probable sequence of construction.

[14] Daras, *Angoumois roman*, 85–86, identified and discussed all elements of the iconographical program.

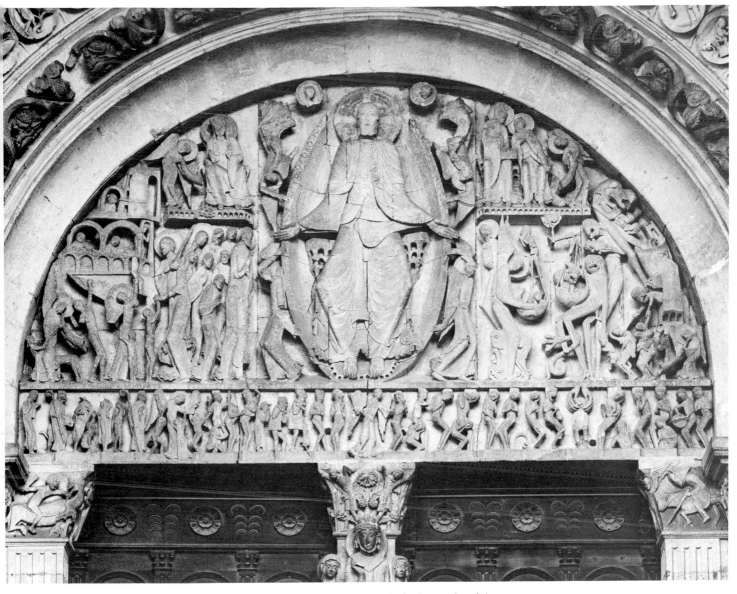

137. Stone tympanum with the Last Judgment, after 1125, Autun Cathedral. (James Austin)

zontal cornice which defined it as a rectangular block, independent of the spatial configuration of the church behind it (pl. 139). If not the first screen facade in France, it was certainly the first with monumental sculpture and its importance lies in the combination of the two. Although the screen facade is constructed as an autonomous block, it is neither an abbreviation nor a relative of the Carolingian westwork. The fact that the church itself is composed of a series of square bays covered with domical vaults could signify general inspiration from Byzantine architecture, seen by the French crusad-

ers a few decades earlier. Byzantine influence has been definitely discerned in the nearly contemporaneous cathedral of Périgueux, for which the church of San Marco in Venice was the model. So it is possible that the Angoulême facade was based on a Byzantine example, such as the late-seventh-century church of the Koimesis in Nicaea.[15] But if

[15] For the date, see Richard Krautheimer, *Early Christian and Byzantine Architecture*, Pelican History of Art (Harmondsworth and Baltimore, 1965), 205–208; for an illustration and discussion of the Nicaea facade, see Fritz Saxl, "Lincoln Cathedral," *Archaeological Journal*, CIII (1946), 111–112.

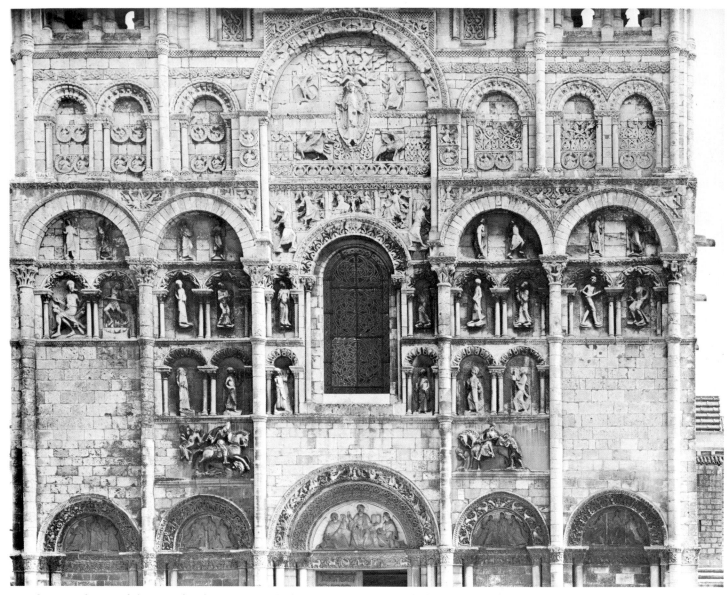

138. Stone sculpture of the west facade, c. 1125 and after, Angoulême Cathedral. (James Austin)

so, the imitation was at best vague and the motive was less likely one of formal emulation than conceptual inspiration based on iconographical meaning. More than likely this inspiration was obtained elsewhere.

The ultimate source of all screen facades, whether in architecture or in other media, is the antique *scaenae frons*, the architectural formula for the theater stage.[16] Long used in Christian art as a setting for sacred personages or symbols, a reduced, symbolic

version of the *scaenae frons* had appeared on sarcophagi and in mosaics and illuminated manuscripts.[17] As a facade, it had been applied to archi-

[16] Erwin Panofsky, *Renaissance and Renascences in Western Art* (Stockholm, 1960), 130.

[17] The relationship of arcaded settings to the *scaenae frons* was recognized by A. M. Friend, Jr., "The Portraits of the Evangelists in Greek and Latin Manuscripts," *Art Studies*, V (1927), 115–150, especially 143–145. While the arcades he discussed were in manuscript painting, examples in sculpture can be found in Marion Lawrence, "City-Gate Sarcophagi," *Art Bulletin*, X (1927), 1–45; and *idem*, "Columnar Sarcophagi in the Latin West," *Art Bulletin*, XIV (1932), 103–185. I am indebted to Carra Ferguson O'Meara for pointing out to me the relevance of the *scaenae frons* to the screen facade tradition and for the references cited above.

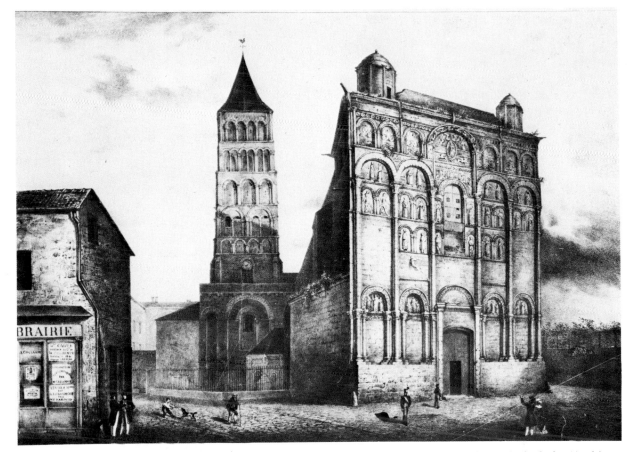

139. Engraving by F. Courtin of the west facade in the 19th century, Angoulême Cathedral. (Archives Photographiques—Paris)

tecture most notably in the Palace of the Exarchs (after 712) and the church of San Vitale (526–547) in Ravenna. The appropriation of such a structural framework, originally intended as a theatrical backdrop, was probably stimulated initially by the meaning which accrued to it in Antiquity. Vitruvius, in *De architectura* (after 27 B.C.), refers to it as signifying an *aula regiae*, or royal palace (V.vi,8),[18] a term obviously not in use in Augustan Rome. What he meant undoubtedly was the house of a theatrical king, which was the appropriate setting for serious drama. This meaning was obviously important because the *scaenae frons* would later become the formula for Roman Imperial palace facades, associated with the concept of ceremonial appearance of the ruler, which was eventually exaggerated as a theophany. The *scaenae frons* was subsequently adopted by Christian art along with other

Imperial symbols and employed for the same purpose. The meaning of such a structural framework was certainly retained in the Carolingian tradition (see the golden altar of Basel, pl. 11) even though it had long since disappeared from architectural usage. Its revival in western France in the early twelfth century remains largely unexplored and the attribution of it to Byzantine influence is not very satisfactory. Moreover, the architectural history of Angoulême Cathedral itself is still sketchy. However, the putative intention to represent the *scaenae frons* in its facade, regardless of its specific historical source, can be accorded a high degree of probability. If that interpretation is correct, the architecture of the Angoulême facade in itself symbolically represents both the house of the Lord and the setting of a theophany, including even a window of appearances in stained glass. Together with the program of sculpture, the facade expands the Ascension–Second Coming theme into a revelation of the apotheosis of Christ the divine ruler and judge.

[18] Frank Granger, ed. and trans., *Vitruvius on Architecture*, The Loeb Classical Library (Cambridge, Mass., 1931), 1, 289.

The factors of style and technique which isolate the great portals from their respective regional traditions, the chronological and geographical clusters which tend to relate them as a coherent group, and the characteristic of highly singular subject matter which they share indicate that these monuments had a commonality of inspiration if not also of origin. But this commonality does not seem to have been grounded in the sculptors. While the style of the great portals marks a break with that of the two early regional schools in France, it does not necessarily signal the disappearance of the regional schools of sculptors. Nor is there evidence in the great portals of the hands of sculptors from other regions. As we shall see later, there are sometimes even sufficient technical similarities between details of the carving in the older regional styles and the new mode to identify the hand of a sculptor in the regional school. However, it is not possible to credit the conception of the great portals to an individual sculptor, nor to describe the development of the great portals in a linear filiation from a single atelier.

Scholars have frequently noted that Moissac, as the first portal of this period in Languedoc, is more nearly related to the style of Burgundy—more specifically, Cluny—than to the Toulouse school style or any other regional mode. That Vézelay and Autun are similarly related to Cluny has never been seriously questioned. Moreover, Yves Christe has adduced sufficient evidence to indicate that the iconography of most of the portals has roots in the theology of the abbots of Cluny.[19] While this stylistic and iconographical association with Cluny is somewhat impressionistic, it suggests, even before additional evidence is marshaled, that the great portals are related as part of a specifically Cluniac phenomenon.

The Cluniac network of monasteries was vast, but it is significant that Vézelay, Moissac, and Beaulieu were included in it. Also, the bishop of Autun who sponsored construction of that church was a Cluniac. And among the monuments listed but not discussed, the abbey of Charlieu and the priory of Carennac had a Cluniac affiliation.[20] Souillac, Angoulême, Cahors, and Conques were sufficiently proximate to Moissac and Beaulieu to have been influenced by them. Finally, some of the iconographical themes and motifs in the portals refer expressly to causes sponsored by Cluny. The pilgrims to Jerusalem and Santiago on the Autun lintel recall Cluniac sponsorship of both. According to Katzenellenbogen, the basic theme of the Vézelay tympanum, Christ's Commission to the Apostles, referred to the Crusade, again of Cluniac sponsorship: its Scriptural source served also as the text for Urban II's sermon initiating the First Crusade.[21] The antiheretical cast of the Beaulieu tympanum reflects the concern of the abbot of Cluny, Peter the Venerable, about a group of heretics who were related in beliefs to the Albigensians.[22] There is, then, a good deal of circumstantial evidence that the iconography was inspired by Cluny.

The inspiration, however, is not likely to have been transmitted through the sculptors, as we have seen. Instead, the complexity of the subject matter of the portals indicates that the iconography came via the ecclesiastical patrons. As Katzenellenbogen has demonstrated, the iconography of the Vézelay tympanum was derived from many sources. From the Scriptures alone there are references to texts in all four Gospels, the Acts of the Apostles, and the prophecies of Isaiah, Jeremiah, and Zechariah. But there are also references to classical authors such as Pliny and to the church fathers, such as Augustine, Jerome, and Isidore of Seville, not to mention various medieval theologians.[23] Clearly only a highly educated person could accomplish such a task, much less conceive it. Katzenellenbogen attributed the program to Peter the Venerable himself, who was abbot of Vézelay until 1122, when he became abbot of Cluny. Katzenellenbogen assumed that Peter composed the program before he left Vézelay, which is possible but not at all necessary. The holdings of the library at Vézelay are unknown, but all the works mentioned above are known certainly to have been at Cluny.[24] And at Vézelay the prestige of his authorship of the program would only have increased after he became abbot of Cluny. At Cluny, Peter is known to have been preoccupied with scholarly activity,[25] of which the portal programs

[19] Christe, *Les grands portails*, 50–57.
[20] Joan Evans, *Monastic Life at Cluny, 910–1157* (London, 1931), 28–31.

[21] Katzenellenbogen, "Central Tympanum at Vézelay," 148–151.
[22] Evans, *Monastic Life*, 109.
[23] Katzenellenbogen, "Central Tympanum at Vézelay," 142–150.
[24] Evans, *Monastic Life*, 99–100; and Jean Adhémar, *Influences antiques dans l'art du Moyen Age français* (London, 1939), 243.
[25] Evans, *Monastic Life*, 38–46, 109.

can be regarded as a plausible outcome. It is well within the circumstances of such a situation and of the psychological constitution of such a man that he would submit these programs to various abbeys of the Cluniac order, either on request or by command. However, even if Peter personally composed several of the programs, at least those situated in Cluniac monasteries, it is likely that his initiative was imitated by other scholarly monks and that some of the extant programs represent other authorship.

The theme of theophany which runs through the great portals was a topic of particular interest at Cluny. As Christe has pointed out, the nature of theophany was the subject of a sermon written by Peter the Venerable on the Transfiguration, in which he discussed this divine appearance as a prefiguration of the Second Coming.[26] Much earlier, the concept of theophany had been more fully explored by Abbot Odilo in a sermon on the Incarnation for the feast of the Nativity.[27] But this interest was more than topical because it was inseparably related to a particular theological and philosophical tradition. In both cases, these erudite abbots were drawing upon the thought of Dionysius the Pseudo-Areopagite, set forth in *The Celestial Hierarchies*. This fifth-century Greek work had been introduced into the West only in the ninth century, most importantly through the Latin translation and commentary written by John Scott Eriugena (815?-877?), the great scholar of the court of Charles the Bald.[28] A copy of Eriugena's treatise had been given to the library of Cluny[29] in the tenth century by Abbot Mayeul, who is recorded as having spent many nights passionately reading it. In the early eleventh century, Raul Glaber, in his *Historiae sui temporis*, attested to continued interest in this treatise at Cluny as well as in others related to it—the *Ambigua* of Maximus the Confessor and the writings of the Cappadocian fathers, all of which had been absorbed by Eriugena in his major treatise, *De divisione*

naturae. Hence it is clear that the Dionysian tradition was already well known at Cluny before the time of Peter the Venerable. However, at no earlier time did the Dionysian tradition flourish more in the West than in the second quarter of the twelfth century. This renewed interest is reflected in the *Commentarium in Hierarchiam Coelestam*, written by Hugh of Saint-Victor in Paris, c. 1137. The influence of this expanded commentary, based on the translation by Eriugena, is manifest in the writings of Abbot Suger on the new construction in his abbey church at Saint-Denis (1137-1144).[30]

Dionysius the Pseudo-Areopagite had been largely responsible for the acceptance of (nonnarrative) images in the Christian East and for the veneration of these images as emanations from the divine which lead man's thoughts to God. In *The Celestial Hierarchies*, he deals with the question of how God is made known to man through visible manifestations of the invisible. God, he teaches, is understood through images. The Scriptures are made comprehensible through the use of (verbal) images and even the Eucharist is a symbolic image of the Christian's participation of Jesus. Indeed, it is only through such images that it is possible to contemplate and know God:

> For the mind can by no means be directed to the spiritual presentation and contemplation of the Celestial Hierarchies unless it use the material guidance suited to it, accounting those beauties which are seen to be images of the hidden beauty, the sweet incense a symbol of spiritual dispensations, and the earthly lights a figure of the immaterial enlightenment.[31]

These images which reveal the unknowable are theophanies and their purpose is to raise man's spirit to the spiritual realm:

> The divine theology, in the fullness of its wisdom, very rightly applies the name *theophany* to that beholding of God which shows the Divine Likeness, figured in Itself as a likeness in form of that which is formless, through the uplifting of those who contemplate the Divine; inasmuch as a Divine Light is shed upon the seers through it, and they are initiated into some participation of divine things.[32]

[26] Christe, *Les grands portails*, 99 and 101, n 17.

[27] *Ibid.*, 29-33.

[28] The basic work on Eriugena is Maieul Cappuyns, *Jean Scot Erigène* (Louvain, 1933). The first translation into Latin was probably that of Hilduin, Abbot of Saint-Denis, after 827; see P. G. Théry, *Hilduin traducteur de Denys: Etudes dionysiennes*, 1 (Paris, 1932), 1-9.

[29] The copy of Eriugena's treatise that was introduced into the Cluny library by Abbot Mayeul still exists and is preserved in the Bibliothèque Nationale as MS. nouv, acq. lat. 1490; see J. Barbet, ed., *Johannes Scote Eriugenae, Expositiones in ierarchiam coelestem, Corpus Christianorum*, XXXI (Turnholt, 1975), xviii-xx.

[30] Erwin Panofsky, *Abbot Suger, On the Abbey Church of Saint-Denis and Its Art Treasures* (Princeton, 1946), 18-22; and Christe, *Les grands portails*, 41-51.

[31] See *The Mystical Theology and The Celestial Hierarchies*, 2d ed., trans. the Editors of the Shrine of Wisdom (Fintry, Brook, near Godalming, Surrey, 1965), *The Celestial Hierarchies*, chap. 1, 22.

[32] *Ibid.*, chap. 4, 32.

The images found in the great portals are revelations or visions of theological concepts which are invisible and difficult to grasp except in material form. Because the images remove the veil from these holy mysteries they correspond to the Dionysian notion of theophany.

In the second chapter of *The Celestial Hierarchies*, Dionysius discusses the form such images or theophanies should take:

> The most holy Mysteries are set forth in two modes: one by means of similar and sacred representations akin to their nature, and the other through unlike forms designed with every possible discordance and difference.

Of these two modes, one is clearly preferable for the representation of the most exalted images:

> Now although such sacred forms are more venerable and seem in one sense to surpass the material presentation, even so they fail to express truly the Divine likeness which verily transcends all essence and life. . . . But the exposition of the hidden Mysteries by the use of unlike symbols accords more closely with that which is ineffable.

Unlike or discordant images are preferable because they uplift the mind more than do harmonious images. Moreover, they reduce the possibility that we might suppose they represent the actual forms of celestial beings:

> But lest this thing befall those whose mind has conceived nothing higher than the wonders of visible beauty, the wisdom of the venerable theologians, which has power to lead us to the heights, reverently descends to the level of the inharmonious dissimilitudes, not allowing our irrational nature to remain attached to these unseemly images, but arousing the upward-turning part of the soul, and stimulating it through the ugliness of the images.[33]

Dionysius, in these passages, appears to describe a mode of presentation parallel in character to the distortions of figural disposition, configuration, and expression found in the tympana of the great portals. He even justifies such a mode as appropriate to the theophanic subject matter represented there. However, what he literally meant by "dissimilar" forms was, for instance, an image of the Deity as the Sun of Justice or as the Morning Star. By discordant

forms he meant lowly images taken from earthly experience, such as a cornerstone, a fragrant ointment, or the admirable quality of a wild beast. And by ugly forms—he cited that of an angel—he undoubtedly meant images conceived as combinations of two different types of earthly creatures.[34] Hence Dionysius's remarks concerning the forms of images did not address issues relating to style and, accordingly, they did not directly inspire the creation of visual images either in his own time or later. Rather, the importance of the Dionysian tradition for style was established by Eriugena when he separated the aesthetic aspects from the doctrine, especially as regards the passages above. While Dionysius wrote of form in a philosophical sense, Eriugena often shifted his meaning to convey an aesthetic concept of form.[35] By the twelfth century, the aesthetic character of Eriugena's translation and commentary had acquired a more forceful and explicit connotation, witness the commentary by Hugh of Saint Victor. In Hugh's version, the discussion of discordant and ugly forms was cast in a distinctly aesthetic mold, in which the *deformitas* of such forms was given a highly positive interpretation to signify expressive beauty (as opposed to formal beauty).[36] When the Dionysian concept of images could be understood in terms of modes of beauty, then it could also inspire the style of artistic images. That this shift did not occur until the early twelfth century is probably the reason why such a style was not applied earlier to images of theophanies.

In Latin Antiquity, deformity in art had been associated only with subject matter that was inherently ugly, for which it was deemed appropriate.[37] St. Augustine preserved this notion of the decorum

[33] *Ibid.*, chap. 2, 24-25.

[34] *Ibid.*, 27.

[35] Edgar de Bruyne, *Etudes d'esthétique médiévale* (Bruges, 1946), I, 359 (cited by Christe, *Les grands portals*, 50). For the most up-to-date edition of Eriugena's Latin text, see *Expositiones*, ed. Barbet, chap. 2, 20-55.

[36] de Bruyne, *Esthétique médiévale*, II, 215-218. For the Latin text of Hugh's *Commentarium*, see *Patrologia Latina*, CLXXV, cols. 955-990.

[37] Plutarch, writing about poetry in terms of visual images, summed up the views of the ancients on the appropriateness of ugliness: "For it is repugnant to the nature of that which is itself foul to be at the same time fair; and therefore, it is the imitation—be the thing beautiful or ugly—that, in case it do express it to the life, is commended; and on the contrary, if the imitation make it a foul thing to be fair, it is dispraised because it observes not decency and likeness." Quoted from A. H. Clough and William W. Goodwin, eds. and trans., *Plutarch's Essays and Miscellanies* (New York, 1909), II, 50: "How a Young Man Ought to Hear Poems."

of ugliness for Christianity in the *Sentences*, when he observed that "the image of a demon, who is in reality ugly, is in itself beautiful, provided that the likeness is accurate."[38] There is no evidence (so far as I know) in the Carolingian era either in art or in literature to suggest that this concept had changed by the time of Eriugena. By the early twelfth century, however, this sense of decorum had been expanded to include the representation of subjects that were too powerful or awesome to be expressed with normal formulations of beauty. A document of singular importance in this respect attests not only to this transformation of the concept of deformity in art but also relates it directly to the abbey of Cluny. When a plowman uncovered an antique head of Mars near Meaux, Fulk of Beauvais wrote about it in a letter to Abbot Hugh of Cluny, couching his description in a poem. The relevant portion follows:

> He found a sculptured head like none of us,
> [like] nothing which lives, [like] nothing which man fashions:
> a rough-looking, frightful head,
> and nonetheless, in this frightfulness, beautiful;
> with terrifying light, and this very terror becomes it;
> beautiful in its wildness, with its wild mouth for its purpose,
> because a form of deformed beauty would be appropriate.[39]

Although this poem concerns an antique work of art it represents medieval attitudes. Regarding both the nature of the style and the decorum of its use, it conveys in every respect the aesthetic applied to the great portals. It also implies a distinction between formal and expressive modes of beauty, each of which has its appropriate application. This separation is clearly in evidence in St. Bernard's *Apologia* (c. 1125), in which he distinguishes the formal beauty of the images of saints inside the church from the expressive beauty of the capitals in the cloister.[40]

His famous phrase "that marvelous and deformed beauty, that beautiful deformity," echoes the same concept of expressive beauty that was represented so fully in the poem by Fulk of Beauvais and which was implicit in the commentary on Dionysius by Hugh of Saint-Victor. Although St. Bernard was applying it to his description of grotesque capitals, its meaning already belonged to a much broader aesthetic context.

Since the concept of expressive beauty was already well established by 1125 and was certainly known at Cluny, the aesthetic implications in Eriugena's commentaries on *The Celestial Hierarchies* could have been readily perceived by Peter the Venerable or any other scholarly monk. Because both the subject matter and the style of the great portals are implicit in the twelfth-century interpretation of the treatise, the likelihood of its having been the actual source of inspiration is considerable. The possibility is increased by evidence for the conscious formulation of style to be found in the exact correspondence between variations in stylistic mode and types of subject matter in the great portals. In order to demonstrate this correspondence it is necessary to review the monuments.

The concept of expressive beauty was applied to the great portals in different ways. Because the central tympanum at Vézelay (pl. 126) represents a mystical moment—the bestowal of the apostolic powers of the Church by Christ upon the Apostles—the theme was appropriately represented with a highly charged expressiveness. In addition to the unstable stances of the figures there is also a maximal use of linear ornament, employed in the manner of Byzantine paintings of the Transfiguration in which Christ's drapery folds are outlined in gold in order to identify the moment as a theophany. Moreover, the figures are packed into the composition in a way that distinguishes the scene from a narrative event. The difference between the nature of this special moment and the vignettes on the lintel and archivolt is immediately clarified by the substantial diminution of expressive intensity in the style of the figures. Since each vignette is an allegory of a specific situation in the apostolic ministry, the style is appropriately graceful rather than deformed except when the allegory is couched in terms of ugly subjects. As we have already seen in connection with the side portals, there is a further distinction in style between those narrative events and the allegorical themes of the central portal. The use of formal

[38] Cited from de Bruyne, *Esthétique médiévale*, II, 105.

[39] I am grateful to my colleague Anne Weis and to William Panetta and Nicholas Jones of the Classics Department, University of Pittsburgh, for this translation of the Latin text: *Nulli par nostro sculptum caput invenit unum,/ nulli quod vivat quodque fecit homo./ Horrendum caput et tamen hoc horrore decorum/ Lumine terrifico, terror et ipse decet,/ Rictibus, ore, ferro, feritate sua speciosum,/ Deformis formae forma quod apta foret.* The text of the entire poem is given by Adhémar, *Influences antiques*, 243. For quotation and discussion of the passage above, see also de Bruyne, *Esthétique médiévale*, II, 105.

[40] For a translation of the relevant portion of the *Apologia*, see Elizabeth Gilmore Holt, *A Documentary History of Art*, I, *The Middle Ages and the Renaissance*, rev. ed. (New York, 1957), 22.

or expressive beauty, then, was a function of the character of the subject matter.

At Moissac (pl. 127) in the theophany of Christ among the Scriptures at the Second Coming, the use of the expressive style in the tympanum was modulated to produce a violent contrast between the immobile form of Christ and the turgidly mobile figures of the Evangelists and seraphim. In the latter, abrupt twists and turns in the corporeal axes were used to maximal effect. As described earlier, the figures of the Elders become more expressively mobile the closer their proximity to Christ. In the side reliefs (pl. 129, 130), on the other hand, the use of the expressive style is severely tempered, employed only in the evil figures in the allegory of Virtues and Vices. On the jambs and *trumeau*, the Apostles and prophets are represented with a degree of stylistic expressiveness appropriate to authoritative and visionary character (pls. 131, 132).

The Last Judgments of Autun (pl. 137) and Beaulieu (pl. 134) represent the most terrifying of imaginable events. To a certain extent the entire scenes were designed with expressive deformity, but this deformity was markedly intensified in the symbolic beasts representing Satan at Beaulieu and in the figures of demons and the Damned at Autun. The Last Judgment of Conques (pl. 136), on the other hand, was not intended to be a terrifying theophany but much more an allegory of good and evil. Accordingly, its style is one of formal rather than expressive beauty and deformity was therefore appropriately employed only in the images of demons and the Damned. Unlike the Last Judgments and similar to the Commission to the Apostles at Vézelay, the Ascension–Second Coming facade of Angoulême is a mystical vision (pl. 138). The upper portions, devoted to this vision, were represented in a highly expressive style. Although the tympana of the lower portion of the program have been heavily restored, their scenes, ostensibly devoted to the Calling of the Apostles, were conceived in terms of formal beauty.

All these great portals, then, were designed with a careful observance of the appropriateness of the style to the subject matter. The formal sophistication that characterizes their sculpture testifies to a new degree of style consciousness and a new exactness of stylistic intention. It is undoubtedly no accident that the precedent for this consciousness, as well as for the original invention of subject matter, was in the hemicycle capitals and west portal at Cluny. Significantly, the great portals, like that at Cluny, were painted in brilliant colors.[41]

Because the iconographical programs and the expressive style of the great portals apparently emanated from Cluny, it is not surprising that this new mode of sculpture did not replace the regional styles in Italy and Spain: the Cluniacs were never welcomed in Italy and, despite their sponsorship of the pilgrimage to Santiago, they had no establishments of primary importance in Spain. Even in France, the great portals appeared only in those areas where the Order of Cluny exerted its greatest influence. Since there is no evidence that the sculptors of Languedoc and western France came from Cluny, the means of transmission was not through the artists themselves. The explanation for the dissemination from Cluny is suggested by two aspects of the Moissac portal. First, as was noted earlier, the style of this portal has a closer general resemblance to the sculpture of Burgundy than to any other. Second, the technique of representing drapery folds with overlapping planes has its closest precedent in the sculpture of Cluny. It would appear, then, that there was a slight Burgundian influence at Moissac, but an indirect one which did not communicate most of the technical details of Burgundian sculpture. Such an indirect influence would well have been transmitted through the agency of a drawing made to set down the design of the ensemble. Such drawings have already been postulated for the Cluny sculptures and if once used there, it would be surprising if this means were not used again. Since a drawing from Cluny would necessarily have come from that scriptorium, it would certainly have been formulated in a style native to Cluny.

If technical and stylistic evidence for the Cluniac origin of the great portal programs can be faintly discerned at Moissac, it is abundantly provided by the Burgundian monuments. Although the expressive style of the tympana at Vézelay and Autun is significantly different from the style of the reconstituted portal of Cluny, the technical mannerisms of their carving can be traced directly back to Cluny. As Francis Salet has observed in the central portal at Vézelay (pl. 126), the facial features, the drapery folds carved in overlapping planes (on all the figures except those of Christ and the Apostles), and the fluttering garments are exactly those of the side

[41] Salet, *Vézelay*, 145; and Denis Grivot and George Zarnecki, *Gislebertus, Sculptor of Autun* (London, 1961), 27.

portals (pls. 124, 125). The side portals, as we have seen earlier, are technically identical with some of the nave capitals (pls. 122, 123) and these works can definitely be attributed to the hand responsible for the hemicycle capitals at Cluny and the larger portal fragments there (pls. 73, 75, 83).[42] At Autun, the style of the portal (pl. 137) is very different from that of the capitals inside the church, but the technical mannerisms of both signify the sole authorship of Gislebertus. George Zarnecki has convincingly traced the hand of Gislebertus to the smaller fragments of the Cluny portal and to the Adam and Eve capital (pl. 82) from the interior of the church where Gislebertus almost certainly began work as an assistant to the Cluny Master.[43] There can be little likelihood of a parallel stylistic evolution in both sculptors to account for the later works, however, because in both cases the new style appeared suddenly, in close proximity to immediately prior sculpture. It seems the first generation of portals in Burgundy was produced by the original sculptors of that region. Hence the change in style was not due to any "progress" effected by the sculptors themselves, but to the nature of the commissions devised by their patrons.

In Languedoc, unfortunately, no evidence has come to light which would link the sculptors of any of the great portals to a monument in the regional style initiated by Bernardus Gelduinus. Despite a great similarity of style among them, none of these sculptors has been definitely associated with more than one of the great portals in the first generation. Nevertheless, their similar interpretations of the new mode cannot be found beyond the geographical limits of the original Toulouse school (that is, Lan-

guedoc and northern Spain) so there is no reason to suppose that these sculptors originated elsewhere. It may well be that they do represent a new generation of artists, especially since the revival of sculpture in Languedoc had begun thirty years before, and apparently earlier than in Burgundy. Even so, the appearance of the new style in Languedoc was just as sudden and just as full-blown from the beginning as in Burgundy. And it was equally related to the new iconography and to the purpose of the programs.

Focillon's theory that the new style resulted inherently from the mature adaptation of sculpture to the framework of an architectural setting does not suffice to explain the appearance of the great portals. Indeed, when the portals are all compared for the purpose of discerning their common qualities, Focillon's theory disintegrates. Technically, all the great portals suggest a rejection of the law of the frame. Iconographically, the architectural setting seems to have been conceived more for the sculpture than the other way around. Stylistically, the mode of carving is related more to the subject matter than to the formal circumstances And in all three respects they signal a disruption of development and a sudden shift of direction. The great portals, we may conclude, were not the inevitable result of a particular formal aspiration on the part of the sculptors but were inspired by a new conception for the use of sculpture by the patrons. While the portals could not have been so effectively created without the technical virtuosity of the artists available, there is no evidence to suggest that the new style would ever have appeared without the impetus of the particular combination of theological and aesthetic ideas behind it.

The Second Generation: Theology Made Manifest

About 1140, a new stylistic phase occurred in monumental sculpture which eclipsed the expressive style of the first generation of great portals. It was introduced in the new facades of the abbey of Saint-Denis, c. 1137–1140, of the cathedral of Chartres, c. 1145–c. 1155, and of the abbey of Saint-Gilles, late 1140s.[44] Although each of these monu-

[42] Salet, Vézelay, 162–165.
[43] Grivot and Zarnecki, Gislebertus, 175. Willibald Sauerländer, "Gislebertus von Autun: Ein Beitrag zur Entstehung seines künstlerischen Stils," Festschrift Theodore Müller (Munich, 1965), 17–29, has attempted to demonstrate in considerable detail that the new style adopted by Gislebertus in the Autun tympanum was derived from the wall paintings of the Cluniac grange chapel at Berzé-la-Ville. While the similarity is very close indeed, it is something of a distortion of the circumstances surrounding the creation of the Autun tympanum in the context of all the great portals to imply that Gislebertus's new style was somehow peculiarly the result of influence from a Byzantine current in the stream of Cluniac painting. The aesthetic conception of this style of painting could possibly have been in the background of considerations when the tympanum was planned, but if so it was a matter of seeking the mode appropriate to the theme. In the context of Gislebertus's oeuvre, both his previous works (see the next section of this chapter) prove the style of the Autun tympanum to be an isolated episode in his career.

[44] The dates of the Saint-Denis and Chartres portals have long been accepted. As for Saint-Denis, the date is figured backward from the known dedication of the facade in 1140, as recorded by

ments has a distinctly different sculptural ensemble, their common characteristic is that they have triple portals that are formally integrated into the architectural setting itself rather than being merely inserted, appended, or randomly applied as in the first generation. They also share a more disciplined relationship between figural style and architectural disposition than the earlier portals. For these reasons they have always been thought to represent a great watershed in the development of monumental sculpture. However, in this discussion I shall attempt to demonstrate that the differences from the first generation portals are primarily distinctions of degree rather than of kind and that the extent of continuity is remarkable indeed.

One of the most compelling attributes of these monuments is the subtle interweaving of the various themes of subject matter so that the composition itself becomes more precisely a vehicle of meaning. All three have been so thoroughly studied that it is neither necessary nor practical to present a full discussion of the iconography except to note some recent revisions. But it is important to review the general thrust of the iconographical programs in order to discern their relationship to the figural style and to determine the place of this style in the development of monumental stone sculpture.

The three portals of the Saint-Denis (pl. 140) facade were terribly mutilated by destruction during the eighteenth century and by misguided intentions during the restoration of the church in the nineteenth century.[45] Nevertheless, through the patient labors of Sumner Crosby and others, a fairly complete knowledge of the subject matter has been restored to us. On the splayed jambs of each portal (pl. 141) were the earliest known column-statues, with approximately life-size figures of the royal lineage of Christ in the Kings and Queens of the Old Testament (pl. 142). In the left and right tympana respectively were scenes depicting the martyrdoms and saintly acts of St. Dionysius (or Denis) and his companions Eleutherius and Rusticus. Flanking the doors of these lateral portals were carved the signs of the Zodiac and the Labors of the Months. On the central tympanum and its archivolts was placed the Second Coming (pl. 143), presaging the Last Judgment with the resurrection of the dead on the lintel and with the Wise and Foolish Virgins, symbolic of the Elect and the Damned, on the jambs. In the middle of the central doorway was a *trumeau* figure of St. Denis parallel in size to the column-statues.[46]

The relationship of these various themes in the program is not an obvious one but it becomes explicable in the light of what is known about the abbey itself and the patron of the new facade project, Abbot Suger. Saint-Denis was a royal abbey and the necropolis of the kings of France. Suger, abbot from 1122 to 1151, had been a close associate and lifelong friend of Louis VI (reigned 1108–1137). Louis, whose energetic efforts raised the French monarchy from the position of a weak overlord to that of an effective ruler, had, at Suger's urging, compromised with the Church over feudal patronage and clerical investiture, thereby earning the honorary title of "eldest son of the Church." Suger's association with the royal house continued under Louis VII (reigned 1137–1180), whom he served as adviser and finally as regent during the Second

Suger himself in *De Administratione* (for a translation, see Erwin Panofsky, *Abbot Suger, On the Abbey Church of Saint-Denis and Its Art Treasures* [Princeton, 1946], 44–47). The date of the Chartres portal is reckoned forward from the date of the fire that swept the city on September 5, 1134, and which apparently spurred the reconstruction of the west front. Documents that refer first to the new north tower and then to the south date from the mid-1130s and the early 1140s respectively. The linkage of the two towers with the triple portal is thus judged to have been begun no later than 1145 and been completed in about a decade. For a concise account of the reasoning, together with the major literature on the subject, see Willibald Sauerländer, *Gothic Sculpture in France, 1140–1270* (London, 1972), 383–386. The date of the facade of Saint-Gilles, on the other hand, has been much disputed, with attributions ranging within the twelfth century from the first quarter to the last. At present, the question seems to have been settled in favor of the late 1140s by two independent studies. Whitney Stoddard, in *The Facade of Saint Gilles-du-Gard: Its Influence on French Sculpture* (Middletown, Conn., 1973), focuses on archaeological evidence and Carra Ferguson O'Meara, *The Iconography of the Facade of Saint-Gilles-du-Gard* (New York, 1977), dates the sculpture on iconographical grounds related to the Second Crusade.

[45] Summer Crosby, "A relief from Saint-Denis in a Paris Apartment," *Gesta*, VII (1969), 45–46.

[46] *Idem*, "The West Portals of Saint-Denis and the Saint-Denis style," *Gesta*, VIII (1970), 508; and *L'abbaye royale de Saint-Denis* (Paris, 1953), 36–37. See also Sauerländer, *Gothic Sculpture*, 379–381, for a summary account made before the Crosby articles were published but with reference to the then extant literature on the iconography of the Saint-Denis portals. Paula Lieber Gerson, in *The West Facade of St.-Denis: An Iconographic Study* (Ph.D. diss., Columbia University, 1970; Ann Arbor, 1973), has written one of the most comprehensive studies on the portals. Her analysis of the portal program, written before Crosby's 1970 article was published, stresses the theological import of the iconography, especially of the central portal and its original bronze doors, more than the interrelationship between the themes of Christ and Saint-Denis on all three portals.

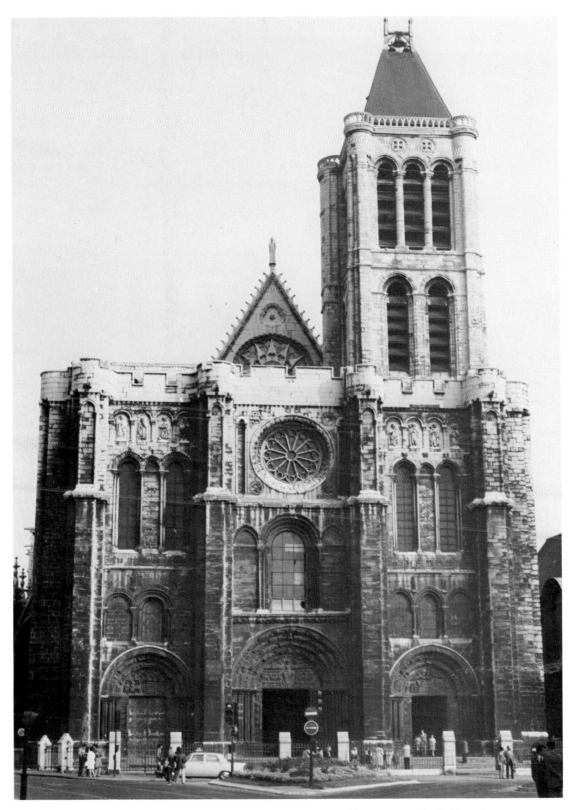

140. The west facade, late 1130s, Saint-Denis Abbey. (Courtauld Institute—M. F. Hearn)

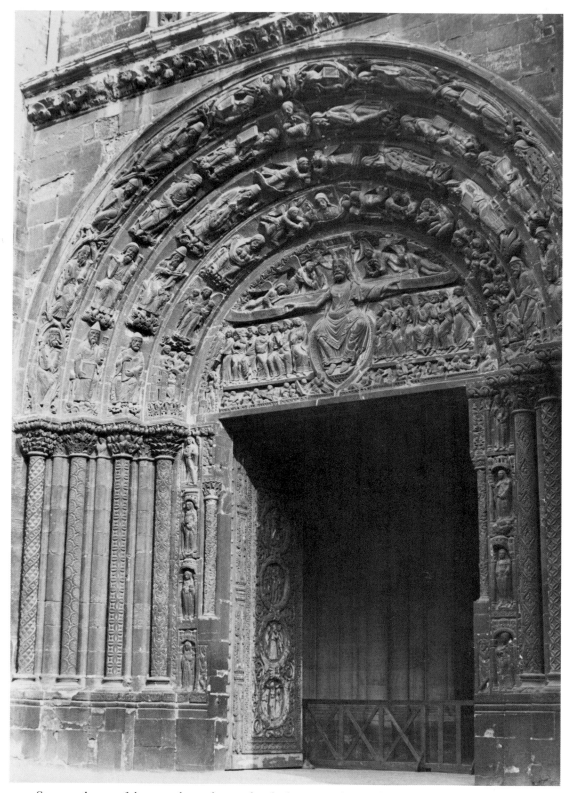

141. Stone sculpture of the central portal, west facade, late 1130s (restored), Saint-Denis Abbey. (Courtauld Institute—M. F. Hearn)

142. Engravings of the Montfaucon drawings of the portal column-statues, Saint-Denis Abbey. (Courtauld Institute—G. Zarnecki)

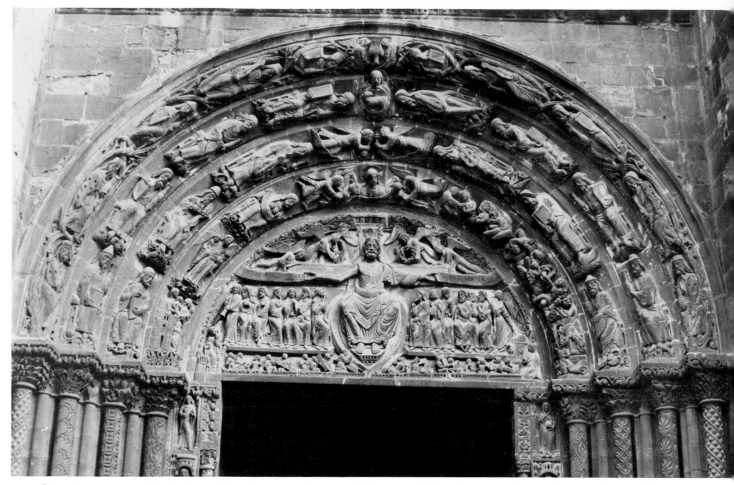

143. Stone tympanum with the Second Coming, central portal of the west facade, late 1130s (restored), Saint-Denis Abbey. (Courtauld Institute—M. F. Hearn)

Crusade. The policy of cooperation between the Church and the Crown was the most important result of this relationship. The abbey of Saint-Denis thus became the ecclesiastical symbol of this policy not only because it was the royal necropolis and the seat of Suger's activity but also because its patron, St. Denis, was the patron of the French monarchy.[47] Hence, in the sculptural program, Christ and St. Denis functioned respectively as symbols of the Church and the Crown in addition to their inherent meaning.

In this program, the intermingling of Old Testament kings and queens with prophets has been interpreted as a prefiguration of *regnum* and *sacer-*

dotium in harmony.[48] With St. Denis on the *trumeau* in the midst of these column-statues, this symbol of the French monarchy transposed the entire group of figures into an allegory of the cooperation between Church and Crown which Suger had arranged. The themes on the lateral tympana, devoted to St. Denis (the first tympana in France given over to a patron saint), testified to the validity of this saintly patron of the monarchy. The temporal symbols flanking

[47] For the most complete, accessible, biographical account of Suger, see Panofsky, *Abbot Suger*, 1–15.

[48] Adolf Katzenellenbogen, *The Sculptural Programs of Chartres Cathedral: Christ, Mary, Ecclesia* (Baltimore, 1959), 27–36. While Katzenellenbogen made, to my mind, a convincing case for the iconographical meaning of the Saint-Denis column-statues, I cannot fully agree to his imputation of the same meaning to those at Chartres. Gerson, *West Facade*, 140–167, has proposed that the column-statues had a more precise and individual identity which was related specifically to the iconography of the portal in which they were located.

these doors, the signs of the Zodiac and the Labors of the Months, acknowledged the earthly character of the monarchy, which shall pass away at the end of time. The Second Coming on the central tympanum justified the role of the Church, in cooperation with the Crown, as the instrument of Christ's mission on earth (represented by the bronze doors). The implication of the program, in sum, was that the monarchs of France both guard and reflect the truth of Christ until the end of time, responsible to Christ but also anointed by him to rule.

The triple west portal of Chartres Cathedral (pls. 144, 145), known since the early thirteenth century as the Royal Portal, is the most complex among the great portals and also one of the best preserved. Its iconographical program has been much discussed and has long been considered settled, at least regarding the main points.[49] However, new questions and new insights can still result in substantial refinements in the interpretation of the individual motifs. As at Saint-Denis, the splayed jambs are embellished with column-statues, both male and female, crowned and nonroyal (pl. 146). Above them is a narrative frieze of the life of Christ carved on the continuous range of capitals. The tympana and lintels of the three portals have been associated with the Incarnation (right), Ascension (left), and Second Coming (center), elaborated with complementary or amplificatory figures in the archivolts. This facade marks the first instance in which the Ascension is separated from the Second Coming. The distinction of the two themes heralds a newly schematic way of describing the significance of the life of Christ as the mission of salvation. Hence within the iconographical program the Advent announces the historical beginning, the Ascension confirms the completion, and the Second Coming fulfills the promise of Christ's mission. A tripartite composition is especially appropriate to this schematic treatment of iconography.

Although the column-statues have been thought to represent the precursors of Christ, royal and prophetic, the identity of these figures has never been

securely established. The reason for this failure may be that identification efforts have been confined to recognizing the figures as specific biblical personages. One important clue to their meaning may reside in the use of architectural canopies over the column-statues of the side portals but not over those of the central portal.[50] The various forms of these canopies closely resemble the images of churches and cities found in other artistic contexts, so the meaning of the figures could be related to that of the canopy images. Another clue may reside in the uneven numbers of column-statues applied to the side doors, three on the outer jambs and four on the inner. This formal inconsistency seems to have been introduced in order to employ the well-known sacred number seven in each of the side portals. The lack of individual identity in the figures, combined with the possibly symbolic use of differentiated canopies and of figures in uneven numbers, indicates that the column-statues are very likely personifications of abstract concepts related to the themes of the tympana, lintels, and archivolts in their respective portals.

The right door has long been recognized as the portal of the Incarnation (pl. 147). Katzenellenbogen demonstrated that the peculiar arrangement of the scenes on the lintels poses the figure of Christ three times on the central axis, first on a sarcophaguslike bed in the Nativity and second on a pedestallike altar in the Presentation in the Temple scene, both as prefigurations of his sacrifice, and third on the lap of the Virgin in Majesty. Such an arrangement not only refers to the interpretation of the Mass as a reenactment of Christ's sacrifice but also permits the door to reach its climax in the enthroned Virgin, thus serving the double purpose of glorifying both the Incarnation and the Mother of God. The image of the Virgin enthroned holding Christ signified her role as the *sedes sapientiae* ("throne of wisdom"), hence the appropriateness of representing the seven Liberal Arts and their personifications on the archivolts around them.[51]

Balancing the Incarnation is the Ascension portal

[49] The standard studies written since World War II are Katzenellenbogen, *Sculptural Programs*, 3–49; Peter Kidson and Ursula Pariser, *The Sculpture of Chartres* (London, 1958); and Whitney Stoddard, *The West Portals of Saint-Denis and Chartres* (Cambridge, Mass., 1952). These were enlarged by Adelheid Heimann in "The Capital Frieze and Pilasters of the Portail Royal de Chartres," *Journal of the Warburg and Courtauld Institutes*, XXI (1968), 73–102; and are synthesized by Sauerländer, *Gothic Sculpture*, 383–386.

[50] This problem has been explored, at my suggestion, by Jean McCullough, in "The Iconography of the Canopies and Column-Statues of the Side Portals on the West Facade of Chartres" (M.A. thesis, University of Pittsburgh, 1979).

[51] Katzenellenbogen, *Sculptural Programs*, 15–22. Because the signs of the Zodiac and the Labors of the Months were more numerous than the Liberal Arts and their personifications, some of these figures were placed in the archivolts of the Incarnation portal.

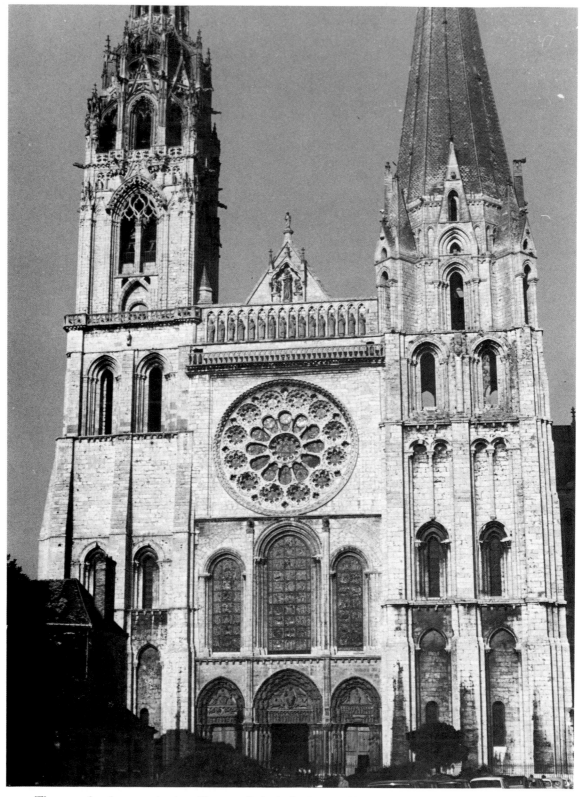

144. The west facade, 1130s/1160s, Chartres Cathedral. (Courtauld Institute—M. F. Hearn)

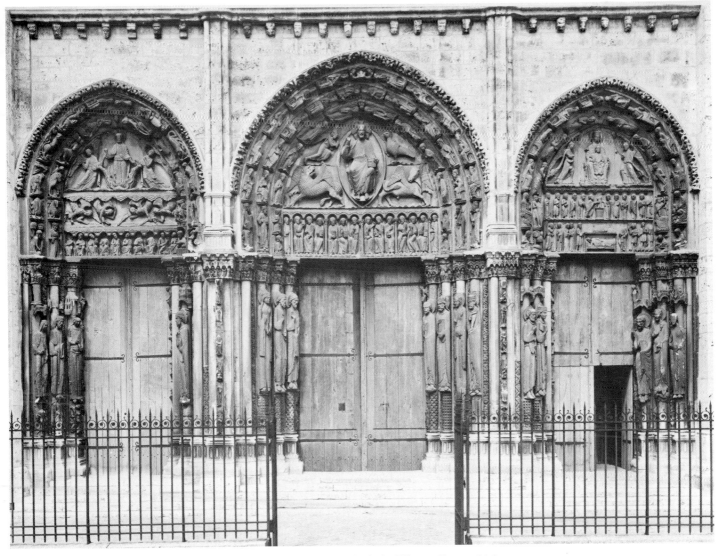

145. The Royal Portal, west facade, c. 1145/c. 1155, Chartres Cathedral. (Hirmer Fotoarchiv)

(pl. 148) on the left. While the imagery of this portal is less complex than that of the Incarnation, it is equally unusual, indeed singular, in its formulation, resembling no known prior image of the theme. (Yet it must be the Ascension as there is no other theme with even an approximately similar image composition.) Although the figure of the ascending Christ is often seen standing, assisted in the upward journey by two angels, this tympanum shows the figure standing on a wavy cloud which is lifted by the angels. Beneath this group, on the upper lintel, four angels swoop downward as if to address the ten seated Apostles on the lower lintel. (As with the right portal, portions of this composition seem to

have been cut off in order to accommodate it to a frame slightly smaller than was originally anticipated. Hence one or two apostles have presumably been eliminated.) It may well be that the separation of the Ascension from the Second Coming obliged the author of the portal program to invent a new image for this theme in order to avert the appearance of duplication. In any event, the ascending Christ seems to bestow a blessing on the seated Apostles. This Ascension may contain an amplified meaning similar to that of the central portal of Vézelay[52]—

[52] This highly plausible suggestion was advanced by McCullough, in "Canopies and Column-Statues," 14–17.

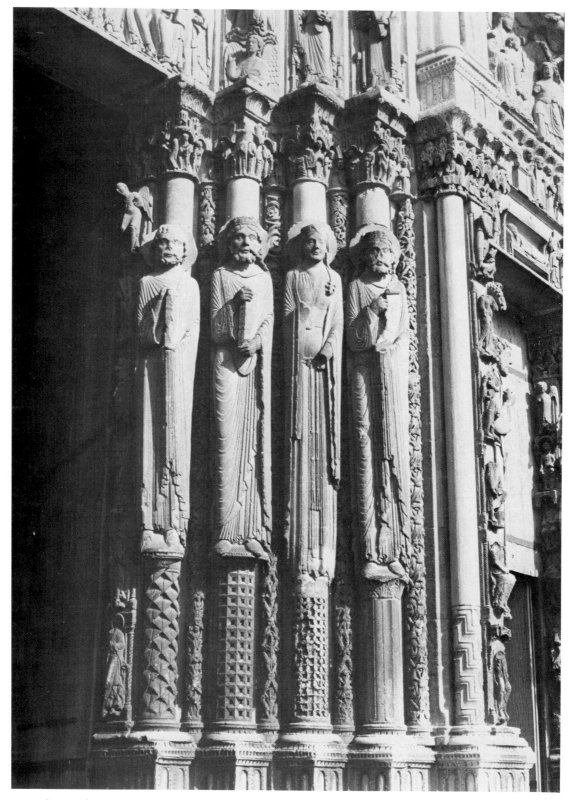

146. Stone column-statues, right jamb, central portal of the west facade, c. 1145/c. 1155, Chartres Cathedral.
(Courtauld Institute—M. F. Hearn)

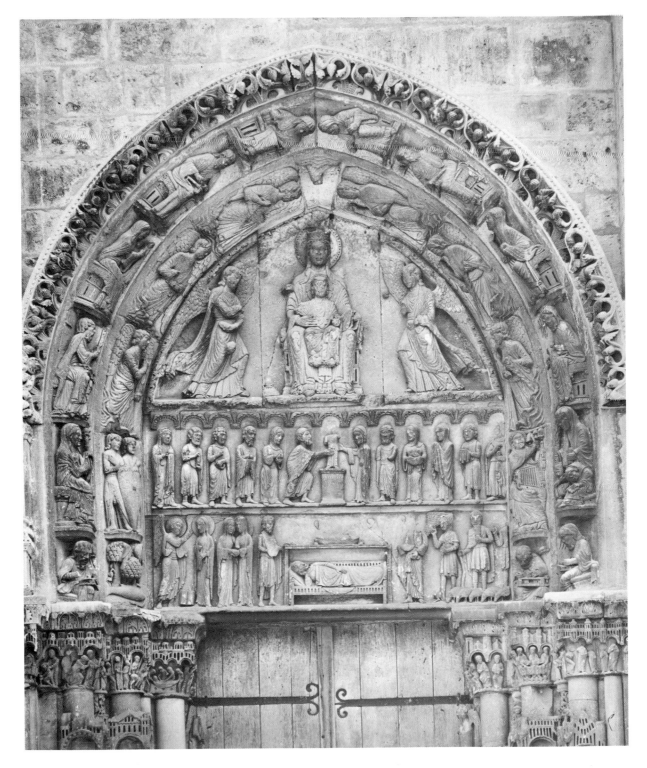

147. Stone tympanum and lintels with the Incarnation cycle, right portal of the west facade, c. 1145/c. 1155, Chartres Cathedral. (Hirmer Fotoarchiv)

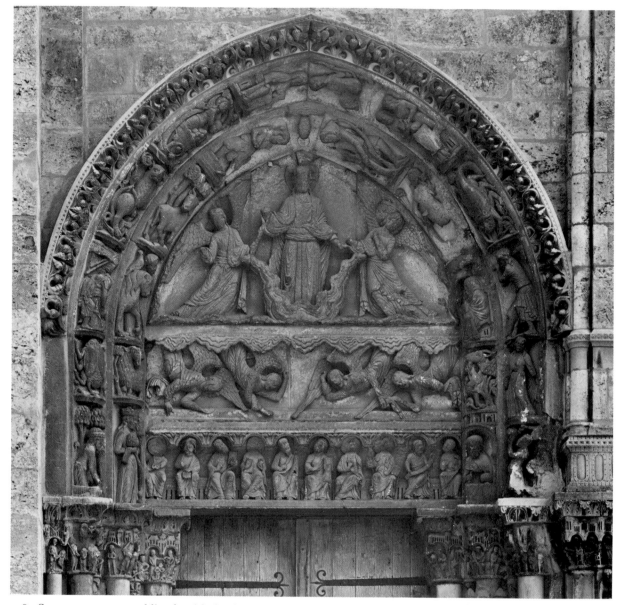

148. Stone tympanum and lintels with the Ascension and the Apostles, left portal of the west facade, c. 1145/c. 1155, Chartres Cathedral. (Hirmer Fotoarchiv)

namely Christ's Commission to the Apostles—thereby adding to the portal the symbolic significance of the founding of the Church. The Labors of the Months and the signs of the Zodiac carved on the archivolts are themes appropriate to express the all-encompassing temporal dimension of the Church's earthly mission. Whether or not Christ's Commission to the Apostles was intended as an aspect of the meaning of the portal, the themes of Time were sufficient to distinguish the Ascension from the Second Coming.

The iconography of the central portal, devoted to the Second Coming (pl. 149), is the most straightforward of any in this sculptural program. On the tympanum is Christ enthroned in a mandorla of light and surrounded by the four beasts of the Apocalypse, the standard image of Christ in Majesty. On the lintel are the twelve Apostles enthroned, as foretold in the description of Christ's coming in glory (Matthew 19:28). The two additional lintel figures are thought to represent Enoch and Elijah, whose appearance is associated

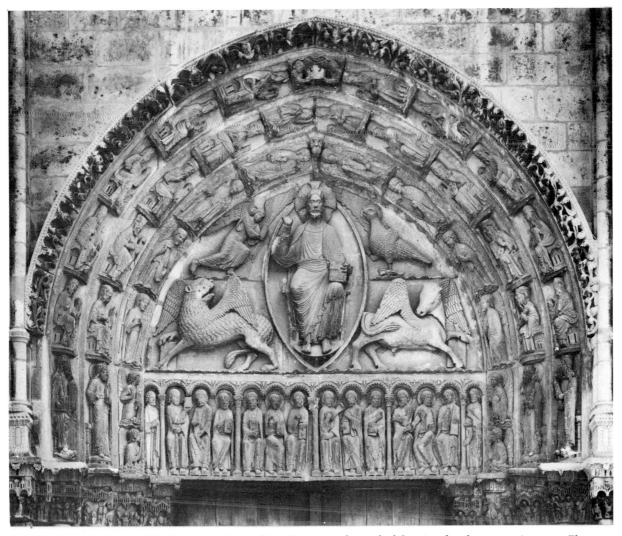

149. Stone tympanum and lintel with the Second Coming, central portal of the west facade, c. 1145/c. 1155, Chartres Cathedral. (Hirmer Fotoarchiv)

with the Second Coming.[53] On the archivolts are the Twenty-four Elders of the Apocalypse (Revelation 4:4), completing the cast of the standard image.

In the aggregate, the upper portions of the three portals serve as a diagram of the divine plan for man's salvation, exemplified theologically by the three most significant events associated with Christ's mission. The narrative frieze of the life of Christ on the capitals and the symbolic figures on the door jambs amplify this program with considerable additional detail.[54] In this context, the precursors of Christ, unless conspicuously identified as the heroes of the Old Testament, are not sufficiently

important as a theme to justify the physical prominence accorded to the column-statues on the jambs. If the architectural canopies over the figures of the left portal, for instance, should signify personifications of the Seven Churches of Asia (Revelation 1:11 and 2:1–3:22), then the symbolic relevance of these figures to the implications of the apostolic mission in the Ascension portal is both direct and appropriate to their size. It is difficult to assign equally apt meanings for the column-statues of each portal and to the twenty-four jamb figures as a group.[55] But it

[53] Katzenellenbogen, *Sculptural Programs*, 25.
[54] Heimann, "Capital Freize."

[55] McCullough, "Canopies and Column-Statues," *passim*. As mentioned in n. 47 of this chapter, Gerson, *West Facade*, 140–167, has proposed that the Saint-Denis column-statues were iconographically related to their respective portals, a parallel to the McCullough interpretation of the Chartres column-statues.

is very likely that the results of further investigations into the meaning of these figures will reinforce a symbolic interpretation. Even so, the thrust of the Chartres west portal program is not fundamentally altered; it is still an elaborate theological explanation of the doctrine of salvation, expressly salvation as it is dispensed through the Church.

It should be noted that the Saint-Denis portals from the outset and the Chartres portals at their completion were set in the front face of new twin-towered facades (pls. 140, 144). Although Suger probably intended a new church behind the facade from the beginning, he had initially justified the new construction purely as a facade.[56] Likewise, although the Chartres facade may not have been originally planned with a triple portal between the front faces of the towers, it was definitely intended to be only a new facade.[57] At Saint-Denis the new two-towered facade may have replaced a smaller version with the same meaning[58] but at Chartres it replaced a single-towered porch[59] which obviously had a different meaning. The point is that the new portals appeared in conjunction with similar facades, constructed primarily to provide only a new west front rather than to begin a complete new church. The architectural setting, then, almost necessarily was part of the meaning intensified in the sculptural programs of the portals. By the second quarter of the twelfth century, the pairing of towers on a facade had a firmly established association with city gates, symbolic of imperial power, long since appropriated to Christ.[60] The term "Royal Portal" as applied at Chartres may not in itself be of overriding importance, but clearly the

associations attached to the two-towered facade complement the intentions implied by the sculptural programs. Both programs serve at once as diagrams of complex ideas—Saint-Denis of the harmony of Church and Crown and Chartres of the whole doctrine of salvation—and as the decoration of portals leading to the interior of the church. The associations held in the Middle Ages between the church and the New Jerusalem[61] suggest that the portal programs were to be regarded as the gates to the New Jerusalem and their meaning to be accepted as duly authoritative.

The triple-portal facade of the abbey of Saint-Gilles (pl. 150) is allied both in general format and in program to Saint-Denis and Chartres, but its very different architectural setting is as retrospective of Roman Antiquity as the others were apparently revolutionary and modern. The Saint-Gilles west front is a screen facade, flanked at its extremities by small square towers. It is articulated by three recessed, arched portals which are unified by means of a colonnade with a continuous frieze above. The use of columns, Corinthian capitals, and various decorative motifs, together with the general composition, makes an unmistakable reference to ancient Roman architecture. Richard Hamann associated it with the triple triumphal arch,[62] but recently Carra Ferguson O'Meara demonstrated convincingly that the facade is based on the Roman *scaenae frons*[63] by virtue of both its proportions and design. There were still several Roman amphitheaters in Provence in the twelfth century, whose state of preservation then is unknown. It is difficult to compare them in their present ruinous condition with the Saint-Gilles facade but the task is made easier by the extant parallels provided by the Roman theaters of Spain and North Africa. Ferguson O'Meara has cogently argued that since the facade represents only the stage story of the *scaenae frons*, it was most likely inspired not by an actual Roman example but by the description of the *scaenae frons* plan provided by Vitruvius (V.vi.8), the layout of which corresponds exactly to that of Saint-Gilles. Vitruvius's *De architectura*, was well known in the Middle Ages from the ninth century on and was widely available

[56] Panofsky, *Abbot Suger*, 45, 89.

[57] The originally intended placement of the portal is open to question because in the Incarnation portal, portions of the tympanum (the Virgin's ciborium) and of the lower lintel (half the shepherd on the right) have been cut away to make them fit the present installation. The theories proposed to explain this anomaly are complex: they involve an expansion of the sculptural program to include more portals after the project was begun (resulting in a reduction of the first work to make it fit the location of the portals) or they envision the triple portal being originally intended for another, slightly wider, location (e.g., between the east corners of the west facade tower). It is clear, though, that the facade was not the beginning of a new church because it abutted the early-eleventh-century nave until the nave burned in the fire of 1194. See Sauerländer, *Gothic Sculpture*, 383–384.

[58] Sumner Crosby, *The Abbey of Saint-Denis*, 1 (New Haven, 1942), 151.

[59] Etienne Fels, "Die Grabung an der Fassade der Kathedrale von Chartres," *Kunstkronik*, VIII (1955), 149–151.

[60] Earl Baldwin Smith, *Architectural Symbolism of Imperial Rome and the Middle Ages* (Princeton, 1956), 74–96.

[61] Lawrence Hall Stookey, "The Gothic Cathedral as the Heavenly Jerusalem; Liturgical and Theological Sources," *Gesta*, VIII (1969), 35–41.

[62] Richard Hamann-McLean, *Die Abteikirche von Saint-Gilles und ihre künstlerische Nachfolge* (Berlin, 1955), 1, 17.

[63] Ferguson O'Meara, *Saint-Gilles*, 63–69.

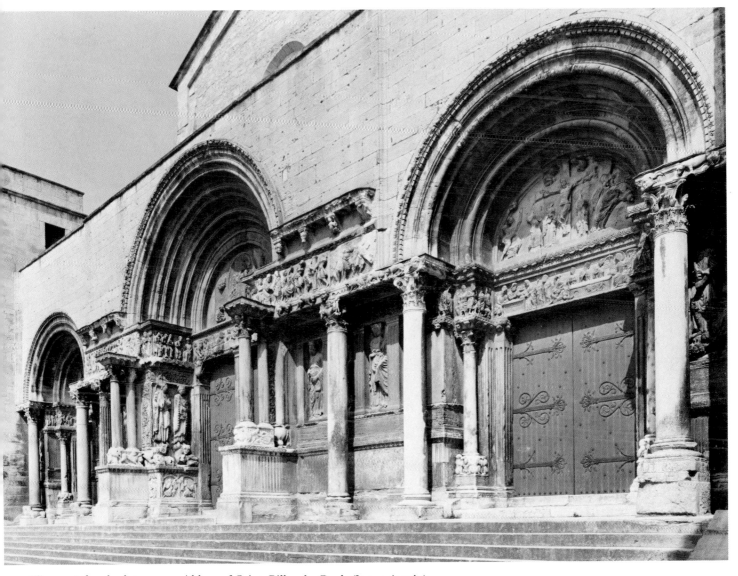

150. The west facade, late 1140s, Abbey of Saint-Gilles-du-Gard. (James Austin)

in the twelfth.[64] Some alterations of the original Saint-Gilles design were apparently made in the course of construction in order not to obscure the sculptural program (which was an innovative addition to the Vitruvian scheme). The frieze between the lateral doors was raised above the colonade, with a consequent heightening of the central portal.[65] The alterations marred the architectural consistency

of the design but gave greater prominence to the superlative sculpture.

The iconographical program begins with a lower zone of life-size relief statues, set for the most part in niches (pl. 151). They represent the twelve Apostles and two archangels. The frieze relates the Passion of Christ, excluding the Crucifixion and Entombment. The left tympanum (pl. 152) relates the Adoration of the Magi and the dream of Joseph, with the Virgin enthroned in the center as *sedes sapientiae*. The imagery of the right tympanum (pl. 153), highly unusual in Romanesque iconography, shows Christ crucified between Mary and John with Longinus

[64] Kenneth John Conant, "The After-Life of Vitruvius in the Middle Ages," *Journal of the Society of Architectural Historians*, XXVII (1968), 33–39.
[65] Stoddard, *Facade*, 3–16, 171ff; and Ferguson O'Meara, *Saint-Gilles*, 53–62.

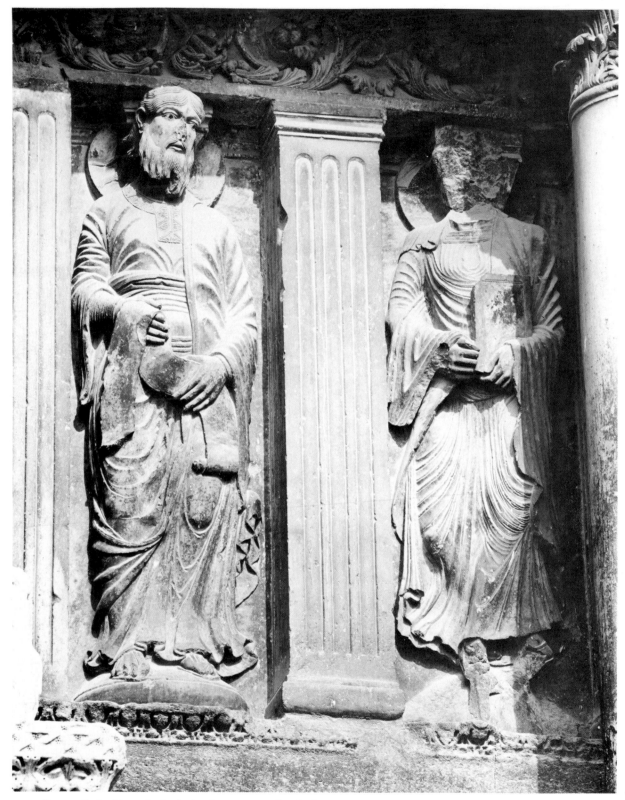

151. Stone reliefs of Apostles in the jamb zone, west facade, late 1140s, Abbey of Saint-Gilles-du-Gard. (James Austin)

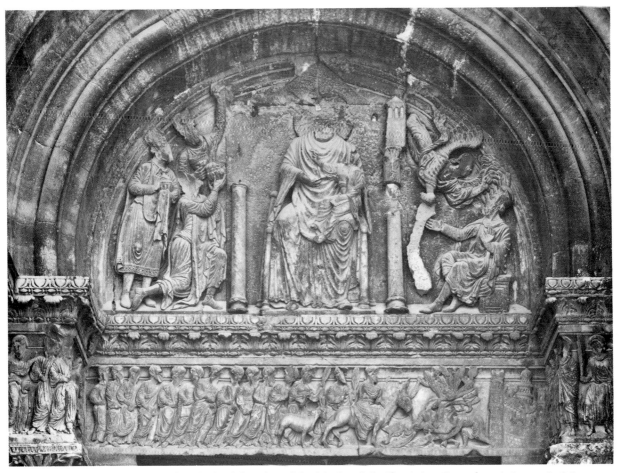

152. Stone tympanum and lintel with the Adoration of the Magi and the Entry into Jerusalem, left portal of the west facade, late 1140s, Abbey of Saint-Gilles-du-Gard. (Hirmer Fotoarchiv)

and flanked by personifications of Ecclesia and Synagoga, the latter of whom is pushed off-balance by an angel. The original central tympanum is lost but the present Christ in Majesty, mediocre in quality, probably repeats the original iconography. On the whole, the program is basically a very straightforward presentation of the significance of Christ's mission on earth, with emphasis on his sacrifice as the culmination. Marcia Colish has interpreted the unprecedented use of the Crucifixion in a tympanum as the key to a program designed to refute the heresies of Peter of Bruys.[66] But the connections between the sculptural program and the events leading to the burning of Peter at Saint-Gilles are strained not only in detail but also in basic mo-

<hr />

[66] Marcia Colish, "Peter of Bruys, Henry of Lausanne, and the Facade of Saint-Gilles," *Traditio*, XXVII (1972), 451–460.

tive. It is highly unlikely that a major facade would be decorated with a negative program, even to refute heresy. Colish and others have accurately recognized that the unifying theme of the sculptural program of Saint-Gilles lies in its unusual details. The most plausible explanation yet advanced is that of Ferguson O'Meara, who discovered coordinated motives in all these exceptional motifs.

In order to understand the iconography of the sculptural program it is necessary to know that the abbey of Saint-Gilles was under the direct patronage of the counts of Toulouse and Saint-Gilles, that it was a major Cluniac house, that the town of Saint-Gilles was the principal port of embarkation for the Crusades, and that the town and abbey were closely identified in interests and administration. The counts of Toulouse and Saint-Gilles were the earliest, and always among the major, secular spon-

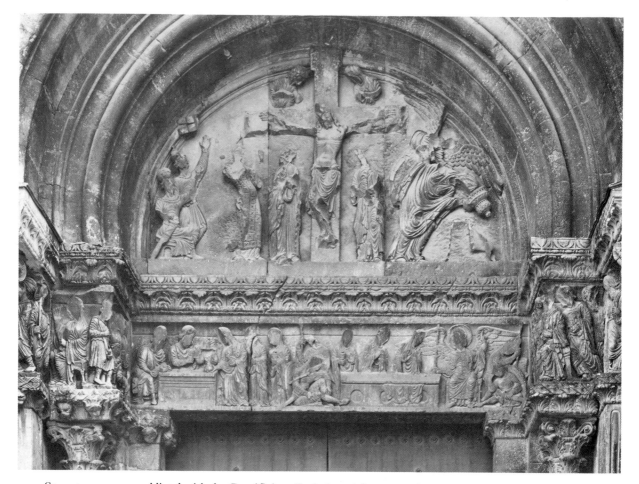

153. Stone tympanum and lintel with the Crucifixion, Ecclesia and Synagoga above the Three Marys at the Sepulcher, right portal of the west facade, late 1140s, Abbey of Saint-Gilles-du-Gard. (Hirmer Fotoarchiv)

sors of the Crusades. Moreover, the abbey of Saint-Gilles became the European headquarters of both the Knights Templars and the Knights Hospitalers.[67] There are numerous details in the sculpture which can be related to various aspects of the Crusades, each supported by ample specific correspondence to historical events or to contemporary theological treatises related to the Crusades. Three salient examples are offered here.

On the lintel of the left door, the scene of Christ's Entry into Jerusalem (pl. 152) represents the Temple precinct and its medieval tower with such accurate precision that it can only be interpreted as a reference to the actual headquarters there of the Knights Templars. On the lintel of the right door, the scene of the three Marys buying spices (pl. 153)

is an apocryphal incident in the Passion narrative, based on a specific twelfth-century church drama and represented in monumental stone sculpture for the first time. The primary association with spices was not gastronomic but medicinal and this scene undoubtedly refers to the Knights Hospitalers.[68] The falling crown of Synagoga, in the tympanum of the right door (pl. 153) is a precise representation of the Dome of the Rock, then held by Christians to be the Temple constructed by Herod which had been subsequently adopted by the Moslems as their most sacred shrine in Jerusalem. The fall of the Temple from the head of Synagoga, pushed by an angel, seems to reflect the association of Jews and Moslems, as heretics in common, made by Peter the Venerable in two treatises, the *Summa totius haeresis*

[67] Ferguson O'Meara, *Saint-Gilles*, 11–51.

[68] *Ibid.*, 135–152.

ac diabolicae sectae sive Hismahelitarum and the *Liber contra sectum sive haeresim saracenorum*. The crown of Synagoga is only the most conspicuous clue to the meaning of the tympanum. Ecclesia is dressed as a Byzantine queen, reflecting the bull of Pope Eugenius III, *Quantam praedecessores*, which not only celebrated the triumph of the First Crusade but called for the liberation of the threatened Eastern Church, in anticipation of the Second Crusade. The figures of the tormentors of Christ are transposed into guarding champions, like the military orders of Crusaders. And the unprecedented use of the Crucifixion in a tympanum fixes upon the triumph of Christ over death at the hand of the Jews.[69]

Hence, the program in general, not only represents the basic aspects of Christ's mission as the instrument of salvation but also is amplified to include the triumph of the Church in specific, historical terms over its enemies. In its detail, the sculptural program is the product of a scholarly mind that could combine current issues and religious themes with subtle precision. The use of the *scaenae frons* in its antique form is an equally scholarly interpretation that implies the facade is that of the Palace of the Lord.[70] The specific connections between the program as a whole, Cluniac interests in general, and Peter the Venerable in particular have led Ferguson O'Meara to conclude that Peter may well have been its author. This attribution is highly plausible and all the more so because of the similar relationship of the first generation of great portals to Cluny. The difference in style between Saint-Gilles and these earlier portals may be ascribed not only to a different purpose but also to a change of ideas about monumental decoration in the decade between Saint-Gilles and the last of the earlier group of programs.

The iconography of the portals of Saint-Denis, Chartres, and Saint-Gilles shares the qualities of subtlety, complexity, and originality found in the programs of the first generation but is also clearly different. In each case, the thrust of the program is the explanation of a complicated idea rather than a theophanic revelation. Also, the thematic material is more rationally ordered. But the iconographical differences pale into virtual insignificance beside the more readily apparent differences in style, which

seem to divide the two generations of portals into quite distinct artistic phenomena. The ecstatic spirituality of the figures in the first generation of great portals (pl. 126) is replaced by an unprecedented degree of dignified humanity in the second (pl. 149). The introduction of large numbers of jamb statues makes the life-size figure for the first time a standard feature of medieval sculptural practice. Moreover, the portals of Saint-Denis and Chartres are located in structures that are the first two recognized as Gothic. Indeed, both the column-statue itself and the portal composition with which it is identified were characteristic features of Gothic portals throughout the succeeding century. Also, the coordination of the column-statue with the framing archivolts introduces the appearance of logical arrangement that parallels that in Gothic architecture (pl. 145). Likewise, the projection of the figure forward of the structural plane and its diagonal orientation both imply a consideration of real space, also equivalent to the concerns of Gothic architecture (pl. 146). The stylistic differences between the two generations of portals thus appear to be especially profound and they have been traditionally regarded as marking the culmination of the Romanesque style and the beginning of the Gothic.

In the light of this interpretation, Saint-Gilles recedes into the background as a highly conservative project, divorced from the mainstream of historical development. But the necessity of discarding what is clearly a major monument from consideration should in itself arouse skepticism about the validity of such an art historical judgment. Certainly this dilemma helps us to recognize that undue emphasis has been placed upon the purely formal aspects of style (at the expense of its meaning) as the basis of historical interpretation. As we have seen, the programs of the three great portals that initiated the second generation are parallel in nature because each is a diagram of a complex idea. This type of presentation does represent a new phenomenon in Romanesque sculpture but the importance of its distinction lies in the realm of the meaning of form rather than in form itself. The change in iconographical thrust is also one of purpose. While the first great portals were intended to move the viewer, those of the second generation were intended to instruct in a pleasing or persuasive manner. The decorum of these two situations required different styles. Accordingly, the differences in formal disposition and configuration may well also have been

[69] *Ibid.*, 97–130.

[70] See the discussion on the facade of Angoulême Cathedral in the first section of this chapter.

related to meaning. Since the column-statue has been regarded as the key to the stylistic change in the second generation, a discussion of the circumstances surrounding its invention will serve admirably as a test case for the significance of meaning in formal development.

If the invention of the column-statue at Saint-Denis had been predicated primarily upon formal considerations for the sake of logical composition (and thereby of a stricter subordination of the sculpture to the architectural frame), the one clear expectation would be a logical consistency in the disposition of sculpture throughout the prescribed architectural setting. Yet, as is well known, Abbot Suger himself pointed out the inconsistency that he introduced into the Saint-Denis portals by ordering the tympanum of the left door to be set with mosaic rather than to be carved in stone.[71] And the installation of three portals to give entrance to the single vessel of the church at Chartres is not the result of a logical relationship of sculpture to architecture.[72] Moreover, if the column-statue was primarily formal in origin, then its development should have evolved in stages rather than appearing suddenly full-blown from the beginning. Although such a device was predicted in many different ways in earlier monuments of Italy (for example, the Ferarra and Verona Cathedral [pl. 118] portal jambs) and Spain (for example, the marble columns [pl. 106] and the jamb reliefs of the Puerta de las Platerías of Santiago Cathedral) as well as France (for instance, the Moissac [pl. 131] and Vézelay [pl. 126] jamb figures), no actual prototype has ever been discovered.

While archaeological evidence tends to negate the argument for formal cogency as the criterion of invention, there is positive evidence in medieval thought that the column-statue was devised initially as an iconographical device. Abbot Suger, describing the new choir of Saint-Denis, associated the "columns" (piers), because of their number, with the Apostles and the (minor) prophets, and related them symbolically to the foundations of the church by quoting Paul's epistle to the Ephesians (2:21–22).[73] More to the point, Marie-Louise Thérel has gathered considerable evidence indicating that Suger conceived the column-statue himself, inspired by the commentaries of Bede and later medieval scholars on the pillars of Solomon's Temple (1 Kings 7:15–22), in which the columns were associated with the precursors of Christ.[74] An equally explicit association with the Apostles and prophets as pillars of the church was made by William Durandus in the thirteenth century.[75] Albeit the column-statues at Saint-Denis represented more kings and queens than prophets, and those at Chartres are not reliably identifiable as biblical figures, the association was evidently generally applicable. Even Bishop Geffroy of Chartres (who had celebrated Mass at Saint-Denis just prior to the completion of Suger's choir) was eulogized at his death as a "column of the church."[76] The column-statue, then, probably should be regarded primarily as a poetic metaphor and only secondarily as a form devised to establish logical clarity in the architectural composition of the portal. The restriction of the column-statue figures to the tubular shape of the column was less likely motivated by stylistic imperatives than by a deliberate intention to relate the figures iconographically to the columns. In the compositions at Saint-Denis and Chartres, these metaphoric columns of the Church support figurative ciboria (the archivolts) which enclose the sacred scenes of the tympana (pls. 141, 145). Hence the desire to present the subject matter of the portals in the symbolic architectural format of the ciborium resulted only incidentally in a configuration which also logically integrated the sculpture into the architectural setting.

A parallel situation exists in the Apostles of the jamb zone at Saint-Gilles (pl. 151). Although they are carved as relief figures they are shown standing on pedestals, as if they were statues made in the Roman manner and set into niches. While the setting of a statue into a niche has no apparent metaphoric meaning, the form adopted is one that

[71] Panofsky, *Abbot Suger*, 47.

[72] The logically cohesive composition of the three portals may not have been originally intended either. The modifications of the sculpture in the Incarnation portal, discussed in n. 54, could mean that this portal was initially conceived as a larger composition, perhaps to stand alone. See Willibald Sauerländer, "Sculpture on Early Gothic Churches: The State of Research and Open Questions," *Gesta*, IX (1970), 32–48, for a review of this problem.

[73] Panofsky, *Abbot Suger*, 105.

[74] Marie-Louise Thérel, "Comment la patrologie peut éclairer l'archéologie: A propos de l'arbre de Jesse et des statues-colonnes de Saint-Denis," *Cahiers de civilisation médiévale*, VI (1962), 145–159.

[75] William Durandus, *Rationale divinorum officiorum*, in J. M. Neale and the Rev. B. Webb, ed. and trans., *The Symbolism of Churches and Church Ornaments* (London, 1906), 21.

[76] Katzenellenbogen, *Sculptural Programs*, 35.

could be perceived as appropriate to the Roman meaning of the *scaenae frons*. In this light, the Saint-Gilles sculptures are neither advanced nor *retardataire* with respect to the column-statue; they are simply different in form but equally appropriate to the meaning of the composition in which they are set.

The key to understanding the relationship, or lack of it, between the first and second generations of great portals, then, lies in the iconographical thrust of the programs. Those of Saint-Denis, Chartres, and Saint-Gilles as a whole present images of ideas. Like the first generation portals, they are visible manifestations of the invisible, images of things that are known but not fully understood. But unlike the earlier portals they are not, strictly speaking, theophanies of ineffable mysteries. Indeed, the most innovative aspect of the programs is that they are diagrams of theological explanations, a category of thought which had previously not been considered the stuff of images. There is no clear reason why a change in notions about types of images should occur at this moment, but it can be sought indirectly in the circumstances surrounding their creation, even though the task is complicated by the lack of parallel evidence for each monument.

Certainly one important area of consideration is the philosophical bent of the authors of the programs, whose identity and intellectual proclivities can only be inferred through circumstantial evidence. Of Saint-Denis, the authorship of the portal program can be assigned to Abbot Suger on several grounds. First of all, he wrote extensively about his building programs for the abbey in which he was directly involved. Although, curiously, he made no reference to the portals except for the mosaic in the left tympanum and the bronze doors in the central portal, the program is so closely allied with his own ideas about the Church and the French monarchy that his authorship can scarcely be doubted. Finally, his attachment to the ideas of Dionysius the Pseudo-Areopagite (whom he confused with the patron saint of his abbey) is clearly enunciated throughout his writings.[77] Therefore, it is possible to see that his intellectual conception of the visible manifestation of the invisible was very close to that which is apparent in the first generation of great portals. At Saint-Gilles, although the patron is unknown, circumstantial evidence related to the content of the pro-

gram points to Peter the Venerable, abbot of Cluny, as its author. We have already seen in connection with the earlier portals that he, too, was inspired by the Dionysian *Celestial Hierarchies*. As for Chartres, much is known about its bishops and the scholars associated with its intellectual tradition, but the program has not been firmly linked with a specific author or patron. Nevertheless, the formal similarity to the Saint-Denis portals suggests that the design of the Royal Portal of Chartres was directly derived from them, hence conceived in the same way. Therefore, the three portals can be associated with the same strain of thought, indeed the same Dionysian tradition that inspired the first generation of portals.

If the conception of the programs was inspired by the desire to make visible manifestations of the invisible, the type of image employed is not inherent in *The Celestial Hierarchies*. The change that had occurred between the inception of the first generation of great portals and the second was an assimilation into the realm of art of a new approach to thought and learning. This new approach replaced a tradition that was centuries old and characteristic of the great monastic schools like that at Cluny, where intellectual cultivation had been largely a process of passive collation of ancient and medieval knowledge and thought. Expansion of knowledge had been achieved through commentary or through the combination of related thoughts from different sources. Emphasis on grammar and rhetoric, the means of expression, had been the basic foundation of education. But in the early twelfth century new centers of learning, located in Paris and in cathedral schools like that at Chartres, shifted the focus of education to dialectic, the means of thought. They emphasized not learning but thought, not persuasion but demonstration, not ancient authority but philosophical clarity.[78] We know them as the originators of scholasticism, typified in its early period by the work of Hugh of Saint-Victor and Abelard in Paris and of Bernard, Thierry, and Gilbert de la Porée in Chartres.[79] The significance for sculpture of this new approach is not that it was logical but that it proceeded dialectically, concomitant to the diagrammatic character of the pro-

[77] Panofsky, *Abbot Suger*, 20.

[78] Jean Leclerq, in *The Love of Learning and the Search for God*, trans. Catharine Misraki (New York, 1961), devotes much of his extensive study to this question, esp. 245-251.

[79] For a concise compendium of information on the early scholastic thinkers, see David Knowles, *The Evolution of Medieval Thought* (New York, 1964), 93-107, 131-141.

grams and, even more important, that it encouraged active speculation which fostered original invention. Although the programs of these portals were original, rational conceptions, they could readily be converted into visual images by virtue of the Dionysian tradition. But the images still had to be formulated within the aesthetic framework of appropriate styles. The principal reason for the stylistic difference between the two generations was that the earlier portals were intended to move the viewer and the later ones were intended to instruct. Consequently, the style of the former had to fill the viewer with awe while that of the latter was intended to delight and thereby attract the viewer to the truth in the message. Thus the mannered grace of allegory, employed at Cluny, and the agitated expressiveness of theophany, employed at Vézelay and Moissac, were no longer appropriate and were replaced by dignified formal beauty at Saint-Denis, Chartres, and Saint-Gilles. Like the inspiration for the images, the mode of formal beauty which characterizes the style of these portals stems from the commentaries on *The Celestial Hierarchies* written by Hugh of Saint-Victor. In formal beauty, as Edgar de Bruyne has characterized Hugh's notion of it, "the beauty of composite things or images is defined in function with the composition, with the harmony of parts, and with the consonance of elements." Moreover, formal beauty results from the unity of multiplicity, reduced to order by virtue of the proportions.[80] This definition succinctly describes the formal qualities of all three of these great sculptural ensembles: the clarity of their composition, the harmoniousness of their internal arrangement, and the consonance of physical parts inherent in their humanistic figural style. Further, it accounts for the attractiveness of such ensembles which are at the same time so complex and yet so visually comprehensible. For Hugh, the purpose of formal beauty is to inspire a love of the subject through the beauty of the object;[81] the viewer who is attracted by the beauty of the sculpture will come to embrace the ideas expressed by it. Hence the style is selected for its appropriateness to the subject matter and is integral with its meaning. Further confirmation of this principle in the portals is that the subtlety of the content is reflected in that of the style,

most notably in the sensitive humanity of the figures and in the rich descriptive detail. Much of this detail at Saint-Denis has been lost through destruction and restoration but it is still abundantly evident at Chartres and Saint-Gilles. Painted in brilliant hues, these sculptural programs were the most attractive conceivable presentations of theological explanations.

It was chiefly in the type and purpose of the programs, then, that the second generation of portals differed from the first. Otherwise, they were closely related both in the nature of the image and in the theoretical background of their style. Evidence to confirm this interpretation exists in the equally close relationship of their artistic production. Fortunately for the sake of disinterested judgment, this evidence has already been set forth by archaeologically minded scholars whose concern has been to observe carefully the technical mannerisms of the work of specific hands.

As early as 1894, Wilhelm Vöge noted the similarity between figures in the Saint-Denis portals (especially the column-statues, pl. 142) and those in the Moissac tympanum (pl. 128).[82] Willibald Sauerländer, in 1970, collated and sharpened this and other comparisons, adding more of his own.[83] The hand of the Moissac Master was evident not only at Saint-Denis, he concluded, but also at Chartres in the personifications of the Liberal Arts on the Incarnation portal (pl. 147). Moreover, some of the Apostles of Saint-Etienne in Toulouse (pl. 154)[84] are very similar to the column-statues on the right embrasure of the Incarnation portal (pl. 155). Like-

[80]de Bruyne, *Esthétique médiévale* II, 216. These remarks refer to *Patrologia Latina* CLXXV, cols, 949 and 943, respectively.

[81]*Ibid.*, 217. This remark refers to *Patrologia Latina* CLXXV, col. 882.

[82]Wilhelm Vöge, *Die Anfänge des monumentalen Stiles in Mittelalter* (Strasbourg, 1894). A translation, by Alice Fischer and Gertrude Steuer, is in Robert Branner, ed., *Chartres Cathedral* (New York, 1969), 146-149. Emile Mâle, in *L'art religieux du XIIe siècle en France*, 2d ed. (Paris, 1924), 179-180, 409, noted that he detected direct influence from Beaulieu and from the southwest in general at Saint-Denis. For more recent opinions, see Whitney Stoddard, *The West Portrals of Saint Denis and Chartres* (Cambridge, Mass., 1952), 44-46; and French, *Beaulieu Portal*, 177-202. French (190ff.) has qualified some of the earlier comparisons which she found less than convincing.

[83]Sauerländer, "Sculpture on Early Gothic Churches," 32-48.

[84]For the Saint-Etienne Apostles, attributed to Gilabertus, see Marcel Durliat et al., *Les grands étapes de la sculpture romane toulousanne* (Toulouse, 1971), 23-44; idem, "Le portail de la salle capitulaire de la Daurade à Toulouse," *Bulletin monumental*, CXXXII (1974), 201-211; and Linda Seidel, "A Romantic Forgery: The Romanesque 'Portal' of Saint-Etienne in Toulouse," *Art Bulletin*, L (1968), 33-42. The similarity between the column-statues of Saint-Denis (in the Montfaucon drawings) and the Saint-Etienne Apostles was discussed in detail by Stoddard, *West Portals*, 44-46.

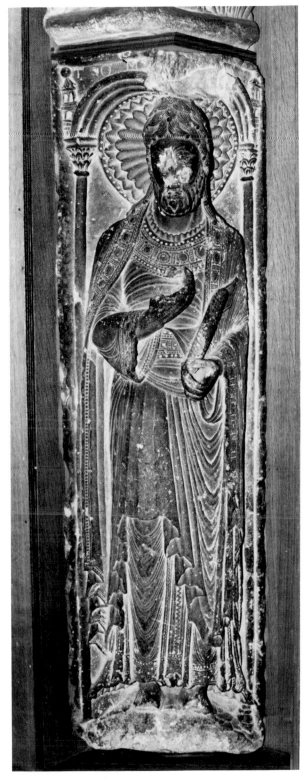

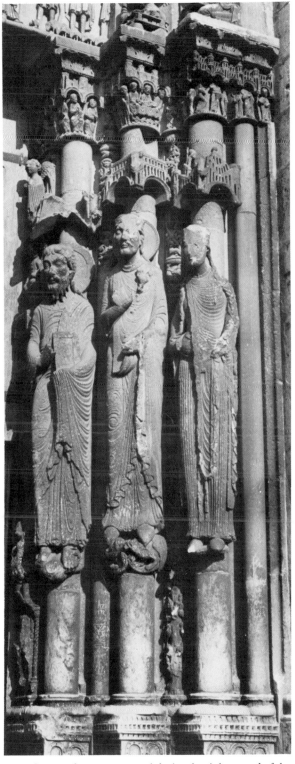

154. Stone reliefs of Apostles, from the chapter house, 1130s, Cathedral of Saint-Etienne, Toulouse. Musée des Augustins. (Courtauld Institute—M. F. Hearn)

155. Stone column-statues, right jamb, right portal of the west facade, c. 1145/c. 1155, Chartres Cathedral. (Courtauld Institute—M. F. Hearn)

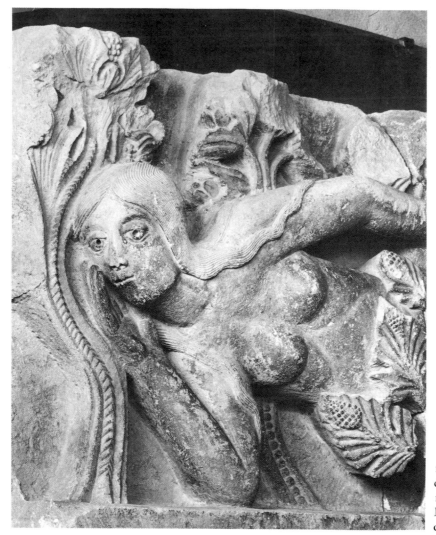

156. Stone relief of Eve from the destroyed north transept portal, c. 1130 or after, Autun Cathedral. Musée Lapidaire. (Hirmer Fotoarchiv)

wise, the master of the second series of capitals in the Toulouse cloister of La Daurade has been detected by Adelheid Heimann in the Chartres capital frieze.[85] More surprising is the remarkable similarity of the head of the Eve fragment by Gislebertus of Autun (assigned to the lost north transept portal) to the head of one of the queens located on a column-statue of the Chartres central (Second Coming) portal (pls. 146, 156). This comparison is added to a series between the sculpture of Gislebertus and that at Chartres which were initially advanced by Bernhard Kerber.[86] Sauerländer also ten-

tatively suggested that the stylistic sources of the Saint-Gilles sculpture might be sought in the later monuments of southern Burgundy, especially the later portal of the Charlieu porch (1140s) and its contemporary at the church of Saint-Julien-de-Jonzy.[87] Yet he was almost incredulous that these various relationships could exist in view of the dramatic differences in figural style and disposition between the earlier and later portals. Characterizing the situation, he stated, "One can scarcely imagine the sculptor of the Autun Eve going the next day to Chartres to create the Queens."[88] But in the infancy of the study of Romanesque sculpture, Vöge could

[85] Heiman, "Capital Frieze," 82.
[86] Bernhard Kerber, Burgund und die Entwicklung der französischen Kathedral-skulptur in 12. Jahrhundert (Recklinghausen, 1966), 25.

[87] Sauerländer, "Sculpture on Early Gothic Churches," n. 22.
[88] Ibid., 35.

not doubt that the change was simply a matter of the sculptors adapting to a different set of circumstances, although for him the determining factor was the design of the architectural framework.[89] The growing recognition that the iconographical programs were devised by the patrons relieves much of the difficulty in explaining the stylistic transition. For, as we have seen, the style was part of the meaning of the program and lay also in the province of the patron.

Another type of evidence which tends to confirm that the style of these portals was determined by the iconography is the patterns of influence exerted by the monuments. In view of their high quality, it is surprising that the portals of Saint-Denis and Saint-Gilles apparently had very little impact, as regards both the proliferation of monumental sculpture and the quality of the sculpture they inspired. Chartres, on the other hand, spawned an enormous number of monuments that extended the life of the second generation of great portals through the third quarter of the twelfth century.[90] There are no reasons unrelated to the sculpture itself to explain this anomaly. But in looking at the programs, it is clear from the exposition of the iconography that the portals of Saint-Denis and Saint-Gilles were based on subject matter peculiar to the circumstances of those specific monasteries: only the most general aspects or some isolated details could be appropriated to other situations. The program of Chartres, on the other hand, was universal and could be abbreviated and adapted anywhere. And that is precisely what happened. Its extensive progeny stretched along the basin of the Loire and its tributaries from Dijon to Angers. Some of the portals, such as those at Le Mans, Angers, Saint-Loup-de-Naud, and Corbeil continued the development toward a humanistic conception of the figure, producing the degree of evolution to be expected in a regional style based on a specific artistic tradition. But even the best of these portals is derivative in quality and none of them exceeds the achievement of Chartres. In subsequent monuments the tradition declined rapidly and became dessicated. This dissipation may have occurred in part because these programs were imitations based on ready-made images rather than original creations based on new ideas.

Regardless of the remarkable formal differences between the first and second generation of great portals, the sculpture of Saint-Denis, Chartres, and Saint-Gilles basically continued the tradition, begun at Cluny, of inventing images to illustrate ideas. As we have seen, the subject matter and the style of the images were coordinated to serve the purpose of the message in the program. The principal contributions to the development of monumental sculpture in the second generation were new and larger formats for individual figures within an ensemble, and a new level of relationship between both the program and the ensemble with the architectural setting.

The Third Generation: Spiritual Truth in Physical Beauty

The third generation of great portals, beginning in the 1170s, appears in many ways to follow directly from the second. Although there are some differences in thematic content, format, and technique, they are initially less obvious than those between the first and second generations. That a transformation of figural representation occurred in the 1170s is generally recognized, but two factors have obscured a full appreciation of the break with the past which it represents. First, the format of these portals continued that initiated at Saint-Denis and Chartres: splayed jambs with column-statues and corresponding orders of archivolts with figures following the curve of the arch, providing together a coherent frame for the doorway, lintel, and tympanum. Hence the impact of the stylistic transformation is somewhat blunted by the familiarity of its formal context. Second, beginning with Saint-Denis and Chartres (especially the central door of the latter), figural style had been gradually refined in the direction of a humanistic conception, so that the new style of the 1170s seems to mark the climax of a development in which only the penultimate link of the evolutionary chain is missing. Yet it is precisely this missing link that signifies the emergence of a new artistic era, the passage from the Romanesque to the Gothic style. This transformation of figural representation not only sets the third generation of portals apart from the first two but it also

[89] Vöge, in Branner, *Chartres*, 131–146.
[90] The two most recent studies that have attempted to be virtually exhaustive are those by André Lapeyre, *Des façades occidentales de Saint-Denis et de Chartres aux portails de Laon* (Paris, 1960); and Sauerländer, *Gothic Sculpture*, 386–416.

signals the completion of the revival of monumental stone sculpture.

The new style may not have originated in a single location; indeed, the stylistic filiations of early Gothic portals are so difficult to determine that they are still not finally settled. There is, nevertheless, a certain consistancy in the conception of style and the relationship of style to iconography so that a single portal can suffice in this context to illustrate the nature of this generation of sculpture. The earliest sculpture that seems to embody the several defining characteristics of the third generation is that on the west portal of Senlis Cathedral, dated by Willibald Sauerländer on the basis of stylistic comparisons to c. 1170.[91]

The iconography of the Senlis portal (pl. 157) is indicative of the new intentions for monumental sculpture in the third generation. The tympanum (pl. 158) is the first of many that were to be embellished with the theme of the Triumph of the Virgin. Christ and the Virgin are both crowned and sit on a double throne. The central axis falls between them so that the two figures are coequal in the composition. They are framed by a heart-shaped arch and flanked by two angels and two heavenly witnesses. The lintel is divided into two scenes, the Death of the Virgin and the Resurrection and Assumption of the Virgin. The archivolts are devoted to the ancestors of Christ in the lineage of David. The image was apparently derived from the iconographic formula for the Tree of Jesse, for the ancestors are all framed by vine scrolls. The column-statues on the jambs represent (from the left on the left jamb, pl. 159) John the Baptist, Samuel annointing David, Moses holding the Brazen Serpent, the Sacrifice of Isaac, and (from the left on the right jamb, pl. 157) Simeon holding the Infant Christ in the Temple, Jeremiah, Isaiah, and David. Each of these figures is prophetic of an aspect of the role of Christ. In the context of the whole program, the emphasis on the Virgin (implied by the lintel) is not literal but symbolic. The Virgin was regarded not only as the Mother of God but also as a symbol of the Church, the Bride of Christ. Although it was Joseph who was descended from the House of David (Matthew 1:1–16), his ancestors were imputed to the Virgin. The ancestors, then, function as precursors of the Church just as the prophets function as precursors of Christ. Hence

the thrust of the portal program seems to be the marriage of the Church to Christ.[92]

As an image this program shares the purposes of the first and second generations of great portals in that it is the visible manifestation of a holy mystery. Although, like the portals of the second generation, the program builds to a climax in the tympanum (with a heavenly scene), there is, by way of contrast, no real sense of hierarchy in the rest of the subject matter because the jamb and archivolt themes have the same value and level of meaning. The only apparent justifications for placing the prophets on the jambs are that they are fewer in number than the ancestors and that their greater identity as individuals warrants their more elaborate representation. Consequently, if the disposition follows a logical order with respect to the setting, it is one of purely formal arrangement, for the disposition does not really enhance the meaning. This tendency, already apparent at Senlis, becomes blatant shortly after 1200 in the north transept portals at Chartres, where, in the Incarnation portal, the program is simply a narrative beginning with the Annunciation and Visitation on the jambs and culminating in the Adoration of the Magi on the tympanum. Or, the program may comprise a homogeneous collection of similar themes, such as the Old Testament portal of the same portal ensemble at Chartres, where the jambs, archivolts, lintel, and tympana show various Old Testament figures and scenes without any hieratic order.[93] Indeed, the column-statue has become a mere formal device because the identity of the figures on them does not permit them to be interpreted as columnar in meaning. In the third generation, then, the portal format is no longer necessarily a part of the iconography of the program.

Stylistically, the figures of the Senlis portal also mark a considerable departure from earlier sculpture. The most immediately noticeable difference is that they are much more mobile. Unlike the stiff and static column-statues of the Royal Portal of Chartres (pl. 146), the jamb figures of Senlis have a restless energy which is emphatically transferred

[91] Sauerländer, in *Gothic Sculpture*, 406–408, states his conclusions and lists most of the relevant earlier literature.

[92] For explications of the iconography, from which I have deviated slightly in details, see Willibald Sauerländer, "Die Marien Krönungsportale von Senlis und Mantes," *Wallraf-Richartz Jahrbuch*, XX (1958), 117ff; and *idem*, *Gothic Sculpture*, 406–408. The concept of the Virgin as symbolic of the Church, the Bride of Christ, is more fully discussed in Katzenellenbogen, *Sculptural Programs*, 59–65.

[93] Katzenellenbogen, *Sculptural Programs*, 67–74.

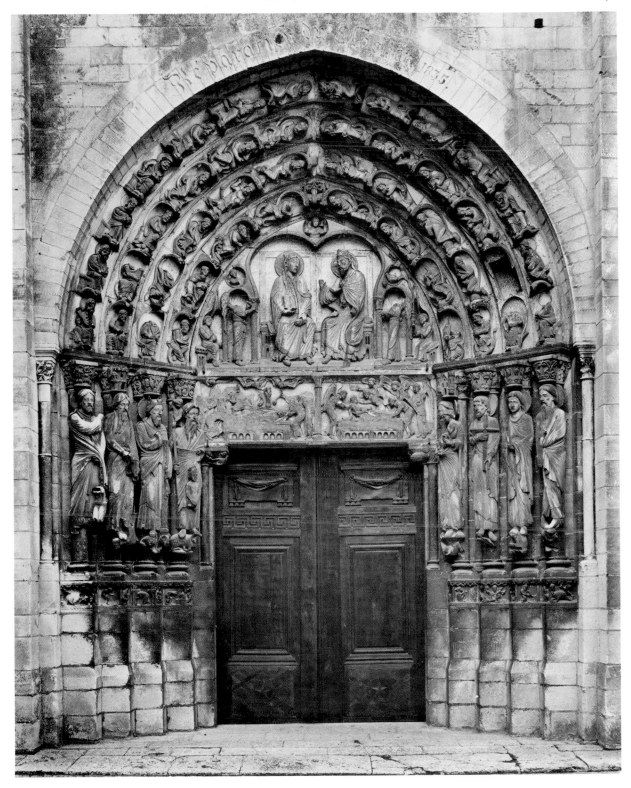

157. West portal, c. 1170, Senlis Cathedral. (Hirmer Fotoarchiv)

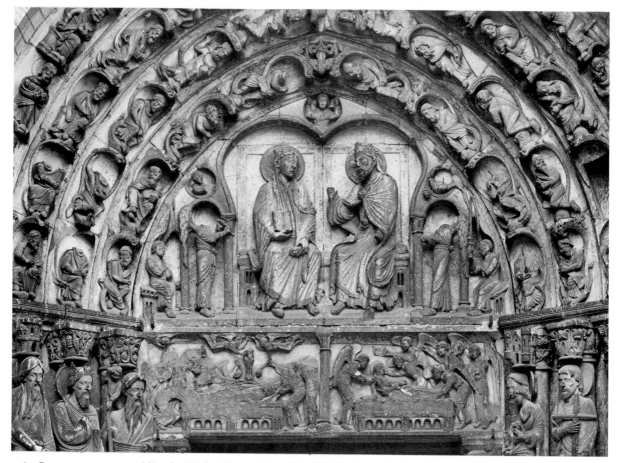

158. Stone tympanum and lintel with the Coronation of the Virgin above the Death and Assumption of the Virgin, west portal, c. 1170, Senlis Cathedral. (Hirmer Fotoarchiv)

to their drapery and several of them are engaged in some action (pl. 159). For instance, John the Baptist, acting as a sort of interlocutor between the viewer and the portal, looks out toward the viewer and points to the scene on the tympanum. Also, Moses points to the Brazen Serpent on his staff and the Angel of the Lord grasps the sword of Abraham just as he is about to sacrifice his son Isaac. (Later, in the north transept Incarnation portal at Chartres, the column-figures were made to turn and address each other, as in the Annunciation and Visitation [pl. 160].) The figures of the Senlis lintel scenes are highly energetic and overlap in such a way as to suggest the illusion of pictorial space. In the archivolts, the ancestors of Christ are enlivened by the counterpoise of their stances. Certainly this mobility was facilitated by the vine framework, but the Tree of Jesse could just as easily have been

represented in a static manner. This general expression of movement endows the sculpture with a quality of inner vitality.

This lifelike quality was considerably increased through the more natural appearance of the figures (pls. 158, 159). They are carved with an unprecedented degree of fullness and expression of weight and their bodies are articulated in a manner that makes them much more plausible as human figures. Their clothing is represented as distinct from their bodies, enhancing the expression of the body beneath. A sophisticated carving technique has realized distinct differences between the texture of hair, skin, and fabric. Traces of paint remain to indicate that the figures were vividly colored, so the effect of the textural differences was enhanced by chromatic ones. (Although the heads of the column-statues are the work of a modern restoration, com-

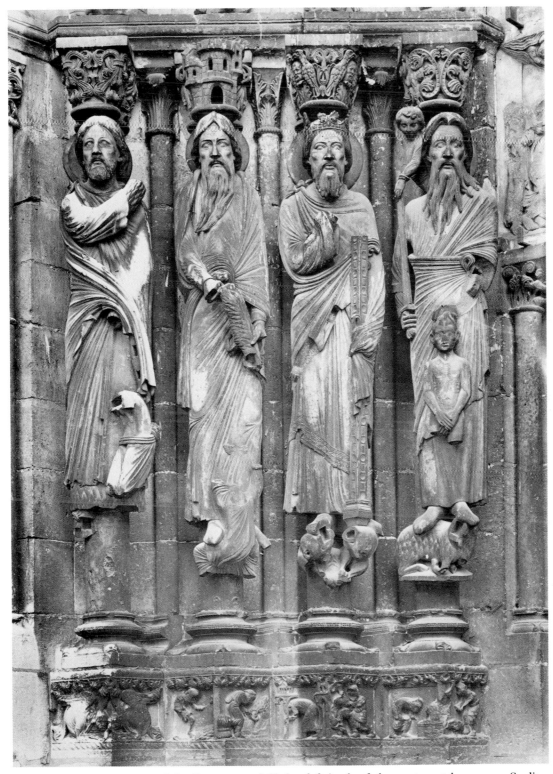

159. Stone column-statues of the Precursors of Christ, left jamb of the west portal, c. 1170, Senlis Cathedral. (Hirmer Fotoarchiv)

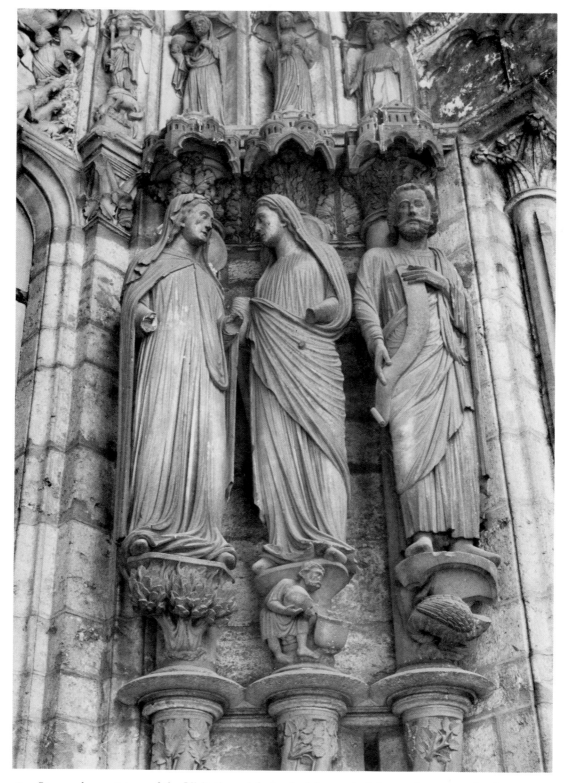

160. Stone column-statues of the Visitation, right jamb, left portal of the north transept facade, c. 1205, Chartres Cathedral. (Courtauld Institute—M. F. Hearn)

parison to remaining fragments in the Musée du Haubergier in Senlis and to the smaller figures on the portal demonstrates that they are basically faithful to the original style.) The disposition of the drapery folds is still artificial, but soon afterward in other portals (for example, Chartres, pl. 160) the drapery acquires a much more natural quality, albeit one still highly artistic. Moreover, the distinctions of age and sex are much more pronounced than in previous sculpture, setting a trend which evolved rapidly in the next three decades. Taken together, all these modifications in stylistic treatment result in creating the illusion that the figures are alive.

How did this new style come into existence? Willibald Sauerländer has noted that, compared to all previous stone sculpture, the Senlis portal most nearly resembles the style and technique of the west portals of Saint-Denis,[94] which we find developed and enhanced in the Saint-Anne portal tympanum at Notre-Dame in Paris, c. 1163. But at most this comparison suggests only that the Senlis sculptor was trained to work in the tradition initiated by Saint-Denis. Indeed, no one would assume that Senlis was a direct outgrowth of a Saint-Denis school. The missing link in the apparent stylistic evolution of sculpture in the region of Paris just prior to Senlis did not exist in stone sculpture and can be explained only by an intrusion from another context. Sauerländer's comparison of the Senlis sculpture to Mosan metalwork, specifically that by Nicholas of Verdun, led him to suppose that this remarkable work influenced the style of monumental sculpture.[95] Yet Sauerländer himself has noted the incongruity of his date of c. 1170 for Senlis and the dates of 1181 for the earliest known work by Nicholas of Verdun, the Klosterneuberg enamels, and of the 1190s for the earliest gold sculptures, the shrine of the Three Kings in Cologne. Although earlier Mosan goldwork, such as the cross base of Saint-Omer, anticipates the new style of Nicholas, the break in the stylisitic evolution of

Mosan metalwork which his work represents is just as great as that in stone sculpture. Finally, there is no reason to suppose that, after decades of stylistic independence from other media and of leadership in the figural arts, monumental stone sculpture would suddenly have its course of development deflected by influence from another medium. Rather, it is much more likely that stone sculpture retained its leadership, that metalwork followed its lead, and that the new style was influenced instead by new developments in aesthetics.

As the visible manifestation of the invisible, the program at Senlis shares the motivations of the two earlier generations of great portals. The theme, the marriage of the Church to Christ, is a holy mystery related in concept at once to both theophanic revelation and theological explanation. Its purpose was to inspire spiritual elevation in a manner not unlike that of the earlier portals. But to serve this end, the appropriate style would certainly be formal rather than expressive beauty because the theme itself is a poetic and gentle one. Hence, within the context of the Dionysian aesthetic tradition it might well have been carved in the manner of the most graceful aspects of Saint-Denis, Chartres, and Saint-Gilles. Yet the style as a whole constitutes a modification in aesthetic concept which goes well beyond that of the second generation. Indeed, the significance of the stylistic transformation is greater than the sum of its component qualities. While the figures of Romanesque sculpture are frankly inorganic in nature, the new style introduced the illusion of organic life. The representation of a holy mystery in such an illusionistic manner could be considered appropriate only after a radical change in the philosophy of the nature of images.

Wilhelm Koehler identified the likeliest context for the ideas that may well have inspired this change in the conception of visual images—the philosophical discussion of the relationship of the body to the soul. As he observed, the twelfth century saw a remarkable revival of interest in this philosophical problem for the first time in several centuries.[96] Significantly, this interest was concentrated in France, particularly in the region of Paris, which from the middle decades of the century was the preeminent center of learning and thought. At least

[94] Willibald Sauerländer, "Beiträge zur Geschichte der 'frühgotischen' Skuptur," Zeitschrift für Kunstgeschichte, XIX (1956), 1–34; and Louis Grodecki, "A propos de la sculpture française autour de 1200," Bulletin monumental, CXV (1957), 119–126.

[95] Sauerländer, Gothic Sculpture, 48–49, 408. For additional discussion on Nicholas of Verdun and the stylistic break in metalwork around 1180, as well as illustrations, see Peter Lasko, Ars Sacra: 800–1200, Pelican History of Art (Harmondsworth, 1972), 240–252, pls. 207, 287–291.

[96] Wilhelm Koehler, "Byzantine Art in the West," Dumbarton Oaks Inaugural Lectures (Cambridge, Mass., 1941), 85.

ten treatises were devoted expressly to this topic and others included a treatment of it.[97] Among the important authors of the former category was William of Saint-Thierry, to whom St. Bernard had written with great concern about Cluniac art.

In his treatise *De natura corporis et animae*, written probably between 1130 and 1138, William composed a chapter on the union of the soul and the body. The soul, he explains, reigns over all parts of the body by virtue of an ineffable union with all of them—ineffable because its nature cannot be precisely stipulated. The soul is neither inside nor outside the body because it cannot be held by a material body, yet in a suprarational fashion it is united with the physical nature of the body and operates in this nature. In the next chapter, William defines how the body serves as the instrument of the soul: the soul operates throughout the body and the body faithfully obeys its impulses.[98] The relevance of this theory to art is that the physical appearance of the human body can be accepted in its own right as the means through which state of the soul is made visible. Applied to the representation of extraordinary beings—Christ, the Virgin, the saints, the heroes of the Scriptures—this means that their bodies should be represented as real bodies but in such a way as to communicate the beauty of their spirits. Elsewhere in his treatise, William indicates the mode in which this beauty can be represented. The human body, he observes, possesses a harmony, agreeable to the eye, which resides in the articulation, disposition, and proportion of its members and in the unity of the whole. In regard to the harmony of the body he is fascinated by the notion that the recumbent human figure, with the hands and feet extended, fits exactly into a circle drawn with its center on the navel.[99] This observation not only expresses admiration for the natural appearance of the human body but it also contains the germ of the concept of ideal beauty. William's treatise, then, provides an exact analogue of the style which we find in Gothic sculpture, beginning with Senlis.

To be sure, a review of other such treatises would add further weight to this evidence from William of Saint-Thierry. But suffice it to indicate that the discussion of the relation of the soul to the body was intensified in succeeding decades, especially toward the end of the third quarter of the twelfth century. As is plainly evident in the summary above, the theory of William of Saint-Thierry that the physical body reflects the spiritual state of the soul could be regarded as an analogue of the Dionysian concept of theophany. It is not mere coincidence, then, that the scholars of Saint-Victor in Paris and their disciples, with their predilection toward the Dionysian tradition and mysticism in general, were particularly prominent in the discussion of this philosophical problem.[100] Because the two theories were compatible, that concerning the body and the soul could readily be assimilated into the other concerning the formulation of images.

Within this context, the motivation for adopting the theory would appear to be the creation of ideal beauty rather than realism. As has frequently been remarked, however lifelike Gothic sculptures may be, their beauty surpasses that of average people. From the early decades of the twelfth century, the notion of ideal beauty had been at large in France. Hildebert of Lavardin, in a poem on the glories of ancient Rome, had described the statues of divinities as more beautiful than the gods themselves. Nature, he wrote, was powerless to create such beauty; only man could create such admirable images.[101] The theme of beauty surpassing nature was taken up in the latter half of the twelfth century as a cliché of courtly literature. Chrétien de Troyes outdid even Hildebert: "Nature could not create such surpassing beauty. Or perhaps she had no share in making it? . . . Surely God created it with His bare hand to astonish Nature."[102] If the beauty of an image is regarded as so far surpassing the beauty of nature that its creation implies divine intervention, then the estimate of the image certainly exemplifies the

[97] J.-M. Dèchanet, ed. and trans., *Oeuvres choisies de Guillaume de Saint-Thierry* (Paris, 1944), 51, lists the following twelfth-century authors: William of Saint-Thierry, Ailred of Rievaulx, Hugh of Saint Victor, Isaac of Stella, Pseudo-Hugh, Alcher of Clairvaux, Arnold of Bonneval, and St. Hildegarde. In addition, St. Bernard and Richard of Saint-Victor touched on the problem in works centered on other themes.

[98] *Ibid., De natura corpori et animae*, 105–107.

[99] *Ibid.*, 94–95. Here William is paraphrasing Vitruvius (in *De architectura*, III.i.3) where that antique authority relates the proportions of the human body to those of the classical orders.

[100] The "Victorine" treatises include those by Hugh of Saint-Victor, his disciple Isaac of Stella, his successor, Richard of Saint-Victor (who discussed this issue in works based on other matters), and Pseudo-Hugh. Another mystic who also wrote on the body and the soul was St. Hildegarde.

[101] de Bruyne, *Esthétique médiévale*, II, 106–107.

[102] Quoted from Ernst Robert Curtius, *European Literature in the Latin Middle Ages*, trans. Willard Trask (Princeton, 1953), 181–182.

Dionysian concept of a theophanic manifestation of the invisible world.

Although the theme of the Senlis sculpture belongs to a category that could be inspired by the Dionysian theory of images, the figural style of the portal, as we earlier observed, signals a disintegration of the relationship of theme to format and style. The formal concept of natural appearance represented as ideal beauty could be conceived and applied without relationship to the theme and this is apparently what happened in early Gothic portals. When the conception of style was divorced from that of subject matter, the creation of images from the patron's point of view involved nothing more than the stipulation of subject matter to an artist who possessed sufficient skill to execute it in an ideally beautiful form. The corollary to this abdication on the part of the patron was a mandate to the artist to assume the burden of giving substance to such a notion of style. Even though the artist had always assumed responsibility for translating his skills into an accurate realization of the formal aims of a commission, the mode of ideal beauty required him to discover his own manner of achieving this goal. It is no coincidence that the masters who carved the early and mature Gothic portals left in their work the mark of very distinct and individual artistic personalities. When, in the third generation of great portals, sculptors assumed a more active role in the creation of art, the medium of monumental stone sculpture had acquired virtually the same nature it possessed in the ancient world, and its revival was complete. (Indeed, at this point some sculptures in the Ile de France appear to have been directly inspired by, or copied from, antique sculpture).[103]

There is no simple or obvious explanation for the changes that occurred in the creation of sculpture around 1170. During the last three decades of the twelfth century the theory that guided nearly every field of intellectual and artistic endeavor was altered to a similar degree. The complexity of this general shift in the approach to thought and art is so great that its analysis would require an account as long again as the present book.[104] Suffice it, then, to acknowledge that the art of sculpture underwent a transformation of great significance to the medieval practice of image making. To create images illusory of their worldly counterparts was to grant to image making a license beyond illustrative suggestion, a license in which the inherent falseness of images was discounted against the virtue of convincing representation of the subject. In so doing, the medieval philosophy of images and image making was turned upside down. From this point, the style of monumental sculpture became a purely artistic consideration, bound up in the concept of beauty and distinct from the formulation of the subject matter. The only variation of style in relation to subject matter which remained was that applied to explicitly ugly subjects, and they were relegated to a very minor role in most portal programs. The Gothic style signals the return of natural beauty in art in much the same sense that it was cultivated by the ancients, but initially without any direct influence from antique art. Although its development was pursued as a virtual rather than an actual imitation of nature, the role of sculpture was to create images that reflect in the mirror of the physical world the higher truths of the spiritual world.

[104] Max Dvořák, in *Idealismus and Naturalismus in der gotischen Skulptur und Malerei* (Munich, 1928; trans. Randolph J. Klawiter, as *Idealism and Naturalism in Gothic Art* [Notre Dame, Ind.], 1967), discussed Gothic sculpture in terms of the spiritual climate in which it was created. He raised the issues discussed above and others besides, but he did not treat either aesthetic theory or the monuments in a systematic exposition of historical development.

[103] Willibald Sauerländer, "Art antique et sculpture autour de 1200," *Art de France*, 1 (1961), 47–56.

Selected Bibliography

This bibliography is intended to guide readers who desire additional information to the works that were most useful to me in writing this book. By no means does it include all works consulted, especially those dealing with matters other than medieval sculpture, nor even all those cited in the notes. And it represents only a fraction of the total literature devoted to Romanesque sculpture, much of which is outdated or not useful.

The works listed here have been classified into categories to assist the reader in exploring specific areas and, to avoid confusion, the categories honor the conventions of classification observed in the field even when they conflict with interpretations made in this book. A number of works are difficult to classify precisely or belong in more than one category. As a rule, I have listed works in the area for which they were most useful in researching this book or, when such a priority could not be assigned, I have listed them in the first appropriate category.

In both the notes and the bibliography, when I have cited works of art that are not illustrated in this volume I have referred the reader to those sources in which good photographs are most readily available, including works of a semipopular nature. Also, when there have been numerous articles dealing with one specific point, such as the date of a particular monument, I have in most cases listed only the source in which the bibliography is collected.

Readers who wish to find copious illustration of numerous monuments of Romanesque sculpture should consult the various volumes in the Nuit de Temps series, published by the Zodiaque Press, only some of which are listed in this bibliography. And readers who wish to consult fuller bibliographies will find them in the *Encyclopedia of World Art* under "Romanesque Art: Sculpture," and in Stephen K. Scher's exhibition catalogue, *The Renaissance of the Twelfth Century* (Providence, 1969), for which Peter Fusco compiled the bibliography.

Pre-Romanesque Sculpture (from Late Antiquity)

Baum, Julius. *La sculpture figurale en Europe à l'époque mérovingienne.* Paris, 1937.

Beckwith, John. *Early Christian Art.* Pelican History of Art. Harmondsworth, 1970.

Beuer-Szlechter, H.-V. "Monachisme colombanien et monachisme bénédictin dans l'art médiéval." *Etudes ligériennes d'histoire et d'archéologie médiévale.* Auxerre, 1975. Pp. 61–76.

Beutler, Christian. *Bildwerke zwischen Antike und Mittelalter: Unbekannte Skulpturen aus der Zeit Karl des Grossen.* Düsseldorf, 1964.

——. "Das Grab des heiligen Sola." *Wallraf-Richartz Jahrbuch* XX (1958): 55–68.

Bianchi-Bandinelli, Ranuccio. *The Late Empire: Roman Art, A.D. 200–400.* Translated by Peter Green. New York, 1971.

Boube, Jean. "Les sarcophages paléochrétiens de martres-toulosane." *Cahiers archéologiques* IX (1957): 33–72.

Braunfels, Wolfgang, ed. *Karl der Grosse, Lebenswerk und Nachleben.* 4 vols. Düsseldorf, 1965–1967.

Bréhier, Louis. *L'art en France des invasions barbares à l'époque romane.* Paris, 1930.

Buddensieg, Tilmann. "Die Basler Altartafel Heinrichs II." *Wallraf-Richartz Jahrbuch*, XIX (1957): 133–192.

Busch, Harald, et al. *Pre-Romanesque Art.* New York, 1966.

Cagiano de Azevedo, Michelangelo. "Stucco." *Encyclopedia of World Art*, XIII (1967). Pp. 634–635.

Clapham, Alfred W. "The Carved Stones at Breedon-on-the-Hill, Leicestershire, and Their Position in the History of English Art." *Archaeologia*, LXXVII (1927): 219–240.

Cramp, Rosemary. "The Position of the Otley Crosses in English Sculpture of the Eighth to Ninth Centuries." *Kolloquium über spätantike und frühmittelalterliche Skulptur*, vol. II. Mainz, 1970. Pp. 55–63.

Durliat, Marcel. "Les sarcophages du sud-ouest de la Gaule." *L'information d'histoire de l'art*, XIII (1968): 243–244.

——. "Tables d'autel à lobes de la province écclésiastique de Narbonne (IXe–XIe siècles)." *Cahiers archéologiques*, XVI (1966): 51–75.

Focillon, Henri. *L'an mil.* Paris, 1952.

Fossard, Denise. "Les chapiteaux de marbre du VIIe siècle en Gaule, Style et évolution." *Cahiers archéologiques*, II (1947): 69–85.

Francovich, Geza de. "Arte carolingia ed ottoniana in

Lombardia." *Römisches Jahrbuch für Kunstgechichte*, VI (1942–1944): 113–256.

———. "Il problema delle origini della scultura cosidetta 'longobarda.'" *Atti del l Congresso internazionale di studi longobardi 1951*. Spoleto, 1952. Pp. 255–273.

———. "Osservazioni sull'altare di Ratchis a Cividale e sui rapporti tra occidente ed oriente nel secoli VII e VIII D.C." *Studi in onore di Mario Salmi*. Rome, 1961. I, pp. 173–236.

Goldschmidt, Adolph. *Die deutschen Bronzetüren des frühen Mittelalters*. Marburg, 1926.

———. *Die Elfenbeinskulpturen aus der Zeit des karolingischen und sächsischen Kaiser, VIII.–XI. Jahrbundert*. 4 vols. Berlin, 1918–1926.

Grabar, André. *Early Christian Art from the Rise of Christianity to the Death of Theodosius*. Translated by Stuart Gilbert and James Emmons. New York, 1968.

Griffe, Elie. *La Gaule chrétienne à l'époque romaine*. 3 vols., 2d ed. Paris, 1964, 1966.

Haseloff, Arthur Erich Georg. *La scultura pre-romanica in Italia*. Bologna, 1930. Republished as *Pre-Romanesque Sculpture in Italy*. Translated by Ronald Boothroyd. Florence, 1930.

Henry, Françoise. *Irish Art during the Viking Invasions (800–1020 A.D.)*. Ithaca, N.Y., 1967.

Hoffmann, Hartmut. "Die Aachener Theodorichstatue." *Das Erste Jahrtausand*. Edited by Victor Elbern. 2 vols. Düsseldorf, 1962–1964. I, pp. 318–335.

Hubert, Jean; Porcher, Jean; and Volbach, Wolfgang Friedrich. *L'empire carolingien*. Paris, 1968.

Jantzen, Hans. *Ottonische Kunst*. Munich, 1947.

Kautzch, Rudolf. "Die römische Schmuckkunst im Stein von 6. bis zum 10. Jahrhundert." *Römisches Jahrbuch für Kunstgeschichte*, III (1939): 2–73.

Lange, Reinhold. *Die Byzantinische Reliefikone*. Recklinghausen, 1964.

Lasko, Peter. *Ars Sacra, 800–1200*. Pelican History of Art. Harmondsworth, 1972.

———. *The Kingdom of the Franks*. London, 1971.

Lawrence, Marion. *The Sarcophagi of Ravenna*. New York, 1945.

Le Blant, Edmund. *Les sarcophages chrétiens de la Gaule*. Paris, 1886.

Maillé, Geneviève Aliette. *Les cryptes de Jouarre*. Paris, 1971.

Mercklin, Eugen von. *Antike Figuralkapitelle*. Berlin, 1962.

Morey, Charles Rufus. *Early Christian Art: An Outline of the Evolution of the Style and Iconography in Sculpture and Painting from Antiquity to the Eighth Century*. Princeton, 1942.

Nordenfalk, Carl. "The Chronology of the Registrum Master." *Kunsthistorische Forschungen Otto Pächt*. Salzburg, 1972. Pp. 62–76.

———. "Der Meister des Registrum Gregorii." *Münchner Jahrbuch der bildenden Kunst*, 3d ser., I (1950): 61–77.

l'Orange, Hans Peter. "Late Antique and Early Christian Art: Sculpture." *Encyclopedia of World Art*, IX (1964). Pp. 100–118.

Petricioli, Ivo. "La scultura preromanica figurativa in Dalmazia ed ill problema della sua chronologia." *Stucchi e mosaici alto medioevali: Atti dell'ottavo Congresso di studi sull'arte dell'alto Medioevo*, vol. I. Milan, 1962. Pp. 360–374.

Rhein und Maas, Kunst und Kultur, 800–1400, 2 vols. Cologne, 1972–1973.

Sakisian, A. "Notes on the Sculpture of the Church of Akhthamar." *Art Bulletin*, XXV (1942): 346–357.

Saxl, Fritz. "The Ruthwell Cross." *Journal of the Warburg and Courtauld Institutes*, VI (1943): 1–19.

Schapiro, Meyer. "The Religious Meaning of the Ruthwell Cross." *Art Bulletin*, XXVI (1944): 232–245.

Schlunk, Helmut. "La Escultura Visigoda" and "Arquitectura Visigoda del siglo VII." *Ars hispaniae*. Madrid, 1947. II, pp. 233–307.

Souchal, François et al. *Art of the Early Middle Ages*. Translated by Ronald Millen. New York, 1968.

Stevenson, Robert B. K. "Sculpture in Scotland in the 6th–9th Centuries, A.D." *Kolloquium über spätantike und frühmittelalterliche Skulptur*, vol. II. Mainz, 1970. Pp. 65–74.

Ulbert, Thilo. "Skulptur in Spanien (6.–8. Jahrhundert)." *Kolloquium über spätantike und frühmittelalterliche Skulptur*, vol. II. Mainz, 1970. Pp. 25–34.

Varagnac, André, and Fabre, Gabrielle. *L'art gaulois*. La Nuit des Temps. La Pierre-qui-vire, 1964.

Verzone, Paolo. *L'arte preromanica in Liguria; ed i relievi decorativi dei 'secoli barbari.'* Turin, 1944.

Volbach, Wolfgang Friedrich. *Early Christian Art*. New York, 1962.

Ward-Perkins, J. B. "The Sculptures of Visigothic France." *Archaeologia*, LXXXVII (1937): 79–128.

Wesenberg, Rudolf. *Bernwardische Plastik*. Berlin, 1955.

Wilpert, Dom Joseph. *I sarcofagi christiani antichi*. 3 vols. Rome, 1929–1936.

Romanesque Sculpture, the Eleventh and Twelfth Centuries

GENERAL WORKS

Baltruŝaitis, Jurgis. *La stylistique ornementale dans la sculpture romane*. Paris, 1931.

———. *Art sumérien, art roman*. Paris, 1934.

Bernheimer, R. *Romanische Tierplastik und die Ursprünge ihrer Motive*. Munich, 1931.

Bréhier, Louis. "Les origines de la sculpture romane." *La Revue des deux mondes*, X (1912): 870–901.

———. "Les thèmes décoratifs des tissus d'orient et leur imitation dans la sculpture romane." *Etudes d'Art*, I (1945): 27–63.

Focillon, Henri. *L'art des sculpteurs romans: Recherches sur l'histoire des formes*. Paris, 1931.

———. *Art d'Occident*. Paris, 1931. Edited by Jean Bony and translated by Donald King. *Art of the West*, I, *Romanesque Art*. London and New York, 1963.

Gaillard, Georges. "De la diversité des styles dans la sculpture romane des pélerinages." *Revue des Arts*, I (1951): 77–87.

———. *Etudes d'art roman*. Paris, 1972.

Gantner, Joseph. *Romanische Plastik: Inhalt und Form in der Kunst des XI. und XII. Jahrhunderts*. 3d ed. Vienna, 1948.

Grabar, André. *L'art de la fin de l'Antiquité et du Moyen Age.* 3 vols. Paris, 1968.

Grodecki, Louis. "Dualité de l'art roman." *L'Oeil,* III (1957): 52–61.

____; Mutterich, Florentine; Taralon, Jean; and Wormald, Francis. *Le siècle de l'an mil.* L'univers des formes. Paris, 1973.

Hamann-MacLean, Richard. "Les origines des portails et façades sculptés gothiques." *Cahiers de la civilization médiévale: Xe–XIIe siècles,* II (1959): 157–175.

Leisinger, Hermann. *Romanesque Bronzes: Church Portals in Medieval Europe.* New York, 1957.

Lyman, Thomas W. "Arts somptuaires et art monumental: Bilan des influences auliques." *Les Cahiers de Saint-Michel-de-Cuxa,* IX (1978): 115–124.

____. "L'integration du portail dans la façade romane méridionale." *Les Cahiers de Saint-Michel-de-Cuxa,* VIII (1977): 55–68.

____. "Terminology, Typology, Taxonomy: An Approach to the Study of Architectural Sculpture of the Romanesque Period." *Gazette des Beaux Arts.* LXXXII (1976): 223–227.

Mély, F. de. "Signature de primitifs, de Cluny à Compostelle." *Gazette des Beaux Arts,* X (1924): 1–24.

Morey, Charles Rufus. "The Sources of Romanesque Sculpture." *Art Bulletin,* II (1919): 10–16.

Oakeshott, Walter. *Classical Inspiration in Medieval Art.* London. 1958.

Oursel, Raymond. *Floraison de la sculpture romane.* 2 vols. La Nuit des Temps. La Pierre-qui-vire, 1973, 1976.

Pächt, Otto. "The Pre-Carolingian Roots of Romanesque Art." *Romanesque and Gothic Art, Studies in Western Art, Acts of the Twentieth International Congress of the History of Art, 1960.* Princeton, 1963. I, pp. 67–75.

Porter, Arthur Kingsley. "Les débuts de la sculpture romane." *Gazette des Beaux Arts,* LXI (1919): 47–60.

____. *Romanesque Sculpture of the Pilgrimage Roads.* 10 vols. Boston, 1923.

Rey, Raymond, *L'art des cloîtres romans: Étude iconographique.* Toulouse, 1955.

Salvini, Robert. *Medieval Sculpture.* New York, 1969.

Schapiro, Meyer. "Über den Schematismus in der romanischen Kunst." *Kritische Berichte zur kunstgeschichtlichen Literatur.* Zurich and Leipzig, 1932–1933. Pp. 1–21. Republished as "On Geometrical Schematism in Romanesque Art" in *Romanesque Art.* New York, 1977. Pp. 265–284.

Sheppard, Carl D. "Pre-romanesque and Romanesque Sculpture in Stone." *Art Quarterly,* XXIII (1960): 341–358.

Slomann, Vilhelm. *Bicorporates: Studies in the Revivals and Migrations of Art Motifs.* 2 vols. Copenhagen, 1967.

Swarzenski, Hanns. *Monuments of Romanesque Art: The Art of Church Treasures in North-Western Europe.* 2d ed. Chicago, 1967.

FRANCE

General Works

Adhémar, Jean. *Influences antiques dans l'art du Moyen-Age français.* London, 1939.

Aubert, Marcel. *La sculpture française au Moyen Age.* Paris, 1947.

Christe, Yves. *Les grands portails romans: Etudes sur l'iconologie des théophanes romanes.* Geneva, 1969.

Deschamps, Paul. *French Sculpture of the Romanesque Period, Eleventh and Twelfth Centuries.* Florence and New York, 1930.

____. "Les débuts de la sculpture romane en Languedoc et en Bourgogne." *Revue archéologique,* ser. V, XIX (1924): 163–173.

____. "Étude sur la renaissance de la sculpture en France à l'époque romane." *Bulletin monumental,* LXXXIV (1925): 5–98.

Durand-Lefebvre, Marie. *Art gallo-romain et sculpture romane, recherche sur les formes.* Paris, 1937.

Durliat, Marcel. "L'apparition du grand portail roman historié dans le Midi de la France et le nord de l'Espagne." *Les Cahiers de Saint-Michel-de-Cuxa,* VIII (1977): 7–24.

____. "L'art roman en France: Etat des questions." *Anuario de Estudios Medievales,* V (1968): 609–627.

____. "Le cloître historié dans la France méridionale à l'époque romane." *Les Cahiers de Saint-Michel-de-Cuxa,* VII (1976): 61–74.

____. "Les débuts de la sculpture romane dans le Midi de la France et en Espagne." *Les Cahiers de Saint-Michel-de-Cuxa,* IX (1978): 101–114.

Focillon, Henri. "Recherches récentes sur la sculpture romane en France au XIe siècle." *Bulletin monumental,* XCVII (1938): 49–72.

Forsyth, Ilene Haering. *The Throne of Wisdom: Wood Sculptures of the Madonna in Romanesque France.* Princeton, 1972.

Garcia-Romo, Francisco. "La escultura romanica francese hasta 1090." *Archivo español de Arte,* XXX (1957): 223–240; XXXII (1959): 121–141.

____. "Influencias hispano-musulmanas y mozarabes en general y en romanico frances del siglo XI." *Arte español,* XIX (1953): 163–195; XX (1954): 33–57.

Grivot, Denis. *Le diable dans la cathédrale.* Paris, 1960.

Grodecki, Louis. "La sculpture du XIe siècle en France: Etat des questions." *L'Information d'Histoire de l'Art,* III (1958): 98–112.

Kraus, Henry. *The Living Theatre of Medieval Art.* Bloomington, Ind., 1967.

Lasteyrie, Robert de. "Etudes sur la sculpture française au Moyen Age." *Monuments Piot,* VIII (1902): 96–102.

Lefrançois-Pillion, Louise. *Les sculpteurs français du XIIe siècle.* Paris, 1931.

Messerer, Wilhelm. *Romanische Plastik in Frankreich.* Cologne, 1964.

Montague, John Stanley. *Romanesque Sculptured Ornament in France.* 3 vols. Ph.D. dissertation, University of Wisconsin, 1974. Ann Arbor, 1975.

Scher, Stephen, K., et al. *The Renaissance of the Twelfth Century.* Providence, 1969.

Vanuxem, Jacques. "The Theories of Mabillon and Montfaucon on French Sculpture of the 12th Century." *Journal of the Warburg and Courtauld Institutes,* XX (1957): 45–58.

Vergnolle, Eliane. "Chronologie et méthode d'analyse:

Doctrines sur les débuts de la sculpture romane en France." *Les Cahiers de Saint-Michel-de-Cuxa*, IX (1978): 141-162.

Burgundy

Aubert, Marcel. "Eglise abbatiale de Cluny." *Congrès archéologique de France, Lyon-Mâcon*, XCVIII (1935): 503-522.

Banchereau, J. "Travaux d'apiculture sur un chapiteau de Vézelay." *Bulletin monumental*, LXXVII (1913): 403-411.

Beenken, Hermann. "Die tympana von La Charité-sur-Loire." *Art Studies*, VI (1928): 145-159.

Beutler, Christian. "Das Tympanon zu Vézelay: Programm, Planwechsel and Datierung." *Wallraf-Richartz Jahrbuch*, XXIX (1967): 7-30.

Conant, Kenneth John. "The Apse at Cluny." *Speculum*, VII (1932): 23-35.

——. *Cluny: Les églises et la maison du chef d'ordre*. Mâcon, 1968.

——. "The Iconography and the Sequence of the Ambulatory Capitals of Cluny." *Speculum*, V (1930): 278-287.

——. "Medieval Academy Excavations at Cluny: The Date of the Capitals." *Speculum*, V (1930): 77-94.

——. "The Third Church at Cluny." *Medieval Studies in Memory of A. Kingsley Porter*, vol. II. Cambridge, Mass., 1939. Pp. 327-357.

Deschamps, Paul. "L'âge des chapiteaux de Cluny." *Revue de l'Art*, LVIII (1930): 157-176; 205-218.

——. "Notes sur la sculpture romane en Bourgogne." *Gazette des Beaux Arts*, LXIV (1922): 61-80.

——. "A propos des chapiteaux du choeur de Cluny." *Bulletin monumental*, LXXXVIII (1929): 514-516.

Evans, Joan. *Cluniac Art of the Romanesque Period*. Cambridge, 1950.

Forsyth, Ilene, H. "The Ganymede Capital at Vézelay." *Gesta*, XV (1976): 241, 246.

——. "The Theme of Cockfighting in Burgundian Romanesque Sculpture." *Speculum*, LIII (1978): 252-282.

Grivot, Denis, and Zarnecki, George. *Gislebertus, Sculptor of Autun*. London, 1961.

Graham, Rose, and Clapham, A. W. "The monastery of Cluny, 910-1155." *Archaeologia*, LXXX (1930): 143-178.

Heitz, Carol. "Reflexions sur l'architecture clunisienne." *Revue de l'art* XV (1972): 81-94.

Jacoby, Zehava. "La sculpture à Cluny, Vézelay et Anzy-le-Duc: Un aspect de l'évolution stylistique en Bourgogne." *Storia dell'Arte*, XXXIV (1978): 197-205.

Katzenellenbogen, Adolf. "The Central Tympanum at Vézelay." *Art Bulletin*, XXVI (1944): 141-151.

Kerber, Bernhard. *Burgund und die Entwicklung der französischen Kathedralskulptur in zwölften Jahrhundert*. Recklinghausen, 1966.

Kleinschmidt, Helen. "Notes on the Polychromy of the Great Portal at Cluny." Written 1930. *Speculum*, XLV (1970): 36-39.

Meyer, Kathi. "The Eight Gregorian Modes on the Cluny Capitals." *Art Bulletin*, XXXIV (1952): 75-94.

Oursel, Charles. *L'art roman de Bourgogne: Etudes d'histoire et d'archéologie*. Dijon, 1928.

——. "Le rôle et la place de Cluny dans la renaissance de la sculpture en France à l'époque romane." *Revue archéologique*, ser. V, XVII (1923): 255-289.

Oursel, Raymond. *Les églises romanes de l'Autunnois et du Brionnais*. Mâcon, 1956.

Pendergast, Carol Stamatis. *The Romanesque Sculptures of Anzy-le-Duc*. Ph.D. dissertation, Yale University, 1974. Ann Arbor, 1974.

Porter, Arthur Kingsley. "La sculpture du XIIe siècle en Bourgogne." *Gazette des Beaux Arts*, CXX (1920): 73-94.

Quarré, Pierre. "Les sculptures du tombeau de Saint-Lazare à Autun et leur place dans l'art roman." *Cahiers de Civilisation médiévale*, V (1962): 169-174.

Salet, Francis. "Cluny III." *Bulletin monumental*, CXXVI (1968): 235-292.

——. *La Madeleine de Vézelay*. Melun, 1948.

——. Review of Elizabeth Read Sunderland, *Charlieu à l'époque médiévale*, Lyon, 1971. *Bulletin monumental*, CXXX (1972): 73-75.

——. "Vézelay." *Bulletin de la Société nationale des antiquaires de France*, 1945-1946-1947: 62-69, 262, 267-268.

Sauerländer, Willibald. "Gislebertus von Autun: Ein Beitrag zur Entstehung seines küntlerischen Stils." *Studien zur Geschichte der Europäischen Plastik: Festschrift Theodor Müller*. Munich, 1965. Pp. 17-29.

Schapiro, Meyer. *The Parma Ildefonsus, A Romanesque Illuminated Manuscript from Cluny and Related Works*. New York, 1964.

——. Review of Oursel, *L'art roman de Bourgogne. . . . Art Bulletin*, XI (1928): 225-231.

Stiennon, Jacques. "Hézelon de Liège, architecte de Cluny III." *Mélanges offerts à René Crozet*. Poitiers, 1966. Pp. 345-358.

Sunderland, Elizabeth Read. *Charlieu à l'époque médiévale*. Lyon, 1971.

——. "The History and Architecture of the Church of St. Fortunatus at Charlieu." *Art Bulletin*, XXI (1939): 61-88.

Talobre, Joseph. "La reconstitution du portail de l'église abbatiale de Cluny." *Bulletin monumental*, CII (1943-1944): 225-240.

Terret, Victor. "Le portail roman du narthex de Saint-Fortunat de Charlieu et sa sculpture décorative du XIIe siècle." *Marburger Jahrbuch*, V (1929): 87-98.

——. *La sculpture bourguignonne au XIIe et XIIIe siècles, ses origines et ses sources d'inspiration*, I, *Cluny*, II, *Autun*. 3 vols. Autun, 1914-1925.

Vergnolle, Eliane. "Les chapiteaux du déambulatoire de Cluny." *Revue de l'Art*. XV (1972): 99-101.

—— et al. "Recherches sur quelques séries de chapiteaux romans bourguignons." *L'Information d'Histoire de l'Art*, XX (1975): 55-79.

Languedoc

Aubert, Marcel. *L'église Saint-Sernin de Toulouse*. Paris, 1933.

——. "Moissac: L'abbaye et le cloître." *Congrès archéologique de France, Toulouse*, XCII (1929): 494-525.

——. "Saint-Sernin, Toulouse." *Congrès archéologique de France, Toulouse*, XCII (1929): 9-68.

Balsam, L., and Surchamp, Angelico. *Rouergue roman*. La Nuit des Temps. La Pierre-qui-vire, 1963.

Bernoulli, Christoph. *Die Skulpturen der Abtei Conques-en-Rouerge*. Basel, 1956.

Bréhier, Louis. "Les sculpteurs des routes de pélerinages." *Revue de l'Art*, XLV (1924): 127–133.

Cabanot, Jean. "Le décor sculpté de la basilique de Saint-Sernin de Toulouse." *Bulletin monumental*, CXXXII (1974): 99–145.

Cannell, Gillian. "A Reconsideration of the problem of the bas-reliefs at Saint Sernin in Toulouse." Master's thesis, University of Pittsburgh, 1976.

Delaruelle, Etienne. "L'autel roman de Saint-Sernin—confrères, pélerins et pénitents." *Mélanges offerts à René Crozet*. Poitiers, 1966. I, pp. 145–158.

_____. "Les bas-reliefs de Saint-Sernin." *Annales du Midi*, XLI (1929): 49–60.

_____. "Le problème des influences catalanes et les bas-reliefs de Saint-Sernin." *Annales du Midi*, XLV (1933): 237–261.

Deschamps, Paul. "L'autel roman de Saint-Sernin de Toulouse et les sculptures du cloître de Moissac." *Bulletin archéologique*, 1923, pp. 239–250.

_____. "Etude sur les sculptures de Sainte-Foy de Conques et de Saint-Sernin de Toulouse et leurs relations avec celles de Saint-Isidore le León et de Saint-Jacques de Compostelle." *Bulletin monumental*, C (1941): 239–264.

_____. "Notes sur la sculpture romane en Languedoc et dans le nord de l'Espagne." *Bulletin monumental*, LXXXII (1923): 305–351.

Dubourg-Noves, Pierre. *Iconographie de la Cathédrale d'Angoulême*. Preface by Marcel Durliat. Angoulême, 1973.

Durliat, Marcel. "L'atelier de Bernard Gelduin à Saint-Sernin de Toulouse." *Anuario de Estudios medievales*, I (1964): 521–529.

_____. "Les cryptes de Saint-Sernin de Toulouse: Bilan des recherches récentes." *Les monuments historiques de la France*, n.s., XVII (1971): 25–40.

_____, et al. *Les grands étapes de la sculture romane toulousaine*. Toulouse, 1971.

_____. "Le portail de la salle capitulaire de la Daurade à Toulouse." *Bulletin monumental*, CXXXII (1974): 201–211.

_____. "La sculpture romane toulousaine." *L'Information d'Histoire de l'Art*, XIII (1968): 245–246.

_____. "La table d'autel de Lavaur." *Anuario de Estudios medievales*, II (1965): 479–484.

French, Jean Marie. *The Innovative Imagery of the Beaulieu Portal Program: Sources and Significance*. Ph.D. dissertation, Cornell University, 1972. Ann Arbor, 1973.

Gerke, Friedrich. "Der Tischaltar des Bernard Gilduin in Saint-Sernin in Toulouse." *Akademie der Wissenschaften und der Literatur, Abhandlungen der Geistes und Socialwissenschaftlichen Klasse*, vol. VIII. Mainz, 1958. Pp. 494–508.

Graillot, Henri. "Compte-rendu de *La basilique de Saint-Sernin de Toulouse*, A. Auriol et R. Rey." *Annales du Midi*, XLIV (1932): 93–95.

Grodecki, Louis. "Le problème des sources iconographiques du tympan de Moissac." *Moissac et l'Occident au XIe siècle: Actes du Colloque international de Moissac, 1963*. Toulouse, 1964; also in *Annales du Midi*, LXXV (1963): 387–393.

Kline, Ruth Maria Capelle. *The Decorated Imposts of the Cloister of Moissac*. Ph.D. dissertation, University of California at Los Angeles, 1977. Ann Arbor, 1977.

Lafargue, Marie. *Les chapiteaux du cloître de Notre-Dame La Daurade*. Paris, 1940.

Lyman, Thomas, W. "Arts somptuaires et art monumental: Bilan des influences auliques préromanes sur la sculpture romane dans le sudouest de la France et en Espagne." *Les Cahiers de Saint-Michel-de-Cuxa*, IX (1978): 115–127.

_____. "Notes on the Porte Miègeville Capitals and the Construction of St. Sernin in Toulouse." *Art Bulletin*, XLIX (1967): 24–36.

_____. "Raymond Gairard and Romanesque Building Campaigns at Saint-Sernin in Toulouse." *Journal of the Society of Architectural Historians*, XXXVII (1978): 71–91.

_____. "The Sculpture Programme of the Porte des Comtes Master at Saint-Sernin in Toulouse." *Journal of the Warburg and Courtauld Institutes*, XXXIV (1971): 12–39.

Mesplé, P. *Toulouse, Musée des Augustins: Les sculptures romanes*. Paris, 1961.

Mézoughi, Noureddine, "Le tympan de Moissac: études d'iconographie," *Les Cahiers de Saint-Michel-de-Cuxa*, IX (1978): 171–200.

Pendergast, Carole Stamatis. "The Lintel of the West Portal at Anzy-le-Duc." *Gesta*, XV (1976): 135–142.

Rey, Raymond. *La sculpture romane languedocienne*. Toulouse and Paris, 1936.

Rupin, Ernest, *L'abbaye et les cloîtres de Moissac*. Paris, 1897.

Sauerländer, Willibald. "Das seckste internationale Colloquium der 'Société française d'archéologie': Die Skulpturen von Saint-Sernin in Toulouse." *Kunstchronik*, XXIV (1971): 341–347.

Schapiro, Meyer. "The Romanesque Sculpture of Moissac." *Art Bulletin*, XIII (1931): 249–350, 464–531.

_____. "The Sculptures of Souillac." *Medieval Studies in Memory of A. Kingsley Porter*, II (1939): 359–387.

_____. "Two Romanesque Drawings in Auxerre and Some Iconographic Problems." *Studies in Art and Literature for Belle da Costa Greene*. Edited by Dorothy E. Miner. Princeton, 1954. Pp. 331–349.

Scott, David, W. "A Restoration of the West Portal Relief Decoration of Saint-Sernin of Toulouse." *Art Bulletin*, XLVI (1964): 271–282.

Seidel, Linda. "A Romantic Forgery: The Romanesque 'Portal' of Saint-Etienne in Toulouse." *Art Bulletin*, L (1968): 33–42.

Shaver, Anne Elizabeth. *The North Portal of the Cathedral of Cahors*. Ph.D. dissertation, Columbia University, 1974. Ann Arbor, 1975.

Other Regions

Bathellier, Jean. "Observations sur la crypte de Saint-Aignan d'Orléans et ses chapiteaux." *Revue archéologique*, XXXIX (1952): 192–206.

Baum, Julius. "The Porch of Andlau Abbey." *Art Bulletin*, XVII (1935): 492–505.

Berland, Jean-Marie. "Le problème de la datation du clocher-porche de Saint-Benoît-sur-Loire." *Etudes*

ligériennes d'histoire et d'archéologie médiévale. Auxerre, 1975. Pp. 61–76.

Daras, Charles. *Angoumois roman.* La Nuit des Temps. La Pierre-qui-vire, 1961.

Defarges, Bénigne. *Val-de-Loire roman et Touraine romane.* La Nuit des Temps. La Pierre-qui-vire, 1965.

Deschamps, Paul. "Tables d'autel de marbres executées dans la Midi de la France au Xe et au XIe siècle." *Mélanges d'histoire du Moyen Age offerts à M. Ferdinand Lot.* Paris, 1925. Pp. 137–168.

Durliat, Marcel. "Les premiers essais de décoration de façades en Roussillon au XIe siècle." *Gazette des Beaux Arts,* LXVII (1966): 65–77.

———. *Roussillon roman.* La Nuit des Temps. La Pierre-qui-vire, 1954.

Grodecki, Louis. "Les chapiteaux en stuc de Saint-Rémi de Reims." *Stucchi e mosaici alto medioevali: Atti dell'ottavo Congresso di studi sull'arte dell'alto Medioevo,* vol. I. Milan, 1962. Pp. 186–208.

Hubert, Jean. "Les dates de construction du clocher-porche et de la nef de Saint-Germain-des-Prés." *Bulletin monumental,* CVIII (1950): 69–84.

Lefevre-Pontalis, Eugène. "Etude historique et archéologique sur l'église de Saint-Germain-des-Prés." *Congrès archéologique de France,* Paris, LXXXII (1919): 301–366.

Lesueur, Frédéric. "La date du porche de Saint-Benoît-sur-Loire." *Bulletin monumental,* CXXVII (1969): 119–123.

———. "Saint-Aignan d'Orléans, l'église de Robert le Pieux." *Bulletin monumental,* CXV (1957): 169–206.

Mendell, Elizabeth Lawrence. *Romanesque Sculpture in Saintonge.* London, 1940.

Rousseau, Pierre. "La crypte de l'église Saint-Aignan d'Orléans." *Etude ligériennes d'histoire et d'archéologie médiévales.* Auxerre, 1975. Pp. 454–473.

Sauvel, Tony. "La façade de Saint-Pierre d'Angoulême." *Bulletin monumental,* CIII (1945): 175–199.

Schapiro, Meyer. "A Relief in Rodez and the Beginnings of Romanesque Sculpture in Southern France." *Romanesque and Gothic Art, Studies in Western Art: Acts of the Twentieth International Congress of the History of Art, 1960.* Princeton, 1963. I, pp. 40–66.

Schmitt, Marilyn Low. *The Abbey Church of Selles-sur-Cher.* Ph.D. dissertation, Yale University, 1972. Ann Arbor, 1973.

Seidel, Linda. "Holy Warrior: The Romanesque Rider and the Fight against Islam." *The Holy War.* Edited by T. P. Murphy. Columbus, 1976. Pp. 3–54.

Verdier, Philippe. "La sculpture du clocher-porche de Saint-Benoît-sur-Loire dans ses rapports, avec l'espagne califale et mozarabe." *Etudes ligériennes d'histoire et d'archéologie médiévale.* Auxerre, 1975. Pp. 327–336.

Formation of the Gothic Style

Aubert, Marcel. *French Sculpture at the Beginning of the Gothic Period, 1140–1225.* Florence and Paris, 1929.

Brouillette, Diane. *Senlis: Un moment de la sculpture gothique.* Senlis, 1977.

Colish, Marcia. "Peter of Bruys, Henry of Lausanne, and the Facade of Saint-Gilles." *Traditio,* XXVII (1972): 451–460.

Crosby, Sumner. *L'abbaye royale de Saint-Denis.* Paris, 1953.

———. *The Abbey of Saint-Denis,* vol. I. New Haven, 1942.

———. "A Relief from Saint-Denis in a Paris Apartment." *Gesta,* VII (1969): 45–46.

———. "The West Portals of Saint-Denis and the Saint-Denis Style." *Gesta,* VIII (1970): 1–11.

Dvořák, Max. *Idealismus und Naturalismus in der gotischen Skulptur und Malerei.* Munich, 1928. Translated by Randolph J. Klawiter as *Idealism and Naturalism in Gothic Art.* Notre Dame, Ind., 1967.

Fels, Etienne. "Die Grabung an der Fassade der Kathedrale von Chartres." *Kunstchronik,* VIII (1955): 149–151.

Ferguson O'Meara, Carra. *The Iconography of the Facade of Saint-Gilles-du-Gard.* New York, 1977.

Gerson, Paula Lieber. *The West Facade of St.-Denis: An Iconographic Study.* Ph.D. dissertation, Columbia University, 1970. Ann Arbor, 1973.

Grodecki, Louis. "A propos de la sculpture française autour de 1200." *Bulletin monumental,* CXV (1957): 119–126.

Hamann-McLean, Richard. *Die Abteikirche von Saint-Gilles und ihre künstlerische Nachfolge.* 3 vols. Berlin, 1955.

Heimann, Adelheid. "The Capital Frieze and Pilasters of the Portail Royal de Chartres." *Journal of the Warburg and Courtauld Institutes,* XXXI (1968): 73–102.

Katzenellenbogen, Adolf. "Iconographic Novelties and Transformations in the Sculpture of French Church Facades, ca. 1160–1190." *Studies in Western Art: Acts of the Twentieth International Congress of the History of Art, 1960.* Princeton, 1963. I, pp. 108–118.

———. *The Sculptural Programs of Chartres Cathedral: Christ, Mary, Ecclesia.* Baltimore, 1959.

Kidson, Peter, and Pariser, Ursula. *The Sculpture of Chartres.* London, 1958.

Lapeyre, André. *Des façades occidentales de Saint-Denis et de Chartres aux portails de Laon.* Paris, 1960.

McCullough, Jean. "The Iconography of the Canopies and Column-Statues of the Side Portals on the West Facade of Chartres." Master's thesis, University of Pittsburgh, 1979.

Sauerländer, Willibald. "Art antique et sculpture autour de 1200." *Art de France,* I (1961): 47–56.

———. "Beiträge zur Geschichte der 'frühgotischen' Skulptur." *Zeitschrift für Kuntsgeschichte,* XIX (1956): 1–34.

———. *Gothic Sculpture in France, 1140–1270.* London, 1972.

———. "Die Marienkrönungsportale, von Senlis und Mantes." *Wallraf-Richartz Jahrbuch,* XX (1958): 115–162.

———. "Sculpture on Early Gothic Churches: The State of Research and Open Questions." *Gesta,* IX (1970): 32–48.

———. "Twelfth-Century Sculpture at Châlons-sur-Marne." *Studies in Western Art: Acts of the Twentieth International Congress of the History of Art, 1960.* Princeton, 1963. I, pp. 119–128.

Schapiro, Meyer. "Further Documents on Saint-Gilles." *Art Bulletin,* XIX (1936): 111–112.

———. "New Documents on Saint-Gilles." *Art Bulletin,* XVII (1934): 415–430.

Stoddard, Whitney. *The Facade of Saint-Gilles-du-Gard: Its Influence on French Sculpture.* Middletown, Conn., 1973.
_____. *The West Portals of Saint-Denis and Chartres.* Cambridge, Mass., 1952.
Thérel, Marie-Louise. "Comment la patrologie peut éclairer l'archéologie: A propos de l'arbre de Jesse et des statues-colonnes de Saint-Denis." *Cahiers de Civilisation médiévale,* VI (1962): 145-159.
Vöge, Wilhelm. *Die Anfänge des monumentalen Stiles in Mittelalter.* Strasbourg, 1894. Translated by Alice Fischer and Gertrude Steuer, in *Chartres Cathedral,* edited by Robert Branner, New York, 1969.

ITALY

Arslan, Edoardo. "L'architettura romanica milanese: La scultura romanica." *Storia di Milano,* III (1954): 525-600.
Belli d'Elia, Pina. "La Cattedra dell'Abate Elia: precisazioni sul romanico pugliese." *Bolletino d'Arte,* LIX (1974): 1-17.
Bergman, Robert Paul. *The Salerno Ivories.* Ph.D. dissertation, Princeton University, 1972. Ann Arbor, 1972.
Bertaux, Emile. "La sculpture en Italie de 1070 à 1260." *Histoire de l'art,* vol. I. Edited by André Michel. Paris, 1905.
Crichton, George Henderson. *Romanesque Sculpture in Italy.* London, 1954.
Deschamps, Paul. "La légende arturienne à la cathédrale de Modène et l'école lombarde de sculpture romane." *Monuments Piot,* XXVIII (1925-1926): 69-94.
Fernie, Eric. "Notes on the Sculpture of Modena Cathedral." *Arte lombarda,* XIV (1969): 88-93.
Francovich, Geza de. "Wiligelmo da Modena e gli inizii della scultura romanica in Francia e in Spagna." *Revista del Reale Instituto di archeologia e storia dell'arte,* VII (1940): 225-294.
Grabar, André. "Trônes épiscopaux de XIe et XIIe siècles en Italie maéridionale." *Wallraf-Richartz Jahrbuch,* XVI (1954): 7-54.
Hutton, Edward. *The Cosmati: The Roman Marble Workers of the XIIth and XIIIth Centuries.* London, 1950.
Jullian, René. *L'éveil de la sculpture italienne: La sculpture romane dans l'Italie du nord.* Paris, 1945.
Krautheimer-Hess, Trude. "Die figurale Plastik der Ostlombardei." *Marburger Jahrbuch für Kunstwissenschaft,* IV (1928): 231-307.
_____. "The Original Porta dei Mesi at Ferrara and the Art of Niccolo." *Art Bulletin,* XXVI (1944): 152-174.
Mâle, Emile. "L'architecture et la sculpture romane en Lombardie, à propos d'un livre récent." *Gazette des Beaux Arts,* CXVII (1918): 35-46.
Porter, Arthur Kingsley. "Bari, Modena, and St. Gilles." *Burlington Magazine.* XLIII (1923): 58-66.
_____. *Lombard Architecture.* 4 vols. New Haven. 1914-1917.
Quintavalle, Arturo Carlo. *La Cattedrale di Modena: Probleme di romanico emiliano.* 2 vols. Modena, 1964-1965.
_____. *Romanico padano, civilta d'Occidente.* Florence, 1969.
_____. *Da Wiligelmo à Nicoló.* Parma, 1969.
Robb, David M. Review of Krautheimer-Hess, "Die figurale Plastik der Ostlombardei." Art Bulletin, XII (1929): 196-200.

Salmi, Mario. *Romanesque Sculpture in Tuscany.* Firenze, 1928.
Salvini, Roberto. *Il duomo di Modena e il romanico nel modenese.* Modena, 1966.
_____. *Wiligelmo e la origini della scultura romanica.* Milan, 1956.
Sheppard, Carl D. "Iconography of the Cloister of Monreale." *Art Bulletin,* XXXI (1949): 159-167.
_____. "A Stylistic Analysis of the Cloister of Monreale. *Art Bulletin,* XXXIV (1952): 35-41.
Toesca, Pietro. *Storia dell'arte italiana,* III, *Il Medioevo.* Turin, 1927.
Verzár, Christine. *Die Romanischen Skulpturen der Abtei Sagra di San Michele: Studien zu Meister Nikolaus und zur "Scuola di Piacenza."* Bern, 1968.
Wackernagel, Martin. *Die Plastik des XI. und XII. Jahrhunderts in Apulien.* Lewipzig, 1911.
Zimmerman, M. G. *Oberitalische Plastik im früher und hohen Mittelalter.* Lipsia, 1897.

SPAIN

Azcarate, Jose Maria de. "La Portada de las Platerías y el programa iconográfico de la catedral de Santiago." *Archivo español de Arte,* XXXVI (1963): 1-20.
Bertaux, Emile. "Santo Domingo de Silos." *Gazette des Beaux Arts,* XCIX (1906): 27-44.
Conant, Kenneth John. *The Early Architectural History of the Cathedral of Santiago de Compostella.* Cambridge, Mass., 1926.
Durliat, Marcel. *L'art roman en Espagne.* Paris, 1962.
Gaillard, Georges. "L'eglise et le cloître de Silos: Dates de la construction et de la décoration." *Bulletin monumental,* XCI (1932): 39-80.
_____. *Les débuts de la sculpture romane espagnole: León, Jaca, Compostelle.* Paris, 1938.
_____. "Notes sur les tympans aragonnais." *Bulletin hispanique,* XXX (1928): 193-203.
_____. *Premiers essais de sculpture monumentale en Catalogne aux Xe et XIe siècles.* Paris, 1938.
Garcia-Romo, Francisco. "Los porticos de San Isidore de León de Saint-Benoît-sur-Loire y la iglesia de Sainte-Foy de Conques," *Archivo español de Arte,* XXVIII (1955): 207-236.
Gomez-Moreno, Manuel. *Catalogo monumental de España, Provincia de León.* 2 vols. Madrid, 1925, 1926.
_____. *El arte romanico español.* Madrid, 1934.
Moralejo-Alvarez, Serafin. "Pour l'interprétation iconographique du portail de l'Agneau à Saint-Isidore de León: Les signes du zodiaque." *Les Cahiers de Saint-Michel-de-Cuxa,* VIII (1977): 137-173.
_____. "La primitiva fachada norte de la catedral de Santiago." *Compostellanum,* XIV (1969): 623-668.
_____. "Saint-Jacques de Compostelle: Les portails retrouvé de la cathédrale romane." *Les Dossiers de l'archéologie,* XX (1977): 86-103.
_____. "Une sculpture du style de Bernard Gilduin à Jaca." *Bulletin monumental,* CXXXI (1973): 7-16.
_____. "Sobre la formacion del estilo escultorico de Fromista y Jaca." *Actas del XXIII Congreso internacional de historia del arte.* Granada, 1973. Pp. 427-433.

Naesgaard, Ole. *Saint-Jacques de Compostelle et les débuts de la grande sculpture vers 1100.* Aarhus, 1962.

Palol, Pedro de, and Max Hirmer. *Early Medieval Art in Spain.* New York, 1967.

Porter, Arthur Kingsley. *Leonesque Romanesque and Southern France.* New York. 1926.

———. "Spain or Toulouse? and Other Questions." *Art Bulletin,* VII (1924): 3-25.

———. *Spanish Romanesque Sculpture.* 2 vols. Paris and Florence, 1928.

———. "The Tomb of Doña Sancha and the Romanesque Art of Aragon." *Burlington Magazine,* XLV (1924): 165-179.

Robb, David M. "The Capitals of the Panteon de los Reyes, San Isidoro of León." *Art Bulletin,* XXVII (1945): 165-174.

Schapiro, Meyer. "From Mazarabic to Romanesque in Silos." *Art Bulletin,* XXI (1939): 313-374.

Williams, John. "San Isidoro in León: Evidence for a New History." *Art Bulletin,* LV (1973): 170-184.

———. "*Generationes Abrahae:* Reconquest Iconography in León." *Gesta,* XVI (1977): 3-14.

———. "'Spain or Toulouse?' A Half Century Later: Observations on the Chronology of Santiago de Compostela." *Actas del XXIII Congreso internacional de historia del arte.* Granada, 1973. I, pp. 557-567.

ENGLAND, GERMANY, AND SCANDINAVIA

Beenken, Hermann. *Romanische Skulptur in Deutschland (11. und 12. Jahrhundert).* Leipzig, 1924.

Blindheim, Martin. *Norwegian Romanesque Decorative Sculpture, 1090-1210.* London, 1965.

Gaul, E. "Neue Forschungen zum Problem der Externstein." *Westfalen,* XXXIII (1955): 113-124.

Jonsdottir, Selma. "The Portal of Kilpeck Church: Its Place in English Romanesque Sculpture." *Art Bulletin,* XXXII (1950): 171-180, 257.

Kluckhohn, E., and Paatz, W. "Die Bedeutung Italiens fur die romanische Baukunst und Bauornamentik in Deutschland." *Marburger Jahrbuch für Kunstwissenschaft,* XVI (1955): 1-120.

Meier, Burkhard. *Die romanischen Portale zwischen Weser und Elbe . . . Mit Unterstutzung der historischen Kommission für die Provinz Sächsen und das Herzogtum Anhalt.* Heidelberg, 1911.

Müller-Dietrich, Norbert. *Die romanische Skulptur in Lotharingen.* Munich, 1968.

Panofsky, Erwin. *Die deutsche Plastik des 11.-13. Jahrhunderts.* Munich, 1924.

Saxl, Fritz. *English Sculptures of the Twelfth Century.* London, 1954.

Stone, Lawrence. *Sculpture in Britain: The Middle Ages.* Pelican History of Art. Harmondsworth, 1955; 2d ed., 1972.

Talbot Rice, David. *English Art, 871-1100.* Oxford History of English Art. Oxford, 1952.

Weigert, Hans. "Das Kapitell in der deutschen Baukunst des Mittelalters." *Zeitschrift für Kunstgeschichte,* V (1936): 7-46.

Wesenberg, Rudolf. "Die fragmente monumentaler Skulpturen von St-Pantaleon in Köln." *Zeitschrift für Kunstwissenschaft,* IX (1955): 1-28.

———. *Frühe mittelalterliche Bildwerke: Die Schulen rheinischer Skulptur und ihre Ausstrahlung.* Düsseldorf, 1972.

Zarnecki, George. *The Early Sculptures of Ely Cathedral.* London, 1958.

———. *English Romanesque Sculpture, 1066-1140.* London, 1951.

———. *Later English Romanesque Sculpture, 1140-1200.* London, 1953.

———. *Romanesque Sculptures of Lincoln Cathedral.* London, 1963.

Iconography, Aesthetics, and the Theory of Images

Alexander, Paul J. "Hypatius of Ephesus: A Note on Image Worship in the Sixth Century." *Harvard Theological Review,* XLV (1952): 177-184.

Baynes, Norman H. "The Icons before Iconoclasm." *Harvard Theological Review,* XLIV (1951): 93-106.

Beigbeder, Oliver. *Lexique des symboles.* La Nuit des Temps. La Pierre-qui-vire, 1969.

Bevan, Edwyn. *Holy Images: An Inquiry into Idolatry and Image-Worship in Ancient Paganism and in Christianity.* London, 1940.

Bruyne, Edgar de. *Etudes d'esthétique médiévale.* 3 vols. Bruges, 1946.

Conant, Kenneth John. "The After-Life of Vitruvius in the Middle Ages." *Journal of the Society of Architectural Historians,* XXVII (1968): 33-39.

———. "The Theophany in the History of Church Portal Design." *Gesta,* XV (1976): 127-134.

Coomaraswamy, Ananda K. "Medieval Aesthetic, I. Dionysius the Pseudo-Areopagite, and Ulrich Engelberti of Strassburg." *Art Bulletin,* XVII (1935): 31-47.

Forsyth, Ilene Haering. "Magi and Majesty: A Study of Romanesque Sculpture and Liturgical Drama." *Art Bulletin,* L (1968): 215-222.

Frankl, Paul. *The Gothic: Literary Sources and Interpretations through Eight Centuries.* Princeton, 1960.

Grabar, André. *Martyrium: Recherches sur le culte des réliques et l'art chrétien antique.* 3 vols. Paris, 1946.

Hall, James. *Dictionary of Subjects and Symbols in Art.* London, 1974.

Ihm, Christa. *Die Programme der christlichen Apsismalerei vom vierten Jahrhundert bis zur Mitte des achten Jahrhunderts.* Wiesbaden, 1960.

Katzenellenbogen, Adolf. *Allegories of the Virtues and Vices in Medieval Art.* London, 1939.

Kirschbaum, Engelbert. *Lexikon der christlichen Ikonographie.* 8 vols. Freiburg, 1968-1976.

Kitzinger, Ernst. "The Cult of Images in the Age before Iconoclasm." *Dumbarton Oaks Papers,* VIII (1954): 83-150.

———. "The Gregorian Reform and the Visual Arts: A Problem of Method." *Transactions of the Royal Historical Society,* ser. 5, XXII (1972): 87-102.

_____. "On the Interpretation of Stylistic Changes in Late Antique Art." *Bucknell Review*, xv (1967): 1ff.

_____. "The Role of Miniature Painting in Mural Decoration." *The Place of Book Illumination in Byzantine Art*. Princeton, 1975. Pp. 109–121.

Koehler, Wilhelm. "Byzantine Art in the West." *Dumbarton Oaks Inaugural Lectures*. Cambridge, Mass., 1941. Pp. 61–87.

LeCoat, Gerard. "Anglo-Saxon Interlace Structure, Rhetoric and Musical Troping." *Gazette des Beaux Arts*, LXXXIII (1976): 1–6.

Mâle, Emile. *L'art religieux du XIIe siècle en France: Etude sur les origines de l'iconographie du Moyen Age*. 2d ed., 1924. Published in English as *Religious Art in France, the Twelfth Century: A Study of the Origins of Medieval Iconography*. Princeton, 1978.

Mango, Cyril. "Antique Statuary and the Byzantine Beholder." *Dumbarton Oaks Papers*, XVII (1963): 53–75.

Murphy, James J. *Rhetoric in the Middle Ages: A History of Rhetorical Theory from Saint Augustine to the Renaissance*. Berkley, Los Angeles, London, 1974.

Pollitt, J. J. *The Ancient View of Greek Art: Criticism, History, and Terminology*. New Haven and London, 1974.

Réau, Louis. *Iconographie de l'art chrétien*. 3 vols. Paris, 1958.

Schapiro, Meyer. "On the Aesthetic Attitude in Romanesque Art." *Art and Thought: Issued in Honour of Dr. Ananda K. Coomaraswamy on the Occasion of His 70th Birthday*. Edited by K. Bharatha Iyer. London, 1947. Pp. 130–150.

Smith, Earl Baldwin. *Architectural Symbolism of Imperial Rome and the Middle Ages*. Princeton, 1956.

Stookey, Lawrence Hall. "The Gothic Cathedral as the Heavenly Jerusalem; Liturgical and Theological Sources." *Gesta*, VIII (1969): 35–41.

Tatarkiewicz, Wladyslaw. *History of Aesthetics*, II, *Medieval Aesthetics*. Edited by C. Barrett; translated by R. M. Montgomery. Mouton, 1970.

Toubert, Hélène. "Le renouveau paléochrétien à Rome au début du XIIe siècle." *Cahiers archéologiques*, XX (1970): 99–154.

Medieval Documents and Literature

Augustine. *On Christian Doctrine: Saint Augustine*. Edited and translated by D. W. Robertson. Indianapolis and New York, 1958.

Davis-Weyer, Caecilia. *Early Medieval Art, 300–1150, Sources and Documents*. Englewood Cliffs, N.J., 1971.

Dionysius the Pseudo-Areopagite. *The Mystical Theology and The Celestial Hierarchies*. 2d ed. Translated by Editors of the Shrine of Wisdom. Fintry, Brook, near Godalming, Surrey, 1965.

Durandus, William. *Rationale divinorum officiorum*. Edited and translated by J. M. Neale and the Rev. B. Webb. *The Symbolism of Churches and Church Ornaments*. London, 1906.

Freeman, Ann. "Theodulf of Orleans and the *Libri Carolini*." *Speculum*, XXXII (1957): 663–705.

Gage, John. "Horatian Reminiscences in Two Twelfth-Century Art Critics." *Journal of the Warburg and Courtauld Institutes*, XXXVI (1973): 359–360.

Holt, Elizabeth Gilmore. *Documents of Art History*, I, *Medieval and Renaissance Art*. Rev. ed. New York, 1957.

Johannes Scote Eruigenae. *Expositiones in ierarchiam coelestem*. Edited by J. Barbet. *Corpus Christianorum*, vol. XXXI. Turnholt, 1975.

Mortet, Victor and Paul Deschamps. *Recueil de textes relatifs à l'histoire de l'architecture et à la condition des architectes en France au Moyen Age*. Paris, 1929.

Panofsky, Erwin. *Abbot Suger, On the Abbey Church of Saint-Denis and Its Art Treasures*. Princeton, 1946.

Theophilus. *The Various Arts (De diuersis artibus)*. Translated and Introduction by C. R. Dodwell. London, 1961.

Théry, Gabriel. *Hilduin traducteur de Denys: Etudes dionysiennes*. 2 vols. Paris, 1932.

Vielliard, Jeanne, ed. and trans. *Le guide du pélerin de Saint-Jacques de Compostelle*. Mâcon, 1938.

William of Saint-Thierry. *Oeuvres choisies de Guillaûme de Saint-Thierry*. Edited and translated by J.-M. Déchanet. Paris, 1944.

Index

References to illustrations are printed in italics following text entries